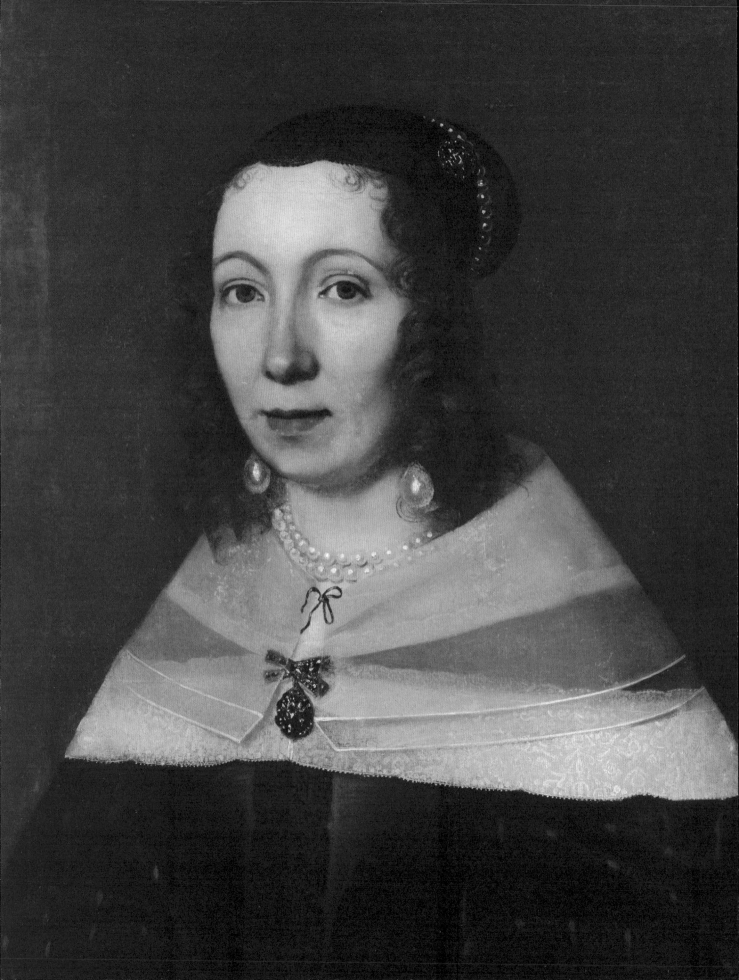

Maria Sibylla Merian

Changing the Nature of Art and Science

Edited by Bert van de Roemer, Florence Pieters,
Hans Mulder, Kay Etheridge & Marieke van Delft

Lannoo

a

Contents

Time Line

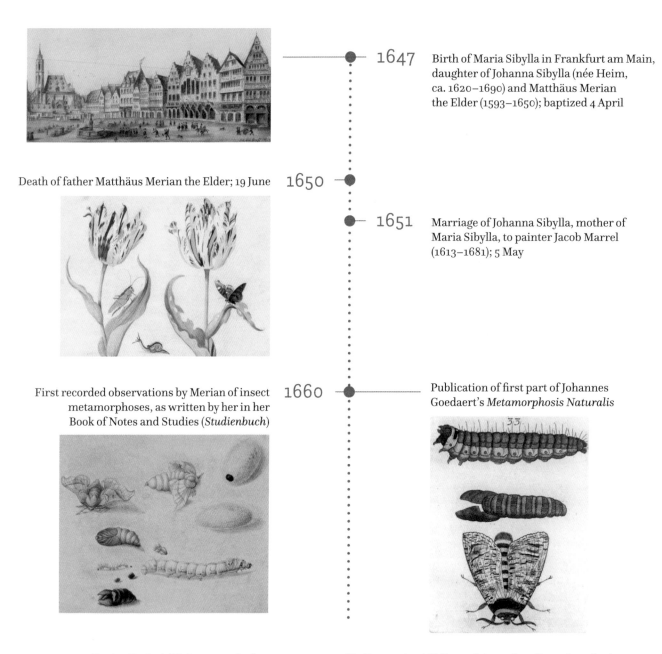

1647 Birth of Maria Sibylla in Frankfurt am Main, daughter of Johanna Sibylla (née Heim, ca. 1620–1690) and Matthäus Merian the Elder (1593–1650); baptized 4 April

Death of father Matthäus Merian the Elder; 19 June 1650

1651 Marriage of Johanna Sibylla, mother of Maria Sibylla, to painter Jacob Marrel (1613–1681); 5 May

First recorded observations by Merian of insect metamorphoses, as written by her in her Book of Notes and Studies (*Studienbuch*) 1660 Publication of first part of Johannes Goedaert's *Metamorphosis Naturalis*

During Merian's lifetime, two calendar systems were used in Europe: the old Julian and the modern Gregorian calendar. In Germany, the Julian calendar was in use until 1700, and in some German regions even longer, whereas in the Dutch Republic (except for Utrecht, Friesland and Drenthe) the Gregorian calendar was used since the end of the sixteenth century. The difference between the two calendars was ten days during the seventeenth century. For instance, Maria Sibylla was baptized on 4 April Old Style, which coincides with 25 March New Style. For the present book, exact Julian dates are given for events up to 1691 because these dates are well-known from primary German sources. For all exact dates ever since, the modern Gregorian calendar system is used in this book.

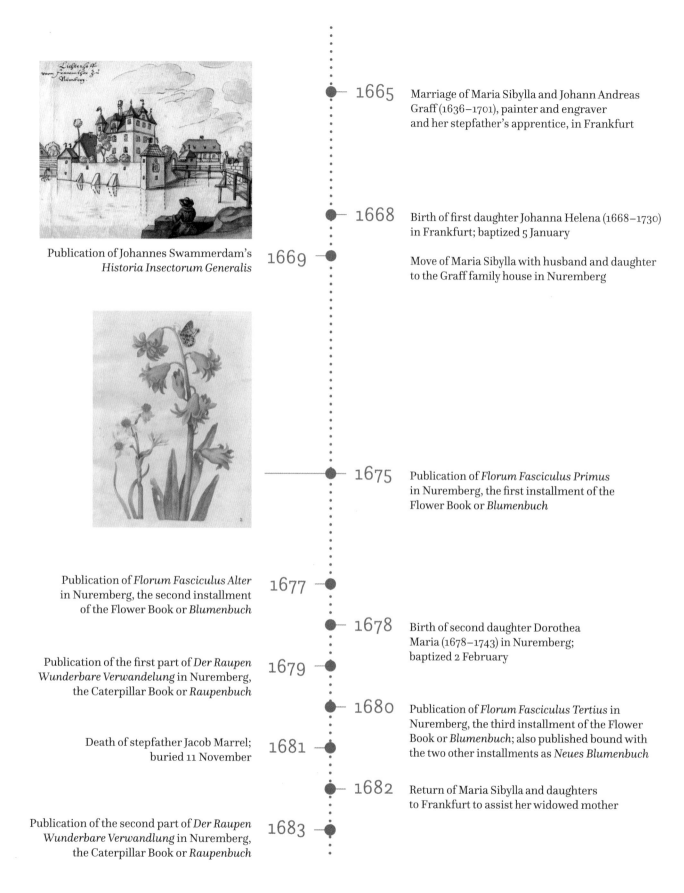

1665 — Marriage of Maria Sibylla and Johann Andreas Graff (1636–1701), painter and engraver and her stepfather's apprentice, in Frankfurt

1668 — Birth of first daughter Johanna Helena (1668–1730) in Frankfurt; baptized 5 January

Publication of Johannes Swammerdam's *Historia Insectorum Generalis* — **1669** — Move of Maria Sibylla with husband and daughter to the Graff family house in Nuremberg

1675 — Publication of *Florum Fasciculus Primus* in Nuremberg, the first installment of the Flower Book or *Blumenbuch*

Publication of *Florum Fasciculus Alter* in Nuremberg, the second installment of the Flower Book or *Blumenbuch* — **1677**

1678 — Birth of second daughter Dorothea Maria (1678–1743) in Nuremberg; baptized 2 February

Publication of the first part of *Der Raupen Wunderbare Verwandelung* in Nuremberg, the Caterpillar Book or *Raupenbuch* — **1679**

1680 — Publication of *Florum Fasciculus Tertius* in Nuremberg, the third installment of the Flower Book or *Blumenbuch*; also published bound with the two other installments as *Neues Blumenbuch*

Death of stepfather Jacob Marrel; buried 11 November — **1681**

1682 — Return of Maria Sibylla and daughters to Frankfurt to assist her widowed mother

Publication of the second part of *Der Raupen Wunderbare Verwandlung* in Nuremberg, the Caterpillar Book or *Raupenbuch* — **1683**

Maria Sibylla settles with mother and daughters in the Labadist community at Waltha Castle, in Wieuwerd, Friesland, where half-brother Caspar Merian already resides

1686

Unsuccessful attempts by husband Johann Andreas Graff to gain acceptance in the Labadist community

Death of half-brother Caspar Merian in Wieuwerd

1690 Death of mother Johanna Sibylla in Wieuwerd

1691 Move of Maria Sibylla and daughters to Amsterdam

1692 Marriage of first daughter Johanna Helena to Jacob Hendrik Herolt (ca. 1660–1715?), former Labadist colony member and trader with Suriname; registered 28 June

Official divorce between Maria Sibylla and Johann Andreas Graff

1694

1699 Voyage from Amsterdam to Suriname with second daughter Dorothea Maria; embarkment in June

1701 Return voyage from Suriname to Amsterdam with Dorothea Maria and a Native American woman

Marriage of Dorothea Maria to surgeon Philip Hendricks from Heidelberg

Publication of *Metamorphosis Insectorum Surinamensium* in Amsterdam, in Dutch and Latin (two editions); January/February

Publication of Georg Everhard Rumphius's *D'Amboinsche Rariteitkamer*

Publication of Charles Plumier's *Traité des Fougères de l'Amérique*

1703 Contact between Merian and London-based pharmacist James Petiver about promoting her work there and translating it into English

1705

Publication of two parts of *Der Rupsen Begin, Voedzel en Wonderbaare Verandering* in Amsterdam, a shortened Dutch translation of the two German Caterpillar Books

1711 Visit of Frankfurter patrician Zacharias Conrad von Uffenbach to Maria Sibylla in Amsterdam; 23 February

1712 Emigration to Suriname of first daughter Johanna Helena and husband Jacob Hendrik Herolt

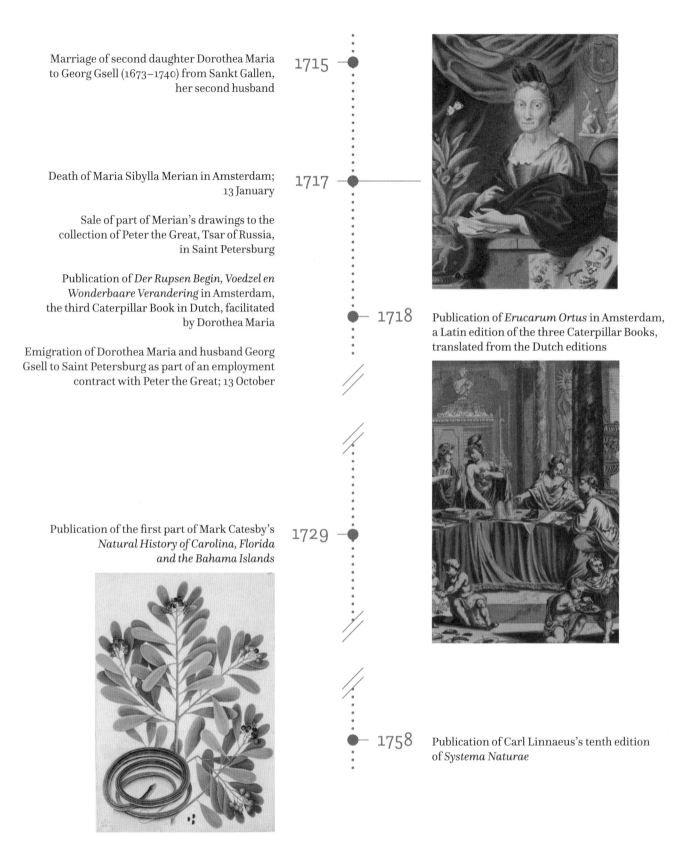

Marriage of second daughter Dorothea Maria to Georg Gsell (1673–1740) from Sankt Gallen, her second husband

1715

Death of Maria Sibylla Merian in Amsterdam; 13 January

1717

Sale of part of Merian's drawings to the collection of Peter the Great, Tsar of Russia, in Saint Petersburg

Publication of *Der Rupsen Begin, Voedzel en Wonderbaare Verandering* in Amsterdam, the third Caterpillar Book in Dutch, facilitated by Dorothea Maria

1718

Publication of *Erucarum Ortus* in Amsterdam, a Latin edition of the three Caterpillar Books, translated from the Dutch editions

Emigration of Dorothea Maria and husband Georg Gsell to Saint Petersburg as part of an employment contract with Peter the Great; 13 October

Publication of the first part of Mark Catesby's *Natural History of Carolina, Florida and the Bahama Islands*

1729

1758

Publication of Carl Linnaeus's tenth edition of *Systema Naturae*

Dactyls in Maria's Book of Notes and Studies

translucent butterfly bordered in black
thistle with girdled abandoned cocoon

thorn-laden branch of the Mexican lime
wild and ungrafted pale sprig of a plum

juvenile lizard omnivorous ground dweller
melons that ripen on sand just like cucumbers

brown-breasted hummingbirds drink from bright shrubs
frogs float with fertilized eggs on their backs

sociable weevils lie next to each other in heaps
circle and separate nimble as mercury

——

Cynthia Snow

DE XVIII. AFBEELDING.

Op dit 18. blad stelle ik voor Spinnen, Mieren, en Colobrietjens op een Guajave-boom [...]

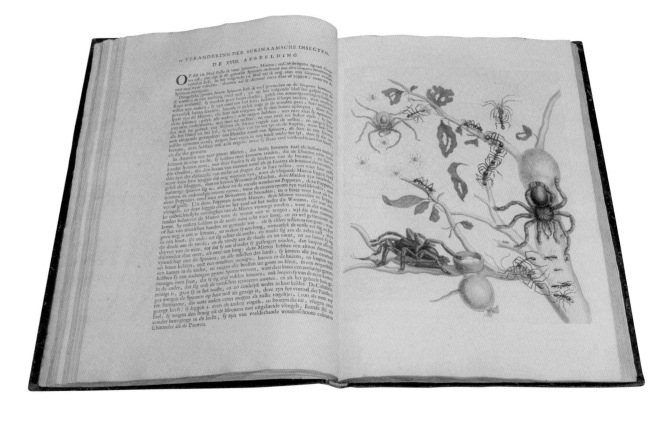

Maria Sibylla Merian. "Between Art and Science, Between Nature Observation and Artistic Intent"

Arthur MacGregor

At three cardinal points in the practice of the natural sciences around the turn of the eighteenth century may be said to have stood the specimen (or collection of specimens), the text, and the image.[1] Advancement of understanding was largely dependent on judicious deployment of all three elements in order to drive the collective effort that had already begun to reveal the structural scaffolding of the natural world. Maria Sibylla Merian occupied an almost unique position at the operational center of this nexus. The specimens she gathered—for the most part insects—formed no part of a static collection in the conventional sense but consisted primarily of reference material for her personal study, although they were also displayed and made available (at a price) to a burgeoning body of enthusiasts. Significantly, she stood outside the emerging networks of exchange developing among contemporary collectors and declined offers of (invariably decontextualized) specimens from others on the grounds that she wished merely to collect information on "the formation, propagation and metamorphosis of creatures… [and] the nature of their diet".[2] For the most part, the lepidopterans which attracted her primary interest lived out their lives under her intense gaze, their progress painstakingly recorded in word and image in her *Studienbuch* for eventual reworking in published form. Merian's aptitude as an observer and recorder, together with her capacity to present her observations as

M.S. Merian, Spider killing a hummingbird and army ants forming a bridge, in M.S. Merian, *Metamorphosis Insectorum Surinamensium*, Amsterdam 1705, plate 18, hand-colored etching, 52 x 35 cm (page). KB, National Library of the Netherlands, The Hague, KW 1792 A 19.

animated compositions—at once accurate, detailed, and aesthetically pleasing—were of an unprecedentedly high order. No less a figure than Johann Wolfgang von Goethe (1749–1832) expressed admiration at her ability to move "between art and science, between nature observation and artistic intent".[3] Her exemplification of so many talents singles her out as the embodiment of much of the best that natural science could aspire to in her era.

The empathy Merian developed for the natural world would have been widely shared by others attracted to the field, but her ability to crystalize her observations in graphic form and to communicate them so vividly stemmed from her independent abilities as an artist and printmaker. Unlike her innate prowess as a naturalist, these skills had been nurtured and honed during a lengthy training in the professional milieu of her parental household, but their application to recording anatomical features in minute detail, first in watercolor and then as prints, represented a distinct personal achievement. The interplay between all of these spheres of expertise is extensively documented and analyzed in the essays that follow in the present volume.

A Naturalist of Her Own Fashioning

The era before the introduction of Linnaean systematics, and particularly the publication of the critical tenth edition of the *Systema Naturae* (1758), imposed a defining framework on the conduct of natural science—a development that brought about the annexing of authority to (inevitably male) academic practitioners, wherein much preliminary fieldwork remained in the hands of nonspecialists; indeed there were no professional naturalists in her day, nor for some time to come. Little sense had yet emerged that individual plants or animals formed components within a broader landscape, and the time remained far off when interdependent elements of ecosystems would be routinely examined in a holistic manner. Hence Merian's particular fascination for the lives of insects was highly unusual for the period. One thinks of her English contemporary, Lady Eleanor Glanville (1652–1709), whose last will and testament was challenged in court by her relations under the Acts of Lunacy, on the basis that "none but those who were deprived of their Senses, would go in Pursuit of Butterflies".[4] Merian was especially precocious in her concern with matters of reproduction and generation, for interactions between species and, more particularly, for the degree to which she took account of the host plants on which her subjects were dependent—some of them proving omnivorous, others highly selective. She herself describes the approach adopted in her volume *Der Raupen wunderbare Verwandelung* (1679) as "an entirely new invention", and indeed the encyclopedic approach she adopted was sufficiently ambitious for her to have been proposed as, perhaps, "the first ecologist".[5] The conceptual leap involved in developing this treatment is scarcely less striking

than the skills Merian brought to capturing and conveying her observations in the form of illustrations. Florike Egmond has detailed the emergence among artists during the previous century of a growing interest in the detailed anatomy of plants and animals, but Merian's attempts to place insect development within the dimension of time in one composition together with the food plants had no precedent.[6] Only personal confrontation with living organisms, sustained over extended periods of time, could facilitate the particular kind of understanding that was to be her hallmark.

A fundamental contrast can be drawn between the nature of Merian's engagement with her subjects and those of her more exalted contemporaries, perhaps especially with Johannes Swammerdam (1637–1680), who epitomizes the furthest development of interest that had been demonstrated to date in insect metamorphosis. In establishing beyond all doubt that the process involved was one of continuous development and not (as hitherto widely believed) of "death and resurrection", however, Swammerdam had revealed to his own satisfaction the hand of the Almighty at work in the design of the least significant of creatures, and hence achieved the ultimate aim of his investigations.[7] While she lived in the intensely religious Labadist community at Wieuwerd, Merian too may have subscribed for a time to a more theological interpretation of the process of metamorphosis,[8] but in general her approach was aligned with that of wider society, within which the precepts of physico-theology none-theless held sway, so that any tension that may have existed between these two approaches may easily be overstated.

Years of diligent observation in the field enabled Merian to demonstrate independently the stable life cycle through which the moths and butterflies she particularly studied regularly passed—not to mention their seasonal behavior, environmental preferences, diet, locomotion, and flight patterns; she even noted the volume of excrement produced by certain caterpillars. Her attention also extended to their predators and parasites: she accurately recorded the emergence of parasitic wasps and insects from host chrysalises well before she came to understand the mechanisms involved in their generation. Her *Studienbuch* records the transition of her subjects from egg to imago—entirely based on observable features—almost a decade before conventional wisdom attributes these discoveries either to Swammerdam or to the Italian scholars Francesco Redi (1626–1697) and Marcello Malpighi (1628–1694).[9] Much of what Redi demonstrated by laboratory experiment and Malpighi by dissection, she had already established incontrovertibly by patient observation and meticulous recording, and even by her own dissections of insect pupae and plant galls. Her researches led her repeatedly to breed a variety of insects—close to three hundred complete metamorphic cycles are recorded—in order to observe their development over time.[10] The practice was one she had already employed in her childhood, and in later life she would

carry with her to the tropics—a methodology that deserves acknowledgement as an independent contribution to the continuing development of the Renaissance construct of the "science of describing".[11]

While the earlier and lesser-known *Raupenbücher* (Caterpillar Books) are now recognized as incorporating some of Merian's most considered and original observations on insect life,[12] the texts accompanying the spectacular images in the *Metamorphosis Insectorum Surinamensium* rarely stray beyond identifying the subjects presented and elaborating on the broader themes they illustrate. Both form a record of her own work and rarely make any appeal to the conclusions formulated by others, an approach she justifies by the fact that this "has already been done at length by Thomas Moffet, Johannes Goedaert, Swammerdam, Steven Blankaart and others".[13] As she wrote in the introduction to her *Metamorphosis*, addressed "Aan den Leezer" (To the Reader): "I could have given a fuller [written] account, but because the views of the learned are so at odds with one another and the world is so sensitive, I have recorded only my observations."[14] The text in fact contains much of interest, but its contribution has tended to be overshadowed by the originality of the illustrations. Merian's particular reliance on the presentation of ocular evidence, together with her reluctance to engage with the discourse of other researchers, certainly contributed to the underestimation from which her work suffered during nearly three hundred years of subsequent history, when privilege was assigned to the discoveries of more assertive (male) academics throughout Europe "doing science" in the approved manner.[15]

If we were to look for an analogous form of publishing, with the image taking precedence over the text, it might be found in the *florilegium*, a genre that gained wide popularity in the seventeenth century and in which, as Brian Ogilvie has observed, "engraved images took precedence over the increasingly atrophied text, until they were soon little but picture books".[16] Ogilvie's linking of these works with the world of self-fashioning rather than narrow academic research seems an apposite characterization for the market found also by works authored by Merian who, from her earliest *Raupenbuch* of 1679, addressed herself broadly to "the nature- and art-loving reader".[17]

To some degree it is an accident of history that so much interest has come to be focused on Merian's obsession with insects, for the surviving drawings make clear that given the necessary time and resources she could have produced other studies on South American reptiles and amphibians in particular—specifically snakes, lizards, and frogs—whose life cycles she was able similarly to observe and record, and perhaps also on plants. For all her facility as a botanical artist, however, it seems unlikely that Merian would have been able to bring a comparable degree of understanding to plant physiology, although the corpus of drawings contains clear evidence that she was already applying the methodology

evolved in her insect studies to the elucidation of the development of plants as well as amphibians and reptiles. Had they been brought to fruition, these investigations would have demonstrated more fully the broad scope of her interests—even though the limited plantation-based sphere within which she collected in Suriname ultimately would have denied her work the status of a representative survey—and cemented her reputation as an early observer of the interdependent nature of the natural world.[18]

Establishing a Genre and a Market

Reconciling Merian's fascination for detail—microscopic in all but the most literal sense—with her painterly ambitions to please the eye was never going to be easy; there was simply no precedent for it. Earlier artists such as those of the school of Joris Hoefnagel (1542–ca. 1600) had, of course, produced beautifully detailed miniature paintings of insects, but the groupings they adopted were invariably random, arbitrary, and lacking in biological relationship, in contrast to Merian's purposeful studies. Her eagerness not only to capture the surface detail of the organisms she represented but to integrate and subordinate it in her image-making, for example, is antithetical to the tendency to visual fragmentation that has been identified as characteristic of the work of contemporary microscopists; Robert Hooke's (1635–1703) identification of the need for "a *sincere Hand*, and a *faithful Eye*, to examine, and to record, the things themselves as

they appear", however, seems singularly apposite for application to Merian.[19]

Merian succeeded brilliantly in creating a one-woman genre that addressed both the requirements of the naturalists for anatomical correctness and the aesthetic interests of the connoisseurs, whose tastes she had learned to cater for in her training as an etcher and engraver. The volumes she produced conjured up a hitherto unimagined world to a wide European audience—all the "Liefhebbers en Onderzoekers der Natuur" (Amateurs and Explorers of Nature) to whom her *Metamorphosis* is dedicated—who in turn responded warmly to her picturesque treatment of the complex lives of the subjects she presented. In particular, the conventions she evolved for compressing weeks or months of elapsed time and metamorphic change into multiple images on a single sheet, while also setting her subjects in context, opened the eyes of her contemporaries. In the words of art historian Martin Kemp, her images began "to breathe an air of romance in suggesting the unfolding drama of life cycles".[20] The major groupings of her original drawings that survive today owe their continuing integrity to their eager acquisition by three of the foremost collectors and connoisseurs of her day: Sir Hans Sloane (now in the British Museum), Dr. Richard Mead (now in the Royal Collection, Windsor Castle), and Peter the Great, Tsar of Russia (now in the Academy of Sciences, Saint Petersburg).[21]

To mention the early reception of Merian's images, however, is to move

beyond the medium of drawing and painting to that of printing—the means by which her work reached a wider audience. Here her ability to etch her own plates placed her in a position of exceptional control, the most fortunate purchasers being favored with editions accurately colored by her own hand. Already in her first Caterpillar Book (1679), in which selected European insects were treated, the fifty plates have been identified as an expression of her mature style.[22] More widely acknowledged as her masterpiece, however, is the *Metamorphosis Insectorum Surinamensium* (1705), although here most of the sixty large-format plates were etched and engraved (under Merian's rigorous supervision and partly by herself, see Heard's chapter in this volume) by "the most renowned masters" she could commission; her role as orchestrator and publisher of the whole exercise was nonetheless a virtuoso performance in its own right. Plans for companion volumes based on records of the reptiles and amphibians of Suriname and on associated plant species observed there remained unfulfilled at the time of her death, at the age of almost seventy, although the numerous supporting appearances made by these species among her published images clearly signal her intent. No one could doubt that the compositions originating in Merian's *Studienbuch* are to be classed as *ad vivum* or *naer het leven* in the most literal sense— her subjects feeding, procreating, crawling, flying, swimming[23]—but it bears mention that in their re-combination in printed form in the aesthetically pleasing

compositions that rendered her work so widely admired, the individual elements were deprived of none of their precise, documentary value and were never themselves rendered merely picturesque.

Among the naturalist community there were some who caviled at erroneous relationships they detected in a few of the life cycles depicted in the *Metamorphosis*, constructed from the numerous vellum fragments on which the various stages of development had originally been recorded and assembled months or years later into animated compositions. Perhaps inevitably, Merian had been misled on occasion into relating the early stages of development of one creature with the later phases of another, or in conflating more than one species with another—failures that are all too understandable in the unregulated and at times positively primitive conditions in which her observations were originally compiled and the lengthy gestation of the finished volumes.

Her technique of telescoping entire life cycles into a single drawing certainly demanded some distortion of reality, with plants shown simultaneously in bud, in full flower, and in fruit (a convention already well-known and accepted among botanical illustrators), when the pupae of certain species normally found underground were represented attached to leaves alongside their mature manifestations, or when nocturnal species were shown alongside diurnal. Critics of these seeming anomalies would have found them explained in her accompanying texts, had they troubled

to read them in their original, unexpurgated form; later editions of her *Raupenbücher* are shorn of much of Merian's supporting evidence, with almost all of her behavioral and ecological observations omitted. One important feature was the care she took to render every insect at natural size as far as possible, facilitating the relating of one subject to another; only occasionally did she stray from this convention, as when tiny ants had to be enlarged in order to make them comprehensible on the page, or when larger reptiles were introduced into the composition at a reduced scale in order to fit the page.[24] At times, however, her readers proved incredulous in the face of the curious truths she portrayed; bird-eating spiders, for example, were simply beyond the imagination of most Europeans, even those with experience in some parts of the tropics.

Not everyone subscribed to the concept that illustrations might form a self-sufficient and self-authenticating body of evidence, or indeed that they might have an independent validity as scientific evidence. Some historians of science have posited a decline in confidence among contemporary naturalists in the evidential power of images, reference being made to the famously withering pronouncement of Carl Linnaeus (1707–1778): "I do not recommend the use of images for the determination of genera. I absolutely reject them... I admit that they offer something to the illiterate... But who ever derived a firm argument from a picture?"[25] Isabelle Charmantier has made plain the mis-

taken basis of the construction widely placed on Linnaeus's words, which were directed specifically to the identification of genera, and has shown him to have been, in fact, a lifelong advocate of the use of illustrations, notably in the depiction of species.[26] Despite lamenting the "absence of names" in the *Metamorphosis*,[27] Linnaeus and other dedicated systematists were, indeed, able to name over a hundred species on the basis of Merian's drawings from Suriname, providing the most eloquent vindication of the general veracity and the detailed accuracy of her recording and validating their now-undisputed scientific authority. Merian's capacities for naturalistic representation surely justify her place of honor as a contributor to the emergence of "a new visual culture that reinforced appeals to eyewitness and first-hand experience", despite the continuing tendency of history "to privilege the scholar, theorizer, and conceptualizer above the maker".[28]

A Legacy Undermined and Recovered

Later publishers less rigorous than Merian herself, along with an increasingly exclusive (and still overwhelmingly male) proto-scientific community, were complicit in bringing about the decline in her reputation witnessed from the later eighteenth century onwards. The fall from grace suffered by Merian's work and the misappropriation to later entomologists of some of the names that rightly should have been given to her, was a process whose origins can be

traced to the multiple editions of her earliest texts. Repeated issues of the *Metamorphosis* also suffered from lack of her personal oversight, particularly those in which the plates were hand-colored without reference to the author's original palette; the "exactly repeatable pictorial statements" promised by print technology proved all too easily subverted when control slipped from the originator.[29] Some late editions of her major works had texts or plates added or combined, for instance from Goedaert (see the chapter by Van de Plas in this volume), or from the more decorative oriented *Blumenbücher* (Flower Books) produced early in Merian's career (1675–1680), intended to serve foremost as embroidery patterns, before she had developed a more scientific purpose, so adding further layers of confusion.[30]

Planned translations of the original (Dutch and Latin) text of *Metamorphosis* failed to appear, perhaps fortunately so, given their increasingly attenuated relationship to the original. Kay Etheridge has noted that the Dutch translations of Merian's 1679 and 1683 *Raupenbücher* shortened the original German text to such a degree that almost all of the groundbreaking descriptions they contained concerning insect ecology and behavior were omitted—a contraction seemingly imposed by Merian herself (with the aid of one of her daughters); one half to a third of the original excursus was lost in this way. The truncated Dutch text was then translated into Latin and French in the posthumous editions of her work, and it was these shortened

versions that many eighteenth- and nineteenth-century naturalists encountered; most of them would never have known of the breadth of information contained in the German original.[31] Further losses would undoubtedly have been imposed in the proposed English translation (from the Latin) of the *Metamorphosis*, for James Petiver (ca. 1663–1718), to whom the task was given, had intended to reorganize the content in systematic form.[32] One can only be thankful that it never appeared, for the images reproduced in his own publications from Merian's originals are reduced to wretched icons, while the accompanying texts—systematic in organization but laconic in the extreme—are shorn of all contextual detail.[33]

Perhaps the most vituperative (not to say condescending) of Merian's critics, Lansdown Guilding (1797–1831), fell spectacularly foul of every misconception generated by the publishing history outlined above. His plate-by-plate analysis of the *Metamorphosis* was published in 1834, that is, more than a century after Merian's death, during which time the academic study of entomology had advanced considerably.[34] While acknowledging that "we can never sufficiently admire the zeal of this female votary of the sciences", he immediately asserts that "the fair author's volume abounds with errors" and proceeds to itemize them over the following twenty pages. Using a late (1726) edition, evidently colored by an inexpert hand, Guilding (who had no first-hand knowledge of Suriname)

takes issue with "the absurd position of many of the figures, and the very great inaccuracy of others", and even the "fanciful and useless" decorative frontispiece; he misinterprets many of the representational devices adopted and he disbelieves many of the phenomena represented, which subsequently have proved accurate. The whole exercise, replete with references to scientific papers published after her death, is noteworthy principally as an illustration of the determined character assassination perpetrated on Merian by a largely misogynistic academic community.

Over the past half century much has been done to rehabilitate the reputation of this extraordinarily resourceful and talented investigator in a field that was largely ignored by contemporary society and which remains today a rather specialized area of research. That Merian was able to achieve so much in revealing the mechanisms of a little-regarded and hitherto almost totally misunderstood form of life, and to present it to the public gaze in such an intelligible, dramatic, and beautiful form, is as remarkable as the oblivion into which her achievements had fallen in the meantime. The insightful and scholarly essays gathered in the present volume further consolidate her reputation as both naturalist and artist, while forming an apposite twenty-first century salute to a true heroine of the early modern age.

* As well as acknowledging the valuable advice and support of this volume's editors, I am grateful for comments received from Dr. Kate Heard, Dr. Dominik Hünniger and Dr. Charlie Jarvis.

The World of
Maria Sibylla Merian

Kay Etheridge

In recent years, Maria Sibylla Merian's story and her contributions to art and science have attracted widening interest, both scholarly and popular, and she has inspired the creative endeavors of a number of artists and writers. In 2017, the tercentenary year of her death, an international conference in Amsterdam celebrated the conjunction of new scholarship and artistic works related to Merian, which led to the publication of this volume. The objectives of the collection herein are to provide new insights into Merian's life and work, to re-examine the existing canon, and to explore her influence on the contemporary arts. Contributing authors variously investigate the settings in which she lived and worked, her personal networks, her processes and products, and her influence on art and natural history. Her work is compared to that of artists and scientists that both preceded and followed her, as well as to that of a variety of contemporaries, both female and male.

This chapter will introduce the contents of the volume, beginning with a scaffold on which to place these diverse offerings. Arthur MacGregor's preface el-

oquently frames Merian's work within her period, and I will describe her contributions to the study of natural history in the context of what came before her. I also will provide a brief overview of her biography, her research on insects, and the books that she wrote, illustrated, and published to disseminate her work. Many rich sources can provide additional historical detail on her life and work, but Merian's own books provide the best insights into her accomplishments as an artist and naturalist.[1] A time line is included in this volume as a guide to this necessarily compact account of decades of biography and accomplishment, and it includes the chronology of related natural history works discussed in this volume.[2]

Before Merian

While it is true that Merian was an exceptional artist whose subject matter was unusual for a woman of her day, it is her contribution to our understanding of the natural world that sets her apart. Before Merian's 1679 *Raupenbuch* (Caterpillar Book), which is described more fully below, European naturalists addressed insects and plants separately. Herbals

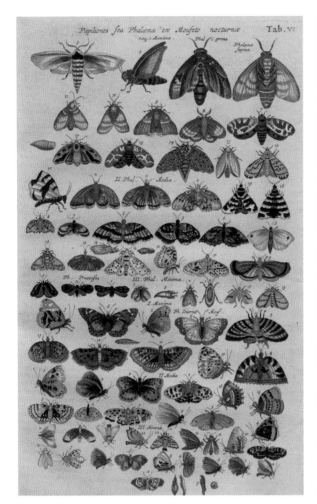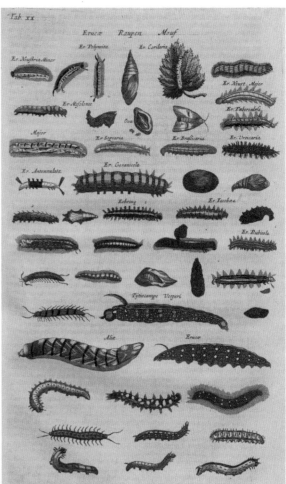

Fig. 1 Unknown copyist after M. Merian the Younger and C. Merian, Lepidopteran adults and caterpillars, in J. Jonston, *Naeukeurige Beschryving van de Natuur der Gekerfde of Kronkel-dieren*, Amsterdam 1660, plates 6 (left) and 20 (right), hand-colored etching, 29 x 17.5 cm (plate). Artis Library, Allard Pierson, University of Amsterdam, AB 126:23.

featuring medicinal plants stretch back long before the advent of the printing press. Flower Books (*florilegia*) proliferated somewhat later, as gardening grew in popularity. Aristotle and Pliny described several common insects, and the first printed books with content on insects referred to these classic sources. Insect encyclopedias by Ulisse Aldrovandi (1522–1605), Thomas Moffet (1553–1604),

Jan Jonston (1603–1675), and others added some new information, but each subsequent volume copied from earlier works.[3] These encyclopedias, like others on animals, reiterated classical knowledge and presented basic descriptions and some early classification schemes. In this period, insects were investigated separately from the plants on which they depend for food and shelter, and the various life

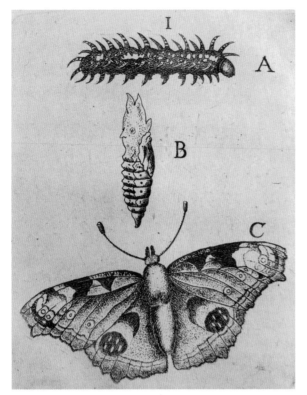

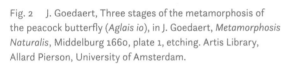

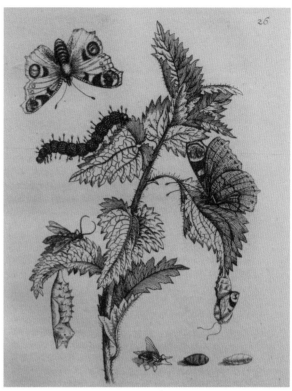

Fig. 2 J. Goedaert, Three stages of the metamorphosis of the peacock butterfly (*Aglais io*), in J. Goedaert, *Metamorphosis Naturalis*, Middelburg 1660, plate 1, etching. Artis Library, Allard Pierson, University of Amsterdam.

Fig. 3 M.S. Merian, The metamorphic cycle of the peacock butterfly (*Aglais io*) on a common nettle, in M.S. Merian, *Der Raupen wunderbare Verwandelung*, Nuremberg 1679, plate 26, etching. Spencer Collection, New York Public Library.

stages of these small animals, if studied at all, were usually presented independently. An example may be seen in Jonston's 1653 insect encyclopedia, which was illustrated and published by Merian's half-brothers, Matthäus Merian the Younger (1621–1687) and Caspar Merian (1627–1686), and published in more than one edition (Fig. 1).[4]

The Dutch naturalist and painter Johannes Goedaert (1617–1668) was the earliest to study metamorphosis to any great extent, and his three volumes on the insects he collected and raised in his Middelburg home provided a reference for Merian. Goedaert often mentioned the plants on which the larvae fed, but without much detail, and he usually did not illustrate this relationship (Fig. 2). Merian's "novel invention", as she terms it in the full title of her 1679 *Raupenbuch*, was to place caterpillars on their host plant. The difference in presentation from that of Goedaert is evident in Merian's depiction of the same species of peacock butterfly, with its life cycle arranged around the common nettle, a preferred food of this caterpillar (Fig. 3). Her image includes an intact pupa and another pupa with the butterfly begin-

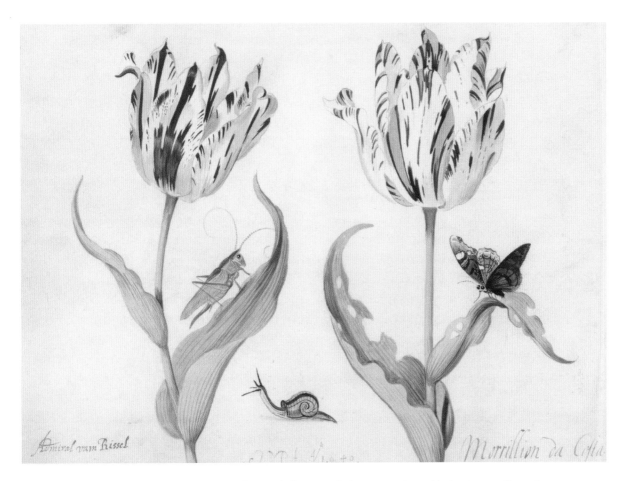

Fig. 4 J. Marrel, Portrait of two tulips (1640), in *Album with drawings of tulips*, watercolor and bodycolor on vellum, 265 x 335 mm (vellum sheet). Rijksmuseum, Amsterdam, RP-T-1950-266-41-1.

ning to emerge, as well as a fly often found with the caterpillars.[5] Unlike the static images in Figures 1 and 2, her moths and butterflies fly or perch on plants, and if the wings are patterned differently on two sides, she shows both, providing another important aid to identification. Merian's dynamic compositions worked hand in hand with her informative text, in which she described ecological interactions of her insect subjects with the plants they lived on. She sometimes included interactions be-

tween insects as well, such as parasitism and predation, and unlike Goedaert and other predecessors, she made it clear that caterpillars hatched from eggs after the mating of the adults. Her writings and images were influential in a number of ways discussed elsewhere, and are further investigated in this volume.[6]

A Brief Biography

How did a young German woman with no formal education come to make such breakthroughs in natural history studies?

Maria Sibylla's family situation and the timing of her birth provided fertile ground for a budding artist and naturalist. Born into a family of publishers and engravers in Frankfurt am Main, she grew up in a city that was home to book fairs, gardens, and a silkworm industry, each of which played a role in developing interests leading to her eventual career. It was not atypical for German girls to participate in an artisanal family business, and Merian received training from her family members. What was unusual for a young girl was for her to become so captivated by the insects that she was learning to paint, that she spent more than five decades dedicated to their study.

As indicated in the time line, Merian was just thirteen when she began to record the metamorphoses of butterflies and moths. Her tenacity and powers of observation were formidable, and these were coupled with her ability to convey what she saw through her art and careful notation. Her well-known father, Matthäus Merian the Elder (1593–1650), died when she was just three, and much of her artistic training and inspiration was provided by her stepfather. Painter Jacob Marrel (1614–1681) married her mother when Maria Sibylla was four years old, and one can see echoes of his work in her earliest compositions of plants and insects. Marrel was one of many artists who painted "tulip portraits", but his were atypical in that they were usually enlivened by insects, snails, or spiders (Fig. 4).[7]

Her half-brother Caspar and one of Marrel's apprentices, Johann Andreas Graff (1636–1701), may also have in-structed young Maria Sibylla in the arts. At eighteen, she married Graff, ten years her senior, and less than three years later she gave birth to their first daughter, Johanna Helena, followed soon after by a move from Frankfurt to Graff's family home in Nuremberg. There, she taught painting to female students, continued with her own paintings, and began an intensive period of research, capturing and then raising caterpillars through metamorphosis and recording their transformations and food plants. Maria Sibylla seemed to remain close to her half-brother Caspar, who may have influenced her later move to Wieuwerd, as well as to her stepfather. A portrait identified as Merian at age 32 is attributed to Marrel (see the frontispiece of this book), who stayed with her and her husband in Nuremberg during part of 1679.

The thirteen years in Nuremberg (1668–1682) were richly productive. In addition to the birth of a second daughter, Dorothea Maria, in 1678, Merian produced three sets of decorative flower plates, the *Blumenbücher*, as well as her first natural history work, the 1679 *Raupenbuch* (Caterpillar Book). It was in Nuremberg that she also completed much of the research for her second and third caterpillar volumes. The *Blumenbücher* she etched served as models for embroidery and painting, primarily by young women such as Merian's students.[8] The production of the decorative plates between 1675 and 1680 overlapped with the beginning of her intensive inquiries into metamorphosis and other aspects of the lives of insects.[9] The

title of her first research publication, the 1679 *Raupenbuch*, describes it as being "for the benefit of naturalists, artists, and garden lovers", acknowledging the connections that she recognized between the various aspects of her work.

After Jacob Marrel's death in 1681, Maria Sibylla and her daughters moved to Frankfurt to assist her widowed mother, while Johann Andreas Graff traveled back and forth between Frankfurt and Nuremberg. Two years later, she published her second Caterpillar Book; it was printed in Nuremberg, where she had completed most of the research for it.[10] Strains on the marriage as well as other factors may have precipitated another move around the turn of the year between 1685 and 1686. Maria Sibylla, together with her daughters and her mother, joined her half-brother Caspar at the Labadist colony at Waltha Castle in Wieuwerd, Friesland (a province of the Dutch Republic) (Fig. 5). Much text has been spent in speculation about her motives for the move and the state of the Graff marriage, but one result of her five-year

Fig. 5 J.A. Graff, *Grundriß vom bekanten Busch zu Wieuwarden [...]*, ca. 1686, colored pen and brush drawing, 337 x 420 mm. Staatsarchiv Nürnberg (StaatsAN), Handschriftliche Karten, inv. no. 212, 1686. Courtesy of Staatsarchiv Nürnberg.

stay with the Labadists was the effective end of the marriage. Graff was not permitted by the group to join his wife and daughters there.[11]

Merian continued her natural history research to some degree while living with the Labadists, as evidenced by dated entries in her *Studienbuch,* which is her collection of research notes and drawings.[12] While at Waltha Castle, she also took the time to organize and recopy the part of her *Studienbuch* that was the basis of her first two Caterpillar Books.[13] Another result from her time at Waltha may have been the connections she forged that led her to move to Amsterdam in 1691, upon leaving the Labadist colony. These connections may also have facilitated her eventual travel to the Dutch colony in Suriname.

Amsterdam was one of the largest cities in Europe at the time and a center of global trade and innovations in art and science. The city was home to a vibrant publishing industry and art market and a well-established botanical garden; it also fostered opportunities for immigrants and for women that were not so readily available elsewhere. In this stimulating environment, Merian continued her painting and her natural history studies, and she became involved with the city's rich network of collectors and naturalists. As discussed elsewhere and in chapters within this volume, she was active in this circle, trading and selling specimens, providing paints and paintings, and visiting natural history collections.[14] Spurred by the exotic butterflies she had seen in Dutch collections, she and her younger daughter, Dorothea Maria (1678–1743), traveled to Dutch Suriname in 1699 for an intensive two years of work in the tropics.[15] Her plan for a longer stay was cut short by serious illness, and she returned to Amsterdam in 1701 to live out her life, continuing her research, art, and writing. As well as publishing the *Rupsenboeken,* Dutch translations of her 1679 and 1683 *Raupenbücher,* Merian wrote, illustrated, and published two more original natural history books during this period. The best known of these is her 1705 folio volume *Metamorphosis Insectorum Surinamensium.* Lastly, her third and final caterpillar volume was published shortly after her death in 1717 by Dorothea Maria, this time written in Dutch rather than German.[16]

Merian's fame continued to grow during her final years in Amsterdam, and collectors such as Sir Hans Sloane (1660–1753) and Richard Mead (1673–1754) sought out her work. She corresponded with collectors such as James Petiver in England, and she knew Caspar Commelin (1668–1731), botanist at the Amsterdam botanical garden, well enough to have him provide Latin names for the plants included in *Metamorphosis.* Merian was also visited by distinguished travelers such as Zacharias Conrad von Uffenbach (1683–1734) in 1711 and Jacopo Guiducci, a legate from Cosimo III de' Medici (1642–1723), in 1714.[17] Around the time of her death, Tsar Peter the Great's physician, Robert Areskin (1677–1718), bought a large portion of her original notes and studies from her heirs, one more indication of the esteem in which her work was held.[18]

Merian's Motivation

Her choice of a life's work was arduous, challenging, and never guaranteed to produce a net income. In contemplating what motivated Merian to study insects, some scholars have emphasized her piety; certainly, natural theology (physico-theology) was a factor in stimulating a great deal of natural history study in her time.[19] In fact, Merian's writings are no more pious in tone than many of her contemporaries, and indeed less so than Goedaert, whose language is often overtly religious. *Metamorphosis*, her Suriname work, contains only one mention of God. However, Merian's time with the Labadist colony at Waltha Castle has provided fodder for the argument that her work was largely devotional in nature. It should be noted that religious fervor was not the only reason to make such a move. For centuries, women retreated to religious communities like convents or beguinages for a variety of reasons, such as widowhood and economic, family, or societal pressures. In Merian's case, family circumstances may have contributed to her decision to move to Waltha Castle; her half-brother Caspar preceded her in joining the colony there, and her mother moved there as well. All of this occurred at a time when her marriage to Johann Graff seems to have been in difficulties.[20]

Whatever the initial impetus for her work on insects, it was sustained for five decades by her insatiable curiosity. Her primary motivation was that typical of most scientists who make valuable contributions—she delighted in new discoveries. Her writings make this clear, as in this excerpt on the emperor moth (*Saturnia pavonia*) from her 1679 *Raupenbuch*:

> *Many years ago, when I first saw this moth, large and exceptionally well formed by Nature, I could not marvel enough at its beautiful shadings and contrasting colors, and at the time I often used it in my paintings. But after I discovered the transformation of the caterpillar some years later, by the grace of God, it seemed to me a very long time until the beautiful moth-bird came forth. Thus, when I did obtain it, I was filled with such great joy and was so pleased in my intent that I can hardly describe it.[21]*

Her drive to understand the nature of insect metamorphosis was sustained well into her later years. Merian was 52 when she set sail for Suriname to investigate tropical insects for the first time, and a *Studienbuch* entry dated 1710 demonstrates that she was still making new observations when she was 63.

Merian's Process and Publications

As shown in the time line, Merian illustrated three sets of decorative flower plates, the *Blumenbücher*, between 1675 and 1680; researched, wrote, and illustrated three books on the natural history of European insects (*Raupenbücher* in German and *Rupsenboeken* in Dutch) between 1679 and 1717; and in 1705 published her landmark volume, *Metamorphosis Insectorum Surinamensium*, on the

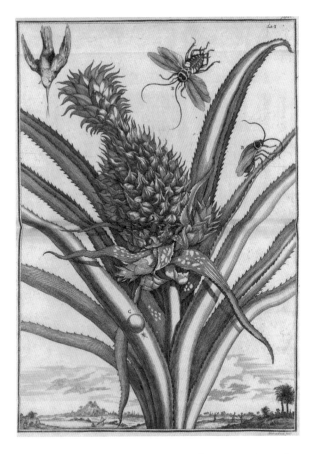

Fig. 6 Pineapple and roaches, in J.Ch. Volkamer, *Nürnbergische Hesperides*, Nuremberg 1708–1714, plate 1 in supplement, etching. Oak Spring Garden Library Foundation, Upperville, Virginia.

plants and insects of the Dutch colony of Suriname. A number of translated editions of her work were published as well, both before and after her death. After publication of the 1705 *Metamorphosis* in Dutch and Latin, her 1679 and 1683 Caterpillar Books were translated from German into Dutch (likely by Dorothea Maria) and published in 1712. The Dutch editions were shortened and condensed, possibly to save on the cost of printing longer volumes; the earlier German editions with more text used three times as much pa-

per, a major contribution to their cost. Although Merian reached a wider audience with the shorter, translated editions, she undercut her own reputation with later readers, because the text, reduced to about one third of the original, was largely descriptive and omitted her hard-won ecological and behavioral observations. Compounding the problem, these severely truncated versions were the source for editions translated into Latin and French after her death. As will be discussed in this book, the posthumous volumes were a mixed blessing for her legacy; they broadened the reach of her work to a larger audience, while at times doing damage to her scientific reputation through clumsy additions, poor coloring, and other problematic changes to her original work. However, Merian's books were much emulated and her images often copied, in particular those from her dramatic tropical plates in *Metamorphosis*. For example, her ripe pineapple was copied for the *Nürnbergische Hesperides* (1708–1714) of Johann Christoph Volkamer (1644–1720) (Fig. 6); as in many cases, she was not credited for the original image, which was the first plate in *Metamorphosis*.

Merian's productivity was remarkable at a time when some of her contemporaries struggled to publish even one volume of their work. John Ray's *Historia Insectorum* was published posthumously by a colleague and included the work of Francis Willoughby (1635–1675), who predeceased John Ray (1627–1705).[22] Similarly, Johannes Swammerdam (1637–1680) published a small subset of his work on insects before his death in

1680, and his more extensive contribution on insects did not appear until 1737.[23] But what is even more remarkable about Merian's productivity and contribution to natural history was the scope of the contents of her books.

In order to appreciate in full the breadth of her work on insects and their plant hosts, one must read Merian's books. To grasp the amount of labor and tenacity involved, it is necessary to put oneself in her shoes, as she collected and raised roughly three hundred species of insects through metamorphosis, supplying them with specific plant foods and carefully recording her observations in notes and small study paintings. She often failed to obtain the complete metamorphic cycle on her first try, and would spend multiple years attempting to get even one adult moth or butterfly of a given type. As she wrote of the dot moth (*Melanchra persicariae*) in her 1679 *Raupenbuch*:

> I had them [the caterpillars] for three years in a row, yet only with great effort did I get a few date seeds [pupae], but no insects from them [...]. Until finally in the fourth year of my investigations, in February of last year, to my great delight, this single one, namely a moth, came forth.[24]

Insect collection and husbandry would have been difficult enough in Germany and the Netherlands, where her collecting sites were fields, orchards, and gardens filled with familiar plants and insect species. The challenges of doing so in a steamy and strange tropical forest were greatly compounded, and her time there curtailed by serious illness—something that can still happen to tropical researchers today. As a point of comparison, almost half of the young men that Carl Linnaeus (1707–1778) sent on collecting expeditions in the eighteenth century died after leaving Sweden.

Not only did Merian do all of the research for her books, she also etched most of the plates. She completely etched all of the 102 plates for the 1679 and 1683 *Raupenbücher* as well as the plates for her decorative *Blumenbücher*. Her etching skills are best appreciated in uncolored copies of her work (see Fig. 3). She also had a hand in plate production for the 1717 *Rupsenboek* and in the 1705 *Metamorphosis*; the latter is discussed in detail in this volume.[25] Finally, Merian colored some copies of her work to sell, and was involved in the marketing of her books. Her degree of involvement in the production of her own books is exceptional for the time, and accounts for much of their quality and subsequent success.

Contents of this Book

The contributions in this volume represent a variety of voices and views, and include historical investigations as well as contemporary artistic responses to Merian and her work. Historical research today is facilitated by digital versions of images, books, archives, newspapers, and auction catalogues, and online access to these sources can promote broader and deeper inquiries than previously were feasible. Some of this new research fills gaps in our knowledge and, in other

cases, findings are used to test statements and assumptions that have become codified and repeated without being questioned. We expect that this book will open new lines of interdisciplinary inquiry related to Maria Sibylla Merian, and look forward to seeing how the seeds planted here will grow.

Woven throughout the book are contributions that address Merian's art and the various ways in which she has influenced the arts today. Kurt Wettengl connects her art and investigations of nature to a variety of artists working in recent decades, some of whom have biological training and others who, trained as artists, moved towards incorporating observations of nature in their art. Some artists have employed animals as co-producers of their work, and Wettengl presents several fascinating examples, including Joos van de Plas, who contributes to this volume in another way, as described below.

Offerings from poet Cynthia Snow and videographer Jadranka Njegovan were another integral part of the 2017 conference, and a sampling of their work is included here as examples of the ways Merian continues to inspire creativity today. Snow's poems cause us to consider Maria Sibylla from more intimate perspectives, including those of her daughters. Njegovan's video of hatching, growing, and metamorphosing cabbage moths captivated the audience at the 2017 conference, demonstrating how nature still has the power to draw us in close. In her contribution to this volume, still images from this video work

together with an account of her own discoveries, which is remarkably similar in feeling to the curiosity and wonder expressed by Merian.

A number of recurring themes ground the historical chapters on Merian in this book. Contributing authors address the effects of her surroundings, her personal and professional networks, and the processes by which she conducted her research and produced her books. In some cases, Merian and her work are compared and contrasted to that of near contemporaries who studied nature in a similar manner. Other chapters focus on her influence on subsequent artists and naturalists and other aspects of her legacy. To aid the reader, the historical chapters are grouped roughly within these themes. However, slotting each chapter into a tidy category was neither practical nor desirable, because the areas of overlap among the topics, as with the intersections between art and science, are some of the most interesting areas of study.

Effects of Milieu and Networks

It is easy to elevate Merian to the status of a singular heroine, but as with any successful person, a number of factors were at play in her life and career, and several of these are addressed herein. In addition to the training and influence of her family in Frankfurt, she benefitted from family, friends, students, teachers, and patrons in Nuremberg, from connections made at Wieuwerd, and from a rich network in Amsterdam. Merian provides an example of someone whose network of supporters, collaborators,

and audience can be traced by a variety of clues, including her contributions to friendship albums or *alba amicorum*.

Merian was unusual for her time in many ways, and one that is often discussed is her separation from her husband Johann Andreas Graff and their eventual divorce. Graff's biography largely has been neglected, and Margot Lölhöffel remedies this by discussing his life, establishing the fact that Graff was a talented artist in his own right. Her chapter is richly illustrated with his images of Nuremberg, giving us a sense of the city in their day. In addition to providing a thorough background on Graff, Lölhöffel offers insight into his support of Maria Sibylla's early career as a natural scientist and artist. She also traces Graff's life and career after the separation from Merian, and lays to rest many of the myths surrounding this overlooked artist.

Elements of Merian's life in Nuremberg also are revealed in the essay by author Christine Sauer, who addresses the use of the flower images from Merian's *Blumenbücher* by women in that city as models for painting and embroidery. Discussion of these crafts gives us insight into the place of women of Merian's social standing in Nuremberg and their relationships with each other. Sauer also describes the use of friendship books, known as *alba amicorum* or *Stammbücher*, used from the sixteenth century onward. Surviving copies of these personal objects provide valuable evidence of connections among people, and this information is tapped by other contributors to this volume.

Florence Pieters and Bert van de Roemer expand upon individuals in Merian's network by discussing contributions to several more *alba amicorum*, beginning with some from Nuremberg and continuing on to examples from her time in Amsterdam. Because she did not leave behind a large volume of personal correspondence, analysis of these albums adds substantial detail to what we know about her relationships with a number of influential people, while at the same providing links to other threads of investigation, addressed by Van de Roemer in yet another chapter in this volume. The *alba amicorum* examined by Pieters and Van de Roemer reveal some entries as artistic expressions and others as clues to rivalries as well as friendships; Merian's own entries tell us more about her personality and personal life.

Liesbeth Missel's essay focuses on a female contemporary of Merian in the Netherlands, Alida Withoos (1661/62–1730), who also painted flowers. Missel's insightful account of her life reveals parallels with that of Merian, with whom she may have had connections. Both women made drawings for Agnes Block (1629–1704), who was a wealthy collector and naturalist, but also a significant patron for artists like Merian and Withoos. Female collectors have not been given attention proportional to their influence in networks of the period, and Missel helps to remedy this by providing a window into the life and significant contributions of Block.

Processes of Observation and Production

Process is broadly defined here as the techniques and methods by which Merian and others made observations and gathered information. Production signifies the steps by which this information was put into their results in written and visual form. Essays on these topics fall into two categories: those that focus on primarily Merian's work and those that compare her work, and thus her processes, to that of some of her near contemporaries. In the former grouping, Katharina Schmidt-Loske and Kay Etheridge detail how she studied and depicted the pupal stage of metamorphosing moths and butterflies. This less showy stage of development can go unnoticed in Merian's illustrations; however, a close look at how she studied and painted the seemingly inert pupae reveals much about her as an artist-naturalist. Schmidt-Loske and Etheridge provide excerpts of Merian's text, painted studies and printed images that demonstrate her fascination with this mysterious but dramatic step in the change from caterpillar to adult insect.

Merian collected almost all of her German and Dutch insect specimens herself, although she occasionally received caterpillars from people in her European network. However, the process of gathering specimens and information about plants and animals in a region new to a naturalist more often than not relies heavily on people living there who are familiar with the terrain and the organisms. This was the case for countless other explorer-naturalists, and Merian was no exception. In Suriname, she relied heavily on enslaved and indigenous people, and without their essential contributions, the 1705 *Metamorphosis* would not exist. Marieke van Delft addresses this reality in her chapter, which is set in the context of the history of the Dutch colonization of Suriname. She examines what is known of Merian's relationship with the people living and working there—indigenous and enslaved persons and colonists alike—and the numerous ways in which the first two groups contributed to her tropical research. Van Delft also provides accounts of several near contemporary naturalists who benefited from enslaved labor, bringing focus to this critical and often neglected component of historical accounts.

The rich materials collected and studied in Suriname were only the first phase of Merian's work on *Metamorphosis*. Upon her return to Amsterdam in 1701, the production phase of the project began in earnest. Financing such a large and heavily illustrated volume was a tremendous challenge that may have thwarted the project for an artist-naturalist less industrious than Merian. Selling subscriptions was a time-honored method of raising funds for a publishing project, and Merian did this as well as selling specimens from Suriname. She went a step further than other naturalists, however, and developed a unique product: luxury editions of her tropical images. These were paintings of her tropical insects and plants produced by using a sophisticated counterproof printing technique on vellum

rather than on paper as she had done with earlier counterproofs. Kate Heard reveals Merian's working practices by evaluating numerous examples of these paintings on vellum in the British Royal collection and in the British Museum. Heard's careful analysis of these rare counterproof editions is valuable in illuminating some of the processes behind the production of the magnificent plates printed for the 1705 edition of *Metamorphosis*. Conventional wisdom regarding this volume has been that Merian painted the plants and animals based on her studies, but that the plates were etched almost entirely by Dutch artisans; Heard's essay challenges this assumption in parts.

What is not in question is that professional printers were responsible for production of the text in Merian's books. Hans Mulder has investigated the various letterpress printers involved in the publication of her books, beginning with the 1675 *Blumenbuch* in Nuremberg and ending with the posthumous 1719 edition of *Metamorphosis* in Amsterdam. He presents evidence tying the different printers to the books and, in doing so, helps us understand details of the printing trade at the time. Mulder also discusses Merian's possible reasons for choosing certain printers, which is relevant to a better understanding her considerable business acumen and contributes to our knowledge of her network. Merian's books provide an excellent case study as Mulder gives us insights into the trail of small clues that must be followed to unravel such puzzles in book history.

In an essay that bridges the themes of production and of Merian's contemporaries in natural history, Bert van de Roemer addresses the question of her possible involvement in a book that was published in Amsterdam the same year as *Metamorphosis*. The beautifully rendered *naturalia* in the 1705 *D'Amboinsche Rariteitkamer* of Georg Everhard Rumphius (1627–1702) have been attributed to Merian in a number of works on her life; Van de Roemer's essay traces how this idea began and then took hold in the literature. He employs detailed visual and textual analyses of the purported evidence for this connection and, in refuting Merian's authorship of the Rumphius images, provides a model method for evaluating artistic attribution. Van de Roemer's investigation also addresses workshop practices of the time, a topic that, as he suggests, should bear close scrutiny in studies of Merian and others.

Comparison to Near Contemporaries

A third group of essays makes comparisons of Merian to naturalists of her period who worked in closely related areas. The similarities and differences in ways of working in both laboratory (generally the home of the researcher) and field elucidate the various means by which nature was studied at the time. Eric Jorink grounds his essay with a central belief shared by Johannes Swammerdam and Merian: that all animals (e.g., insects) have the same basic structures and underlying mechanisms of growth and reproduction. Swammerdam preceded Merian by a few

years, and Jorink argues that his work may have influenced her views. Both naturalists broke new ground on insect reproduction, and their means of study and visual representation had some common elements but divergent approaches. Jorink's chapter illustrates Swammerdam's skillful use of microscopy and his carefully drafted details of metamorphic stages, comparing this close-up viewpoint to Merian's focus on a larger ecological picture of insect relationships with plants.

Two contributors describe the methods of other artist-naturalists working in European colonies in the Americas and, by comparing them to Merian, shed light on the processes of gathering and recording information. Jaya Remond considers the practice of botanical image making by Merian and French botanist Charles Plumier (1646–1704) as they explored the neotropics and recorded the plants they encountered. Like Merian's *Metamorphosis*, Plumier's *Traité des Fougères de l'Amérique* appeared in print in 1705; he completed his research by 1694 and the book was published after his death. Remond's essay reveals fascinating similarities and differences in their approaches and visual strategies; she also discusses the role of Merian and Plumier's accompanying text. The pivotal role of artist-naturalists like Plumier and Merian in conveying information regarding new species to a European audience emerges in a way that grounds us in the colonial setting in which the work occurred.

Henrietta McBurney's essay forms a bridge between the theme of Merian's contemporaries and that of her legacy as she explores parallels between Merian's work and that of artist-naturalist Mark Catesby (1683–1749). Catesby's *Natural History of Carolina, Florida and the Bahama Islands* (1731–1743) was influenced by Merian's *Metamorphosis*, although he worked in temperate habitats as well as the subtropics. McBurney provides insight into the methods used by these naturalists in the production of their artistic and informative images, detailing their use of color and their means of composing images that integrated plants and animals. Her essay also gives us an appreciation for the rigors of their pioneering fieldwork, even as Catesby and Merian worked to "balance art and science".

Influence and Legacy

A final group of essays addresses Merian's legacy and influence from additional angles. Like Mark Catesby, other naturalists knew of her work, and many cited her. Anja Grebe follows the trail of her influence on the development of entomology in Germany, which began with Merian's work. Merian, celebrated by Christoph Arnold (1627–1685) in a laudatory poem that compared her favorably to a number of earlier naturalists, had her work cited as early as 1687. Grebe's investigation of several seventeenth- and eighteenth-century German naturalists reveals Merian's extensive impact on entomology in that country and also tells us something about how her books were used. Most of the German scholars included in Grebe's essay likely had access to German editions of her *Raupenbücher*. As mentioned

earlier, the posthumous editions of Merian's books disseminated her work more broadly. However, the translated text on European insects deviates from her original German *Raupenbücher* and, as we shall see in this volume, other changes to her work were made as well.

Awareness of how these later editions of Merian's books were constructed is essential in understanding how she and her research on insects were perceived through history. In her chapter on the visual branding of Merian, Lieke van Deinsen demonstrates the key role that Amsterdam publisher Johannes Oosterwyk (1672–1737) played after he bought her text, images, plates, and the rights to publish all of her work after her death. Central to Van Deinsen's essay are two different portraits of Merian that Oosterwyk commissioned to appear in the front matter of her books. These visual devices elevated her status to that of a female intellectual authority, something that was perhaps unprecedented for the time. Van Deinsen situates these commissioned portraits in the context of other author portraiture of the time as she recounts their creation and importance to Merian's legacy.

Soon after publishing his editions of Merian's work, Oosterwyk sold all of her copperplates and texts to another publisher in Amsterdam, Jean Frédéric Bernard (1680–1744). He produced a very different kind of book, combining all of her previously published work into a variety of volumes described in the essay by the artist Joos van de Plas. For example, Bernard's 1730 volume, *De Europische*

Insecten, included not only the text and plates from Merian's European Caterpillar Books and *Metamorphosis* but also most of the flower plates from her early *Blumenbücher*. Van de Plas begins her essay by describing her own search for artistic inspiration in the works of Merian. Along this journey, she has made discoveries of her own regarding Merian's work, the latest of which solves a mystery regarding odd additions to Merian's flower plates in Bernard's *De Europische Insecten*. By turning her keen artist's eye on these anomalous images, Van de Plas determined the source of these awkwardly placed additions and identified the artist who added these insects. Further detective work led Van de Plas to the person who plagiarized the earlier naturalist's text, adding it to Merian's. The added insects did not fit either aesthetically or scientifically into Merian's decorative flower plates. Sadly, anyone buying these adulterated volumes had no way of knowing that Merian was not responsible, and these additions may have diminished her reputation with some audiences.

Merian's influence and legacy can be assessed to a degree by learning who owned her books. Alicia Montoya uses databases of auction catalogues to document the presence of Merian's publications in a sampling of eighteenth-century private libraries. Her analysis profiles the other kinds of books that owners of Merian's work held in their libraries, and she discovers some intriguing trends. Many of these collectors also held works on physico-theology, a connection that Montoya explores along with the tendency

for these libraries to contain other well-illustrated natural histories, such as Georg Everhard Rumphius's *D'Amboinsche Rariteitkamer*. Interestingly, Montoya found that the majority of the Merian editions in Dutch libraries in the eighteenth century were the posthumous editions, linking her findings to other essays in this book that address the negative effect that some aspects of these volumes had on her reputation.

Bibliophiles were one readership that sought Merian's books, but another important audience were scholars pursuing their own research. Yulia Dunaeva and Bert van de Roemer recount several examples of naturalists for whom Merian's books, and even her unpublished *Studienbuch*, were sources of reference that aided in organizing and naming insects with a degree of consistency. It is ironic that Merian herself was uninterested in this aspect of natural history, yet her accurate images assisted people like James Petiver and Carl Linnaeus in their endeavors to classify and name organisms. Dunaeva and Van de Roemer describe how Merian's images are used even today to identify unknown specimens in historic collections such as the Kunstkamera in Saint Petersburg. This final essay provides an excellent example of the ways in which Merian's artful scientific observations have influenced art and science for generations.

Conclusion

The subtitle "Changing the Nature of Art and Science" alludes to the contents of this book, as well as to many aspects of Merian's life and work. Her own titles include the words transformation or metamorphosis—the element of natural history studies of insects that fascinated her the most. Her curiosity about this process and the ecological settings in which it occurred set her apart from most other naturalists of her time; it also sustained her through more than five decades of research, including a perilous journey to work in the tropics. Merian herself changed over time, both in the type of work she produced and in the increasing authority in her writings about the natural history of insects. A comparison of her humble and somewhat pious tone in the 1679 *Raupenbuch* to a passage in the 1705 *Metamorphosis*, questioning a statement by Antonie van Leeuwenhoek (1632–1723), provides one example of this change.[26]

The evolution of Merian's images is most evident if one begins by observing the flower prints in her earliest published work, which were primarily artistic in nature. Even as the scientific content in her writing and images increased, her artful nature shines through, and she is clear about her audience, addressing her books on European and Surinamese insects to lovers of art and nature equally. As she modeled new ways of understanding and presenting nature for generations to come, she changed the relationship of art and science. Perhaps her greatest contribution was to remind us of the inextricable connections between these two fields.

Maria Sibylla Merian Reconsidered. Art and Nature in Contemporary Art

Kurt Wettengl

The biography of the artist and naturalist Maria Sibylla Merian could in some respects be that of a contemporary artist working at the current interface of art and science, coming from a patchwork family and working largely as a single parent. Her independence on the one hand, and adaptability to the wishes of clients on the other, are considered important qualifications for artists today. Merian's ability to develop her own projects as a matter of course, but also to have to find financial backers for them, is reminiscent of how artistic activities are financed today. Merian lived in different places and was therefore flexible and mobile, living as a migrant in the Netherlands and moving easily in cosmopolitan and various cultural circles.

But then Merian is also clearly a witness to past developments. She worked as an artist and naturalist at a time when science was only gradually differentiating itself and entomology was in its nascent stages.[1] In this respect she undoubtedly did pioneering work. She worked in a phase before Linnaeus's new systematization of nature, but she also experienced the beginnings of the new taxonomy used to identify European species as well as the thousands and thousands of newly discovered species brought to Europe from colonized regions.[2] The extent to which Merian's empirical research was linked to religion and theology can be clearly seen in her Caterpillar Books; yet entomology also had to defy religious dogma.

In Merian's time, art still played an important role in the visualization of natural history research, something which it has no longer done since the middle of the nineteenth century at the latest. The separation of scientific disciplines as we know it today is about two hundred years old. Originating from an "internal differentiation dynamic of the sciences themselves",[3] it is only since the nineteenth century that we recognize the division of natural sciences and humanities, which seems self-evident to us today and establishes the Cartesian

dualism of nature and mind, nature and culture.[4] There is, however, a counter-movement. The sociologist Bruno Latour—one of the best-known representatives of science and technology studies (STS)—already stated in the 1990s that we have always lived in a universe of the hybrid and recommended cultivating the willingness to live with the hybrid, the assemblages of knowledge and explanations. For him, the dichotomization of culture and nature is untenable. Equally outdated, according to him, is the dichotomy of object and subject. For science studies, according to Latour, it makes no sense to speak of "'out there,' or nature; 'in there,' or the mind; 'down there,' or society; 'up there,' or God".[5]

Such perspectives on STS are elucidating when looking back at the research of the artist and naturalist Merian in the early modern period, when—as already mentioned—the natural sciences, being not differentiated in themselves, were still called "natural history" and the visualization of knowledge through art was still part of it.

They are also illuminating when looking at today's artists, who move at the interface of art and science in their artistic research. The artist Mark Dion's statement that scientists do not have a monopoly on the idea of nature, but rather that it is a realm of ideas shaped by culture, to the creation of which many areas of society contribute, is representative of this current artistic self-image.[6] In other words, the separa-

tion of the natural sciences and the humanities and the dichotomy of nature and culture is being called into question today from various perspectives, while art is contributing to this.[7]

Today's artists often—and at the same time—reflect on the framework of their investigations in historical, sociological, and global perspectives. With this, they also scrutinize the nature-culture split, examining the theories, methods, and concepts whereby artists and scientists approach nature. Here, the artist Merian would not be considered as such in terms of contemporary art. As a world traveler, for example, she unconcernedly brought exotic objects back to Europe that both promoted new knowledge and served as trade goods. Such a combination of the object as simultaneously a means of knowledge and commodity is critically examined today—also in art. For the artist as well as for the collectors of *naturalia* and ethnographic objects, such problematizations were as yet unforeseen at that time, like questions about the structures of violence or the ethical aspects of killing animals for taxidermy. This includes taking for granted the use of the Dutch colonial infrastructure in the colony of Suriname—comprising seagoing trade and the structures of the slave-owning society—which would not only be alien to today's artists but also critically questioned.

Under different aspects, some examples of today's artistic research in the field of nature will be presented in the following. In some cases the artists refer directly to Merian; in others, it is easy to

form connections between Merian and today's artists across the centuries. In doing so, we also recognize the similarities and differences mentioned above.

Aesthetics of Nature

In the nineteenth century modern biology rejected Merian's entomological research, mainly with the reservation that her depictions were decorative.[8] At that time, new genres of illustration emerged to which Merian's pictorial forms no longer corresponded. The artist and naturalist had found a previously unknown pictorial form that narrated the metamorphosis of the butterfly from egg to imago on a single sheet and placed it in the context of the food plant. Outside of the scientific context, Merian was also not appreciated by art history until after the Second World War. The depictions were considered to be not artistic enough and too heavily oriented towards natural history. In the context of art, it was the painter and writer Anita Albus (*1942) who, even later, not only appreciated the achievements of the pictorial inventions and the research on which they were based but also took them up in her own pictorial language and with traditional painting means. Albus oriented herself not only according to Merian but also to the tradition of the "scientific naturalism" of Georg Hoefnagel (1542– ca. 1600), who had influenced the early still life painter Georg Flegel (1566–1638) and through him also Jacob Marrel (1614–1681), Merian's stepfather.[9] In addition to Joos van de Plas (to whom we will return later), the painter Pia Fries (*1955) also referred to the aesthetics of Merian's watercolors and publications. She entered into a dialogue with Merian across the ages in her series "Les Aquarelles de Leningrad" (2003) and in the later series "Merian's Surinam" (2008/09). At first glance, the fact that she tears the reproductions on which she paints into two pieces may seem iconoclastic, but this is an already familiar artistic gesture with which Fries creates space on the 80 x 60 cm sheets of paper, and thus a "gap" for her examination of the artist of the Baroque era of the seventeenth and eighteenth century. Fries herself metaphorically compared the dangers of an expedition and the risks of failure in the act of painting: "The act of painting is like a journey, alone and without a guide for the first time, without a routine, like Merian's expedition to Suriname, an unknown continent, which in the seventeenth century posed the question of survival, a real threat to life."[10] While Fries reacts to Merian's models with bright colors and applies the oil paint impasto on the paper, the artist Markus Huemer (*1968) takes away all sensitivity from Merian's complex animal-plant depictions. He reduces the pages from the Caterpillar Books and the *Metamorphosis Insectorum Surinamensium*, taken by him as templates in his series since about 2014, to black and white and gray values, to which sometimes a bright yellow is added for the flowers or the leaves of the plants. This yellow evokes especially the aspect of infestation by a virus, which is echoed in the titles of the paintings.[11] The

pictorial form chosen by Huemer removes the informational content that makes Merian's *Metamorphosis* paintings so special. Apparently, the biological virus—the parasite that sometimes remained hidden from Merian the naturalist, but which she sometimes also put into the picture—is brought into a relationship here with the digital virus that can also seize image software. In any case, Huemer's loss of the aesthetic dimension of the models he adopted in the sense of appropriation art goes hand in hand with the loss of knowledge transfer that Merian's pictorial forms represent.

From Metamorphosis to Mutation

Merian's studies of natural history showed the close connection between animals and food plants, and we can therefore place them in the context of the study of biodiversity. In view of today's climate change and the daily extinction of animal species, including insects, brought about by humans, an increasing number of artists are making biodiversity their subject. Human encroachment into the habitats of wild animals is creating previously unheard of human-animal encounters, which also—as we are experiencing drastically with the outbreak of the Covid-19 pandemic—bring new dangers for humans.[12]

Danish artist Tue Greenfort (*1973) has been concerned with ecological issues since the beginning of his artistic career.[13] His first artwork on the relationship of humans to animals in the city was the 2001 photo series *Daimler-strasse 38*, in which foxes photographed themselves on a vacant brownfield site in Frankfurt's industrial area. As they fed on the bait the artist had laid out, they triggered a camera with a self-timer that he had built out of trash objects:

This place interested me as an urban ecological niche that became an unexpected animal habitat. [...] What particularly interested me here was to create an image, both exotic and fascinating, of a nature that has nestled itself in the urban space that is actually alien to it. This shows the ability of nature to adapt. It is not just "out there" for instance, but present throughout the biosphere.[14]

Greenfort's photographs were taken as part of a quasi-scientific research project the artist commissioned himself to undertake. Since Greenfort is familiar with recent art history, and in some cases he explicitly refers to it—for example, to Hans Haacke's Real Time Systems in the 1960s—he is also familiar with other artists who worked intensively on issues of ecology, sustainability, and the natural sciences in the 1980s and 1990s, and who continue to do so today. Mark Dion is one of them.

Since the 1990s, the American artist Mark Dion (*1961) has symbolically and drastically shown with his drawings, sculptures, and installations where the destruction of nature and thus the basis of all human and non-human animals can lead.[15] His artistic work is closely connected with Merian, whose activity must

44

Fig. 1 M. Prüfer, *Bestäubung & Ernte*, Performance Handbestäubung (*Pollination & Harvest*, Performance Pollination by hand), 2018, fine Art Print, 70 x 46.5 cm. Courtesy of Maximilian Prüfer.

also be seen in the dialectic of knowledge about nature and its destruction. Through her trade in "exotic" animal preparations, she participated in early modern forms of the exploitation of nature by serving the needs of collectors: they obtained coveted animal preparations that served their need for representation and at the same time included the possibility for new knowledge. Dion has for decades been concerned with questions of the systematization of knowledge about nature in the period from the Re-

naissance to the present day, as well as the problems that arise from humans' striving to dominate nature.

When Dion conceived and realized his multipart spatial installation *Frankenstein in the Age of Biotechnology* in 1991, public discussion about genetic manipulation of field and garden plants and animals was just starting to emerge.[16] The space of his walk-in installation evokes associations with an attic or a rumpus room. A concentrated look, however, reveals that almost all of the more than seven hundred objects refer to our appropriation of nature to the point of creating the same in a retort: from cuddly animals in a discarded baby carriage to animal and hunting still-life paintings, from dog sleds and hunting implements to genetically manipulated petunias and laboratory tables. The installation combines the myth of Mary W. Shelley's (1797–1851) character of Victor Frankenstein from 1818, who brings great misery upon humankind with the creation of an artificial being, with current debates about genetic engineering and its consequences. Even Frankenstein warns of the consequences of a science that follows only the principle of feasibility in a fictitious newspaper interview, which is included in the installation's research laboratory. With his artistic work, Dion critically observes and accompanies processes in the sciences. He poses the question of what is lost for the alleged gains, thereby paraphrasing the well-known aphorism "Every solution to a problem creates new problems."

Similar to Dion's study of biology for some time after graduating from art

school, in order to gain more detailed insights into the natural sciences, the Swiss artist Cornelia Hesse-Honegger (*1944) likewise followed a path via natural science to art. She worked for 25 years as a scientific draftsperson at the Zoological Institute of the University of Zurich, and now for a long time in the border area between art and science. For this she invented the term *Wissenskünstlerin* (knowledge artist).[17] She has a difficult position vis-à-vis biologists and zoologists, and this despite—or precisely because of—her important findings, which were made through her research on the connection between low doses of radiation and mutations in insects. The crossing of boundaries between art and science, however, offers possibilities to be rediscovered if one thinks back to the artist-researchers from the Renaissance to the eighteenth century and their collaboration with the sciences. One of the trailblazers in this regard was the artist and naturalist Merian.

While Hesse-Honegger painted mutated fruit flies and houseflies that she bred in laboratories from 1967 onwards, because she felt they were "prototypes of a future man-made form of nature", she seems to have believed even more unwaveringly in the natural sciences as the means to discover truth at that time—as was generally the case. However, the catastrophe of the nuclear accident at Chernobyl in 1986 had a drastic effect on Hesse-Honegger. Self-commissioned and self-financed, she researched, drew, and published the results of her field studies on the "true bugs" of the suborder Heteroptera and on fruit flies (*Drosophila melanogaster*). She recognized that morphological damage had occurred in the specimens she studied due to the ionizing radioactivity released after the nuclear accident, but noticed this also in the vicinity of Swiss and international nuclear facilities. She was met with rejection from scientists, or was accused of being completely ignorant. The artist and researcher continues her *Seh-Forschung* (vision research) and—as publications of the Smithsonian Institute in Washington, D.C., indicate—is now taken very seriously in certain scientific circles.[18] Her large-format drawings and watercolors are created after close examination with a binocular loupe. They are not, however, scientific illustrations:

> *On a neutral white background, she emphasizes the architectural proportions of the insects, their structure and monumentality, but also their decorative surface. The postures are formal and sophisticated. She alters leg and wing positions to emphasize deformity, while for the same reason she often omits limbs and body parts.*[19]

Yet, for the artist, each insect is an individual. By noting the location and date of discovery, as well as the anomaly observed, the attached labels meet scientific standards. When artists become involved in social and political processes, as Hesse-Honegger does, and also advocate environmental protection, as Dion does, they can only hope to be noticed. The realization that the understanding of the world

Fig. 2 Gruppe Finger, *Frankfurter Bienenhaus* (*Frankfurter Beehouse*) in front of the Museum Ostwall in Dortmund in the Dortmunder U, 2014. Courtesy of Gruppe Finger.

through science is limited is one of their goals, as is the idea of the equivalence of research in art and science.

The impact of humans on our ecosystem, more specifically the drama of insect mortality for plant pollination, was brought to the attention of German artist Maximilian Prüfer (*1986) in an artistic research that took him to China and the remote, mountainous region of Sichuan. During Mao's Great Proletarian Cultural Revolution, sparrows were eradicated as pests in the course of land reforms. The ensuing plague of insects was controlled by insecticides to such an extent that in some regions the flowers have been pollinated by humans since the 1980s. Prüfer traveled to this region at both pollination and harvest time, and acquired a pear tree, which he also pollinated himself. Through photo tableaux and in the video *A Gift from Him* (Fig. 1), showing the hardships people go through, from pollination to harvesting and selling at market, the scope of the human destruction of the Earth becomes clear.[20]

Animals as Co-Producers

The closeness to animals that Merian had as a breeder of butterflies, whose

stages of development she wanted to observe, characterizes many projects by contemporary artists. Here, too, the ecological crisis and the extinction of species is a motive for artistic projects.

In their *Stadtimkerei* ("urban beekeeping" project), the two German artists Florian Haas (*1961) and Andreas Wolf (*1969), together known as Gruppe Finger, have been combining animal husbandry with social and artistic activities since 2007.[21] Communicating the ecologi-cal, social, and cultural aspects of beekeeping is of great concern to them. In 2014 their numerous projects, which often take place in international museums, included the *Frankfurt Bee House*, designed for the forecourt of the Museum Ostwall in Dortmund (Fig. 2).[22] The motifs of the house's colorfully designed outer shell refer to the cultural history of beekeeping and the overlapping worlds of humans and animals, as well as the bee itself. It depicts various pollens, the mono-

Fig. 3 S. Kannisto, *Private Collection*, 2003, chromogenic dye coupler print, 129.5 x 160 cm. Courtesy of Persons Projects.

culture resulting from the industrialization of agriculture, genetically modified pollen created by Monsanto (MON 805), a queen bee with drone and worker bees, maggots as food for the parasitic mite *Varroa destructor*, Saint Ambrose as the patron saint of beekeepers, and a honeycomb with worker bees performing different tasks. Although "urban beekeeping" can be considered a win-win project, including animals in aesthetic production is always a conscious intention on the part of the artists.

While the aforementioned artist Prüfer has created collaborative works with snails and insects, Björn Braun (*1979) has in recent years more frequently created artworks with the participation of birds.[23] In his studio, zebra finches built nests prefabricated in nature by other birds using artificial materials provided by the artist. However, he also supplied his zebra finches exclusively with materials such as grasses, wool, jute, synthetic fibers, or wire wrapped in colored plastic and let them use these materials to create their nests. The objects created by the birds are aesthetically designed "small sculptures" and at the same time have a natural and functional form.[24] Braun makes use of the instinctive behavior of the birds, which naturally use plastic scraps and scraps of paper to build their nests in their urban habitat today. The results of this process in which birds adapt to the environment could be called "animal architecture" by zoologists.[25]

Joos van de Plas (*1952) also discovered animals as collaborators in artistic production. A few years ago, she built a butterfly house in her studio because she wanted to recreate and better explore Merian's way of working. A rather accidental observation in the behavior of the caterpillars led her to systematically include other "unnatural" material: she not only gives the caterpillars leaves and twigs as food, but also building material in the form of shredded paper, painted cardboard, plastic particles and threads, and other materials. The caterpillars intuitively add these materials to their pupae, which provides them with protection as they continue to develop. They produce a sticky mass that holds the various parts together, even after they have fully developed into butterflies.[26] The empty pupa has the appearance of a small work of art. The terms "architecture" and "sculpture" are obvious, but for the animals themselves these are natural stages, even if they use material foreign to them. Like the artists Prüfer and Braun, Van de Plas thus initiates an "interspecies collaboration" that highlights the questionability of separating culturalized and natural habitats.[27]

Field Trips and Research Journeys

Through her natural history research on her doorstep, in the gardens and surroundings of her homes in Frankfurt am Main, Nuremberg, Amsterdam, and Wieuwerd, Merian gained new insights into the flora and fauna and their interrelationships. After having seen exotic butterflies in Wieuwerd and in Amsterdam collections, the Dutch colony of Suriname became a place where she

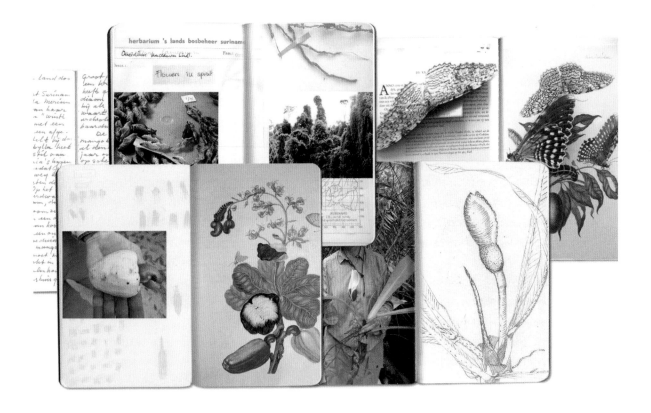

Fig. 4 J. van de Plas, spreads from *Proeftuin Suriname* (*Experimental Garden Suriname*), sketchbooks, 2008. Courtesy of Joos van de Plas.

longed to travel, and eventually did. In contemporary art, field trips and research journeys of all kinds belong to the performative aspects of many artists' actions, in which they make use of scientific methods: sociological, anthropological, archaeological, botanical, geological, and the like.

Among those explorers is the Finnish artist Sanna Kannisto (*1974), who works in the rainforest and takes photographs in a field studio. By making the arrangements—stretched white cloths as a background, lamps, tripods, etc.—that she needs to stage nature in front

of the camera, she makes the image-making process transparent (Fig. 3).[28] In other words, we see here studies of the "experimental systems" that interested Latour when he accompanied a team of researchers on an expedition in the Amazon in 1991. How is information about a state of affairs produced? How are "the sciences, at once realistic and constructed, immediate and mediated, robust and fragile, near and far"?[29] Such questions about the construction and representation of the Other made into a research object were still far from the minds of those biologists who, in the nineteenth

century, dismissed Merian's pictorial inventions as merely decorative.

Today, however, such questions occupy an increasing number of artists. Dion, for example, in *The Brazilian Expedition of Thomas Ender – Reconsidered*, traces an expedition in Brazil from July 1817 to June 1818, in which the Austrian painter Thomas Ender (1793–1875) was part of an imperial mission, along with the zoologist and ethnographer Johann Natterer (1787–1843) and many others:

> *[The project] was based on the anachronistic model of expeditions and aimed at questioning the historical idea of a form of traveling dedicated to nothing but the production of knowledge and attempting a reinterpretation of the expedition concept which, due to its colonial associations, has had a negative undertone for a long time. Ender's works serve as a medium for the consideration of nature, traveling, history, and ethnography in today's discourse.*[30]

A comparison of this expedition team, commissioned and financed by the emperor and diplomatically secured, with the journey that led Merian and her daughter Dorothea to Suriname from 1699 to 1701 shows us once again the historical dimension and the daring of the naturalist and artist. A good three hundred years later, the Dutch artist Van de Plas set out on her own in the footsteps of Merian. She is thus one of the very few Merian researchers who went to the former colony of Suriname to investigate the research conditions of the early modern artist.

In contrast to the historian Natalie Zemon Davis, who experienced the "taste of the archive" (Arlette Farge) onsite, Van de Plas penetrated the jungle in an adventurous and highly dangerous way and made novel discoveries (Fig. 4).[31] Back in the Netherlands, her own caterpillar breeding fundamentally changed her oeuvre, without following in Merian's footsteps. Through aesthetic studies in the studio, through the comparison of Merian's butterfly preparations preserved in the Museum Wiesbaden with the butterflies depicted in the Suriname book, and through her intensive research on Merian and Johannes Goedaert (1617–1668), the artist is one of the most productive Merian researchers of our time. Her artistic practice, the acquisition of scientific knowledge about flora and fauna, goes hand in hand with historical research (see also the chapter by Van de Plas in this volume). In Latour's sense, the artist cultivates the "willingness to live with assemblages of explanations" and thus leads us to new insights.

Johann Andreas Graff. Forgotten Artist and Partner of Maria Sibylla Merian for Twenty Years

Margot Lölhöffel

Johann Andreas Graff (1636–1701) was the primary supporter and promoter of his young wife, Maria Sibylla Merian, in her career as a renowned naturalist and artist in Nuremberg. But Graff was also an independent, innovative artist. He shows us his hometown of Nuremberg towards the end of the seventeenth century with true perspectives and absolute accuracy, down to the last detail: streets, squares, bridges, the interiors of churches, and the villages and estates of the surrounding countryside that was also part of the Nuremberg territory at the time. These drawings and copper etchings, together with Graff's detailed descriptive captions, are not only artistic masterpieces but also an important source for historical research.

Youth, Training, and Journeyman Years

At the time of his birth in that city, in May 1636, Nuremberg had just survived a terrible plague epidemic and the deadliest period of the Thirty Years' War. Johann Andreas Graff's life in the decades that followed is an example of the educational and artistic possibilities Nuremberg offered its citizens. Many such opportunities were also available to newcomers, and even to women. Nuremberg was an Imperial city with a self-confident citizenry. No prince or bishop had authority over it. Rather, it was governed by a council appointed by educated "upper-class" families, the so-called patricians. As a city of merchants and craftsmen, Nuremberg was internationally connected and receptive to new ideas in the arts and sciences.

Graff's father, who came from the province of Thuringia, was rector of the

Municipal Grammar School near the Egidienkirche (Saint Giles Church) and bore the title of poet laureate from the Nuremberg University in nearby Altdorf for his contributions in the field of language and rhetoric. Even though both of Johann Andreas's parents died young, he completed his secondary education and could have entered the university, but decided instead to study drawing with an established Nuremberg artist, Leonhard Heberlein (1584–1656).[1] Graff spent the years 1653–1668 away from his native city. For the first five of those years he apprenticed in Frankfurt am Main in the workshop of the painter Jacob Marrel (1614–1681), the second husband of Maria Sibylla's widowed mother. During his apprenticeship, he probably lived in his master's household, as was then customary. Marrel and his wife were persons to whom the youngster, orphaned at such an early age, remained attached all his life, and we can imagine that he thought of Maria Sibylla as a little sister at the time. Graff did copper etchings of designs by Marrel, and there is even a watercolor signed by him from that period in the Historical Museum Frankfurt (Fig. 1).

Upon completion of his apprenticeship, Graff embarked on his journeyman years. Like many draftsmen and painters before and after him, he was drawn to Italy for its wealth of artworks dating back to antiquity and for the lively contemporary arts scene in various Italian cities. Following a stay in Venice, he traveled

Fig. 1 J.A. Graff, *Römerberg*. Town hall square in Frankfurt am Main, with Alte Nikolaikirche (Saint Nicholas Church), 1658 or earlier, watercolor on paper, 193 x 393 mm. Historical Museum Frankfurt, inv. no. HMF C. 15273. Photo by Horst Ziegenfusz.

on by way of Genoa and Florence to Rome, where he remained for four years. His later work in Nuremberg shows the influence of the extensive drawing and painting he did in Rome. When Graff returned to Frankfurt around 1664, things had grown quiet in the Marrel workshop. The master must have been staying long and often in the Netherlands, for we know that he was made a member of Saint Luke's Painters Guild in Utrecht in 1669. The art market had probably become his main source of income, as he also traveled to Nuremberg to make sales.

Twenty Years of Marriage with Maria Sibylla Merian

In 1665, Johann Andreas, who had turned twenty-nine just a few days earlier, and the eighteen-year-old Maria Sibylla Merian were married in Frankfurt. Several intriguing finds tell something about the wedding festivities. In the library of the Ratsschule (Council School) in Zwickau, Saxony, a large volume of occasional verse (congratulatory poems) from several towns has been preserved, including two printed booklets with verses "on the festive nuptial joys" of Graff and Merian. Poems by "good patrons and true-hearted friends" invoke—in both German and Latin— a number of gods and nymphs. The poems give a vivid impression of a merry, literate wedding party, well-versed in the world of ancient deities. The young couple is urged to "Daub to outdo each other from dawn to dusk!"[2] This rare glimpse of the private sphere is testimony to how highly regarded the young

woman's talent and diligence as an artist were, as well as an acknowledgement of the skills of her new husband.

In Frankfurt, three months before her twenty-first birthday in early 1668, Maria Sibylla gave birth to her first daughter, Johanna Helena. That same year, the young couple and their infant child moved to Nuremberg, where Graff had inherited from his parents a spacious house on Alter Milchmarkt (Old Milk Market), just in the shadow of the Kaiserburg (Imperial Castle). In the warmer months, behind the bullseye panes in the south-facing gable, Maria Sibylla must have had many wooden boxes in which caterpillars were supplied with leaves from each one's particular host plant. The spacious house afforded the couple plenty of room for their activities; both of them drew and painted, and needed to prepare quantities of paints for their work. They prepared copperplates and etched their drawings; the intaglio printing may also have been done on a press in their own house. To supplement the household income, Johann Andreas gave lessons in drawing and painting for young men, as Maria Sibylla did for young women.

In this productive period for the young couple, Graff also lent his wife ongoing support as a promoter and publisher of her book projects: the *Blumenbücher* (Flower Books), three sets of a dozen flower plates, issued successively in 1675, 1677, and 1680, with a second printing combining the three, and the two *Raupenbücher* (Caterpillar Books) in 1679 and 1683. In the preface to the 1679 *Raupenbuch*, the author, otherwise very sparing

with personal remarks, expressly mentioned collaborating with her husband and described how she depicted butterflies and moths: "And I further undertook, with the generous help of my beloved husband, to include paintings from nature of the food for each type."[3]

Unlike Merian's books, Graff's works were almost forgotten in the centuries following his death, but some of his astonishing masterpieces survived in museums, among them, two of Graff's first etchings from 1681. Exactly between the publication years of the two *Raupenbücher*, Graff brought out two master etchings with different subjects, illustrating the breadth of his work. He signed them as draftsman, as etcher, and as publisher. One, showing a public square with a church, a gate tower, and the Deutschordenskommende (local residence of the Teutonic Knights), would have found ready buyers. The other print is more unusual: a view of interior restoration work in the fire-gutted Barfüßerkirche (a German equivalent of the Franciscan Church) in Nuremberg—a building site with rubble, scaffolding, and workmen—an early and exceptionally detailed study of the world of construction works (Fig. 2).

Both Maria Sibylla and her husband were specialists in their respective areas of work, and prospects for success in the coming years were good for both of them. In the midst of this busy time, Maria Sibylla became pregnant again and, in early February 1678, ten years after the birth of their first daughter, Johanna Helena, a little sister, Dorothea Maria, was born in Nuremberg. However, in late 1681, everyday married life and the prospects for a shared future changed dramatically with the death of Jacob Marrel. In 1682 the Graff family returned to Frankfurt to resolve questions regarding the inheritance and to support the destitute widow, Maria Sibylla's mother. In the years that followed, Graff traveled back and forth between Frankfurt and Nuremberg, where he was able to supplement the family income with commissioned works for wealthy Nuremberg families.

In the mid-1680s the Graff-Merian family once again left Frankfurt and moved to the Labadist community in Wieuwerd, Friesland. Graff had the firm intention of starting life over with his family in that strict, self-supporting religious commune. He was not deterred by the fact that its members lived frugally and were sexually abstinent, without personal property, and preparing for a rebirth yearned for in the earthly present through Bible study. However, his efforts were unsuccessful, and he was not accepted by the Labadists; for Maria Sibylla, this signaled the end of their marriage. For Graff, the rejection was the most devastating event of his life. Recovering from the end of his marriage, the physical strain of work demanded by the Labadists, and the definitive separation from his daughters must have been hard indeed.[4]

The Fifty-Year-Old's Return to Nuremberg: Starting Over

Following his return from the Netherlands in 1686, Graff worked indefatigably for the last fifteen years of his life. He no longer transferred his drawings to the

copperplates himself, but had them etched and printed in the Augsburg workshop of Johann Ulrich Kraus (1655–1719). That shop had been capably managed until 1685 by Johanna Sibylla Küsel (ca. 1650–1717), a granddaughter of Matthäus Merian, after the death of her father Melchior Küsel (1626–1683), one of Merian's former apprentices and the husband of Merian's daughter Maria Magdalena (1629–1665). It was not until she married the thirty-year-old Kraus that the business finally had a new master craftsman at its head. As one of her father's pupils, Kraus was no newcomer, and he was considered one of the best copper etchers of his time. Johanna Sibylla Küsel also continued to work as an etcher.[5] Thus, for the next decade and a half, Graff's drawings were in the best of hands for printing. The Kraus collaboration has been a great help to anyone interested in Graff's works today; these high-quality prints were popular acquisitions in their time, and examples can be found in many museums and private collections. Researching them is complicated, however, since they were often catalogued under just the name "J.U. Kraus, Augsburg". The artistic credit belongs to the original designer, J.A. Graff, which is clearly evident when the prints are compared with some of his few extant drawings. Unfortunately, that connection has often been lost, and with it the credit for much of Graff's lifetime achievement.

Fig. 3 J.A. Graff (designer and publisher), J.U. Kraus (etcher and printer), *Poeten Wäldlein*. Poets' Grove on the river Pegnitz, about 1688, copper print, plate 124 x 175 mm. Stadtbibliothek Nürnberg, inv. no. Nor. K. 6, f. 4. Total print and two details: of the Kaiserburg and front of the former Graff-Merianin family garden.

Collectors were especially interested in series of prints. So, in 1688, Graff and Kraus tested the market for "mini-landscapes" in a small format. Figure 3 shows such a landscape along the river Pegnitz, with the Kaiserburg in the distance. The precision of this view can be seen in the enlarged detail with the green rectangle, measuring 5 x 3 mm in the original

Fig. 2 J.A. Graff (designer, printer, and publisher), *Barfüßerkirche*. Interior of the burned-out Franciscan Church during reconstruction, 1681, copper print on paper, plate 485 x 324 mm. Kunstsammlungen der Stadt Nürnberg, inv. no. Gr. A. 10022.

drawing and shown in the third illustration. To the right of the castle's great hall, between two towers, one can make out a tree and a small garden house. This was the location of the little family garden, which Maria Sibylla had described in her *Studienbuch* (Book of Notes and Studies) number 119 as lying "next to the Castle Church or Imperial Castle Chapel in Nuremberg".[6] In the same period in which Graff was producing these small-format views, he continued to work on large cityscapes, which were also accurate down to the smallest details.

Graff had still not completely resigned himself to the separation from his wife, but some resolution was becoming ever more urgent. He needed a new "woman of the house" for his domestic affairs, not only for practical reasons but also for the sake of his good name. He did not file an application for divorce with the Nuremberg city council until 1692. Because there was no question that his wife had left him years earlier, Graff hoped for a resolution of the matter *absque strepitu iudicii*—without the publicity of a trial. However, the council disallowed a closed hearing and put the case before the municipal court. Opinions were sought from several legal advisers. Three attempts to prompt a response from "Maria Sibylla Gräfin", now residing in Amsterdam, were unsuccessful. In a total of seven entries in the minutes of the council, we can trace the proceedings: in late May of 1694 the Nuremberg city council pronounced and published the official divorce and transmitted this judgment to Amsterdam.[7]

Graff's New Family, Recognition, and Success

On 25 June 1694, Graff was finally able to marry again. His second wife, Anna Maria, née Hofmann (1666–1711), was thirty years younger than he was. It is possible that, as the daughter of the Nuremberg colorist Johann Erhard Hofmann (1636–1672), she assisted in hand-coloring the black-and-white prints produced from Graff's drawings in Kraus's Augsburg shop. The year 1694 was an exceptional one for Graff, not only in his personal life but professionally as well. He turned out the series *Grand City Prospects*, comprising large-format

Fig. 4 J.A. Graff (designer), J.U. Kraus (etcher, printer, and publisher), *In Rom die St. Peters-Kirche im Vatican*. Interior at the canonization of five saints in 1695, 1696, copper print, plate 493 x 432 mm. Germanisches Nationalmuseum, Nuremberg, inv. no. HB 15244 capsule 1252a. Photo by Monika Runge.

Fig. 5 J.A. Graff (designer and publisher), J.U. Kraus (etcher, printer, and publisher), *Egidienberg*. Ruins of the Saint Giles Church and School after the fire of 1696, 1696, hand-colored copper print, plate 334 x 466 mm. Kunstsammlungen der Stadt Nürnberg, inv. no. Nor. K. 00057.

views of streets, public squares, bridges, and church interiors—for many buyers surely a welcome and attractive complement to his small-format "mini-landscapes". These views of Nuremberg sights also could be purchased in hand-colored versions, making them an additional and more profitable source of income (see Figs. 5, 6, 7).

The relationship of the city and its surrounding territory was a theme that continued to interest Graff. The Germa-

nisches Nationalmuseum in Nuremberg owns a two-meter-long drawing by him that was shown in a 2014/15 exhibition: a panoramic view seen from the Laufer Schlagturm (Clock Tower and gate in the old city wall). For Yasmin Doosry, curator of the exhibition and its catalogue, this view into the distant countryside, "unusual for its time, stands… at the threshold of a momentous development in eighteenth-century *veduta* painting with the aid of optical devices…. We cannot rule out the

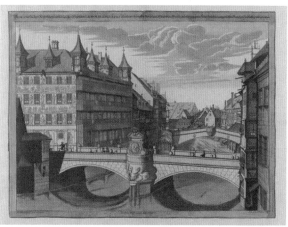

Fig. 6 J.A. Graff (designer and publisher), J.U. Kraus (etcher, printer, and publisher), *Museumsbrücke*. River Pegnitz with new bridge, looking east, 1700, hand-colored copper print, plate 368 x 478 mm. Kunstsammlungen der Stadt Nürnberg, inv. no. Gr. A. 12734.

Fig. 7 J.A. Graff (designer and publisher), J.U. Kraus (etcher, printer, and publisher), *Museumsbrücke*. River Pegnitz with new bridge, looking west, 1700, hand-colored copper print, plate 368 x 478 mm. Kunstsammlungen der Stadt Nürnberg, inv. no. Gr. A. 12735.

possibility that the draftsman employed optical aids such as the *camera obscura*."[8]

The very next year, 1695, found Kraus offering printed views of Basilica di San Pietro (Saint Peter's Basilica) in Rome etched from drawings that Graff had brought back from Rome thirty years earlier (Fig. 4).[9] A grand interior view of the crossing and apse was combined with five additional, smaller subjects. The lower frame section contains a detailed key identifying locations in the images. This view was available in various sizes, as either an architectural study or as the record of a ceremony of five canonizations, thus appealing to the widest possible range of prices and individual preference for religious observances or magnificent buildings. The most exclusive item offered was a composite print of twelve individual etchings that measured four square meters overall.

In another etching depicting an event, Graff documents the aftermath of a terrible fire in Nuremberg in 1696 (Fig. 5). A conflagration in the Egidienberg (Saint Giles Hill) Quarter destroyed not only the church and the school where his father had been rector, but involved the entire neighborhood. The destruction included the building with the rector's official dwelling, where Johann Andreas was probably born. He depicts the damage with great visual precision and also describes it in a band along the top edge. The detailed legend reads like a formal record of the events and includes a key to the nearby buildings, identified by letters. This print well demonstrates that Graff the artist was also a chronicler of his time.

In June of 1697, Graff's wife Anna Maria gave birth to her first son, baptized Christoph Friedrich. Graff was sixty-one years old at the time. In the years that fol-

lowed, everything seemed to turn out well for his new family in the house called "Zur Goldenen Sonne" (The Golden Sun). A second son, Georg Burkard, was baptized in June 1701. Graff was now sixty-five, and recognition for his work in Nuremberg had grown in his own lifetime. He had already received "considerations" in the form of cash gifts from the city council in 1693 and 1696, paid to him as special acknowledgments, that is, without any future obligation. In September 1701 the city even pledged a "recompense", or advance payment, for new pictures of the Barfüßerbrücke (now named Museum Bridge) from both sides, east and west (Figs. 6, 7). Evidently, the authorities wanted a high-quality view of the bridge so that this modern addition to Nuremberg's infrastructure could be admired far and wide.[10] With another large new commission from the council, Graff could look confidently to the future, but completion of his work was not to be—death overtook him just three months later. The record of burials in Sankt Sebald parish, under the date "9.10bris" (9 December) reads: "The esteemed and artistic Johann Andreas Graff, painter and draftsman, of Alter Milchmarkt."

Graff's Works as Documentation of the Urban Culture of His Time

Despite the blow he was dealt when his first wife left him, Graff never lost his creative powers, and he worked actively to the very end of his sixty-five years. Johann Ulrich Kraus, who knew Graff's work better than anyone, expressed his admiration in the caption to the twelve-section view of Basilica di San Pietro more than three hundred years ago: "One cannot marvel enough at this man's dedication." Thanks to his great gift as a draftsman and his keenly observant eye, Graff left behind a tremendous legacy of historical information for the city of Nuremberg. With pencil, pen, and brush, he depicted the city with its notable sights and the countryside surrounding it. Nuremberg and its environs, interrelated as they were, constituted the "fatherland", as the citizens of that time called their city-state with its sizable territory. For only one's status as citizen of the town promised protection and security in a period without a strong central state authority.

Graff's works were neglected in scholarly research until recently because prints by other artisans, who copied his designs in their own etchings, were better known. Imitators added more street scenes and new buildings. After Graff's death, their prints were more readily available than the Graff designs published in Augsburg. In addition, fictional accounts of Merian's life have created a mistaken impression of Graff's character as an unreliable, irascible, often drunken weakling, and this unsubstantiated image has been accepted as authentic. Such fictional publications—even paperbacks—have been very successful in the last seventy years, some of them also bizarrely depicting the Nuremberg of that time as a dirty, backward city. However, since 2017, the three-hundredth anniversary of Maria Sibylla Merian's death, interest in the

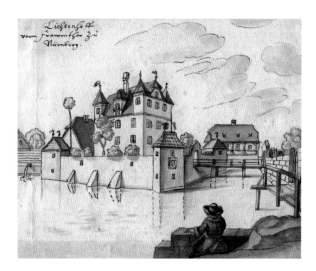

Fig. 8 J.A. Graff, *Lichtenhof*. Moated manor house with artist in foreground, seen from behind, undated, watercolor with pen and ink on paper, 155 x 196 mm. Kunstsammlungen der Stadt Nürnberg, inv. no. Nor. K. 2441.

man at whose side she lived for twenty years has been growing in Nuremberg. As the city's visual chronicler, Graff was a pioneer—much more than simply the partner for a stage in Merian's life. It cannot be mere coincidence that he was a prominent subject of presentations at the Kunstbibliothek der Staatlichen Museen zu Berlin in 2008, the Kunsthistorisches Studienzentrum an der Ludwig-Maximilians-Universität in Munich (as part of the permanent online exhibition of this center for art history studies), and the Germanisches Nationalmuseum in Nuremberg in 2014. An exhibition in the Stadtbibliothek Nürnberg from June through August 2017 showed, with works discovered up to that time, that Graff has been unjustly forgotten.[11] We do not know what Johann Andreas looked like; we know of no portrait of him. In just a few places in his drawings, he has included a figure, seen from behind, that we might suppose to be the artist himself (Fig. 8). In this watercolor on pen and ink sketch made for one of his "mini-landscapes", Graff shows only his back, situated in the marginal field of the picture. But he is not a marginal figure; he is an important witness of his times, one whose works Erich Mulzer was the first to reassess in a landmark 1999 article: "With an incomparable precision extending all the way to altar-piece images and the details of family crests, they are so fanatically meticulous as only works done on site could be."[12]

* The author would like to thank her caring and experienced translator, Michael Ritterson, and Dieter Lölhöffel, her partner in all research and *Gedankenspiele* (intellectual imagination).

Painting Flowers with Needles

Christine Sauer

The impact of Maria Sibylla Merian's flower motifs on contemporary embroideries was a neglected topic until Janice Neri published her groundbreaking study in 2011.[1] This is an astonishing fact, because as early as 1675, Joachim von Sandrart (1606–1688) had praised the artist's masterly skill in painting lifelike flowers with brushes as well as with embroidery needles and etching needles. In his book *L'Academia Todesca* [...] *Oder Teutsche Academie*, he placed keywords in the margins to serve as catchwords for the skimming reader. In the margin to his eulogy of Maria Sibylla Merian, he inserted three summaries praising her as a "delicate painter of flowers" ("zierliche Mahlerin in Blumen"), as an embroiderer "of lifelike and vivid flowers" ("Nehet auch mit der Nadel gar natürliche und lebhafte Blumen"), and as an etcher of such flowers ("Ezet solche [i.e., 'gar natürliche und lebhafte Blumen']").[2] In addition, the introductory text attached to the *Neues Blumenbuch*, the second edition of Merian's first publication, states that, among other functions, the etchings had to serve one main purpose: They were supposed to be used as patterns by women who practiced needlework (to serve "dem Frauenzimmer zum Naehen").[3] Hence, the written sources on Maria Sibylla Merian's early life in Nuremberg between 1668 and 1682 provide clues for the rising success of the young woman. Her skill in rendering lifelike depictions of flowers in paint, silk, and print not only made her a role model for upper-class females but also granted her economic success, for she taught a group of women (called her *Jungfern Combanny* in Nuremberg) and published a pattern book to be used by her pupils.[4]

This study attempts to give examples of the long-term influence of Maria Sibylla Merian's *Blumenbuch* on needlework in Nuremberg. Numerous copies of the first three-part edition, published in 1675, 1677, and 1680, and of the second edition of all parts, from 1680, seem to have circulated in the city well into the eighteenth century.[5] Evidence is provided by two sources, namely, friendship books with hitherto neglected contributions of women and women's drawing exercise books. It seems that the *Blumenbuch* remained in high esteem and extensive use long after Maria Sibylla Merian had left Nuremberg. The publication apparently was a success—a fact that the extreme rarity of surviving copies seems to contradict.

Female Arts in Friendship Books

Alba amicorum (friendship books) or *Stammbücher*, the predecessors of autograph books, came into use in German- and Dutch-speaking regions around 1550; whereas the use by noblemen and noblewomen ended around 1620, the circulation in the academic milieu proved to be a success.[6] The owners, mostly students, presented small portable books in oblong horizontal format with blank pages to professors, fellow students, noblemen, or famous persons in order to collect handwritten contributions. These autographs usually include a literary quote, a dedication, a date and location, as well as a signature; an enrichment of the handwriting by pictorial elements was possible, but not mandatory. Due to the strong ties to an academic environment, the owners of and contributors to *alba amicorum* were almost exclusively male; in Germany the participation of women remained scarce during the seventeenth and eighteenth centuries.[7] The few female entrants generally belonged to one of the following three groups: close female relatives, either of the manuscript owner or of his friends, female artists, or women of learning.[8] Whereas the last type emulated male inscriptions by choosing quotes of authors in the languages of learning, the first and second types preferred their native tongues. Remarkably often, these women not only embellished their entries with pictorial elements in various techniques but also tended to substitute the literary quote with an image, to which they only added their handwritten name, thus choosing art to be their actual token of friendship.[9]

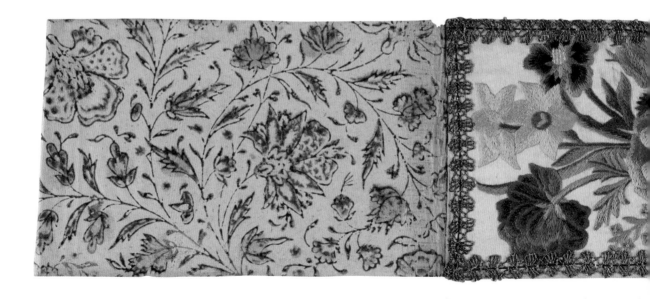

With her rising fame as a painter of natural history objects, Maria Sibylla Merian became a popular contributor to *Stammbücher* owned by art connoisseurs (see also the chapter by Pieters & Van de Roemer in this volume).[10] She usually was asked for a painting, to which she would add a literary quote, a dedication, and her name in German. In addition to actually preserved paintings of flowers and shells in *Stammbüchern*, evidence for a now lost example is found in her letters. In June 1685 she sent a parchment leaf, probably with a flower painting and an inscription, from Frankfurt to Nuremberg. The accompanying letter was addressed to a member of her *Jungfern Combanny*, her former pupil Clara Regina Imhoff (1664–1697), who was supposed to pass the painting on to her brother Christoph Friedrich Imhoff

(1666–1723), the apparent commissioner of the image. Maria Sibylla Merian refers to the single leaf of parchment as "the desired [entry] for your brother's friendship book" ("daß begehrte in ihres herren bruders stam bug") and continues: "I hope it will please or at least will not arouse displeasure, that I wrote the entry directly on the parchment leaf; I had to, since the album itself had not been in my hands" ("ich hoffe es Soll ihnen gefallen, oder nicht miß fallen, daß ich die schrifft auf daß bergement geschrieben, dan ich nicht anderst gekönt, weillen das bug nicht bey handen gehabt").[11] The same brother, a collector of fine arts and of objects of natural history, visited Maria Sibylla Merian in Amsterdam twelve years later, in 1697.[12] Since he had brought along his friendship book, Maria Sibylla Merian had the opportunity to leaf

Fig. 1 C.W.H., Autograph, embroidered bouquet, and protective sheet, 1753, in *Album amicorum* of J.A. Bartels, Nuremberg, needlework, 10.5 x 54 cm. Stadtbibliothek Nürnberg, Nor. H. 1278, f. 51v-52r.

through it and to discover an inscription and a depiction of flowers by her former pupil. In a letter, she expressed her delight of having seen an example of Clara Regina Imhoff's artistic mastery: "I had the honor to see a piece of your beautiful art in your brother's friendship book; I was delighted about that" ("ich habe die Ehre gehabt, ihro schöne kunst zu sehen in deren herren bruders stam büchlein, worüber ich mich erfreuwet habe"). This incident not only provides an example of close female relatives of the owner of an *album amicorum* acting as contributors, it also allows us to conclude that friendship books were valuable assets. They were passed around to be looked at, the contributions were read and the images admired. Therefore, *alba amicorum* always were objects with a certain publicity—and the entrants knew about the public functions of these manuscripts and produced their contributions with a possible audience in mind. This statement is even more valid in the case of the participating women, because more often than men they enhanced their handwritten part using pictorial elements, especially with paintings and textile works of different techniques.

A typical example of such an enriched contribution was provided in 1753 by an unidentified woman with the initials C.W.H. (Fig. 1).[13] She filled the front side of a leaf in the *album amicorum* of Johann Andreas Bartels (1734–?) with a poem about roses and forget-me-nots. On the reverse side of the opposite leaf, she pasted an embroidered bouquet including specimens of the flowers mentioned in the lyrics. The bouquet is stitched on a white piece of silk, trimmed to fit the size of the page and framed by a sewn-on, prefabricated border of fake gold wire. A cutting of a colored paper glued to the page with the embroidery completes this composition. When folded back, this sheet served to protect the image, thus indicating the admiration for the handcraft of the unknown woman. The embroidery was made in the technique known as *Nadelmalerei* or *Bilderstich*, a satin stitch variant which may be translated as needle painting. Small stitches of colored threads of silk dyed in a variety of different hues are cleverly set next to each other to emulate the gradual color transitions in paintings.[14] Embroideries of this kind were what Maria Sibylla Merian had in mind when she published her *Blumenbuch* as a pattern book for women doing needlework.[15] This interpretation receives confirmation by a *Neh- und Stick-Buch* issued in Nuremberg around 1720. Its author, Amalia Beer (1688–1724), explicitly states in the descriptions of the etchings with patterns including naturally depicted flowers that they were to be reproduced in the *Bilderstich*, or rather, they were to be "painted with needles".[16]

Some of these women needleworkers seem to have achieved a certain fame. For instance, the three daughters of the merchant Johann Friedrich Bauder (1713–1791) in Nuremberg's university town Altdorf contributed to at least nine different *alba amicorum* between 1758 and 1772, partly by embellishing the handwritten part with images of flowers. They

Fig. 2 A.M. Bauder, Embroidered bellflower, 1764, in *Album amicorum* of J.C.S. Löhner, Nuremberg, needlework, 10.5 x 17.5 cm. Germanisches Nationalmuseum, Nuremberg, Hs. 163.750, f. 86r.

seem to have had a small stock of flower motifs at hand, which they used in varying combinations and with different stitching techniques. On 12 July 1758, each of the three sisters signed an autograph in the album of the student Georg Ernst Weber (1734–1791).[17] On the opposite page, respectively, each woman pasted a needlework showing a single stem of a flower on a green backdrop. The motif of the rose used by Sabina Barbara Bauder (1739–1806), the later wife of the album's owner, reappears in a needlework by her sister Maria Christina (1735–1796) in 1764, this time in combination with a hyacinth.[18] For the owner of another album,

Johann Christoph Sigmund Löhner (1740–1796), the third sister, Anna Maria Bauder (1737–1799), produced a flower image in a technique that required even more skill; she stitched a bellflower directly on a paper sheet, thereby employing the *Bilderstich* in such a fashion that the perfect image of the flower appears on both sides of the leaf (Fig. 2).[19] In a further embroidery dated 1752, she combined the motif of the bellflower with a butterfly.[20] Anna Maria Bauder seems to have been the most active and the most skilled of the three sisters; in 1771 she also contributed a painted version of a rose and a hyacinth to a friendship book.[21]

67

The Progress of Motifs Invented by Maria Sibylla Merian

A daffodil (*Narcissus tazetta*) embroidered in the so-called *Bilderstich* is the most striking example of the long-lasting influence of Merian's *Blumenbuch* (Fig. 3). It is part of a series of three embroideries contributed by women related to the owner of the album, Christoph Carl Grundherr (1727–1796). Anna Maria Ebner (1729–1789) dated her handwritten German poem 9 August 1749; on the page opposite to her autograph, she pasted a piece of white silk with a single stem of a flower.[22] The depicted daffodil is a slight variation of a motif invented seventy years earlier by Maria Sibylla Merian. The model transferred by the young patrician woman into embroidery can be found in the second etching of the first sequence of the *Blumenbuch* published in 1675 and republished in 1680 (Fig. 4).[23] Here, Maria Sibylla Merian had combined the daffodil with a hyacinth. At about the same time, the artist herself had reused the motif for a painting on parchment with a bouquet of flowers in a Chinese vase.[24]

Further examples for its long afterlife in Nuremberg are preserved in drawing exercise books of girls from patrician families dating from the early eighteenth century.[25] Regina Clara Stromer von Reichenbach (1696–1735) received her first lessons in drawing and painting in 1710, when she turned fourteen. A close look at the pencil drawings and paintings of flowers in her three surviving sketchbooks reveals that she had several model books at hand, among which the *Blumen-*

Fig. 3 A.M. Ebner, Embroidered daffodil, 1749, in *Album amicorum* of C.C. Grundherr, Nuremberg, needlework, 9.5 x 15.5 cm. Stadtbibliothek Nürnberg, Nor. H. 1305, f. 85r.

buch was by far the most prominent and extensively used.[26] The girl was introduced to the art of flower painting by copying motifs from the *Blumenbuch* in various techniques, alternatively using pencil, red chalk, ink, and colors. In the case of the daffodil, she managed an almost literal reproduction in pencil and red chalk in 1710 (Fig. 5); in 1711 she produced a colored version.[27] At about the same time, the art teacher of another un-

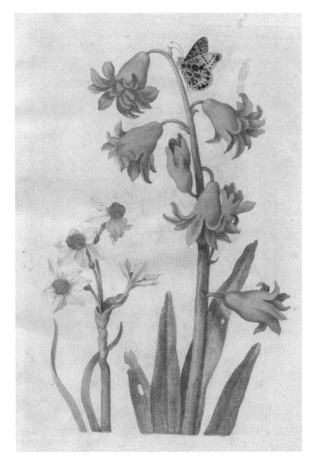

Fig. 4 Daffodil (*Narcissus*) and Common hyacinth (*Hyacinthus orientalis*) in M.S. Merian, *Florum Fasciculus Primus*, Nuremberg 1675, plate 2, republished in M.S. Merian, *Neues Blumenbuch*. Nuremberg 1680, hand-colored etching. Saxon State and University Library Dresden (SLUB), Botan.84,misc.1. Courtesy of SLUB Dresden.

Fig. 5 R.C. Stromer von Reichenbach, *Reißbuch*, page with a daffodil in pencil and red chalk, 30 x 20.5 cm. Stadtbibliothek Nürnberg, Nor. H. 1665, f. 23.

known noblewoman in Nuremberg used the left side of a page in an exercise book to outline the stem of a daffodil in pencil and red chalk. Right next to the model, the girl placed her copy in the very same technique.[28] In this case, the master had chosen a slight variation of the flower invented by Maria Sibylla Merian; the stem has been enriched by an additional blossom and an extra leaf on the right side. A pattern of the flower with these same

modifications was translated by Anna Maria Ebner into embroidery in 1749 (Fig. 3). The variant was also known to Regina Clara Stromer von Reichenbach, who integrated it in 1711 into her pattern for an embroidered insert of a camisole.[29]

Margaretha Wurfbain, wife of the Nuremberg physician Johann Paul Wurfbain (1655–1711), achieved excellence in yet another technique. Her name and skills are known to posterity

Fig. 6 M. Wurfbain, Wreath in spread-out silk fibers, 1703, in *Album amicorum* of J.L. Leincker, 9.5 x 15 cm.
Stadtbibliothek Nürnberg, Nor. H. 1621a, f. 114r.

only because of a short passage in a sermon held upon the death of her husband in 1711. Here, the woman is praised for her lifelike depictions of animals and birds in a special needlework technique using silk particles. It is also mentioned that her objects were admired and sought by noblemen.[30] According to this text, Margaretha Wurfbain was famous in her time for pictures in needlework and a kind of appliqué technique involving silk fibers and tiny pieces of silk being spread out and glued onto different backgrounds.[31] Three examples of such images—in German also called *Spickelarbeit* or *Fleckelarbeit*—have sur-

vived in the *album amicorum* of Johann Lorenz Leincker (1682–1735).[32] They are not signed and were apparently produced on commission, because Margaretha Wurfbain's two daughters and an unknown third woman used the spare room in the margins of the pages for their handwritten names (Fig. 6). For a landscape with ruins and shepherds in an oval frame formed by a garland and a wreath, Margaretha Wurfbain likewise used spread-out and sprinkled-on fibers and tiny pieces of silk. In the case of the wreath, she might have consulted the *Blumenbuch* as a model. The imperial lily with a bent stem in the top of the

circle echoes the etched opening page of the first sequence executed by Maria Sibylla Merian in 1675.[33] It is intriguing to imagine that Margaretha Wurfbain might have bought a copy of the *Blumenbuch* after she had moved into her husband's house. For a short time in 1681/82, the two women lived in close proximity to each other at the Milchmarkt in Nuremberg—and right there in the private quarters of the building owned by Merian's husband, Andreas Graff (1636–1701), the *Blumenbuch* was offered for sale.[34]

Delicate Hands and Fame: The Relevance of Female Arts

The paintings, embroideries, and appliqués preserved in the *alba amicorum* are a valuable source for otherwise lost ephemeral arts in which the outstanding artists were almost exclusively women. According to the ideal of a good mistress of the household put forward in contemporary normative texts, young girls from well-to-do families had to acquire expertise in such arts, generally known as *Frauenzimmerarbeiten*. In an early manual concerning the household and duties of a *Hausmutter*, published in Nuremberg in 1703, the unknown author reserved an entire 150-page section for the description of 36 of these arts.[35] He or she focuses on needlework and the production of artificial flowers and fruits in various techniques using different materials such as cloth, wax, sheet metal, feathers, papier mâché, etc. The esteem enjoyed by these artifacts grew in direct relation with one quality: the degree of resemblance to their models in nature. In order for an object to appear lifelike, women had to know to draw according to the laws of perspective and to use colors for a three-dimensional modeling. The author of the manual therefore praises the *Bilderstich* as the most advanced stitching technique, because the silk threads allowed women to emulate paintings: "Yet needle painting merits special praise / because thereby women with clever hands can match the most artful painters / and depict images as well as landscapes / flowers and fruits / lifelike by using yarn or silk" ("Vor allem aber behaelt der Bilderstich den Preiß / weil damit die geschickte Haende deß Frauenzimmers es den kuenstlichsten Mahlern gleich thun / und so wohl Bilder als Landschafften / Blumen und Fruechte / mit Garn oder Seite recht lebendig vorzubilden wissen").[36] Equally instructive is a sampler by the Nuremberg embroiderer Anna Magdalena Braun (1734–1794). From 1773 to 1793, she assembled a *Kunstbuch* divided into three volumes with 100 demonstrations of different "FrauenzimmerArbeiten".[37] According to the author's introductory text, some of the techniques originated as early as the 1670s and 1680s, when her grandmother had been a young girl. It includes demonstrations for flowers painted with needles ("Genuine needle painting according to the rules of painting using silk"; "Aechter Bilderstich nach den Regeln der Mahlerey von Neh-Seiden") and for landscapes with spread-out or sprinkled-on silk fibers ("Landscape done completely in sprinkled on silk"; "Landschaft Ganz von

Seiden aufgelegt", Fig. 7).[38] In other examples, materials such as fish scales, feathers, straw, pearls, or hair are involved.

Instead of interpreting the *Frauenzimmerarbeiten* of the good mistress of a household solely as an attempt to confine women to the domestic sphere and deter them from painting as high art and a male domain, recent studies have stressed the positive effects of this role model.[39] Women actually began to strive for perfection in arts with materials and techniques they were able to handle at home. Their products enjoyed esteem and admiration because of a set of clearly defined qualities; the images emulated paintings and appeared lifelike and true to nature. Thus it was possible for a female embroiderer to achieve the status of a celebrity and for her products to become cherished items.[40] Additionally, all artifacts presented by the *Haus-Halterin* in 1703 and by Anna Magdalena Braun at the end of the eighteenth century have in common that they are of tiny dimensions and require patience for their production.[41] With these qualities, the arts produced by women met aspects of the curious that excited collectors in the seventeenth and eighteenth centuries and resulted in the foundation of the then ubiquitous cabinets of curiosity (*Kunstkammern*). In his companion for collectors printed in

1704, Leonhard Christoph Sturm (1669–1719) presented the draft of a building housing an ideally organized collection. He actually advised the installation of a separate room for artifacts by dilettantes next to the rooms with paintings and sculptures.[42] Here, among other things, he described the display of "all sorts of curious female handicrafts" ("allerhand curieuser Frauen-Zimmer-Arbeit"), meaning objects rendered lifelike in various techniques, for example, "In embroidering a realistic picture" ("Im Naehen nach dem Leben") or "In reproducing all sorts of flowers lifelike using patches of silk"; "[In] Verfertigung allerhand Blumen aus Seiden-Fleckgen nach dem Leben"). In 1730, Esther Barbara von Sandrart (1651–1731/33), widow of Joachim von Sandrart, was known to possess an art collection with its own section reserved for *Frauenzimmerarbeiten*.[43]

Anna Magdalena Braun's *Kunstbuch* marks the end, while Maria Sibylla Merian's *Blumenbuch* marks the beginning of a period in which delicate arts produced by delicate female hands flourished. From the second half of the seventeenth to the second half of the eighteenth century, women were expected to learn the art of drawing and painting flowers by copying model books. This knowledge was the prerequisite for the invention of embroidery patterns or the production of artificial flowers, fruits, and animals. At the same time as women began to perfect their skills, a growing number of contemporaries became interested in collecting these arts. They possessed a room, a cabinet, or an *album amicorum* where they archived and displayed such art objects, hereby documenting the high esteem for female arts known as *Frauenzimmerarbeiten*. This situation formed the foundation and background to Maria Sibylla Merian's success in Nuremberg. She understood the needs of women and responded by beginning to teach them how to draw, to paint, and to embroider flowers after nature. Long after she had left Nuremberg, and indeed long after her death, the *Blumenbuch* remained one of the major pattern books. This long-term success is not only evidenced by embroideries preserved in the *alba amicorum* or drawings in the exercise books of young girls but also in reprints of the *Blumenbuch* produced around 1713.[44] By looking at the small-scale works preserved in the *Stammbücher*, a group of famous women who are unknown today, yet at their time were respected or even famous, awaits rediscovery.

* I would like to thank the editors for the thorough readings of the manuscript and Dr. Christine Jakobi-Mirwald as well as Dutton Hauhart for the improvement of my English.

In Search of Friendship. Maria Sibylla Merian's Traces in Friendship Albums (*alba amicorum*)

Florence F.J.M. Pieters & Bert van de Roemer

This chapter will discuss a specific set of sources concerning Maria Sibylla Merian: visual and textual evidences of her contributions in what are known as *alba amicorum*, or friendship albums. These were special booklets, mostly of oblong format, popular among people in the early modern period to keep track of their social circle and collect tokens of affection or prestige. They served as important testimonies of polite and social conduct. In the German language these books were called *Stammbuch*—a word used by Merian herself—or in Dutch *Stamboek*, terms that are nowadays more associated with genealogical registers of domestic animals and livestock ("studbook" or "herdbook"). They form a fascinating category of ego documents and excellent sources to learn more about the social and cultural circles in which historical persons circulated.

In 1997 art historian Werner Taegert discussed two such contributions by Merian from her German period, but in recent years more have been discovered.[1] Christine Sauer detailed the influence of Merian's early floral designs on friendship album contributions by others in paint and silk in 2017. Her research is published here for the first time in English (see the chapter by Sauer in this volume). The present essay will serve as an extension of Taegert's and Sauer's creditable research and will explore additional material concerning Merian and the tradition of the *album amicorum*. In Merian's case these sources have an additional significance: they form solid reference points in the complex matter of stylistic attribution, as they are certainly done by her hand and are often dated. In this way they can contribute to a better understanding of her total oeuvre.[2] But here we will attempt to gain more insight

into the dynamics of Merian's social network while also contributing to general knowledge on the practice of keeping an *album amicorum*.

Often these *alba amicorum* are seen as predecessors of a person's "wall" on Facebook and Instagram, on which friends and acquaintances leave their comments and pictures. However, these written and painted evidences of social intercourse were less casual and certainly more laborious. Nowadays, more traditional friendship albums are still in use by some artists and art lovers, while many young girls in European countries cherish their poetry albums, full of rhymes, stickers, and sometimes even original drawings by their friends and family.[3] These albums have a long history. Because the most common illustrations in the oldest friendship albums are coats of arms, an old theory presumes that friendship books originated from armorials or weapon books, which were used as identification documents at tournaments in the late Middle Ages.[4] Recently, it has been proven that the use of friendship books became popular in the middle of the sixteenth century around the Protestant University of Wittenberg, under the influence of the famous professors Martin Luther (1483–1546) and Philipp Melanchthon (1497–1560). The use of armorials in the genealogical sense was extinct by then. The term *Stammbuch* came into use only towards the third quarter of the sixteenth century.[5] Martin Luther's signature with accompanying exegetic texts can be found in innumerable "Luther Bi-

bles", and likewise in the *alba amicorum*, which was gaining in popularity at the time.[6] They spread from Protestant to Catholic universities and eventually throughout Europe, only to diminish in the nineteenth century. Keeping an *album amicorum* seemed to be especially popular in the German-speaking countries. Students, scholars, artists, craftsmen, merchants, and other literate people used them as a way to record and remember their studies abroad, but also to collect autographs from nobles and important people.[7] As this tradition was especially popular among cultural and literate persons, it is no surprise that Merian left her mark on this aspect of civilized exchange.

Roses for Father and Son

The first known example of a contribution by Merian's hand is a drawing with text on paper that is kept in the State Library of Bamberg (Fig. 1). Taegert argued convincingly that this individual sheet was painted for the *album amicorum* of Christoph Arnold (1627–1685), which now resides in the British Library.[8] Arnold was a professor of Greek, Rhetoric, Poetry, and History at the Egidien-Gymnasium in Nuremberg and also a deacon at the Frauenkirche (Church of Our Lady) in the city. In addition, he was a meritorious poet and member of the poetic society in the city, named *Pegnesische Blumenorden* (Pegnesian Order of the Flower), after the river Pegnitz running through Nuremberg.[9] Like all members, Arnold adopted a nickname, "Lerian", derived from the German word *lehren,*

Fig. 1 M.S. Merian, Album leaf with a rose, presumably to be added as the last entry to the *album amicorum* of Christoph Arnold, watercolor, bodycolor and ink on paper, 85 × 136 mm. Staatsbibliothek Bamberg, inv. no. I R 90.

"to teach", and a special flower, in his case the wild rose, or *Heckenrose*. For his album, Merian painted a beautiful cultivar rose in full bloom on a curvy trifurcated stem, with an additional bud on the lower stem and some leaves on the upper. In the upper right corner of the sheet, Merian wrote, "Man's life is like a flower" ("Deß Menschen Leben ist gleich einer Blum"), and below, "Such was painted in honor of the Magister by Maria Sibila Gräffin née Merianin Ao 1675, on February 17th in Nuremberg." Merian and Arnold must have known each other fairly well, as the scholar contributed three laudatory poems for the two parts of Merian's

Der Raupen wunderbare Verwandelung.[10] Merian probably used his library to make her first steps in studying insects.[11] As Taegert asserts, the inscription is inspired by the Book of Job in the Bible and reflects on the transitoriness of life. The drawing in the album is certainly related to plate 24 of Merian's first *Raupenbuch* from 1679, which shows a more elaborated version with two extra buds and additional leaves.[12] Perhaps the drawing in the album represented a preliminary stage of the published print, or more likely both depictions hark back to one original drawing from which Merian made variations.

76

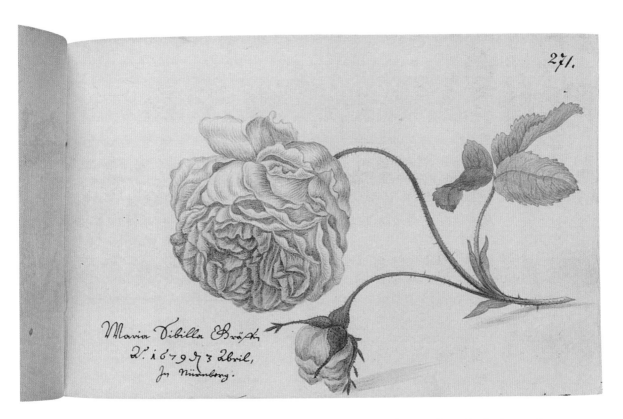

Fig. 2 M.S. Merian, Album leaf with a rose, in the *album amicorum* of Andreas Arnold, watercolor and bodycolor on vellum, 187 × 147 mm. Herzog August Bibliothek Wolfenbüttel, inv. no. 1497, f. 271r.

Four years later, in the year 1679 when the first *Raupenbuch* was published, Merian made a comparable drawing, this time for Christoph Arnold's son, Andreas Arnold (1656–1694), who was at the time a student of letters, philosophy, theology, and mathematics at Altdorf University near Nuremberg. Fortunately, this drawing is still in its original state, bound in the album that is kept in the Herzog August Bibliothek in Wolfenbüttel (Fig. 2).[13] The drawing is dated 3 April 1679, around the time Andreas was about to finish his studies, leaving the university in December of that year.[14] The accompanying text reads: "Maria Sibilla Gräffin Ao 1679 den 3 Abril, In Nürnberg", but it bears no pious motto. Since it differs only in details from the aforementioned drawing, it could be that father or son asked Merian to paint the same image.

Other members of Merian's family contributed to the album of Andreas as well. On the same day, her husband Johann Andreas Graff embellished the album with a drawing of a hilly landscape with the temple of Hercules Invictus on the Forum Boarium along the Tiber river in Rome, accompanied by a small fantasy pyramid. Two months later, Merian's stepfather, Jacob Marrel (1614–1681),

painted a wild rose in the album.[15] Andreas Arnold's album is a good example of how these documents went from hand to hand within certain families, so everybody could contribute. These are the only two hitherto known album contributions by Merian from her period in Germany, although there is evidence that she made others and was in high demand.

Long-Distance Affection

The third piece of "evidence" of a contribution is rather indirect, but no less interesting. In 1685, six years after her addition for Andreas Arnold, Merian wrote two letters to her student and friend, Clara Regina Imhoff (1664–1697).[16] They show how album entries were also made on request and that Merian must have been a sought-after contributor. This is not surprising, as her first publications, the three *Blumenbücher* (Flower Books; 1675–1680), consisted of sets of prints with flowers, bouquets, and garlands that served as models for artists and embroiderers to follow in their own work. In her essay in this volume, Christine Sauer discusses how these examples were repeatedly copied by others and ended up painted or embroidered in friendship albums. Imhoff was part of a circle of friends and students, a *Frauenzimmer* or a *Jungfern Combanny* (a company of young maidens), whom Merian instructed in the art of painting.[17] In her first letter to Imhoff, Merian announces that she will provide "daß begehrte" (the desired) for the "stam bug" of Clara Regina's brother, Christoph Friedrich Imhoff (1666–1723), but apologizes that she did not yet get it done, as she still was in the process of organizing her things after moving. The second letter, written almost one month later, evidently accompanied the desired entry for her brother's friendship album. She apologizes for writing the "schrifft" on parchment, as the album itself was not available.[18] Apparently it was customary to write and paint things directly in the album as it circulated from hand to hand, which was the case with the Arnolds, but it was also possible, like in the case of Imhoff, to make a long-distance entry that would be sent over and later incorporated in the album.

Twelve years later, in 1697, Clara Regina's brother, Christoph Friedrich Imhoff, visited Merian, who was now living in Amsterdam. He brought his *Stammbuch* with him, and Merian admired the entry of her pupil Clara Regina, as she tells in a third letter.[19] Apparently Clara Regina also contributed to her brother's album. Merian expresses her admiration for her pupil's art, but does not mention her own contribution of twelve years earlier. Considering that friendship albums had a broad range of circulation, in time as well as in topography, it is likely that they were talking about the same *Stammbuch*. Also, as Sauer asserts, people were aware that these "were objects with a certain publicity".

At this point we would like to mention another drawing by Merian that is kept in the Germanisches Nationalmuseum in Nuremberg and has all the traits of an *album amicorum* contribution (Fig. 3). It is made on parchment in oblong format

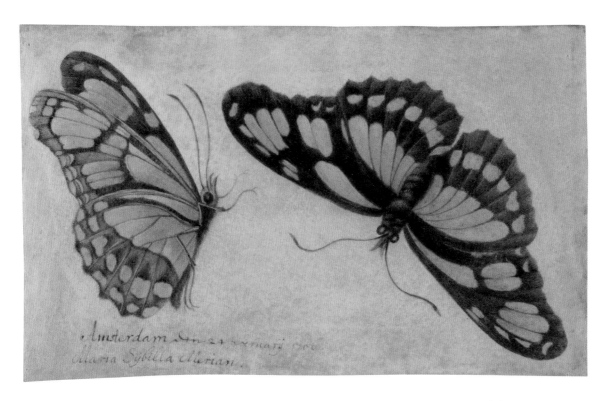

Fig. 3 M.S. Merian, Leaf with two butterflies that was once pasted in Merian's *Studienbuch* (preliminary study for *Metamorphosis*, plate 2), watercolor and bodycolor on parchment, 90 × 145 mm. Germanisches Nationalmuseum, Nuremberg, inv. no. Hz 371.

and measures 90 by 145 mm. It also holds a date and a signature: "Amsterdam, den 24 Feberuarij 1706. Maria Sijbilla Merian." This is quite strange. It dates from her period in Amsterdam, a year after the publication of *Metamorphosis Insectorum Surinamensium*. It is a small drawing of two butterflies from Suriname, which also appear in plate 2 of the *Metamorphosis*, where they flutter around a pineapple. Wolf-Dietrich Beer, the editor of the 1976 facsimile of Merian's *Studienbuch*—the book where she kept notes of her observations and her original drawings—thinks this parchment was taken out of this notebook and sold. According to Beer, the

date is the date of sale. There is an empty space in the *Studienbuch* and a duplicate of the green butterfly was later pasted in.[20] A depiction of the flying butterfly can still be found in it, with below, hardly discernible, some pencil strokes that suggest the head of the second butterfly. To our knowledge, there are no other drawings known with dates of sale. We suggest that this drawing might also have been intended for an unknown *album amicorum*, in the manner she made a contribution for Christoph Friedrich Imhoff. A combination is also possible: Merian took it out of her *Studienbuch* to use as a contribution for an album of an unknown acquaintance.

Tokens of Friendship and Envy

Thanks to a recent inventory project of *alba amicorum* in Dutch libraries by the KB, national library of the Netherlands, in 2014 we discovered probably the most elaborate contribution by Merian's hand.[21] In the drawing, Merian combined a flying lanternfly with two *Conus* shells. On the opposite page she wrote an inscription, dated 2 March 1709 (Fig. 4). She painted this directly in the *Stammbuch* of the Amsterdam engraver and cartographer Petrus Schenck (1660–1711), who was also German and was born in the town Elberfeld (presently within Wuppertal). He was famous because of his landscapes, townscapes, and maps, and especially his portraits in mezzotint. Furthermore, he was an art dealer in Amsterdam and Leipzig, to which he traveled every year to work in his shop and attend the fairs of the Leipziger Messe. During these travels he took several detours to visit his customers (mostly noble or magistrate), to make their portraits in mezzotint and also ask them to write something in his album. Schenck's album covers the period 1700–1713 and holds 273 inscriptions, among these many names of nobility and royalty. For instance, among the first names

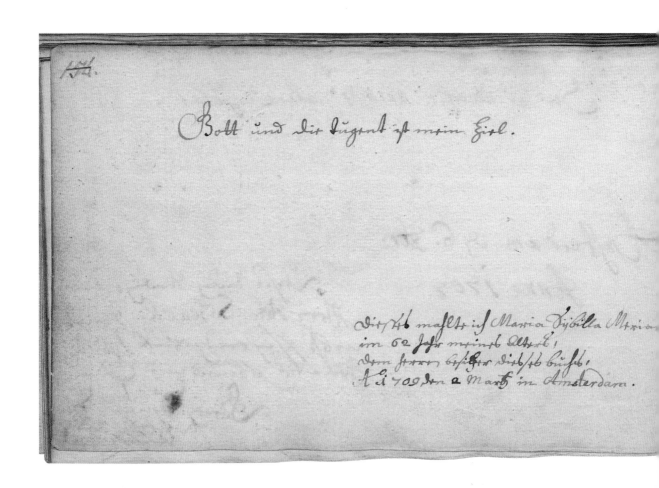

occurring in the album are Georg Ludwig, Elector of Brunswick-Lüneburg (from 1714 also King George I of Great Britain and Ireland), Anton Ulrich, Duke of Brunswick-Wolfenbüttel, and Friedrich August I "the Strong", Elector of Saxony and King Designate of Poland, who appointed Schenck as his "court engraver".[22] More important for our purposes, the album holds many names belonging to Maria Sibylla's network, such as Christian Schlegel (1667–1722) of Arnstadt, with whom she corresponded, her nephew Johann Matthäus Merian (1659–1716) (later Von Merian, after having been raised to nobility in 1706),[23] and Amsterdam mayor Nicolaes Witsen (1641–1717), whose cabinet Merian visited to study insects. Schenck and Merian obviously circulated in the same social networks. Schenck started his career in Amsterdam as a pupil of the cartographer and publisher Gerard Valk (1652–1726), who also sold Merian's Suriname book in his shop at Dam Square and married Valk's sister, Aafje, in 1687.

Fig. 4 M.S. Merian, Album leaves with lanternfly and two shells, in the *Stammbuch* of P. Schenck, watercolor, bodycolor and ink on paper, 118 × 193 mm. Leiden University Libraries, inv. no. LTK 903, f. 101v-102r.

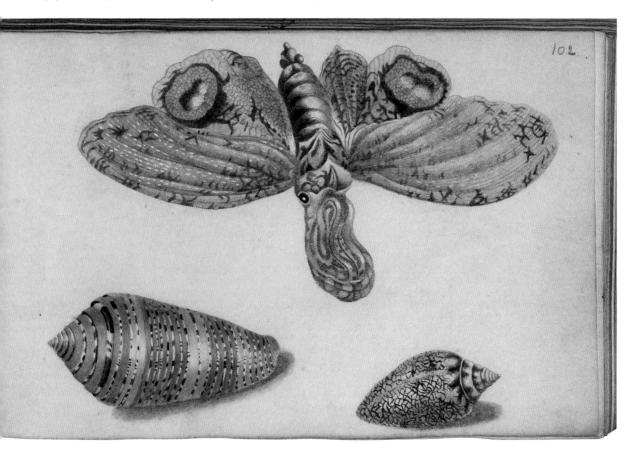

Maria Sibylla Merian's inscription in Schenck's *Stammbuch* is particularly interesting. It reads:

> *God and virtue is my aim.*
> *this I painted Maria Sibylla Merian*
> *at 62 years of age,*
> *for the gentleman owner of this book,*
> *Anno 1709 on the 2nd of March*
> *in Amsterdam.*[24]

The pious phrase "God and virtue is my aim", or translated more freely "To God and virtue I aspire", could be traced back to the penultimate line of a poem written by the contemporary and popular German poet and educator Christian Weise (1642–1708); the poem was also known in those days as a "mountain song" (*Bergliedchen*).[25] According to an authoritative book on *Stammbücher*, Christian Weise's rhymes were often cited in such books at the time.[26] The poem instructs how one should deal with envious people in a righteous way. The last of six verses reads:

> *Though people often envy me*
> *God's will is only to indulge*
> *and thus in adverse times*
> *my bliss delights me still*
> *To God and virtue I aspire*
> *and thus I have what I desire.*[27]

It might be a coincidence, but there is a strong connection between the theme of envy and the insect depicted in Schenck's album. In a manuscript kept in the Artis Library of the University of Amsterdam, written by an unknown naturalist-entomologist, there is an account of a discussion between Merian, the anonymous writer, and the famous anatomist and collector Frederik Ruysch (1638–1731). The lanternfly was the matter under debate.[28] In her Suriname book, Merian depicted the insect with a large-headed green fly that, according to her, was a preliminary stage of the lanternfly. Ruysch and the anonymous writer tried to convince her of her mistaken insights, saying that this was impossible and against nature, but—as the writer states—she still depicted them together. After recounting this discussion, the envious writer states that the work of Merian holds incorrect observations and there is not "much of substance" in her books. Furthermore, he considered it ill-fit for a woman to crawl around in bushes. He states that Merian's main motive was to become famous. Merian's phrase, "God and virtue is my aim", can be read as a direct answer to this accusation. The fact that this man obviously had plans to publish a treatise on the metamorphosis of European insects himself, which never was published, might be cause for his harsh criticism and envy. Is it a coincidence that Merian painted exactly this lanternfly in the *album amicorum* and combined it with a devout sentence from a poem entirely on the subject of envy? Did Petrus Schenck, like her, a successful German immigrant in Amsterdam, know about this discussion? We do not know, nor is the identity of the mysterious envious writer known. However, this entry in a friendship album shows

that these documents not only express friendly relationships, but also indirectly can be connected to relations that entail envy.[29]

Below the insect, Merian painted two shells; on the left, a *Conus aurisiacus* and, on the right, a *Conus textile*. Merian might have painted the latter especially for this occasion, but the *Conus aurisiacus* is known from another source; it is depicted in *D'Amboinsche Rariteitkamer* by Georg Everhard Rumphius (1627–1702), a book about the crustaceans, shells, and minerals of the Indonesian archipelago, published in the same year as Merian's *magnum opus*.[30] The shell and the drawing are discussed in greater detail in the chapter by Van de Roemer in this volume, where this friendship album entry is used in matters of attribution.

Sociable Portraits

Merian was not only represented in friendship albums through her art, but also through her effigy. Recently we discovered that the drawings made for the now lost *Stamboek* of Johanna Koerten (1650–1715) were accompanied by two portraits of her, made by others. Koerten was a renowned Amsterdam paper-cutting artist and widely known all over Europe at the time. In 1701 the aforementioned Petrus Schenck made Koerten's portrait in mezzotint, which is reproduced here to give an impression of his art (Fig. 5). The legend below the portrait was written by Katharyne Lescailje (1649–1711), one of the first Dutch female poets whose works were published during her lifetime, and

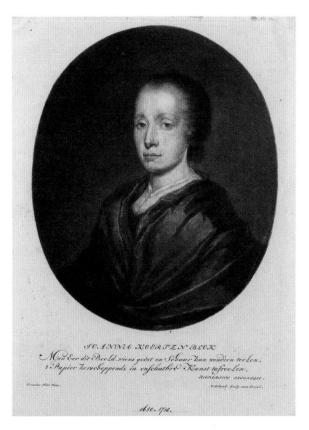

Fig. 5 D. van der Plas (design), P. Schenck (etching), Portrait of Johanna Koerten, 1701, mezzotint on paper, measuring inside of plate margin 245 × 181 mm. Courtesy RKD, The Hague.

reads: "Honor this Icon in whose soul and scissors wonders be created / Turning mere paper into priceless crafty artful clips."[31] Koerten's *Stamboek* was so famous that two anthologies of laudatory poems written by different authors over the years were published, in 1735 and 1736. Her *Stamboek* surpassed the typical *album amicorum*, as it consisted of several folio bindings with poems, inscriptions, calligraphies, and portraits (many representing Koerten herself), as well as the traditional friendship album entries. It was auctioned in separate

pieces around 1751, and since then its contents have become widely dispersed. An auction catalogue in the library of the Rijksmuseum in Amsterdam gives a detailed overview of its contents.

Concerning Merian, the auction catalogue mentions two drawings with flowers and fruit by her, and two portraits depicting her.[32] One portrait was done by her son in law, Georg Gsell (1673–1740, here spelled as "Gesellen"), who married her youngest daughter, Dorothea Maria (1678–1743). Gsell's posthumous portrait (dates of birth and death are faintly visible next to the coat of arms) is reproduced and discussed in detail in the chapter by Lieke van Deinsen in this volume (Fig. 1, p. 216). An inscription at the bottom left corner tells us the drawing originates from Koerten's collection: "Uit 't kabinet van juffr. Koerten Blok". The auction catalogue reveals that this portrait was attached on a double folio with a drawing of fruit. It also mentions a second portrait in red crayon by one of the Houbrakens. This portrait was accompanied by a floral wreath, designed by Merian, below it. This item is most likely still present in the Artis Library. In a copy of *De Europische Insecten*, a floral wreath on paper is pasted opposite the title page that correlates with the description in the catalogue (Fig. 6). It garlands an undated dedication by Maria Sibylla Merian to Johanna Koerten, consisting of a small poem in Dutch. The

hand-colored etched floral wreath had served 35 years before as the engraved title of Merian's *Neues Blumenbuch*. It is a lovely piece of text on female friendship:

I've given thee fruits drawn
with pencils,
Johanna, fine and famous all 'round.
With artful use of paper and scissors
Thine album may be richly enhanced.
M. S. Meriaan[33]

It is very well possible that this item was auctioned in the middle of the eighteenth century and ended up in this copy of Merian's book in the Artis Library. This poem was also reprinted, with slight linguistic alterations, in both abovementioned anthologies of poems. This collection holds a second poem by her daughters Johanna Helena (1668–1730) (married to Jacob Hendrik Herolt) and Dorothea Maria, but written for their mother. The poem reveals that it once accompanied a drawing with fruit, flowers, and worms offered to Koerten—which is probably the one mentioned in the auction catalogue. Remarkably, this drawing is presented here as a "joint venture" between the mother and her two daughters, which reveals something about early modern concepts of authenticity and authorship while also raising interesting questions about our present-day fixation on attributing artworks to a single person:

Fig. 6 M.S. Merian, Dedication for the *Stamboek* of Johanna Koerten, on a hand-colored etching, the wreath from the *Neues Blumenbuch*, pasted in the front matter of a copy of *De Europische Insecten*, 21 x 15.5 cm (plate). Artis Library, Allard Pierson, University of Amsterdam, AB Legkast 018.01.

Aan
Juffre
IOANNA KOERTEN
Blok

K heb u penceelen oeft geschonken
Joanna wyd en zyds berugt ——
Door konst papiere Schaaren vrugt
Oft mee mogt in uw Stamboek pronken
M S. Meriaan

M: Sibilla Merian.

Dear friend, with thy
Silhouette Paper-cutting
So innovatively employed
and never enough praised
Thou hast connected thy skilled
Art with ours.
Therefore, as a token
of great appreciation,
A Mother and her two
Daughters come offer
Thee these strokes of the brush, a sketch
With fruits and creepers foliaged,
As fixed as it may be transmogrified.

This wishes to bring forth an emblem
Exposing the inconstancy
Of human life, brief as it is and transient,
Varying from hour to hour, continually,
As if it cried to thee Memento Mori.
When Fruits and Flowers wilt and wither,
They'll bud to life once
more through seed.
The Caterpillar turns its
whole manifestation
Into a Pupa, as if unmistakably dead,
Yet soar the sky a moment next.

Thine art, o KOERTEN, has bloomed,
And as ripened fruit, it has matured;
Insignificant on the face of it at first,
Crawling along the surface of the earth
but metamorphosed taking to flight
propelling the air with quivering wings
to all four quarters of creation.
Thus will thy soul and body in the end
After the farewell even get more lure.
And lightened by
the shedded mortal frame
Thou wilt ascend to heaven
with that delight

That warmed thy soul when earlier alive;
This the brush wanted to demonstrate,
Without the need to have it said.

For MARIE SIBILLA MERIAAN,
J.H. HOROLT [sic], born MERIAAN,
D.M. MERIAAN[34]

The research into Merian's contributions in *alba amicorum* will be an ongoing process as more and more libraries in Germany and the Netherlands publish their hidden treasures on the Web in high-quality digitized representations. Each album that is now opened to a wider public forms a *Fundgrube* of texts and images that not only reveal new threads in an intricate web of human relationships but also open a door to intimate and singular artistic production that has not yet attracted very much attention from researchers. Recently, a drawing of a head of a woman in red crayon in an *album amicorum* kept in the Herzogin Anna Amalia Bibliothek in Weimar was recognized as a portrait of Maria Sibylla Merian.[35] However, there is no inscription or other indication in the album that this is really Merian. Even though there is a faint likeness with the two other known portraits of Merian, we consider the evidence too insubstantial to be certain. Yet this example shows how many hidden fragments are still to be unearthed in these albums, and also points to the caution with which these fragments should be arranged and ordered. As material objects of the past, the albums themselves form important knots in the intricate networks of human relationships, civilized conduct, and artistic expressions.

Alida Withoos and Maria Sibylla Merian. Networking Female Botanical Artists in the Netherlands

Liesbeth Missel

At Vijverhof, a beautiful Dutch country estate situated along the river Vecht in the province of Utrecht, owned by the German-born, Dutch horticulturalist and art collector Agnes Block (1629–1704), both Maria Sibylla Merian and Alida Withoos (1661/62–1730) worked as botanical artists. There they drew columbines on the same sheet of paper: Withoos an *Aquilegia flore pleno variegato* (European columbine) and Merian an *Aquilegia "Virginiana"* (American columbine hybrid). We know this from a manuscript catalogue of the art collection of Valerius Röver (1686–1739) that describes some of the Flower Books from Agnes Block's collection.[1] Withoos also made a drawing on her own, of a similar wild columbine or Canadian *Aquilegia*, which was auctioned in 2004 (Fig. 1).[2] Several of Merian's drawings of columbines are still around today. Unfortunately, the whereabouts of the sheet of paper with the drawings by both women is not known. It is thought that Agnes Block's Flower Books were sold to the Duke of Hessen-Kassel in Germany, but these disappeared around 1813, after being looted by Jérôme Bonaparte (1784–1860) during his retreat.[3] However, the coexistence of drawings by Withoos and Merian on one sheet of paper raises a few questions. Did they work together, and did they know each other? I will explore these questions here, while also examining the development of their respective careers. Was the success of these two women sheer chance—or were there factors which, no doubt, they made the most of?

Maria Sibylla Merian is recognized for her skilled and entrepreneurial work in the fields of botanical art, entomological research, and scientific illustration—seemingly an unusual career for a woman in the seventeenth and eighteenth

Fig. 1 A. Withoos, *A Columbine*, probably *Aquilegia canadensis*, no date, watercolor, 340 x 222 mm. Present location unknown, previously Unicorno collection; auction 2004.

century. While Merian may have been one of the most skilled and best recognized female artists, she was not the only talented and productive woman of this dynamic period. Alida Withoos was another important female artist from this era. Although less well-known, Withoos also had a successful career with her oil paintings, and especially with her drawings. She contributed to some of the most important natural history projects of her time.

The multitalented Merian is the subject of this book, so I will not go into detail about her life here. This contribution focuses on the life, network, and works of Withoos. The Dutch Republic during her time was an interesting cluster of seven small provinces, where the privileged classes were largely made up of enterprising and wealthy burghers. The country was flourishing, both economically and culturally, despite being frequently at war and experiencing fierce political and religious upheavals. Women from different backgrounds benefited from this window of opportunity, Withoos and Merian among them.[4] Several factors, which will be discussed below, were relevant for their success, such as their family, training, commissioners, working environment, and marriage. In the following, I will treat Withoos's life in detail and relate it to Merian's life.

Artistic Family, Upbringing, and Education

Pater Familias

Alida Withoos and Merian both grew up in an artistic family: Merian in Germany and Withoos in the Dutch Republic. Alida's father, Matthias—or as he often signed his name, Mathias (ca. 1627–1703)—was an established citizen and artistic oil painter in the city of Amersfoort, located in the middle of the Dutch Republic.[5] His father Jan Jansz. Withoos (ca. 1600–?) became acquainted with artist Jacob van Campen (1596–1657), the famous architect who built the new town hall (now Koninklijk Paleis Am-

sterdam) on Dam Square in the middle of Amsterdam (1648–1655). Van Campen owned a country estate outside Amersfoort, called Randenbroek, where he tutored young painters in an inspiring artistic setting. It was arranged for Mathias to become a pupil. He studied there for six years, depicting city views just as Van Campen did, and Merian's father and brothers as well. In 1647 Mathias registered as a painter at the Amersfoort Guild of Saint Luke.

As many young male painters did in the seventeenth century, Mathias went abroad to finish his artistic schooling. Together with some fellow Van Campen students, he traveled to Rome around 1648–1650. These young men became members of the fellowship of Dutch painters in Rome, known as the *Bentvueghels*. In Italy, Mathias also met Willem van Aelst (1627–1683) and Otto Marseus van Schrieck (ca. 1620–1678). Marseus van Schrieck and Withoos developed the new subgenre of the forest still life. This *sottobosco*, as it was called in Italian, depicts a forest scene with small animals in the foreground set against elaborate ornamental plants in the background. Mathias frequently added antique ruins and *vanitas* artifacts to his works, while Marseus van Schrieck's works were more sinister, focusing on the grimmer aspects of the animal kingdom: the creepy-crawly creatures being chased and eaten.[6]

Merian also grew up in an artistic family. Her father, Matthäus Merian the Elder (1593–1650), was a well-known engraver and publisher who died when she

was three. A year later Jacob Marrel (1614–1681), an accomplished flower painter, became her stepfather. He and his student Abraham Mignon (1640–1679), who both had been studying and working in the Netherlands with some Dutch floral still-life painters, tutored the young Merian.

Artistic Siblings

Both women had siblings who worked as artists. Merian's half-brothers were well-known engravers, and inherited their father's workshop. She probably learned engraving and etching from them. Throughout her life, she remained proud of her artistic Merian lineage and her background, which led her to publish her own books.

Alida Withoos also had artistic siblings. Her father, Mathias, married Wendelina van Hoorn (1618?–1677) in 1653 and together they had eight children, four sons and four daughters.[7] Alida's date of birth is not known. Unlike her younger siblings, no baptismal records of hers have been handed down. The children, including Alida, received their initial artistic schooling from their father, and several of them became successful artists, possibly driven by a little sibling stimulation and competition.

Alida's eldest brother, Johannes (1656–1687/88), went to Rome to finish his schooling, just as his father had done. Johannes became the court painter of the Duke of Saxen-Lauenburg in Germany and is noted for his landscape oil paintings. He also made a collection of botanical drawings.[8] Might Alida have

Fig. 2 A. Withoos, Forest still life with mouse, butterflies, honeysuckle and other flowers, ca. 1700, oil on canvas, 77 x 69 cm. Museum Flehite, Amersfoort, inv. no. 2005-368. (© photo Ep de Ruiter).

Alida Withoos did not have the opportunity to go abroad, but she would later make *sottobosco* oil paintings with a Roman setting, inspired by her fathers' examples and style (Fig. 2). Merian is not known to have made similar work. As far as we know, she concentrated herself totally on depicting *naturalia* under influence of her stepfather, Jacob Marrel, who is well-known for his drawings of tulips and still life paintings of flowers with insects.

Fellow Students and Marriage

Besides his children, Mathias Withoos taught other pupils aspiring to become a painter, including Caspar van Wittel (ca. 1652–1736), an Amersfoort-born artist who would become famous in Italy as Gaspare Vanvitelli, one of the first *vedutisti*, or painters of topographical views.[11] Van Wittel stayed six years with Withoos, until 1674, even moving with the family to Hoorn in 1672. An Italian biographer of Van Wittel noted that Mathias was so impressed by the sketches that Van Wittel sent him, that he offered one of his daughters for marriage by way of compliment. This was at that time a quite common way for successful art students to bond.[12] Particularly if the bride-to-be also had some artistic talent, they could more easily and cheaply obtain entrée to the Guild of Saint Luke. Nothing came from it, however, as in 1697 Van Wittel married an Italian woman in Rome.

Eighteen-year-old Merian, on the other hand, married her stepfather's pupil, Johann Andreas Graff (1636–

contributed to these as well? Alida's second elder brother, Pieter Withoos (ca. 1657–1692), is known primarily for his drawings of birds, butterflies and other insects, and some flowers. Her younger brother, Frans or François (1665–1705), was employed as a draughtsman in Batavia, in the Dutch East Indies. Alida's younger sister, Maria Withoos (1663–after 1699), is mentioned in some art historical sources as a painter of still life forest scenes and ornamental flower bouquets as well.[9] However, it is more likely that the few works attributed to her, signed M. Withoos, are done by her father, or by Maria Weenix (1697–1774).[10]

1701), after he returned from a long voyage through Italy, where he specialized in architectural drawing. Graff did not influence Merian's style of working, but he helped her when she published her first books.

So both Alida Withoos and Merian were influenced by their families. They were both educated by their (step)-father, and their siblings influenced their artistic development. Withoos, for example, worked in a similar genre as her father and siblings, depicting natural history and landscape settings. This indicates that their work inspired and influenced her, and vice versa. Merian was stimulated and influenced by her stepfather in her subjects, and used the engraving and etching technique she had learned and observed from her brothers to reproduce her drawings.

One can imagine the young girls at their family atelier: learning the basics of pigments and paints, taking care of canvases and brushes, and developing techniques of sketching and drawing before being permitted to work on their tutors' works of art. An apprenticeship to become a professional female artist outside a family setting, let alone abroad, was not customary.[13] Women rarely became member of the Guild of Saint Luke. Female artists were also bound to work in the more lovely, gentle genres of flower bouquets and still life tableaux. Both Withoos and Merian benefitted from artistic environments that provided opportunities to employ their talents and succeed by excellence.

Patrician Patronage

Hoorn, a Thriving Town in the Province of North of Holland

In 1672 the tiny Dutch Republic was at war with England, France, and some German cities. The year was, rightly so, called the Disaster Year (*Rampjaar* in Dutch). France invaded the country from the south by land, and came close to Amersfoort. As painter and writer Jacob Campo Weyerman (1677–1747) put it, *pater familias* Withoos was afraid for his daughters, "who were like delicate dishes that the French locusts would eagerly consume as lunch and dinner".[14] And he decided to leave Amersfoort for the northern city of Hoorn.

Hoorn was a very prosperous town in those days, housing one of the chambers of the VOC (*Vereenigde Oostindische Compagnie*, or Dutch East India Company). Wealthy merchants and even lower-class burghers liked to buy fine art to decorate their houses. Decorative flower and fruit pieces were quite in vogue. The family Withoos became well-known. Inventories of estates in Hoorn mentioned *"Withoosjes"*. indicating a small painting or drawing made by one of the members of the Withoos family.[15] There was a small circle of natural history artists also working in watercolor in Hoorn, including Johannes Bronckhorst (1648–1727) and his pupil Herman Henstenburgh (1667–1726).[16] These artists excelled particularly in making detailed naturalist drawings for the elite owners of garden estates a niche of their own. Several of them, including Alida Withoos

and her brother Pieter, were later employed by Agnes Block at her estate, Vijverhof, near Breukelen.

Artists, Plants, and Menagerie at Vijverhof

In the liberal republic of the Netherlands, women from the elite and rich mercantile classes like Agnes Block took part in the latest fashion of building country estates, growing exotic plants, keeping menageries and collecting all kinds of objects in curiosity cabinets, and patronizing the arts.[17] Block bought the initially simple Vijverhof estate in 1670, a few months after the death of her first husband, Hans de Wolff (1613–1670). Situated along the river Vecht, it was within easy reach from Amsterdam by boat. She found her calling in creating a unique collection of exotic plants and animals in its gardens with orangeries and menageries. This was enabled through contacts and exchanges with

Fig. 3 J. Weenix, Agnes Block and family at her country estate Vijverhof, 1684–1704, oil on canvas, 84 x 111 cm. Amsterdam Museum, inv. no. SA 20359.

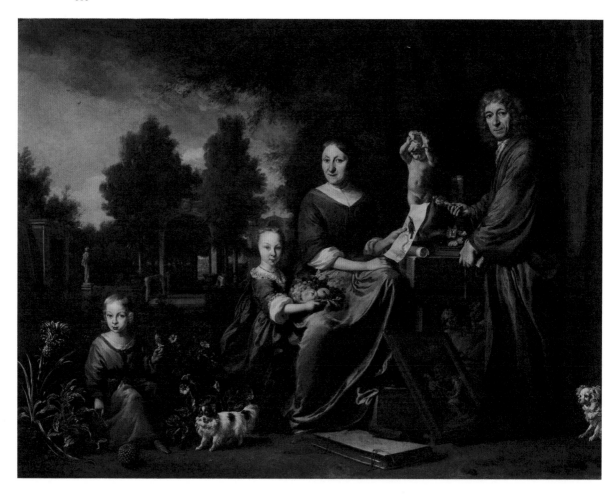

the Dutch overseas trading companies, the VOC and the WIC (*West-Indische Compagnie*, or Dutch West India Company), and botanical gardens and scholars throughout Europe. Block claimed to have had more than five hundred plants in her collections, more than the Hortus Botanicus in Leiden.[18]

To document her collections, Agnes Block needed paintings, engravings and etchings, and drawings of her botanical achievements out of bloom. In 1705, a year after Agnes died, her estate and art collection were sold. Part of her paintings and drawings were bought by the aforementioned Valerius Röver, another collector of the time. A manuscript catalogue of his collection from 1731 onwards describes some of the Flower Books he had bought from Block's collection. We know from this inventory that she owned the work of at least nineteen artists, probably working on her estate between 1671 and 1697. Several fine art painters from Hoorn were employed by her: Bronckhorst, Henstenburgh and Alida, Johannes, and Pieter Withoos.

In 1687, Agnes Block was the first to grow a ripe fruit of the pineapple in Europe. She asked Alida Withoos to paint this "*Ananas Linscotti ... after life*".[19] Block was so proud of her cultivation of the pineapple fruit and other plants, that she had a commemorative silver medal made with herself imaged as Flora Batava. Around 1694, she and her second husband, Sijbrand de Flines (1623–1697), were portrayed by Jan Weenix (1641–1719) (Fig. 3). We see the family in front of the Vijverhof estate with attri-

butes to Block's interests, including the fully grown pineapple plant. Clearly, the commission to paint the pineapple was a huge honor for Alida Withoos.

Four women worked for Agnes Block, according to the catalogue of Valerius Röver's collection. Withoos made six drawings for her, mainly exotic plants from Asia and Africa. The only drawing that dates from Withoos's time at Vijverhof is that of the pineapple, from 1687. From Röver's catalogue we know that Merian and her eldest daughter, Johanna Helena Herolt (1668–1730), also worked at Vijverhof. Merian worked on nineteen drawings, fifteen solely by her hand and made additions to four by other artists. Only one was dated, namely 1696. Remarkably, ten drawings that Merian made solely were of birds. Merian is also mentioned as having added butterflies to two botanical drawings by Willem de Heer (1637/38–1681), one being made by him in 1679. Herolt made two drawings, both on her own, one being dated 1697. Herolt may have done a whole Flower Book for Block on her own, of which only the title plate is known.[20] The fourth female artist was Maria Moninckx (1673/76–1757), who made five undated drawings.

Considering the few dated drawings, Withoos and Merian with Herolt worked at Vijverhof about ten years apart. The Rijksmuseum in Amsterdam owns one of Agnes Block's Flower Book that was not in the collection of Valerius Röver.[21] It has slips of paper on the back of Sijbrand de Flines's stationery with notes, probably by Block, asking to add extra plants on some drawings in earlier works. As we

saw before, Merian added butterflies to a drawing by Willem de Heer. Also, one of Merian's drawings of a flower bouquet was added upon by Jan Moninckx (1653/57–1708/09) with some flowers and a lizard. Adding animals and insects to a botanical drawing may have been done to enhance the artistic value. But adding other plants by other artists demonstrates that Block saw her books with drawings more as a practical herbarium, cataloguing her collection, rather than as independent works of art. It also shows an altogether different view on the perception of integrity of this kind of artwork at the time. And this practice makes it hard to conclude that the two women did actually work side by side on the aforementioned *Aquilegia* drawing.

Science Meets Art and Art Becomes Science

Amsterdam Hortus Medicus
In October 1694, Alida Withoos was paid 55 florins and three pennies by the commissioners of the Hortus Medicus of the city of Amsterdam for drawing thirteen plants on vellum.[22] These drawings were destined for the so-called *Moninckx Atlas*, a collection of 425 beautiful botanical drawings bound in nine volumes.[23] Most of the drawings were made by Jan Moninckx (273) and daughter Maria (101), who both also worked for Agnes Block. Withoos's works can be found in five of the volumes. Merian's daughter, Johanna, was paid for two watercolors for the atlas and three other works in black art by the Hortus in 1699, the same

year her mother and younger sister, Dorothea Maria Graff (1678–1743), left for Suriname.[24] Withoos's drawings are mostly from lesser attractive plants such as succulents. These watercolors were partly used to illustrate the elaborate printed catalogues of the Hortus published by commissioners Jan and Caspar Commelin in 1697–1701. The Commelins were among the botanists with whom Block exchanged exotic plants, which is perhaps why a number of artists who had worked for Block were also involved with this Hortus project. Five of Withoos's drawings were used in the second part of the Hortus catalogue, published in 1701.

Several oil painters specialized in the *sottobosco* genre regularly visited the Amsterdam Hortus, being inspired by the intriguing appearances of the new plant species from other continents. Among them were Mathias Withoos's friends from Rome, Otto Marseus van Schrieck and Willem van Aelst. Merian and her daughters lived nearby, and no doubt they too visited the garden frequently.[25] Frederik Ruysch (1638–1731), from 1685 the botany professor at the Hortus, was a fervent collector of curiosities, among them butterflies, and was acquainted with Merian. Contrary to the usual tutoring of professional female artists by their family, he had his talented daughter, Rachel Ruysch (1664–1750), and her sister Anna (1666–after 1741) tutored by painter Willem van Aelst. They also started as *sottobosco* painters. Rachel became an internationally well-known artist in her time with her flower

bouquet paintings, even while being married and having ten children. Another daughter of Frederik Ruysch, Pieternel, married Jan Moninckx. Being of the same age group and working in the Hortus, no doubt Withoos too was inspired by this circle of natural history oil painters.

Natural History Collections

Alida Withoos's and Merian's drawings appear in many collections that were gathered to study natural history. Their collectors were trying to understand God's creation of all living species on Earth, in their genera, families, and systematic order. We find the work of Withoos often in collections together with drawings by her brother, Pieter Withoos, and with work by Merian. In a collection of botanical drawings brought together by Simon Schijnvoet (1652–1727) in his loose-leaf *Konst-boeck*, Alida's work and that of Pieter is found together with that of Johannes Bronckhorst and of Pieter Holsteyn II (1614–1673), who also worked for Agnes Block.[26] In one of the so-called Witsen codices, containing art collected by burgomaster and VOC governor Nicolaes Witsen (1641–1717), three drawings by Alida of Cape flora (dated ca. 1686) were added along with some by Hendrik Claudius (ca. 1655–1697).[27] A large collection by Dutch botanist and encyclopedic writer Johannes le Francq van Berkhey (1729–1812) contained eighteen drawings attributed to Alida Withoos and four to Merian.[28] Work by Bronckhorst, Henstenburgh and Holsteyn is also mentioned in Le Francq van Berkhey's catalogue. This collection

ended up in Madrid and has several drawings attributed to Withoos.[29] Some of these seem to have been done by differently skilled hands and might be copies by Le Francq van Berkhey. However, the listing of drawings by Withoos in the 1784 collection catalogue drawn up by Le Francq van Berkhey is genuine. Without any doubt, Alida Withoos, just like Merian, had made a name for herself in the world of art and science of natural history.

Signature with Pride

On 23 January 1701, at the age of 39, Alida Withoos married Andries Cornelisz. van Dalen (1672–1741) in Amsterdam as a "young daughter" from Hoorn. They paid three guilders, which is one of the lowest income taxes paid for a marriage at the time.[30] He was ten years younger and also a fine art painter. Nothing else is known of him, and no works of art are attributed to him. In the seventeenth-century Dutch Republic, many now unknown artists worked in production ateliers making large quantities of paintings marketed to the middle classes of society.[31] Withoos probably married to be more secure in her old age. Her father was no longer able to work due to spells of gout. The couple had no children and no works of art by Withoos are known to date after her marriage. When she died on 5 December 1730, they were living on the Prinsengracht, a canal with stately houses. She was buried in the Westerkerk in Amsterdam. The cost of the funeral was fifteen guilders.[32] It appears they had managed to improve their financial status. An interesting question,

95

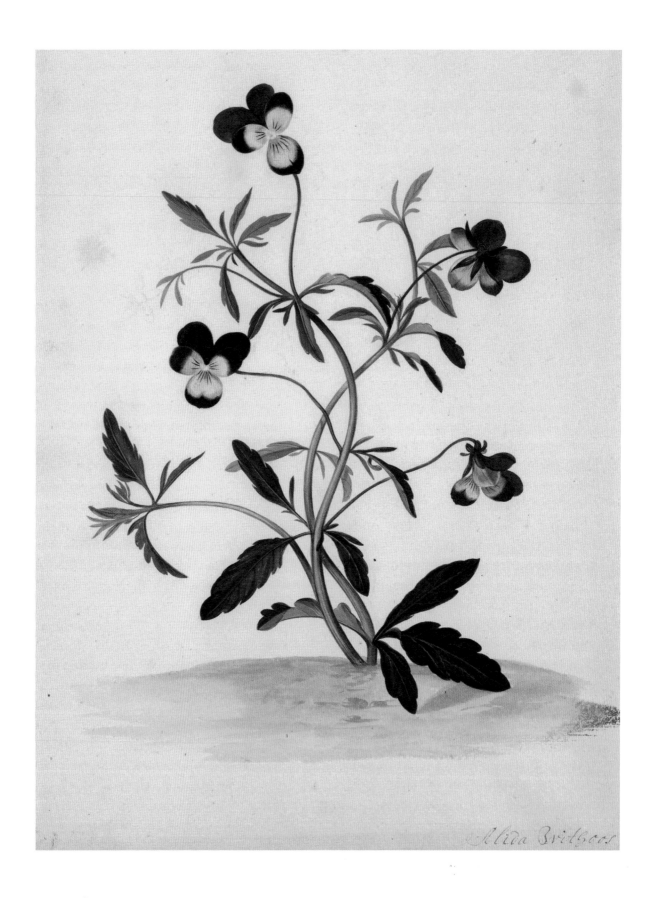

Alida Bridgoos

though, is why she did not marry earlier. Was Alida determined to become an artist and keep working and developing her skills as long as she could, because married women were not supposed to work as an artist?

Merian had married a pupil of her stepfather at the age of eighteen. As a married woman, she was still able to develop her artistic skills while making floral embroidery patterns and Flower Books, as well as her scientific skills while doing research for her Caterpillar Books. However, after twenty years of marriage, and having had two children, she chose to leave her husband for a religious colony in the north of the Netherlands. There she could not work as an artist but was allowed to study nature. After later leaving the colony, Merian began blooming again as an artist and scientist interested in depicting the life cycle of insects. Merian's life story shows that, although limited, there were several options for female artists to pursue a professional career.

Alida Withoos did not study nature outdoors and had not been to foreign places. But her work demonstrates her fascination in depicting the natural world, dark forest scenes, and antique scenery as if she had. Although less trained and skilled than Merian, Herolt, and Ruysch, her work reflects a keen interest in the newly introduced plant discoveries of the New World. She made many of her drawings on commission at the hotspots of botanical interest. And she is obviously proud of her work. All her known work is signed with her full name and with a remarkably strong and daring signature, be it a large oil painting or a drawing of the common wild pansy, the *Viola tricolor* (Fig. 4).[33]

So, what about Withoos and Merian? Did the two women meet and work together? Or did they visit all those botanical hotspots separated in time, never crossing paths at Vijverhof or any other locations? We will never know for sure. But surely they knew of each other, and of each other's work, since both were established botanical artists in their own right in the relatively small but well-connected female world of the Dutch Republic in the second half of the seventeenth century. And both careers could develop thanks to their family background, the teachings of their (step)father, the inspiration of their siblings, and their talents.

Through their stories we discover a floral network that transcends political, social, and religious boundaries, in which women played a far more important role in art and science than used to be told. Using their network of natural history scientists, collectors, and painters, they acquired a reputation in their own right with their work. As is written in the *Vaderlandsch Woordenboek* in 1794 about Alida Withoos: "Her works of art were by a tender brush. They gained her a not insignificant rank among the female artists, which our fatherland produced in such great numbers, more than any other region."[34]

Fig. 4 A. Withoos, *Viola tricolor*, ca. 1690, watercolor and bodycolor, 339 x 217 mm. Private collection.

The Transition Stage. Merian's Studies of Pupa, Chrysalis, and Cocoon

Katharina Schmidt-Loske & Kay Etheridge

Viewers of Maria Sibylla Merian's work are captivated by the eye-catching moths, butterflies, and charming caterpillars that appear on and around beautifully rendered plants. However, in examining her naturalistic and informative studies of the life cycle of lepidopterans, some may overlook two other stages that appear in her carefully constructed images. If she had a moth or butterfly that laid eggs in captivity, she included this stage in the image she created; certainly, she understood that insects produced eggs whether or not she directly observed them.[1] The other key stage in metamorphosis is pupation, and Merian included an image of a pupa in every plate that she made. Pupae may not have the visual appeal of caterpillars and butterflies, but her curiosity extended to this less colorful and seemingly inert stage of development. The phrase "wondrous transformation of caterpillars", which Merian employed in her early book titles, begins in all lepidopterans with the change from larval into the pupal stage. Within this small capsule, the final metamorphosis into the adult stage occurs, a process that is still not fully understood. In addition to portraying the color, form, texture, and other physical traits of pupae, Merian described the timing of pupation for each species of moth or butterfly and where she found them. The variety in pupae can be astounding, and she was the first to represent such a wide range, doing so for almost three hundred species of insects from both Europe and Suriname. Herein we will discuss Merian's description and depiction of a variety of pupal types, the earliest and most wide-ranging investigation of its type.

The Biology of Pupae

Two of her earliest insect studies provide a clear introduction to pupae and some differences between moths and butterflies. Merian had an important experience as a young teenager, when she observed the metamorphosis of silkworms in Frankfurt am Main (Fig. 1); these were likely given to her by some-

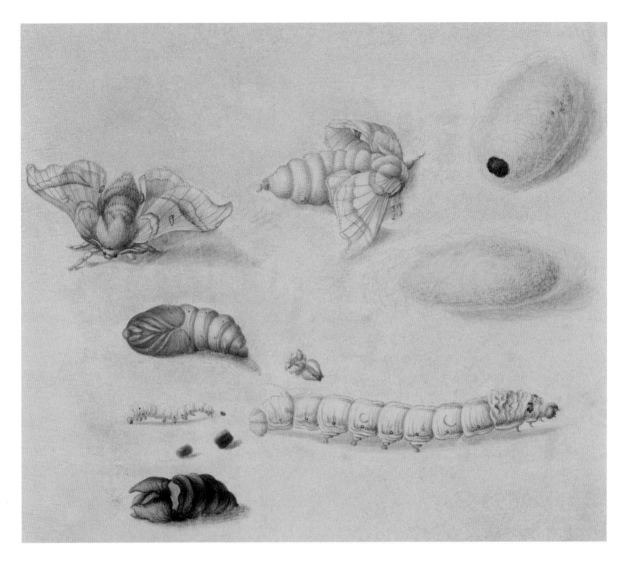

Fig. 1 M.S. Merian, Metamorphosis of the silk moth (*Bombyx mori*), in M.S. Merian, *Studienbuch*, entry 1, ca. 1660, watercolor and bodycolor on vellum. Library of the Russian Academy of Sciences, Saint Petersburg, inv. no. F 246.

one who raised them for commercial purposes. *Bombyx mori* was introduced into Europe around 550 AD for silk production and existed only in captivity by her time. Her observations of silkworms spurred her on to investigate other moths and butterflies to see if they went through the same changes, and the first native species that she raised was the small tortoiseshell butterfly (*Aglais urticae*), which, like the silkworm, appears in her 1679 *Raupenbuch* (Caterpillar Book) almost two decades later (Fig. 2). Merian was just thirteen when she initially raised the small tortoiseshell, as evidenced by what she recorded above her small study of its metamorphosis in her *Studienbuch*: "Anno 1660: My first

observation in Frankfurt am Main."[2] For more than five decades after this entry, she continued her research, collecting caterpillars in gardens, meadows, and forests wherever she lived. From this point, she kept them in wooden boxes in her home and provided them with their preferred plant foods until they stopped feeding and entered pupation.

The first plate of her 1679 *Raupenbuch* is dedicated to the mulberry tree, with its fruit and the metamorphosis of the beneficial silkworm. This creature made her aware of the moth's life cycle, the different instars (stages of the caterpillars between molts), which she called silkworm (*Seidenwurm*), their construction of a silken cocoon (*Ey*) before pupation (*Dattelkern*, or "date seed"), and their wondrous transformation into an adult moth (*Motten-Vögelein*). She observed the mating process of male and female silk moths and the female specimens laying eggs (*Eylein*). As became her lifelong habit, she documented the metamorphosis by making a watercolor and bodycolor study on vellum, which she later etched to become the first plate in her 1679 *Raupenbuch*. Her images and the accompanying text are more detailed for the silkworm than for any other insect that she studied, and can serve as a primer on lepidopteran metamorphosis. The painted study shows the silkworm's cocoon from two angles and two views of pupae with the cocoon removed, as well as the adult moths, a caterpillar with frass (feces) and some tiny eggs. The etched plate includes even more infor-mation, and depicts the adult male silkworm moth, a female moth laying eggs, tiny hatchling caterpillars, five instars of growing larvae, the various views of cocoon and pupae, and part of the white mulberry plant, essential food for the growing caterpillars.[3]

Other moths produce cocoons that are similar in structure though not of such economic value, yet many species pupate without this extra layer of self-made protection. Merian's work contains numerous examples of both types of moth pupae. She has been criticized by some for occasionally positioning moth pupae lying on a leaf, stem, or fruit of a plant, which would not occur in nature (see, for example, Fig. 1 in the chapter by Heard in this volume). However, this was merely a compositional device and her text generally explains where she actually found the pupae of an insect, for example, in soil or leaf litter.

Butterflies differ from moths in several ways, including some variations in pupation. A butterfly pupa is also termed a chrysalis, derived from the Greek word *chrysós* (gold), due to the fact that some species produce a metallic-colored pupal casing. Merian aptly described this in the preface of her 1679 *Raupenbuch*: "Some appear as if they had been clad or sprayed with gold, whence some people rightly call them *goldlings*; and some appear like silver or mother of pearl, so that one could well refer to them as *silverlings*."[4] Alternatively, chrysalides may be camouflaged in green or brown colors, or even shaped to look like a leaf or other vegetation, and

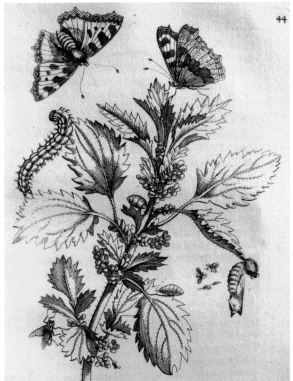

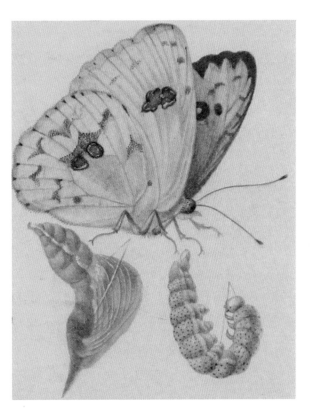

Fig. 2 M.S. Merian, Small tortoiseshell butterfly (*Aglais urticae*) on the small nettle (*Urtica urens*), in M.S. Merian, *Der Raupen wunderbare Verwandelung*, Nuremberg 1679, plate 44, etching. Spencer Collection, New York Public Library. Ichneumonid wasp larvae (shown near the pupa) often kill caterpillars and pupae. The Phorid fly (lower left) is not parasitic, but Merian found these living in the droppings of some species of caterpillar.

Fig. 3 M.S. Merian, Metamorphosis of the cloudless sulphur butterfly (*Phoebis sennae*), in M.S. Merian, *Studienbuch*, entry 262, ca. 1700, watercolor and bodycolor on vellum. Library of the Russian Academy of Sciences, Saint Petersburg, inv. no. F 246.

Merian depicted these accurately as well. The larvae of butterflies generally do not produce cocoons, and their pupae are usually attached to a plant by a series of hooks at the rear end (a "cremaster"), which is locked into a silken pad left by the caterpillar. The small tortoiseshell pupae in plate 44 of her 1679 *Raupenbuch* is one of many that she shows in this position (Fig. 2).

By close observation of her small subjects, Merian learned about variations in the pupal stage. For example, some butterflies such as swallowtails and pierids rely on a tough silk thread (girdle) to secure them to a plant or other surface. Her *Studienbuch* painting of the cloudless sulphur (*Phoebis sennae*) from Suriname shows the caterpillar, chrysalis, and the butterfly (Fig. 3). Her "time-lapse" images demonstrate the caterpillar beginning to pupate, supported around the middle by a silken girdle that will ultimately attach the resulting

P. Sluyter sculp.

53

chrysalis to a plant. The cloudless sulphur is found in plate 58 of *Metamorphosis Insectorum Surinamensium* (1705), which nicely illustrates the attachment of caterpillar and chrysalis to the ice cream-bean plant (*Inga edulis*).[5]

A Difficult Task

The artful and informative images in Merian's books do not reveal the challenges that she faced in raising insects through metamorphosis. Sometimes Merian was puzzled by her entomological observations. What she later understood to be parasites (or more correctly, parasitoids), she initially termed "false transformations", where flies or wasps emerged rather than a moth or butterfly (see, for example, the ichneumonid wasp in Fig. 2).[6] The mortality rate due to these invaders of caterpillars and pupae is only one of several challenges to successful husbandry of lepidopterans; other obstacles include dehydration, fungal infestations, inadequate food supply or cannibalism in some caterpillars. For several of the European species on which she published, she was successful only after patiently trying for a number of years.[7] For some species, she never achieved an adult insect from a caterpillar, and in these cases she did not publish their life cycle.

Another complication in learning which pupa developed into which adult

was presented by the tremendous species diversity that Merian encountered in the Neotropics; Suriname has at least 15,000 species of moths and butterflies, compared to roughly 3,700 species in Germany. Her relatively short time in Suriname and the difficult conditions in a tropical forest added to her challenges. Merian studied insects in Europe for more than four decades, but she spent only two years in Suriname, a place completely alien to her. In Germany and the Netherlands, she also had the advantage of familiarity with the plants on which her subjects fed, as opposed to the alien flora of Suriname. For her German and Dutch Caterpillar Books, she correctly matched the caterpillars, pupae, and adults of a species, but in some cases she made errors in matching the stages of the Surinamese insects. The blue morpho butterfly (*Morpho menelaus*) on plate 53 of *Metamorphosis* is shown with what appears to be a caterpillar of the Gulf fritillary (*Agraulis vanillae*) and an unidentifiable pupa of some other species (Fig. 4).[8] Here, a jug-like handle is added to the upper side of the pupal case, possibly that of a sphinx moth (see below for more on this type of moth). These types of errors in the Suriname work may have resulted from a combination of the abovementioned challenges, and issues with labeling, packing, and shipping specimens for her return to Amsterdam. Merian made

Fig. 4 M.S. Merian, *Morpho menelaus* adults, a caterpillar of the Gulf fritillary (*Agraulis vanillae*) and unknown pupa on *Drymonia serrulata*, in M.S. Merian, *Metamorphosis Insectorum Surinamensium*, Amsterdam 1705, plate 53, hand-colored etching, 52 x 35 cm (page). KB, National Library of the Netherlands, The Hague, KW 1792 A 19.

images of plants, caterpillars, and probably some pupae in Suriname when she had fresh specimens. This is particularly important in order to obtain accurate form and color from soft-bodied animals like caterpillars that do not preserve well. However, adult insects and some pupae can be preserved with little loss of color, and she probably did not paint most of these until she was back in Amsterdam.

Textual Information on Pupae

Merian is best known for her images of insects and plants that reveal their life cycles, but one must read her text in order to understand all aspects of her investigations and findings. For example, she describes her efforts to discover what was happening inside the mysterious pupal capsules. She did not have access to microscopes of the quality used by Johannes Swammerdam (1637–1680), although she does mention the use of magnification in places. Most of her observations seem to have been with her eyes alone, but this did not deter her from dissecting pupae in an attempt to discover their secrets. Her description of the "date seed" (pupa) of the purple clay moth (*Diarsia brunnea*) is in the second entry of her 1679 *Raupenbuch*, emphasizing the importance that she placed on understanding this metamorphic stage; her writing describes things that cannot be seen in her images:

After it had reached the size and form of which I speak: dark below, but a light wood color with cross-markings above, it lay down, very still and as if resting, and turned into the shape of a date

seed, appearing to be completely dead. But as soon as it was placed on a warm hand, it began to move, and one could clearly see that in such a changed caterpillar—or rather, in its date seed.[9]

Merian continued to cut into pupae to see what she could find, and just three chapters later in the same *Raupenbuch* she documents her discoveries with the tiger moth (*Arctia caja*). Interestingly, in both the study image (Fig. 5) and her finished plate, she chose to depict details of the pupa without showing the loose cocoon constructed by this species. However, she mentions it in her text, which describes the results of her dissection, working hand in hand with the image she made:

When they are fully grown they enter their change, losing all their hair beforehand, and make a gray cocoon in which they become a date seed, entirely black. One such can be seen above the caterpillar, without its cocoon and broken open, since the adult has come out of it. But if the topmost skin is peeled away before they come forth, one can see how the insects are lying inside, as the image at the bottom, opposite the caterpillar, shows.[10]

In a number of places in her text, Merian describes the most miraculous event in metamorphosis—the emergence of the adult from the pupa. She pictured this transformation for the first time in 1679 with the peacock butterfly (*Aglais io*), including in the plate both an intact pupa on the lower right and one from which

Fig. 5 M.S. Merian, Metamorphosis of the tiger moth (*Arctia caja*), in M.S. Merian, *Studienbuch*, entry 25, ca. 1678, watercolor and bodycolor on vellum. Library of the Russian Academy of Sciences, Saint Petersburg, inv. no. F 246.

The Art of Presenting the Pupa

At first glance, pupae and cocoons may not seem visually interesting, but Merian brought the observant eye of an artist/naturalist to bear on this subject, rendering them in detail and accurate color. She was accustomed to choosing realistic colors to represent her subjects as they occur in nature; this must have been a joyful challenge for the artist, who was a specialist in using and selling pigments. From a naturalist's point of view, it is useful to understand that there is an observable shift in color during metamorphosis, a physiological process that she depicted and described. Within the pupae, deposition of the wing pigments and development of wing vein patterns progress as the insect develops. She illustrates this in her 1683 *Raupenbuch* with the maturing pupa of a red admiral butterfly (*Vanessa atalanta*) in the lower left (Fig. 7).[12] The red-and-black wing pattern of the developing butterfly shows through the semi-transparent cuticle of the brown pupa in a moment frozen in time by Merian's art.

In addition to her careful use of color in painting, Merian indicated nuances of color in her written descriptions. Pupal color usually changes over time, and this is not possible to depict in a static image. Additionally, textual color descriptions were of critical importance to readers who had obtained an uncolored copy of her books, which might be painted later by the buyer or someone they commissioned. Merian's precise description of the changing color of a red underwing moth pupa (*Catocala nupta*) from the 1717

the adult is emerging headfirst on the left (Fig. 6). Her text added information: "From all of this, one can see how a summer-bird [butterfly] is formed when it emerges. For it has quite small wings at first and is lighter in color; but after half an hour its wings are stiff, in their full size and natural color, so that they can fly away with them."[11]

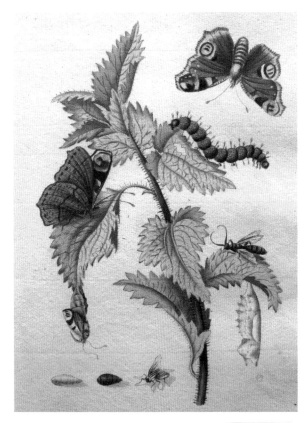

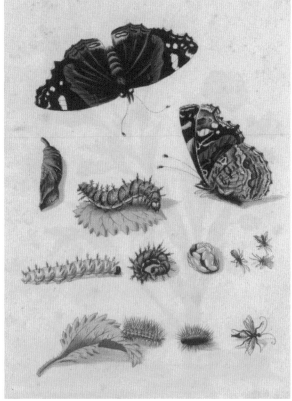

Fig. 6 M.S. Merian, Metamorphosis of the peacock butterfly (*Aglais io*) and a Phorid fly (lower left) on the common nettle (*Urtica dioica*), in M.S. Merian, *Der Rupsen Begin, Voedzel en Wonderbaare Verandering*, Amsterdam 1712, plate 26 (originally published in *Raupenbuch* volume 1, 1679), hand-colored etching, counterproof. Artis Library, Allard Pierson, University of Amsterdam, AB Legkast 019.02.

Fig. 7 M.S. Merian, Metamorphosis of the red admiral butterfly (*Vanessa atalanta*), in M.S. Merian, *Der Rupsen Begin, Voedzel en Wonderbaare Verandering*, Amsterdam 1712, plate 41 (originally published in *Raupenbuch* volume 2, 1683), hand-colored etching, counterproof. Artis Library, Allard Pierson, University of Amsterdam, AB Legkast 019.02.

Caterpillar Book in Dutch provides an example: "This nice caterpillar is feeding on willow tree, and on 22 June it transformed into a pupa, getting browner and browner day by day, comparable with [whitish] dew on top of blue plums."[13] The comparison with ripe blue plums is very apt, because the pupae are covered with a white dust or bloom, also known as pruinescence. This dusty-looking coating on the pupal surface is caused by wax parti-

cles on top of the insect's cuticle that partially cover the underlying coloration.

Some insects have evolved to generate pupae that are hidden or camouflaged in various ways. In one of the illustrations of Merian's *Studienbuch*, the basis for plate 23 in *Metamorphosis*, we can see a Teucer giant owl butterfly (*Caligo teucer teucer*) on the upper left side, posed above its caterpillar and pupa (Fig. 8). In the finished plate, the pupa is depicted as sitting

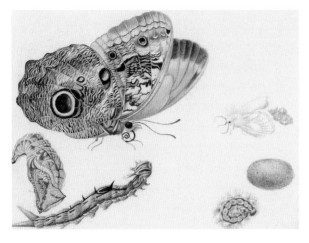

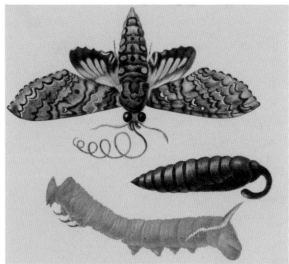

Fig. 8 M.S. Merian, Teucer giant owl butterfly (*Caligo teucer teucer*) and white flannel moth (*Norape ovina*), in M.S. Merian, *Studienbuch*, entries 275 and 276, ca. 1700, watercolor and bodycolor on vellum. Library of the Russian Academy of Sciences, Saint Petersburg, inv. no. F 246.

Fig. 9 M.S. Merian, Duponchel's sphinx moth (*Cocytius duponchel*), in M.S. Merian, *Studienbuch*, entry 280, ca. 1700, watercolor and bodycolor on vellum. Library of the Russian Academy of Sciences, Saint Petersburg, inv. no. F 246.

on a banana fruit, a compositional decision by Merian. In nature, the large, stocky pupa hangs from woody stems or among dead leaves, and its pale brown color with dark stripes cause it to blend in with dead foliage. Her description is brief: "On December 3 it [the caterpillar] attached itself and became a wood-colored pupa with two silver spots on each side. A lovely butterfly emerged from this pupa on December 20."[14] While this species uses a cremaster to attach the hind end of the pupa to a twig or other structure, Merian added a silken girdle to her painted study, which does not exist in reality. This small error does not negate the other details she described and painted, including the accurate color, silver spots, and the spines on the surface of this specific pupa. The other insect on the same

small piece of vellum (Fig. 8) is the much smaller white flannel moth (*Norape ovina*), depicted with eggs, caterpillar, and cocoon. The flannel moth is featured on plate 14 of *Metamorphosis*, along with Duponchel's sphinx moth (*Cocytius duponchel*) (see Fig. 8 in the chapter by Heard in this volume).[15] From these examples, we can see that the position of insects in her painted studies on vellum had no correspondence with where these same insects appeared in the final plates; this was true both for the Suriname volume and for her European insects.[16]

Merian's images of sphinx moth pupae (family Sphingidae) provide good examples of the distinctive structural differences that she observed, even among related species of insects. The study of Duponchel's sphinx moth

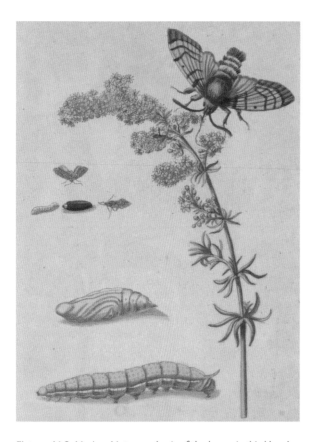

Fig. 10 M.S. Merian, Metamorphosis of the hummingbird hawk-moth (*Macroglossum stellatarum*), in M.S. Merian, *Der Rupsen Begin, Voedzel en Wonderbaare Verandering*, Amsterdam 1712, plate 29 (originally published in *Raupenbuch* volume 2, 1683), hand-colored etching, counterproof. Artis Library, Allard Pierson, University of Amsterdam, AB Legkast 019.02.

proboscis of some insects is a characteristic feature in Merian's images and may be an aesthetic choice, a space-saving device, or perhaps what she observed when the animals were preserved. She also chose plant motifs that show loop-shaped tendrils in her figures or plates of *Metamorphosis*, which has led some art historians to describe her images as baroque.[17] In contrast, there are also sphinx moth species in nature where the proboscis is much shorter and is fused with the pupal case, such as can be seen in the pupa of the hummingbird hawkmoth (*Macroglossum stellatarum*), a species familiar to Merian from Europe (Fig. 10).[18]

A last example of a distinctive pupa returns us to what appears to have been one of Merian's favorite tropical butterflies, another stunning morpho, illustrated in plate 7 of *Metamorphosis* (Fig. 11).[19] The fully-grown caterpillar on the branch also is striking, patterned with thin longitudinal lines and covered with fine brown hairs, which are tufted near the head and tail and in the middle of the back. She was very lucky with this species, remarking that she found only two of these caterpillars and that one had died. The surviving caterpillar transformed into a pale green, bulbous pupa that looks very much like a living leaf. Merian depicted its attachment to the stem of the Barbados cherry (*Malpighia glabra*) in such a way that it emphasizes

shows the unusual-looking pupa under the imago and above the striking green caterpillar (Fig. 9). The side view of the pupal case clearly shows the strongly curved casing around the long proboscis of this species, which is even more evident in the adult, unrolled in curling loops. This way of illustrating the long

Fig. 11 M.S. Merian, *Morpho deidamia* on Barbados cherry (*Malpighia glabra*), in M.S. Merian, *Metamorphosis Insectorum Surinamensium*, Amsterdam 1705, plate 7, hand-colored etching, 52 x 35 cm (page). KB, National Library of the Netherlands, The Hague, KW 1792 A 19.

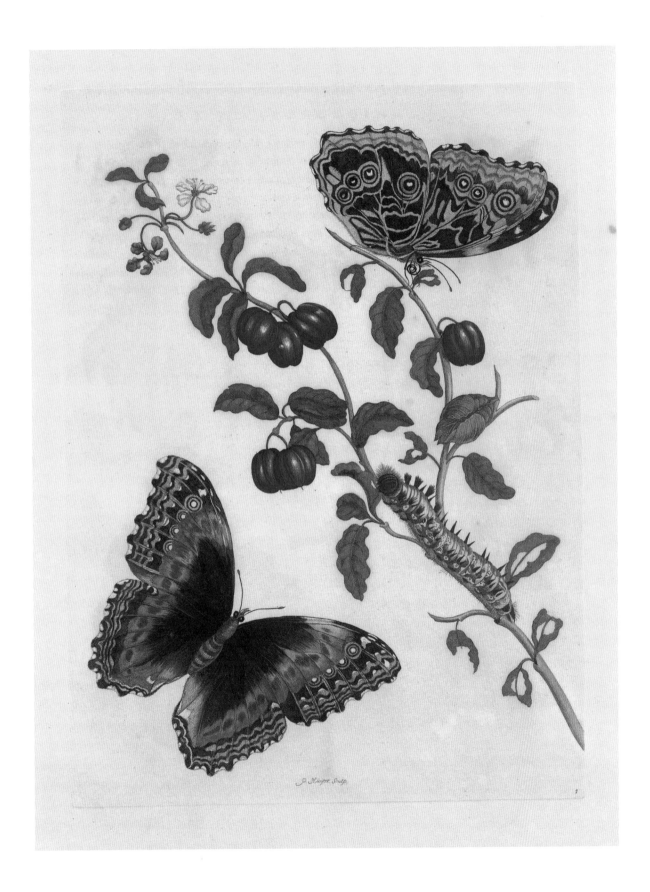

J. Mulder Sculp.

the camouflaged appearance of the pupa; one has to look closely to find the pupa just below the upper right hand fruit.

Lifelong Interest Leading to Significant Contributions

Morpho butterflies, colored in metallic, shimmering shades of blue and green, likely were stars in some of the collections Merian visited in the 1690s. Her curiosity about the exotic adult specimens she saw led to her frustration that the origin and the reproductive stages of these brilliant insects were missing. This gap in knowledge led to her desire to risk the costly and dangerous journey to nature's treasure house in Suriname. Her lifelong passion to uncover the secrets of metamorphosis is expressed in the preface of her 1705 book by that name:

> From my youth onwards, I have pursued the study of insects. Initially, I began with the silkworms in my home town of Frankfurt am Main. Afterwards, I noticed that far more beautiful butterflies and moths emerged from other caterpillars than developed from silkworms. This moved me to gather all the caterpillars that I could find in order to observe their transformation.[20]

Although she does not mention the pupal stage in the preface of *Metamorphosis*, she does introduce us to these "date seeds" in her 1679 *Raupenbuch*. However, in all of her published work and in her *Studienbuch* entries, her curiosity about this most critical stage of metamorphosis shines through. Both her detailed images of pu-

pae and the supporting text demonstrate that the intermediate stage between larva and adult was of equal if not more interest to her than colorful adults like the morpho butterflies. Her close study of the pupal stage reflects her strong desire to understand the process of change. In fact, the titles of her books tell the same story, emphasizing the "wondrous transformation" and "metamorphosis" of insects.

Maria Sibylla Merian's publications on the ecology, behavior, and metamorphosis of insects from 1679 almost until her death in 1717 are a prominent contribution to the history of entomology. Furthermore, the observational studies (handwritten texts and illustrations) in her *Studienbuch* constitute an important, early contribution to the biology of insects, even though she did not publish all of these observations. We can see her influence on naturalists who followed her in the chapters by Grebe, McBurney, and others in this volume and elsewhere. Moreover, publications by entomologists and plant/insect ecologists cite her work even today, as do databases and other websites of lepidopterists' societies. Modern scientists refer to Merian's work as they conduct field studies in the tropics and attempt to breed insects, and her books can provide clues to the changes in the range of insects with changes in the environment. It is perhaps easier to appreciate her accomplishments when we realize that, even today with the availability of digital photography and all manner of technology, the complete life cycle of a number of butterflies and moths, especially larval stages and pupae, remains unknown.[21]

A Story of Metamorphosis

Jadranka Njegovan

When applying to participate in the conference on Maria Sibylla Merian, *Changing the Nature of Art and Science* (Amsterdam, 2017), all I knew about Merian was from the beautiful exhibition of her life and work I had seen in 1998 at the Teylers Museum in Haarlem. Although I did not study Merian's work in any context, I saw a purpose for my film's presentation at the conference: to show the audience a small part of the living world that inspired Merian to create her work.

As a member of the insect study group of the Koninklijke Nederlandse Natuurhistorische Vereniging in The Hague, I have been making photographs of insects for years, mostly to aid in identifying them. In 2013, I started to film, at first by accident. But soon I discovered that I was much more interested in the behavior and developmental stages of insects than in their identification. For this type of investigation, video is a much more suitable medium than static photography. I started growing my own vegetables in a garden behind the dunes in a suburb of The Hague in 2014, and this became a source for a variety of insects that I have been collecting and rearing in improvised terraria ever since. In this way, I have observed insects and tried to docu-

ment their behavior and the most vulnerable stages of their development.

For my presentation at the conference in 2017, I wanted my story to be about an insect or a group of insects appearing in the German editions of Merian's books on European plants and insects, the 1679 and 1683 *Raupenbücher*. I had different options for my presentation of the images in these *Raupenbücher*, and found several images that reflected my film clips, such as predators of aphids, parasitic wasps on cabbage white caterpillars, and others. In the end, I decided simply to tell a story of metamorphosis as I saw it for the first time through the lens of my camera while observing the stages of development of the cabbage moth (*Mamestra brassicae*).

Metamorphosis, Film, and Story

I had been rearing, observing, and filming *Mamestra brassicae* for two years. It all started in May 2014, when I found clusters of eggs on the underside of broccoli leaves in my garden. Driven by curiosity, I took the leaves home and started to document the development of the eggs. I did not have any idea what to expect, but I should have known, or at least anticipated, seeing one of the most common pests of cabbage and related

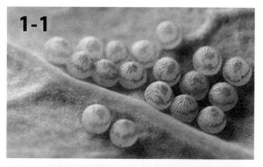

1-1

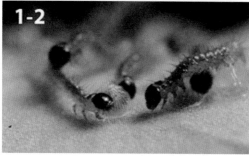

1-2

1-3

1-4

1-5

crops in the world. I had worked for years in agriculture with cabbage crops in the past, but somehow I did not expect to find this particular pest in my mini-garden. As one who had never observed the details of insect metamorphosis in detail before, I was open to any possibility. Here is what I saw, in words and stills from my video clips.

The color of the eggs was changing, first white, then getting darker and darker each day (Fig. 1-1), and within a week small caterpillars started to hatch. Almost immediately, they began eating their egg cases (Fig. 1-2) and within an hour they discovered how to chew through the epidermis of the broccoli leaf (Fig. 1-3). Upon digesting the soft tissue of the leaf and its cells full of chlorophyll, their color changed almost instantly. The skin (exoskeleton) of the caterpillars is transparent, without any color, so the green that we see comes from inside the insect. At this stage they are 1.5 mm long. After a few days I noticed that all the caterpillars stopped eating, each one laying itself out in a straight line without moving. They were obviously growing (now 3–4 mm long) and their skin was now too tight. These were signs that it was the time for shedding (molting) to take place. Because I had never seen a shedding before, I did not know where to look or how the shedding would start. When I looked more

Fig. 1 Video stills of the cabbage moth eggs, the caterpillars hatching, and their first feeding and shedding.

closely, I noticed the caterpillars had "a double set" of ocelli, which are simple insect eyes. Typically a caterpillar has a set of six ocelli on each side of the head. I saw the ocelli on the (black) head and also on the "shoulders" (Fig. 1-4). This black head was now only a shell and what I saw as "shoulders" was the actual living head coming out of the shell. The tissue protecting the head is much tougher than the skin on the rest of the caterpillar's body, so it has to break away and be pulled partly off first. This is the location where the shedding begins. A caterpillar frees itself from the rest of the old skin by a waving movement, as if taking off a dress that is too tight. The old skin left behind is transparent. Finally, the old shell of the head also falls away. In this period the caterpillars are barely visible to the human eye and are even difficult to see with a magnifying glass, because they are very small and the same color as a leaf. The damage they make to leaves is also very small (Fig. 1-5).

The caterpillars continued to grow and shed several times, until they were about 3 cm long. After this cycle of shedding (Fig. 2-1), they changed color (Fig. 2-2) and did not move until the evening. The morning after they changed color, I found all the caterpillars moving about on the floor, desperately looking for something. Up to this point, I had not

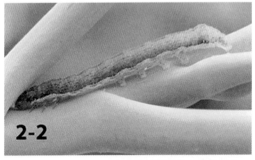

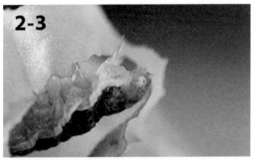

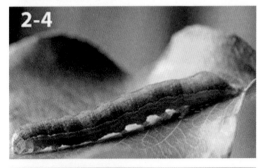

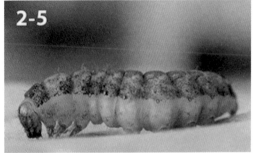

Fig. 2 Video stills of the final shedding and behavioral change.

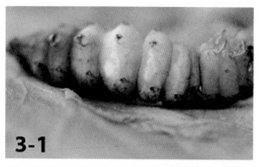

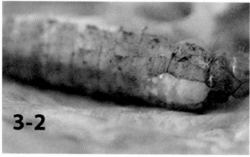

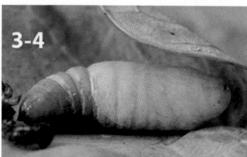

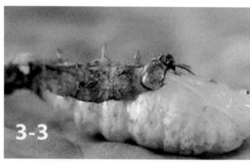

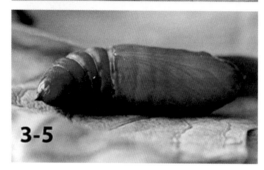

closed them in cages and they moved around freely on the leaves of broccoli in a vase. My first thought upon seeing them on the floor was that they were looking for a different type of plant to feed on. I put them back on the broccoli leaves, closed them in a cage, and went outside to collect leaves of different plants, hoping they would accept some of them as food. To my surprise and joy, they continued feeding on the broccoli leaves. The conclusion was simple: they were not looking for another type of food, but for a place, perhaps soil, in which to hide. They were now big enough (3.5–4 cm) to be easily seen by predators such as birds (and gardeners).

I had also posted a question on an online forum (www.waarneming.nl) where users can share images and ask experts about their findings. I received some comments along with several suggestions, including the species name *Mamestra brassicae*, which I already had in mind after seeing the color change. The caterpillars continued to feed in the late hours of the day (Fig. 2-3) and to rest in the shade of the leaves during the day. I did not provide them with soil, because then I would not be able to film them as well. By this time the caterpillars had become fatter and looked precisely as described in entomology books I had seen and in the comments Merian wrote to accompany plate 49 of her 1679 *Raupenbuch* (Figs. 2-3, 2-4).[1] After accumulating

Fig. 3 Video stills of the pupation.

enough nutrition, the caterpillars stopped eating. At this stage, the caterpillars normally remain under the ground and do not visit plants nor feed anymore (Fig. 2-5). Inside their bodies, the transformation process was beginning.

At this stage the body is shortened, the skin has become darker, and contractions of the body begin (Fig. 3-1); the skin or exoskeleton of the caterpillar splits and the pupa underneath is revealed (Fig. 3-2). On the pupa's skin (exoskeleton), the forms of wings, antennas, eyes, and legs are already visible (Fig. 3-3). After few hours, the color of the pupa changes from light green to yellowish, then dark orange, and finally a light brown (Figs. 3-4, 3-5). Through the colored but still transparent skin we can see the white substance, a miraculous soup, where the transformation is happening.

The color will continue to change and in two weeks the pupa looks very dark (Fig. 4-1). In actuality, the skin is brown and transparent, but we can look inside and already see dark and light lines from the legs, wings, eyes, and other structures. A moth emerges by breaking open the pupa with its head (Fig. 4-2). Several individuals carried a drop of water (or another clear fluid) on their tongue. I checked the film footage I had made of some other species (*Pieris* sp. and *Epirrhoe* sp.), but I did not observe the

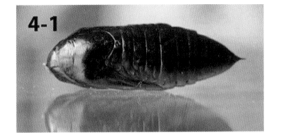

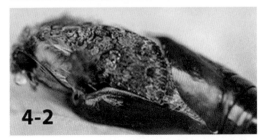

Fig. 4 Video stills of the moth emerging and mating.

same phenomenon. All of the moths secreted the meconium, a big drop of waste, that each moth discharges via the anus after emerging from its pupa. Meconium of the cabbage moth is a milky-colored, latex-like substance. I learned later that the color of meconium is related to the species. It took some time until the wings were fully developed (Fig. 4-4), but until then, some moths were very active and ran around quickly (Fig. 4-3). They were aware of being watched, because some were hiding and avoiding the camera. When the wings were fully developed (Fig. 4-5), they began to mate. Some males and females remained attached to each other for eleven hours. Two days later, a female began laying eggs everywhere. Although I had put some leaves in the cage, she laid her eggs (I counted about 450) on the net and glass wall, probably a sign of stress. If not in captivity, she would have been flying around and spreading her eggs over several plants. From the literature, I found that a female moth may lay two to three thousand eggs during her life.

This process continuous the whole summer. The cabbage moth produces two or three generations per year.

Maria Sibylla Merian on *Mamestra brassicae*

Maria Sibylla Merian depicted the cabbage moth on a carnation plant (*Dianthus caryophyllus*) in plate 49 of her first *Raupenbuch* of 1679 (Fig. 5).[2] The choice of a carnation surprised me, but then I read her text and understood that she observed this moth on several crops, including its

more usual foods, cabbage and cauliflower. She described the insect without giving it a name. As Merian discovered, the cabbage moth caterpillar is a polyphagous insect, eating a number of different types of plant.[3] The first scientific name given in 1758 by the Swedish botanist, zoologist, taxonomist, and physician Carl Linnaeus (1707–1778) was *Phalaena brassicae*, in which the species name refers to its feeding on cabbage (part of the Brassicaceae family). The name *Mamestra brassicae* appeared much later.

The second detail from Merian's work that was different from my own was that my caterpillars were not attacked by any parasitoids (parasites that kill their host); her plate depicts Tachinid flies (Fig. 5), a group of species often found with the cabbage moth. I found parasitoids on the caterpillars of other species I took from the field. However, I always reared *Mamestra* from the eggs I found, meaning the caterpillars were hatching and growing in a protected environment and were not infected by parasitoids. I assume that Merian collected these caterpillars from gardens and fields, and did not rear them from eggs, so her caterpillars that developed parasitic flies and wasps would have been infected before she brought them home.

The third detail I noticed is that Merian describes these caterpillars as follows: "I have never seen these caterpillars eat during the day, but only at night... I have often come across them in the ground, too, where they remained all day but crawled out at night in search of their food."[4] Here, I would dare to pro-

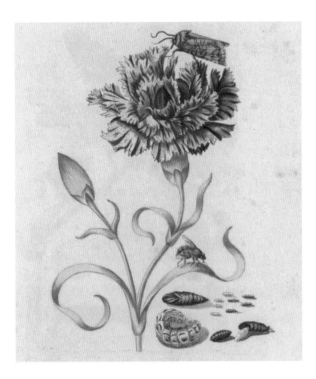

Fig. 5 M.S. Merian, The cabbage moth on a carnation plant, in M.S. Merian, *Der Rupsen Begin, Voedzel en Wonderbaare Verandering*, part I, Amsterdam 1712, plate 49, hand-colored etching, counterproof. Artis Library, Allard Pierson, University of Amsterdam, AB Legkast 019.02. Same image (reversed) as in *Der Raupen wunderbare Verwandelung*, Nuremberg 1679.

pose that she followed them from their last stage as a caterpillar; she did not see or describe the earlier stages, when the caterpillars were much smaller, camouflaged by their green color and hidden on their food plants during the day. Late-stage caterpillars do much more visible damage than the early stages, which might go unnoticed. Actually, I think that she did what all gardeners do when they see damaged plants and insect droppings, which is to search for the source of the damage. When she did not initially find the cause, she returned at night and saw the caterpillars feeding

on the plants. In order to find where they were hiding during the day, she dug in the ground near the plants and found them resting in the soil.

Observation, Then and Now

To observe, observing, observation—the meaning of these terms in essence has not changed over the centuries. In the processes of rearing and observing insects, there is a strong emphasis on the verb "to serve": to provide food and clean their enclosure every day. Above all, if you want to witness the interesting moments of their life, you have to master the art of waiting. The range of technology available today for our observations and documentation was beyond imagination in Merian's time, three hundred years ago. It is superfluous to name all the possible tools we have today. However, this same technology makes distortion of reality possible, and we can lose the feeling of scale—how small or big a creature really is. Nature films also use slow-motion or time-lapse photography, so we lose the sense of the speed at which something is happening in real time.

To make a drawing or painting of an insect and plant takes much more time than to make a photograph or a video. But a drawing can be made from memory and from notes. If you miss a moment while making video, there is no other way to recapture this event other than to wait for the next generation of insects, which may take a year. Hopefully this essay and the still images from my videos can offer a contemporary glimpse into the inspiring world of Maria Sibylla Merian.

Maria Sibylla Merian and the People of Suriname

Marieke van Delft

In June 1699, Maria Sibylla Merian and her daughter Dorothea Maria (1678–1743) set sail for Suriname with the aim to continue their research on the metamorphosis of caterpillars into butterflies. Merian had published two books on the metamorphosis of European caterpillars, and the preserved specimens of butterflies from Suriname she had seen in cabinets of curiosities in Amsterdam made her wonder what stages of their metamorphosis she could find there. She was convinced that there was no real alternative for her research than to go to Suriname and study the insects first-hand. So although Merian seems to have been driven by a genuine interest in nature, she still contributed to the system of colonial biology, wherein exotic flora and fauna and indigenous knowledge was commercialized for the European market.[1] In light of this discussion and today's deeper examination and debate involving slavery, I will focus here on Merian's relationships with the inhabitants of Suriname and how they contributed to her research. For perspective, I will compare this with how other contemporary naturalists who visited the region, such as Willem Piso, Charles Plumier, Sir Hans Sloane, and Mark Catesby, gleaned information from local people, as Georg Rumphius also did while investigating the world in the East.

The Situation in Suriname

When Merian traveled to Suriname, the colony had been occupied by the Dutch for 32 years (Fig. 1). In 1667, near the end of the Second Anglo-Dutch War, the Dutch had attacked the colony of Suriname, then occupied by the English, to gain a better position for peace negotiations. They conquered the colony and it was decided at the Treaty of Breda in 1667 that both countries would keep the foreign lands they occupied at that time. Hence, New Amsterdam (presently New York) came under English control and Suriname became a Dutch colony. It was not until 1975 that Suriname gained its independence. Thus, when Merian visited Suriname from autumn 1699 to June 1701, the region was considered part of the Dutch Republic.

This did not mean, however, that the majority of the European people there

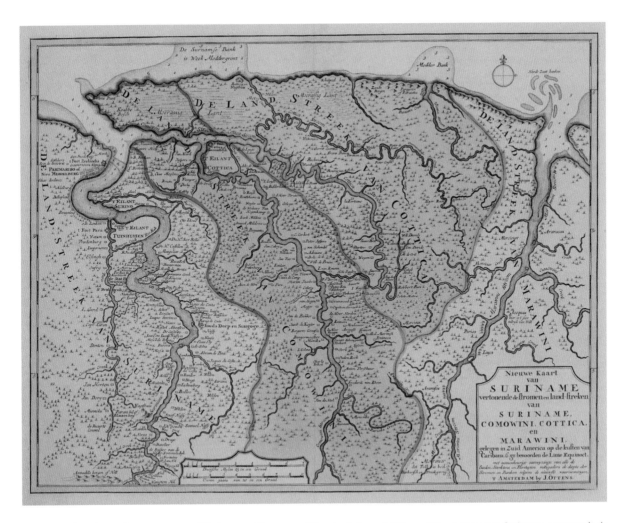

Fig. 1　Early eighteenth-century map of Suriname with names of the plantations. J. Ottens, *Nieuwe Kaart van Suriname, vertonende de stromen en land-streken van Suriname, Comowini, Cottica, en Marawini*, Amsterdam before 1718, hand-colored engraving, 39 x 50.5 cm. Allard Pierson, University of Amsterdam, HB-KZL 33.24.69.

were Dutch. Due to the unstable situation in the Atlantic region, many Europeans moved from one place to another. This resulted in a very varied population in Suriname. Besides the Native Americans who traditionally inhabited the region, various groups of people of European origin had also settled there. Among these were numerous Spanish and Portuguese Jews, expelled from

Brazil after the Portuguese reconquered that country. And although twelve hundred British people, who had also started to bring enslaved people of African origin to the country, left after the conquest by the Dutch, some of their compatriots stayed. There were also many Germans living in the region. Still, the total European population of around nine hundred was too small to transform Suriname

into the profitable colony desired by the Dutch. More people were needed, and thus, more European inhabitants were sought. A series of pamphlets was published to interest people in Suriname.[2] This propaganda, based on the description of the region by Walter Raleigh and Lawrence Keymis from 1598, stated that the Guyana region was "overflowing with milk and honey".[3]

Many workers were needed for the plantations. For this, the planters relied on the Native Americans who had been enslaved (termed "red slaves") and the growing number of Africans transported to Suriname (called "black slaves"). After the arrival of the Dutch, Suriname's involvement with slavery increased due to the growing number of plantations, which multiplied from around fifty in 1680 to roughly two hundred in 1702; some of these were small in size, but others were very large.[4] In the beginning the colony's governance was handed over from one party to another. Between 1667 and 1682, it was governed by the province of Zeeland, then by the Dutch West India Company (WIC), and from 1683 by the Society of Suriname (Sociëteit van Suriname), which was formed by three parties: the city of Amsterdam, the WIC, and a private person, Cornelis van Aerssen van Sommelsdijck (1637–1688), who we will meet later on. The work on the plantations was accomplished through the use of enslaved people. They were essential to the economy of the colony, which relied heavily on sugar production, and slavery was an accepted practice at the time.

Merian's Knowledge of Slavery in Suriname

Many scholars admire Merian as the independent woman who traveled the Atlantic for her natural history research and they are inclined to see her as a good woman, a heroine, who avoided getting caught up in a situation we now consider inhumane. But before turning to Merian, we must consider what was known in the Dutch Republic about the slave trade and slavery in the colonies in general. The cruel treatment of enslaved people in Spanish and Portuguese colonies was notorious among the Dutch. They compared it to their own experiences with the Spaniards during the Eighty Years' War between Spain and the Low Countries (1568–1648). This war had engendered a flow of publications on the "Spanish Tyranny", in which the treatment of inhabitants of the Low Countries by the Spaniards was compared with their cruelties against enslaved persons. But from 1630 onwards, the Dutch criticism of slavery declined and theological and other arguments were sought to accept and allow enslavement and, before long, Dutch practices were the same as the ones for which they once despised the Iberians.[5]

Could Merian have been aware of all of this? She came to the Dutch Republic in 1685 to join the Labadists in Wieuwerd. This pietist community in the province of Friesland had arrived there in 1675 after years of wandering in search for a place to settle.[6] They lived at Waltha state, a manor house that Cornelis Aerssen van Sommelsdijck,

one of the founders of the Society of Suriname, had put at the disposal of his three sisters, all Labadist believers. After he became governor of Suriname in 1683 and moved to the colony, forty of the Labadists joined him to investigate whether a new Labadist establishment could be founded there.[7]

A year later, the Labadists returned with ambiguous stories that have come to us via Petrus Dittelbach (1640–1704), a preacher who stayed in Wieuwerd for a while as a teacher. After he left, he wrote a negative pamphlet about the community. He became very critical of the movement after his stay there, and his account should be read with this in mind.[8] Some that returned praised the land, with its delicious and remarkable fruits and plants, the sugar fields and the friendly natives. Others complained about the climate and about pests such as mosquitoes, ants, and snakes. Although the overall conclusion was negative, the Labadist leader Pierre Yvon (1746–1707) decided that the plans for an overseas settlement should go forward. Hence a group of Wieuwerd inhabitants, among them one of the Van Sommelsdijck sisters, left for Suriname early in the summer of 1684. Van Sommelsdijck advised the Labadists to settle in the neighborhood of Paramaribo and Fort Zeelandia, but the group wished to live far from civilization and decided to start a plantation forty miles up the Suriname River. There, the negative report of the earlier explorers turned out to be true. The inexperienced colonists ran into all sorts of problems; there was not enough food and many became ill. They reported back to Wieuwerd, writing that they would try to find a better place for a settlement. As a result, a second group of Labadists embarked for Suriname, accompanied by a second Van Sommelsdijck sister.[9] After an adventurous journey during which their ship was hijacked and all the goods they intended to bring to the plantation were taken, they finally reached the Labadist plantation Providence, which they found in a very poor state. Many of the colonists were ill, badly clothed, harassed by mosquitoes, and hungry because of failed harvests. As L. Knappert writes: "They did not find Eden, but a hospital."[10]

The colonists sent written reports to the Labadists in Wieuwerd that were read aloud.[11] Merian had arrived in 1685/86, so she must have known about the difficulties her fellow Labadists encountered in the New World. Even if some negative letters were not shared with the entire community, they certainly were known to the abovementioned Petrus Dittelbach. In his pamphlet on the Labadists, *Verval en Val der Labadisten*, he described the attitude of the Labadists towards Native Americans and enslaved persons, writing that:

> They knew that in that land everything was done by male and female slaves and this could be very uncomfortable for the leaders and the household: but they thought that everything could be overcome through goodness and benevolence towards those poor people that were treated barbarously by the other

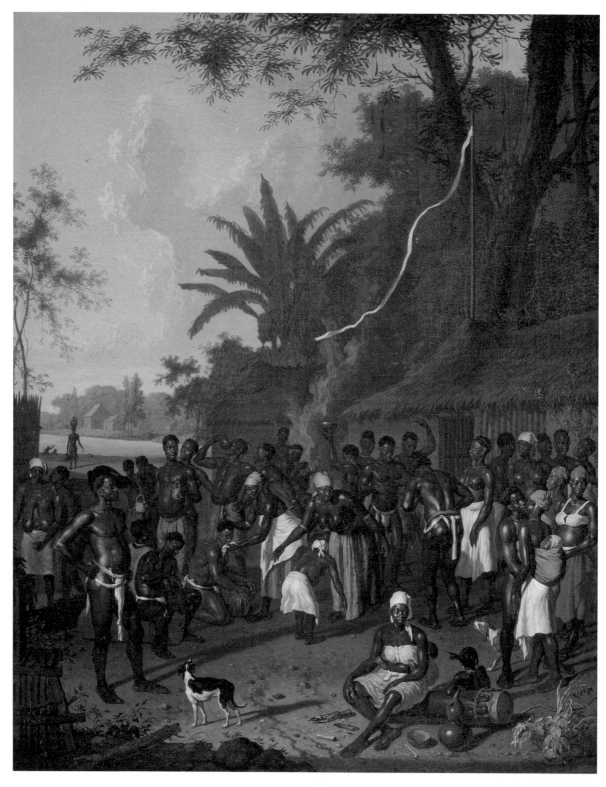

Fig. 2 D. Valkenburg, *Slave dance on a plantation [Palmeneribo?] in Suriname*, ca. 1707, oil on canvas, 58 x 46 cm. SMK (Statens Museum for Kunst), Copenhagen, KMS376.

plantation owners. So they bought many slaves, treated them well, but discovered that what others had told them was true, that one cannot own the will of this beastly kind of people but through beastly lashes.[12]

Then follows a description of the Spanish whip (*Spaanse bok*), a very harsh kind of punishment dealt upon the enslaved people. The intention of the Labadists to treat the enslaved with benevolence seems to have disappeared as a consequence of the hard life on the plantation.[13] Moreover, no opposition by the Labadists to slavery is known, although there were some protests against slavery in these days.[14] Dittelbach's booklet was published in Amsterdam in 1692, where Merian had arrived the year before. So she could have read it and known about the hard conditions in Suriname, and that the Labadists treated the enslaved persons very badly. However, this did not keep her from going to Suriname.

In her visits to plantations, she must have seen how enslaved people were treated, because the system of slavery was present at every plantation.[15] During her stay at Palmeneribo, the plantation was in a state of transition because its owner, Johan van Scharphuijzen, had died in 1699. Via the heiress Elisabeth Basseliers (1680–1702), it came in the hands of a nephew of her acquaintance Nicolaes Witsen (1641–1717), together with two other plantations. In 1706 this nephew, Jonas Witsen (1676–1715), sent a Dutch artist to Suriname, Dirk Valkenburg (1675–1721), to depict his new possessions, because he wanted to know what they looked like.[16] Valkenburg made drawings and the famous painting *The Slave Dance*, perhaps situated at Palmeneribo, around five years after Merian's visit (Fig. 2). If the enslaved people on this picture were painted after existing persons, then Merian may have known some of them. The story does not end well. When Jonas Witsen became the owner of the plantation, he sent orders to his director there to be more strict with the enslaved people, so their treatment became very severe. In 1707 the plantation was the scene of a horrifying punishment of a group of enslaved persons who had revolted. Was Merian aware of this revolt and the harsh treatment of enslaved people when she visited the cabinets of curiosities of the two Witsens?

Merian's Methods

As preparation for her journey, Merian must have collected information on Suriname. She probably read Dittelbach's book, but may also have read a short description of Suriname by George Warren. This was published in English, but a Dutch translation was available in Amsterdam in 1669 and an anonymous German adaptation appeared in 1673.[17] The booklet describes the country, its geography, climate, food, animals, fruits, and population (indigenous and enslaved people). However, the information in her *Metamorphosis Insectorum Surinamensium* (1705) differs from the information in Warren's book, from which we can conclude that she did her own research.

Warren, for example, mentions that guava fruit tastes like currants, which Merian does not include.[18] And although both write about the bread made from the *Cassava* and the venomous juice of this plant, Merian omits that indigenous people also use it to make liquor.[19]

In her Suriname book, Merian made a clear distinction between the various people living in Suriname in her time.[20] She mentions "Indians" (*indianen*), "inhabitants" (*inwoonders*), "slaves" (*slaven, slavinnen, zwarte slavin*), and "Europeans" (*Europianen, Hollanders*). When she stayed in Suriname, both "red slaves" and "black slaves" were still mentioned in the yearly lists of inhabitants.[21] So "slaves" can refer to enslaved Native Americans or enslaved Africans. Based on her distinction between the various groups, it seems that the Native Americans she cites were not enslaved, whereas the "slaves" were. Only once does she use the adjective "black," indicating that the enslaved woman she mentions was an African woman (plate 27). "Indians" are mentioned in eleven texts that accompany the plates and "inhabitants" six times; it is likely she refers to Native Americans using both words. From these people she received information about the use of plants. The "slaves" helped her in practice by hacking an opening in the forest vegetation (plate 36) or bringing her a worm (plate 27). The Europeans did not give her information on the flora and fauna—in Merian's view they were incapable of doing so, because they were only interested in sugar—but they offered her a place to stay on their plantations. On some occasions, when she sighs that natural resources of the country could be more profitable, she uses the word "people" (*mensen, lieden*): "The people [*mensen*] there do not feel like investigating something like that. Indeed, they mocked me for looking for something other than sugar in the country" (plate 36), and "It is a pity that there are no curious people [*mensen*] in that country who are interested in cultivating such things and look for some more, which could doubtless be found in that vast and fertile country" (plate 25). "[The figs] would be more abundant in Suriname if the people [*lieden*] would only want to cultivate them" (plate 33), and "It is regrettable that one does not find people [*mensen*] there who want to cultivate [grapevines]. One should not have to bring wine to Suriname, but one should be able to bring it from there to Holland, since the grapes could be harvested many times a year" (plate 34).[22] I am inclined to think that all these examples refer to the planters, because they commercialized the fruits and produce of Suriname.

Certain observations of Merian are cited again and again.[23] In this chapter I will examine her texts from a different perspective. Merian is well-known for making first-hand observations of nature and raising insects through metamorphosis, and this is what she did in Suriname as well. She caught caterpillars, raised them with their food plants, observed which butterflies emerged, painted and drew what she saw, and noted everything, with dates. But in the

alien environment of Suriname, she also needed to rely more heavily on the knowledge and experience of others than she did in Europe.

She used three methods to collect knowledge on the flora and fauna of Suriname that she could not gain from her own work: she mapped existing knowledge, she observed the interactions of people and nature, and she interacted directly with local people. First, she noted the prevailing names, knowledge, and habits. Some examples follow: "I have retained the names of the plants as they are given in America by the inhabitants and the Indians" (foreword); "This plant, called Slaapertjes [sicklepod; *Senna obtusifolia*] in Suriname, I had in my garden. It is used to apply on wounds, because it is beneficial for their healing" (plate 32), or "This tree is called Marmelade-Doosies-Boom [marmalade-box tree; *Duroia eriopila*] because of the fruit that it yields" (plate 43). In these cases she did not mention a specific interaction with anyone, but instead sums up general knowledge that prevailed in the colony.

Secondly, she used her skills as a naturalist when observing Native Americans, enslaved people, and planters, and noted their (traditional) uses of both plants and insects: "The Indians put these in water to soften them. Then the red dye comes off, and sinks to the bottom. Afterwards they gradually pour off the water, and dry the dye that lies at the bottom. With it they paint all sorts of figures on their naked skin, which constitute their adornment" (plate 44); "This plant is called Okkerum [*Abelmoschus*

esculentus] or else Althea in Suriname [...] Slaves in America cook and eat the fruit" (plate 37); "The Indians lay the green leaves on fresh wounds to cool and heal them", and "The Indians spin this cotton, from which they make hammocks to sleep in" (plate 10); "The Indians spread it on their bread when they eat. The Dutch cut it up small and eat it with meat and fish. They also use it in sauces and vinegar, etc." (plate 55).

Lastly, Merian engaged actively with the people: "I have also added the reproduction of the West Indian spiders, ants, snakes, lizards, wonderful toads and frogs, all painted and observed from life by myself in America, except for a small number, which I have added based on the accounts of the Indians" (introduction); "It was brought to me by a black female slave who told me that lovely grasshoppers would emerge from it" (plate 27; *Studienbuch* p. 279); "I found this plant in the forest, and since one cannot cut off any plants there because of the heat or they would wither at once, I had my Indian dig it up by the root and carry it home and plant it in my garden" (plate 36); "One day the Indians brought me a large number of these lantern flies [*Fulgora laternaria*] (before I knew they gave off such a glow at night), which I placed in a large wooden box." (plate 49); "Because the forest is so densely grown with thistles and thorns, I had to send my slaves ahead of me with axes to hack out an opening for me, to get through it at all, which was still very troublesome" (plate 36); "The Indians brought this from the woods and told me they found it on a wild tree" (*Studienbuch*,

p. 283). So it seems sometimes the interaction was initiated by the indigenous or enslaved people who brought her specimens, because they knew she was interested in these things. On other occasions, Merian wanted them to do things for her, planting a certain food plant in her garden or hacking a path through the forest.

Of course, the distinction between the three methods is fluid, but grouping them makes clear how she collected additional knowledge on the flora and fauna of Suriname and how she interacted with its inhabitants. Occasionally she does not mention any source for the information she gives. In the text for plate 38, without giving a source, she states that the buds of this plant "are used as purgatives and enemas. They are also cooked, and the water is given to those who have Beljak (a certain disease in the country) to drink". She may have seen or heard this and appropriated the knowledge.

Did Merian Own Enslaved People?

In a few texts, as mentioned previously, Merian writes about enslaved and indigenous people. She mentions "my slaves". who walk ahead of her in the bush to cut a path so she can do her natural history research, or "my Indian". who digs up a specific plant to put in her garden so she can feed a certain caterpillar (both plate 36). The possessive pronoun could suggest that she owned these persons, but no document exists to confirm this. In the archives of the Society of Suriname, tax documents are kept with information about the colony's inhabitants.[24] The doc-

ument lists the number of enslaved persons in the years that Merian stayed there: in 1699 there were 669 European colonists who possessed 8,575 adult enslaved persons (red and black) and 957 children (up to fifteen years of age); in 1700, 745 European colonists owned 8,926 adult enslaved persons (red and black) and 1,024 children. In 1701 there were 618 adult colonists and 105 children under twelve of colonists, and 7,353 enslaved persons (red and black) with 1,193 children under twelve of enslaved persons. The name of Merian does not occur in these lists, so she probably did not own enslaved people, but had access to them at the plantations were she stayed, as Ella Reitsma suggests.[25] When she loaned or hired enslaved people, she still could use the possessive pronoun "my" when writing about them. Other authors have proposed that Merian did own enslaved persons, but as we have seen there is no evidence of that.[26] Whether or not she owned people, she benefitted from their labor and the information they conveyed as she conducted her research. On the other hand, her relationships with both the Native Americans and imported Africans may have involved a level of trust, because they shared sensitive information with her, such as the often cited description of the *Flos Pavonis* shows:

> This Flos Pavonis [peacock flower, Caesalpinia pulcherrima,] is a plant measuring 9 feet tall. It bears yellow and red flowers. The seed is used by women giving birth to carry on the labor. The Indians, who are not treated

Fig. 3 M.S. Merian, Tobacco hornworm (*Manduca sexta paphus*) on *Flos Pavonis* or peacock flower (*Caesalpinia pulcherrima*), in M.S. Merian, *Metamorphosis Insectorum Surinamensium*, Amsterdam 1705, plate 45, hand-colored etching, 52 x 35 cm (page). KB, National Library of the Netherlands, The Hague, KW 1792 A 19.

country of their friends, as I heard from their own lips (plate 45).[27]

She states here that the Native Americans used the *Flos Pavonis* for abortion. An observation of enslaved African women follows, but she does not write that they use the plant for this purpose as well, only that they needed to be treated kindly. However, one can perhaps conclude that they used it for this purpose as well, because this statement appears in the same commentary on the *Flos Pavonis*. The addition that she heard it from their own lips in particular indicates that there was a kind of trust between her and those enslaved women, and that she respected their knowledge. But besides this remark on the *Flos Pavonis*, nowhere does she mention the dark side of slavery in her book—which probably would have been risky, in view of her relations with people from the upper class like the Witsens—and seems to take the situation for granted.

Last but not least, it is interesting to mention that she took an indigenous woman with her on her return to Europe.[28] This was not uncommon. Other planters or colonists had taken enslaved Africans or—less often—Native Americans with them to Europe.[29] In Merian's time these people became free once they arrived in the Dutch Republic. But, if they had left as an enslaved person, upon returning to Suriname they would become enslaved again. Reitsma attributes an important role to this indigenous woman as an informant for Merian's book on Suriname and supposes that

well when in service with the Dutch, use it to abort their children, not wanting their children to be slaves, like them. The black female slaves from Guinea and Angola have to be treated very kindly. Otherwise they do not want children in their state of slavery and will not have any. Indeed, they sometimes even kill them because of the harsh treatment commonly inflicted on them, because they feel that they will be reborn in a free state in the

she stayed with her in Amsterdam. Natalie Zemon Davis also assumes that she was a servant rather than a slave.[30] But in fact we know nothing about this woman, not even whether she arrived in Amsterdam. She is mentioned in the passenger list as "Indianin", without a name. If she arrived in Amsterdam and lived with Merian, she was no longer present in 1711, because in that year Merian made a testament and the woman is not mentioned as part of her household.[31] Was this a free indigenous woman, or did Merian own her? Did she arrive in Amsterdam and did she stay there, or was she only accompanying the exhausted and ill Merian and sent back to Suriname immediately after their arrival? We do not know.

Merian's Contemporaries

Almost ten years ago, Tomomi Kinukawa wrote an article on Merian and her *Metamorphosis* from a feminist perspective. As mentioned above, she writes (without any evidence) that Merian owned enslaved persons. But she also addresses another issue. In her view, Merian and other naturalists appropriated indigenous knowledge and in doing so also caused racial inequality. It seems that, for her, slavery is not the primary issue, but rather the piracy and commercialization of indigenous knowledge.[32] Although it seems Merian was driven by sincere scientific curiosity, she definitely earned money from her journey through the specimens she collected and her book. Yet she and other naturalists also preserved indigenous

wisdom by recording it on paper. Of course, this was also passed on to following generations by oral transmission, but Merian's book and publications by others made this knowledge available throughout the world and for all time.

Merian was not the first naturalist who traveled to the New World to research the natural world.[33] In 1637 the Dutch physician and naturalist Willem Piso (1611–1678) went to Brazil on the invitation of count Johan Maurits van Nassau-Siegen and the Dutch West India Company. He stayed there for seven years. Together with Georg Marcgraf (1610–1644), he wrote the *Historia Naturalis Brasiliae*, published in Leiden in 1648. This book gives an early insight from a European perspective on the flora and fauna of Brazil. Piso and Marcgraf noted, as Merian did, the habits of the African people there and their uses of plants (i.e., the method of mapping existing knowledge and observing), but they do not mention or recognize the active assistance and information coming from enslaved Africans and indigenous people.[34]

The region was also visited by Charles Plumier (1646–1704) from France, who published his results in 1693 in *Description des Plantes de l'Amérique* (see also the chapter by Remond in this volume). The descriptions of the plants in his book are objective, and although he mentions where he found certain plants, he does not mention his sources or the people who helped him.

Around the same time, in 1687, the Scottish physician Sir Hans Sloane (1660–1753) went to Jamaica to serve as

the personal physician of the newly appointed governor of the island.[35] His task was unsuccessful, because the governor died soon after, but during his fifteen months on the island he traveled around and collected plants and information on Jamaica and its population. His experiences were published in his two-volume work, *A Voyage to the Islands Madera, Barbados, Nieves, S. Christophers and Jamaica* (1707–1725). This work is a combination of a travel account and a natural history book. In a lengthy introduction, he describes the country and the people living there. He writes about the punishments of the enslaved people and even depicts the whip and ropes that were used. He illustrates these in the same manner as he illustrates the plants, as if he is not touched by the inhumane treatment of the enslaved grown-ups. Like Merian, he discerns three groups of people living there: planters, enslaved Africans, and Native Americans. However, in his accounts he does not mention explicitly that these groups helped him. His information is based on mapping and observing; no interaction is evidenced.

Another European naturalist who visited the Americas, almost a contemporary of Merian, was Englishman Mark Catesby (1683–1749, see also the chapter by McBurney in this volume). He went to North America and the Caribbean and published his findings in *The Natural History of Carolina, Florida, and the Bahama Islands* (1731–1743). In his book, Catesby describes the flora and fauna of the regions he visited but without mentioning the people who helped him. However, from his letters we know that in 1723 he bought an African boy.[36] And although this boy is mentioned nowhere in Catesby's published work, his descriptions of the use of plants for food and medicine by Africans (and Native Americans) indicate that he learned from both enslaved people and Native Americans.

Comparing these contemporary naturalists, Merian is the only one who mentions that indigenous and enslaved people contributed to her book. Although she does not reveal their names, she credits them. For Merian, this was exceptional. She does not even credit her own daughters—neither Dorothea Maria, who went with her to Suriname and helped her with her research and drawing, nor Johanna Helena (1668–1730), who also contributed to the book.

Another naturalist, however, Georg Everhard Rumpf, or Rumphius (1627–1702, see also the chapter by Van de Roemer in this volume), whose *D'Amboinsche Rariteitkamer* was posthumously published in the same year as Merian's *Metamorphosis*, did mention his informants in the same manner as Merian—anonymous, but with reference to the indigenous people. He describes, for example, that shells were brought to him by indigenous persons or that divers informed him.[37] We also know he was assisted by several enslaved persons, who remain nameless in his text as well.[38] In the year 1672, there lived in his household 24 enslaved persons: fifteen men, nine women, and

five children.[39] However, the contribution of the indigenous and enslaved people to Rumphius's botanical studies cannot be underestimated. Rumphius arrived in the Dutch East Indies in 1653 and would remain there the rest of his life. He integrated in the native Ambon society, which must have helped him to acquire information and artifacts. A major difference with Merian is that Rumphius sent his manuscripts to the Dutch Republic, where other people turned them into printed books that he would never see, because they were published after his death. So his research was interpreted by others, whereas Merian was deeply involved in the publication of her Suriname book and decided its content.

Conclusion

In the seventeenth and eighteenth centuries, European naturalists traveled to the global periphery in search of new worlds and exotic flora and fauna. Sometimes they were familiar with certain objects, plants, or animals because these had been brought to Europe by traders who had visited these regions. But through their explorations they could give a systematic overview of the flora and fauna of a certain region. Merian was drawn to Suriname because of the time she had previously spent with the Labadist community and through the beautiful caterpillars she saw in the cabi-

nets of curiosities in Amsterdam. A close reading of her Suriname book reveals her working method and sources. It shows what she learned from people living and working in Suriname and that she acknowledged the Native Americans and enslaved Africans who helped her with her research. Although she does not reveal their names, she mentions their assistance and writes that they brought her caterpillars and plants. Much, if not most, of her investigation of tropical plants and insects would have been impossible without the contributions of these people. Whether or not she owned enslaved persons has not been determined, but it is clear that she benefitted from the system of slavery and—like most of the Europeans in the colonies and in their homelands in those days—did not protest it. From her book, however, it seems justified to conclude that Native Americans and enslaved people trusted and helped her. Maybe this is the best we can expect. In the end we must realize that even a great investigator like Merian, who undertook an extraordinary journey to conduct advanced research, was a child of her time, just as we all are.

* I want to thank Mariana de Campos Francozo, Kay Etheridge, Johan Francke, Carl Haarnack, Henk den Heijer, Mark Ponte, Bert van de Roemer and Reinder Storm for their information and help while writing this chapter.

"One of the most Curious Performances... that ever was published." Maria Sibylla Merian's Drawings in the British Royal Collection and the *Metamorphosis Insectorum Surinamensium*

Kate Heard

Merian's *Metamorphosis* Illustrations at Windsor Castle

Some time before 1810, George III (1738–1820) acquired 95 drawings attributed to the German artist and entomologist Maria Sibylla Merian, which are today housed at Windsor Castle.[1] Merian's beautiful watercolor studies of natural history were based on her close examination of insect metamorphosis, which she had undertaken both in Europe and in the Dutch colony of Suriname in South America, where she carried out fieldwork between 1699 and 1701.[2] Her pioneering entomological studies won her fame across Europe through her meticulously illustrated publications. The most important of these was the *Metamorphosis Insectorum Surinamensium* (1705), which presented her observations of the flora and fauna in Suriname, and which was published in Amsterdam in both Dutch and Latin.[3] The *Metamorphosis* was enthusiastically received. In 1710, Merian was described as "that great *Naturalist* and *Artist*" in the *Philosophical Transactions* of the Royal Society of London, and in August 1711 her work was

Fig. 1 M.S. Merian, *Coffee Senna with split-banded owlet butterfly*, luxury version of plate 32 from M.S. Merian, *Metamorphosis Insectorum Surinamensium*, 1702/1703, watercolor and bodycolor with gum arabic over lightly etched outlines on vellum, 35.7 × 27.4 cm (sheet). Royal Collection, RCIN 921188. Royal Collection Trust / © Her Majesty Queen Elizabeth II, 2022.

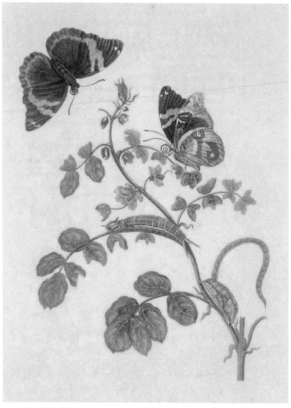

Fig. 2 P. Sluyter after M.S. Merian, *Metamorphosis Insectorum Surinamensium*, Amsterdam 1705, plate 32, counterproof edition, etching with hand-coloring, 53 × 38 cm (volume). Royal Collection, RCIN 1085787. Royal Collection Trust / © Her Majesty Queen Elizabeth II, 2022.

praised in the London journal *Memoirs of Literature, Containing a Weekly Account of the State of Learning, both at Home and Abroad*: "The great Industry and Generosity of Mrs. Merian cannot be sufficiently commended; and the Lovers of Natural History will doubtless receive her Present with great satisfaction. This Work is certainly one of the most Curious Performances in its kind that ever was publish'd."[4] This paper will ask what a close study of the Windsor drawings can tell us about Merian, her working practices, and the production of her celebrated "Curious Performance", the *Metamorphosis Insectorum Surinamensium*.

Although they have been together since at least 1755, when they were recorded in the possession of the collector Dr. Richard Mead (1673–1754), the 95 drawings acquired by George III were not always one group.[5] Rather, they fall into a number of distinct sets. First, there are sixty luxury versions of plates

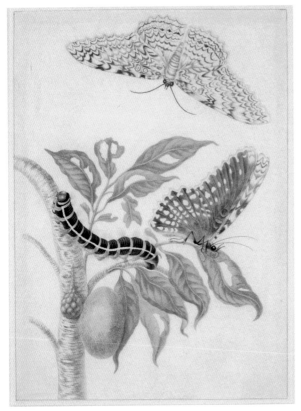

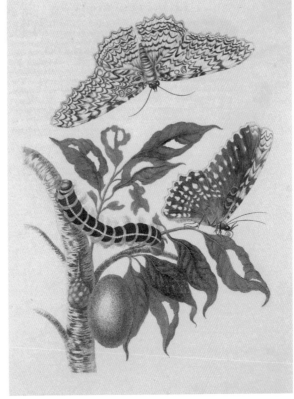

Fig. 3 M.S. Merian, *Branch of the gumbo limbo tree with white witch moth*, luxury version of plate 20 from M.S. Merian, *Metamorphosis Insectorum Surinamensium*, 1702/1703, watercolor and bodycolor with gum arabic over lightly etched outlines on vellum, 41.2 x 29.8 cm (sheet). Royal Collection, RCIN 921174. Royal Collection Trust / © Her Majesty Queen Elizabeth II, 2022.

Fig. 4 J. Mulder after M.S. Merian, *Metamorphosis Insectorum Surinamensium*, Amsterdam 1705, plate 20, counterproof edition, etching with hand-coloring, 53 x 38 cm (volume). Royal Collection, RCIN 1085787. Royal Collection Trust / © Her Majesty Queen Elizabeth II, 2022.

from Merian's *Metamorphosis*. Alongside these, and surely always belonging with them, are nine drawings by Merian of European subjects, which were probably made for sale to collectors after her return from Suriname, but were based on earlier studies. There is a group of 23 drawings which are not by Merian, but are clearly by an artist or artists who were closely associated with her, who appear to have had access to her sketchbooks and working materials. In addition to these groups, there are two drawings of large lizards, which feature in posthumous editions of the *Metamorphosis*, and a composition of the lifecycle of the frog. These last three drawings (versions of which exist in other collections) are traditionally attributed to Merian, but require further work on their authorship, which remains unclear.[6] The final drawing in the group acquired by George III is by Herman Henstenburgh (1667–1726).[7]

It is the sixty luxury versions of plates from the *Metamorphosis* which are the focus of this paper. These are on vellum, and were clearly made as an expensive item for sale to a wealthy collector (perhaps Mead himself). It was recognized in the 1990s that the majority of these luxury versions are not entirely freehand drawings, but are partially based on printed lines.[8] Furthermore, most are not direct facsimiles of the final plates (Figs. 1, 2). An analysis of the Windsor version of plate 20 of the *Metamorphosis*, for example, has demonstrated that Merian used the process of partial printing to vary her compositions, creating what are, in essence, individual works of art (Figs. 3, 4).[9] The Windsor drawings are not the only such set to survive—there is a similar group at the British Museum, which was previously owned by Mead's friend and colleague, Sir Hans Sloane (1660–1753).[10]

I would like to ask how these luxury illustrations may relate to the production of the *Metamorphosis* itself.[11] Alongside the Royal Collection works, I would like to discuss the versions of the *Metamorphosis* plates at the British Museum, which although clearly a sister set to those at Windsor, are subtly different. As I hope to show, these two sets can be closely dated, and were probably created to raise funds for the publication of the *Metamorphosis*.

Combining Printing and Drawing

The printed lines on the Royal Collection illustrations most commonly occur under the insects. In 53 of the plates, some

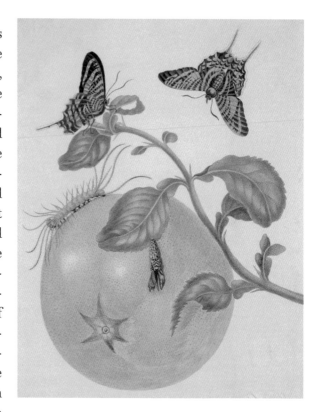

Fig. 5 M.S. Merian, *Branch of pomelo with green-banded urania moth*, luxury version of plate 29 from M.S. Merian, *Metamorphosis Insectorum Surinamensium*, 1702/1703, watercolor and bodycolor with gum arabic and gold paint over lightly etched outlines on vellum, 36.7 x 28.9 cm (sheet). Royal Collection, RCIN 921148. Royal Collection Trust / © Her Majesty Queen Elizabeth II 2022.

or all of the insects have underlying printed lines, while the accompanying plants are drawn freehand. An exception is plate 8, where the plant appears to be based on printed lines and the two butterflies have no underlying printing. A combination of printing and freehand drawing is found in the British Museum versions too, although sometimes there is a difference in the extent of the underlying printing between the Royal Collection and British Museum plates.

Fig. 6 M.S. Merian, *Branch of pomelo with green-banded urania moth,* luxury version of plate 29 from M.S. Merian, *Metamorphosis Insectorum Surinamensium,* 1702/1703, watercolor and bodycolor with gum arabic and gold paint over lightly etched outlines on vellum, 36.7 x 28.9 cm (sheet). Royal Collection, RCIN 921148 (detail). Royal Collection Trust / © Her Majesty Queen Elizabeth II 2022.

These printed lines are produced by the counterproof technique, in which a newly printed impression, the ink still wet, is pressed against another sheet, in this case vellum, onto which the lines of wet ink are transferred. This has the advantage of reversing the image, already reversed by the printing process, to return it to its original orientation. This is not the only example of Merian using the counterproof process, which she also employed to produce expensive versions of the *Metamorphosis* itself, as she did with other of her publications.[12] She also used the process to make luxury versions on vellum of the plates from her earlier *Der Raupen wunderbare Verwandelung* (1679–1683), although in that case the whole image was transferred by counterproof and did not differ from the published illustration.[13] The Royal Collection and British Museum *Metamorphosis* illustrations are unusual in the partial use of counterproof, with some

lines of the composition transferred in this manner and others drawn freehand. To create the partial counterproofs under the Royal Collection and British Museum works, Merian appears in many cases to have masked off areas of the composition (either on the original plate or on the resulting print from which the counterproof was to be taken), or to have printed sections on pieces of paper trimmed to size. The occasional, apparently accidental, appearance of other parts of the composition in these counterproof sections shows that Merian was selectively choosing those areas which she wished to print rather than simply taking counterproofs of the lines that had so far been added to the plate. This is clearly seen in the case of the caterpillar in *Branch of pomelo with green-banded urania moth,* the luxury version of plate 29 at Windsor (Figs. 5, 6), where part of the hatching on the fruit can be seen around the caterpillar's feet. This demonstrates that more of the plate had been worked on at this point, and that Merian was choosing to reproduce the caterpillar and not other parts of the plate.

Why did Merian choose to reproduce sections of her plates? In concentrating on the insects, she could give these uniform dimensions, a consideration which was important to her project, since she stated that all insects in the *Metamorphosis* illustrations were shown at exact life size. By transferring the printed lines of the insects, Merian was ensuring that these were shown at the same size in the luxury versions of her plates,

too. However, there is a second, more compelling, reason why it is mainly the insects that are based on printed lines and the plants depicted freehand: the different hands which were involved in the production of the plates. It seems that Merian etched the initial compositions, concentrating on the insects, before handing them to the professional engravers to finish (whether Merian continued to add etching to the plates after taking the counterproofs, or whether she then passed them straight to the engravers is unclear). To date, only etched lines have been found on the Royal Collection sheets. That these were printed before modeling was added to the plates can be most clearly seen in the version of plate 14, the prickly custard apple. A comparison of the Windsor drawing (Fig. 7) and the published version (Figs. 8, 9) shows that the etched outlines were counterproof-printed onto the Windsor sheet before any of the modeling lines were added. The plants were probably only lightly indicated by Merian in preliminary etching (as in plate 14), while she appears to have delineated the insects more comprehensively at this stage.[14] As the luxury versions were taken before the fine modeling was added to the plate, the insects were, in most cases, much more complete than the plants.

The counterproofs used to make the Royal Collection and British Museum sheets were undoubtedly taken by Merian herself, since, as will be discussed further below, a number of the sheets show creative interventions in the rearranging of the composition; alterations which are

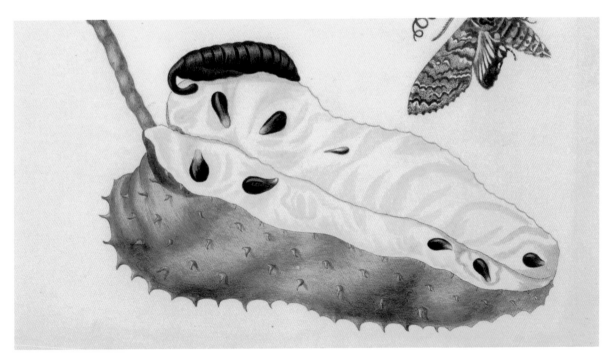

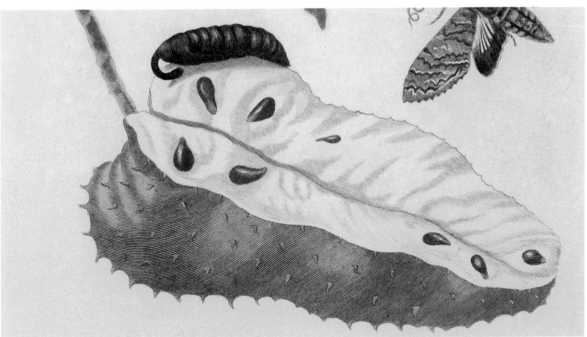

Fig. 7 M.S. Merian, **Prickly custard apple with hawkmoth and tussock or flannel moth,** luxury version of plate 14 from M.S. Merian, *Metamorphosis Insectorum Surinamensium*, 1702/1703, watercolor and bodycolor with gum arabic over lightly etched outlines on vellum, 38.8 x 31.1 cm (sheet). Royal Collection, RCIN 921168 (detail). Royal Collection Trust / © Her Majesty Queen Elizabeth II, 2022.

Fig. 8 Unknown engraver after M.S. Merian, *Metamorphosis Insectorum Surinamensium*, Amsterdam 1705, plate 14, counterproof edition, etching with hand-coloring, 53 x 38 cm. Royal Collection, RCIN 1085787 (detail). Royal Collection Trust / © Her Majesty Queen Elizabeth II 2022.

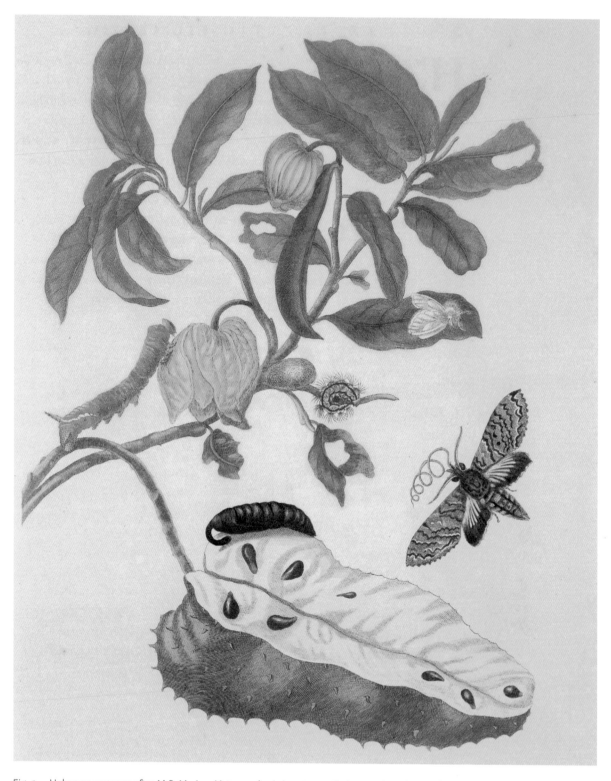

Fig. 9 Unknown engraver after M.S. Merian, *Metamorphosis Insectorum Surinamensium*, Amsterdam 1705, plate 14, counterproof edition, etching with hand-coloring, 53 x 38 cm. Royal Collection, RCIN 1085787. Royal Collection Trust / © Her Majesty Queen Elizabeth II 2022.

unlikely to have been made by anyone but the artist herself. The exclusive appearance of etching on the vellum sheets at Windsor, therefore, also leads to another conclusion. In order to make the counterproofs, Merian must have had the plates in her possession, probably taking them to a nearby printing press to run off the impressions she wanted. It seems most likely that she herself etched the plates before passing them on to the professional printmakers to be worked up for publication. Those printmakers carefully followed Merian's etched lines, adding tone mainly in the plants, and occasionally adding depth to a chrysalis or caterpillar. The counterproofs on the Windsor and British Museum versions were evidently taken before the plates were handed over, while they still bore only the etched lines produced by Merian herself. With this in mind, it is possible to suggest a tentative narrative for the printing of the *Metamorphosis*. In doing so, I am not offering a definitive interpretation, but rather showing one way in which the facts might be read to deepen our understanding of the production of the *Metamorphosis* plates.

The Royal Collection Illustrations and the Production of the *Metamorphosis Insectorum Surinamensium*

Of the sixty *Metamorphosis* illustrations in the Royal Collection, seven are almost entirely based on etching and six have no underlying printing at all.[15] All of these thirteen illustrations are exactly the same in composition as the finished *Metamorphosis* plates—here Merian has not used the opportunity to vary the positioning of the insects or add tendrils to vines. Where the sheets are almost entirely printed, this is unsurprising, but where the illustrations are entirely freehand, this approach is unexpected, since here Merian had every opportunity to vary the composition as she did with a number of the partially printed plates.

There are two possible reasons for there being no printed lines on six of the sheets. Either Merian had not started work on them yet or she had already handed the etched plates over to the engravers and so could not use them to produce the counterproofs. As each of these sheets matches the finished composition exactly, it seems likely that the etching on these plates had been completed and that Merian was forced to draw these by hand, since she had already passed the plates to the engravers. At this stage, she seems to have been planning to create exact luxury replicas of the finished *Metamorphosis* plates for sale. Perhaps at some point after this first group had been handed over, Merian realized that she needed more funding for this large and expensive undertaking, particularly since her attempts to gather English and German subscribers was proving unsuccessful.[16] Certainly, obtaining suitable engravings for scientific books at this time was no easy task; on 16 December 1702, John Ray (1627–1705) complained to Sloane of his own publishing project that "I conceive the great Difficulties will be in procuring Gravers, & Supervisors, to make choice of the best patterns that are already published & to get such delineated

as they can procure specimens of; & to superintend the Gravers to see they does their work well & to put Titles to the severall Sculps &c."[17]

It can be argued, therefore, that Merian decided to produce the luxury vellum sets at this point (after the first six plates had been handed on) as a means of raising funding from prominent collectors who would pay handsomely for such beautiful and important works. The sheets would allow Merian both to raise capital and to advertise her project. She provided samples of some of the finished plates, probably printed on paper, to James Petiver (c. 1663–1718) in London for the same reason. An advertisement placed in the *Philosophical Transactions* of the Royal Society of London noted that she "hath sent [to Petiver] several Tables, and some in Colours, to shew their Curiosity, and how admirably they are engraved".[18] Petiver himself described sending one of these to Jacob Bobart the Younger (1641–1719), superintendent of the Physic Garden in Oxford, noting "it will be a Book highly deserving encouragement".[19]

If it is correct to assume that six of the plates were drawn entirely freehand because Merian had already handed the plates over to the engravers, then it follows that the plates for the illustrations based entirely on printed lines must still have been in her possession. She could, therefore, run off full counterproofs of the next group of plates which was ready—those seven at Windsor which are completely based on printed lines—before they were handed to the engrav-

ers. By now, thirteen plates had been handed to the engravers: seven to Pieter Sluyter (1669–1726), five to Joseph Mulder (1658–1742), and one to the unidentified engraver of the unsigned plate. At around this point, we can place Merian's letter of 28 June 1703, when she wrote to Petiver that "thirteen plates have already been finished".[20] Although it is unclear whether by "finished" Merian meant she had completed the initial etching or that the plates were fully completed, we can date the Windsor vellum sheets to before 28 June 1703 and suggest that these first thirteen plates referred to by Merian in her letter to Petiver were numbers 6, 9, 10, 11, 18, 21, 37, 40, 42, 45, 49, 50 and 58. One of these plates must have been that referred to as complete by Baltasar Scheid (?–1729) in a letter of 17 April 1703.[21] It also suggests that the third named engraver to work on the *Metamorphosis* plates, Daniel Stoopendaal (1672–1726; whose name appears only on plate 13) did not begin to work on the project until after June 1703, unless he was also responsible for the unsigned plate included in the initial thirteen. The further progress of the plates can be traced through a series of letters in Erlangen, in which their continuing production is described.[22]

But why did Merian not continue to run off full counterproofs before she passed plates to the engravers? As we have seen, the majority of the plates based on partially printed lines were clearly largely etched by the time Merian used them to take the vellum counterproofs, so she could easily have done so,

and this would have been easier than isolating individual motifs for counterproof transfer. By printing the insects alone, Merian was able to vary the positioning of different elements of the composition, and she chose to do so to a significant degree in nine of the illustrations.[23] Comparison of these illustrations suggests that this was not due to the varying size of the vellum sheets; in none of these watercolors does the changed design provide a means of accommodating the varying sizes of the supports. Rather, the changes can be best explained as a creative process. It seems that Merian became more ambitious as she continued, at first producing facsimiles of the finished illustrations (those first thirteen plates), then later varying the layouts to greater and greater extents to create increasingly variant compositions. As she worked on the project, she seems to have become bolder in placing her butterflies and moths in different orientations. Essentially, she was setting the insects free again on the page, allowing them to move around her compositions as if they were living rather than dead specimens. This creativity is not apparent in the published volume, where the plates are not included in order of production, but can be seen by reconstructing Merian's working process through the presence of the printed lines on the Windsor sheets. While not easily apparent to those who purchased her works (since it required comparison of different versions of the same plate), it must have given her personal pleasure and artistic satisfaction, so that working on the luxury vellum sets became a process of continued creation rather than simple reproduction. If we accept that she became more ambitious as the project progressed, starting out by following the final composition closely, but increasingly moving elements around, then it is possible to argue that the final plates that she worked on for the project were those that show the most variation from the finished plates. That is numbers 2, 16, 17, 19, 20, 25, 32, 33, and 39.

All of this is speculation, and speculation which may appear to be hampered by the presence of plate 11. This is one of the Windsor sheets which is entirely hand drawn, so according to this narrative it was among the first plates to be handed over. The corresponding illustration in the *Metamorphosis* was worked on by an unknown engraver who did not sign the finished plate. It has been suggested that Merian engraved the three unsigned plates in the volume herself.[24] But if this is the case, she would have retained this plate in her possession and been able to take a full or partial counterproof from it at any point, so printed lines should appear on the Windsor sheet. A close comparison of the published versions of two of the unsigned plates makes clear that they are by different engravers; the engraver of plate 35, whose work is much less tidy than that of his colleagues, used cross-hatching to strengthen the darker areas, whereas the engravers of the other two plates used hatching only. I would like to argue, therefore, that the three unsigned plates cannot all be by Merian,

and that as plate 11 appears to be more competent in execution than the others, it is more likely to be by one of the three named engravers, who for some reason did not sign the plate, or by a fourth professional engraver who produced only one or two illustrations for the project.

It is likely, therefore, that the vellum sheets at Windsor and the British Museum were made over a short period in 1702 or 1703, probably to be sold as sets to raise money for the production of the *Metamorphosis*. Differences in the extent of underlying etching between the two sets may indicate that they were not made at the same time, but they were probably produced within weeks of each other (if not days) since these differences are only slight. We could conclude that Merian had completed the etching of the plates by mid- to late 1703, with the next year, partly funded by the sale of these luxury illustrations, devoted to the completion of the illustrations by the engravers and preparation of the text. The whole process must have been finished by 6 March 1705, when Levinus Vincent (1658–1727) could write to Petiver from Amsterdam, "Le livre de Mad. Merian est présentement parachevé, Il ce imprime...," suggesting that the book was at that moment on the press.[25] This is a slight adjustment to the date suggested by a letter of February 1705, in which Baltasar Scheid ordered a colored copy of the finished volume. As a well-informed collector, we can assume that Scheid knew the volume would be complete imminently and was placing his order a few weeks ahead of completion.[26] As wealthy collectors with a known interest in natural history, Mead and Sloane seem very likely to have been the original owners of these sets, although no evidence has been found to prove that the luxury versions were made specifically for them—the intermediary for the sale to Sloane seems to have been Petiver, who may also have facilitated the sale to Mead.[27]

Continuing analysis of the Windsor Merians and their British Museum counterparts can surely bring us closer to the production history of the *Metamorphosis*, shedding light on the process by which Merian planned and executed this ambitious publishing project, which would have such an impressive impact on European art and natural history.

* This paper presents the initial conclusions of ongoing research by the author into the Merian drawings in the Royal Collection. It was presented as a paper at the 2017 conference *Changing the Nature of Art and Science: Intersections with Maria Sibylla Merian*, and I am grateful to the organizers of that conference for the opportunity to present the research (both in person and through this essay) and to those who attended for their generous and helpful comments and encouragement. I owe a large debt to Alan Donnithorne, previously Head of Paper Conservation at Royal Collection Trust, who has carried out significant work on the Royal Collection watercolors and spent much time examining the drawings closely with me and offering advice. At the British Museum, Giulia Bartrum, Angela Roche and Christopher Coles kindly facilitated study of the Merian drawings previously owned by Hans Sloane. I am also grateful to the following for their advice on and support for aspects of the research presented here: Martin Clayton, Carly Collier, Karen Lawson, George McGavin, Daniel Partridge, Clara de la Peña McTigue, Puneeta Sharma, Rachael Smith, Ad Stijnman, Kate Stone, Emma Stuart, Emma Turner, Bridget Wright, and Eva Zielinska-Millar.

The Printers of Merian's Texts

Hans Mulder

In the preface of *Die Buchdrucker des 16. und 17. Jahrhunderts im deutschen Sprachgebiet*, Christoph Reske gives a definition of a book printer.[1] He writes that someone is considered a printer when that person individually operates a typographic (letter) press. This includes people who own such a press and employ artisans who do the work for them, while the definition also encompasses printers who work independently, for instance, at a royal printing house. In short, this huge compendium lists all the letterpress printers in the German-speaking countries. However, the compendium does not involve printers of intaglio plates made by etchers and engravers.[2] This is the reason why the Matthäus Merian publishing house in Frankfurt does not appear in Reske's work: Merian and his successors, being publishers, etchers, and engravers, did not print typographic books. And this holds true for his daughter, Maria Sibylla, and her husband Johann Andreas Graff (1636–1701) as well.

In this chapter, I will try to make plausible who printed the texts of the books by Maria Sibylla Merian which, except for most of the *Blumenbücher*, are all a combination of text in relief printing and images in intaglio printing.

The Nuremberg Book Printers

Merian published her first book in 1675. It was called *Florum Fasciculus Primus*, followed two years later by a second volume and in 1680 by a third. These volumes do not have letterpress printing. The combined edition of these texts, the *Neues Blumenbuch* (1680), however, did. It has an anonymously printed preface. As I will show, it is sometimes possible to identify unmentioned printers. But because the method to do so needs some elaboration, I will briefly postpone my attempt to identify the text printer of the *Neues Blumenbuch* and first introduce the printers we do know.

The first book in which Merian described and depicted the metamorphosis of caterpillars was published in Nuremberg in 1679.[3] On the title page it reads: "Gedruckt bey Andreas Knortzen." The printing house of Andreas Knortz (?–1685), or Knorz, had a difficult start.[4] The archives show that Knortz worked as a book printer at the printing house of Wolfgang Moritz Endter (1653–1728) in Nuremberg in 1673. Early in 1675, Knortz asked the Nuremberg city council to allow him to set up his own workshop. The council turned down the request. One of the arguments was that seven printing houses were the maximum

for Nuremberg, whereupon Knortz turned to the emperor's court in Vienna. The court ruled that Knortz should be allowed his printing house. The city council was not pleased, to say the least, but was now obliged to grant Knortz's request. The relationship between the city council and Knortz remained troublesome, especially since he now and again printed books that were not approved by the censors. One could assume that he was looked upon as a controversial man. But his production of around two hundred books, printed between 1676 and his death in 1685, suggests that he must have been well-renowned for his work. It therefore does not seem strange that Merian and Graff asked him to print their book. Knortz could have printed the second *Raupenbuch* as well. But in 1683, with Merian on the verge of moving to Frankfurt am Main, she chose Johann Michael Spörlin (fl. 1683–1706) instead.

After working a few years as a printer in Dillingen, Spörlin came to Nuremberg in 1682, where he married the widow of the book printer Christoph Gerhard in late October that year.[5] In this way he became owner of his own printing house. Johann Michael was the son of Johann Georg Spörlin, book printer in Frankfurt am Main.[6] Johann Georg printed books for Matthäus Jr. (1621–1687) and Caspar Merian (1627–1686).[7] The families obviously were acquainted and, although direct proof is not at hand, it does not seem too far-fetched to assume that Maria Sibylla would give Johann Michael a chance to prove himself as a book printer

by giving him what must have been one of his first assignments in Nuremberg.

As we know that Merian liked to have some say in, or even be in control of, as much of the making of her books as possible, being acquainted would have helped. Interestingly, both the 1679 and the 1683 *Raupenbücher* have five of the same printer's ornaments (flowers and butterflies).[8] This seems to indicate that these ornaments belonged to, and were probably made by, Merian and Graff. Another, but rather unlikely, explanation could be that Spörlin got them from Knortz. But why would Knortz have lent his ornaments to his competitor?

The Amsterdam Book Printers

After her return to Frankfurt, Merian did not publish a new book until 1705. Then, in Amsterdam, she presented her *magnum opus* on insects of Suriname. About the process of making that book she herself gives interesting information, though she does not reveal the printer of the book. But library catalogues do, although mistakenly. They often name Gerard Valk (1652–1726) as the printer of both *Metamorphosis Insectorum Surinamensium* (1705) and the first two parts of *Der Rupsen Begin, Voedzel en Wonderbaare Verandering* (1712).[9] This is an understandable conclusion, because Valk is mentioned on the title page (Fig. 1). It does not actually say that he printed the books, though he is named in his capacity as bookseller. We know that Valk was a renowned engraver and an important bookseller, and for a short while also foreman of the Am-

144

sterdam guild in which booksellers and printers were united. He ran his shop at Dam Square with his brother-in-law, Petrus Schenck (1660–1711). There is no record in the Amsterdam archives—which have been extensively researched in the twentieth century by M.M. Kleerkooper and W.P. van Stockum, and later by Isabella van Eeghen—that Valk actually printed books.[10] However, there is at least one book Valk is recorded to have printed, Andreas Cellarius's *Harmonia Macrocosmica* (1708), but that book is solely a compilation of engravings (with the exception of one index

page). Valk was not a book printer, but it cannot be ruled out that engravings and etchings that were published and sold by Valk were also printed in his workshop.[11] So, if not Valk, who did print the texts of the Amsterdam publications by Maria Sibylla Merian?

Presses and Etching

Letterpress printing calls for a different press than intaglio printing, such as engravings and etchings.[12] The typographic press prints what sticks out, and the intaglio press prints what has been cut away. It has been established that the images in Merian's books are etchings of which the lines were sometimes sharpened with a burin, the work tool of the engraver.[13] These etchings could have been printed by Merian herself, helped by her husband Johann Andreas Graff.[14] Many etchers and engravers owned a plate press, primarily to be able to check if the etching matched the original. We know from her writings that Merian mastered the art of etching and engraving, which she probably learned from her stepbrothers (Matthäus Jr. and Caspar) and her husband. And it is safe to say that Merian could also handle a plate press. However, we know that Merian did not make most of the plates of *Metamorphosis* herself, because 57 were signed by other artists. And it does not seem likely that she printed those plates, because the strict guild regulations in Amsterdam did not allow her to do so. It would be interesting to further investigate how the production and printing of the Merian plates came about (see also

the chapter by Heard in this volume). Although that research surpasses the scope of this article, a case could be made for Gerard Valk, as it would explain his prominent place on the title page.

Metamorphosis

In her introduction to the reader in *Metamorphosis*, Merian writes that she wanted to follow the example of the work of Govert Bidloo (1649–1713) on human anatomy that was printed in Amsterdam in 1685 and 1690 by the widow of Joannes van Someren (active 1678–1710).[15] Bidloo's book in folio shows an image and the explanatory text opposite the image. Sometimes Bidloo's texts continued on the verso page, which obviously required more paper. Merian confined her texts to one page only, and all her images were printed on one side: a technique she had also applied in the *Raupenbücher*. And although letterpress printing and intaglio printing required different presses, very often intaglio images were printed (afterwards) on text-printed pages on which space was left to be filled, or in the case of larger images, on the verso side of the text-printed page. Merian left those verso sides of the image blank, because she intended the images to be colored and she of course knew that the watercolors would show through the paper and blur the text (Fig. 2).

Text obviously does not have this problem. The printing of the text using the recto and verso side of the paper required thirty sheets of paper for sixty pages. In all, with title page and introduction included, the text part of *Meta-morphosis* therefore consists of 32 sheets of paper.[16] Paper was expensive, and printing the text in this way brought the costs to a minimum. Merian must have ordered a substantial set of texts, though. When Johannes Oosterwyk (1672–1737) bought the contents of Merian's studio from Dorothea Maria Merian (1678–1743) in 1717, it must have included a considerable stack of sheets of the printed texts of the Dutch and the Latin copies, because the text of the first sixty pages of the 1719 edition published by Oosterwyk is identical to the 1705 edition—there is no evidence of new typesetting.[17]

Comparing Decorated Initials

Identifying anonymous printers is not easy. Already in the sixteenth century, church and government officials tried to identify printers of pamphlets wherein the anonymous writer attacks or ridicules religion or state. When printers limited themselves to using only simple lettering, they would be almost impossible to catch. However, when they used ornaments or decorated initials, remnants from the medieval handwritten culture, they might give themselves away. It would be a dangerous mistake: printers have been caught, imprisoned, and even executed. In his dissertation, Paul Dijstelberge used a self-made database with late sixteenth- and early seventeenth-century decorated initials called *Ursicula*.[18] It enabled him to identify many anonymous printers. In 2014 two of Paul's students used this method to identify the printer of Spinoza's *Ethica*.[19] A good reason for me to follow

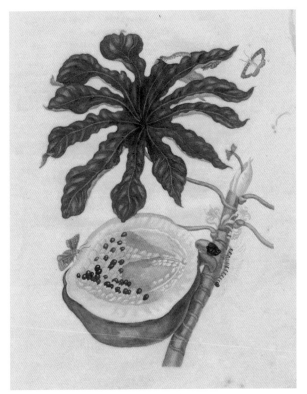

Fig. 2 Front and backside of plate 40 in M.S. Merian, *Over de Voortteeling en wonderbaerlyke Veranderingen der Surinaemsche Insecten*, Amsterdam 1719, hand-colored etching, counterproof. Artis Library, Allard Pierson, University of Amsterdam, AB Legkast 019.01.

their path. I could not use Dijstelberge's database, though, because it only goes up to 1650.

The "I"

But there was another small problem. Both texts, Latin and Dutch, of *Metamorphosis* only have one decorated initial: the "I" in the introduction.

The first printer I investigated was François Halma (1653–1727), who came to work in Amsterdam in 1699 after a career as city and university printer in Utrecht for many years. Halma was asked to print the *D'Amboinsche Rariteit-*kamer by Georg Rumphius (1627–1702) in the early years of the eighteenth century. Merian is often mentioned as one of the artists who participated in the making of Rumphius's work. We know of a number of watercolors on parchment attributed to Merian that could be interpreted as copies for some of the plates in the *D'Amboinsche Rariteitkamer*. They are part of what are known as the Saint Petersburg watercolors.[20] The Artis Library of the University of Amsterdam keeps a copy of Rumphius's work, in which is written that Merian colored the images.[21] Although her exact

Fig. 3 Initial "I" in, respectively, M.S. Merian, *Over de Voortteeling en wonderbaerlyke Veranderingen der Surinaemsche insecten*, Amsterdam 1719 (left) and C.C. Tacitus, *Alle de werken*, Amsterdam/Utrecht/Leiden 1704 (right). Artis Library, Allard Pierson, University of Amsterdam, AB Legkast 019.01 and Allard Pierson, University of Amsterdam, KF 61-100.

contribution remains a puzzle, it seems likely that there was a connection between Merian and Halma, while Halma, as a well-established publisher and printer, would have had no problem printing these large folio texts. Because of the size of the initial, I could limit my search to folio or large quarto copies. I studied many books printed by Halma, but found no match.

For the next choice of possible printers, I used Merian's advertisement in the *Amsterdamse Courant* of 24 April 1704, in which she advertised *Metamorphosis* and wrote that the book could be bought at her place in the Nieuwe Spiegelstraet in de Roose-tak and also at the houses of Gerard Valk, Hendrik Wetstein, Willem de Coup, her son-in-law Jacob Herolt, and others. Some of these booksellers were printers as well.

The most interesting person on this list, apart from Valk, whom I ignored on account of the abovementioned argu-

ments, was Hendrik Wetstein (1649–1726). Wetstein was born in Basel. He was a member of the Walloon Church in Amsterdam, the same church at which Jean de Labadie preached before he started his own religious community, the community in Wieuwerd where Merian stayed for almost six years. The fact that Wetstein was a native German speaker and his Protestant faith could have been of some influence, too. It would certainly have been easier for Merian, for we know from her letters that she was more at ease with her mother's tongue.

I pursued the same method as with Halma and was very pleased to find the "I" in the complete works of Tacitus, published by Wetstein in 1704 (Fig. 3). There are three more names on this title page: Daniel van den Dalen (Leiden), Willem van de Water (Utrecht), and Pieter Scepérus (Amsterdam). So why Wetstein? First, it was his name in the Merian advertisement. None of the

Fig. 4 Initial "H" in, respectively, volume 1 of M.S. Merian, *Der Rupsen Begin, Voedzel en Wonderbaare Verandering*, Amsterdam 1712 (left) and J. Ruyter, *Klaagschrift over de Onchristelyke Beschuldigingen tegen den Onschuldigen Johannes Ruyter*, Amsterdam 1712 (right, upside down). Artis Library, Allard Pierson, University of Amsterdam, AB Legkast 019.02 and Allard Pierson, University of Amsterdam, UvA Pfl N l 13.

others were mentioned. And then, I argued, that it would not have been logical for Merian to ask a printer from another city to print her text, so I ruled out Van de Water and Van den Dalen. The other Amsterdam printer, Pieter Scepérus was a printer of pamphlets and other small work. His bookshop, however, was very centrally located, at the Dam, which probably made him an interesting partner in the "Tacitus" enterprise.

Rupsen 1712

The second work Merian published in Amsterdam was a concise edition in Dutch of her *Raupen Wunderbare Verwandelung*, translated as *Der Rupsen Begin, Voedzel en Wonderbaare Verandering*. Parts one and two were printed in 1712.[22] The plates are the same as the ones Merian used in 1679 and 1683, with several new metamorphoses added. The text is in Dutch and much more condensed.[23] And, like with *Metamorphosis*, clearly printed separately. Parts one and two are almost always found bound together with the third part, which had new plates and descriptions and was published posthumously in 1717 by her daughter Dorothea Maria.

By the time I started looking for the printer of the first two parts of *Rupsen*, I had tremendous help: the results of the Google digitization project at Dutch

149

University Libraries and the KB, the national library of the Netherlands, had been published online, so I could look for the initials there, which saved me a lot of time. However, after finding the right initial online, of course I needed to compare and measure the initial in the printed book to be completely certain. What also helped was that this time there were more initials to look for, namely the "D", "H", "M" and "G".

I started with Wetstein, who was still active as a printer and publisher, but that research yielded no results. And then I thought perhaps his sons, Rudolph and Gerard, were good candidates, but had no luck there, either. Subsequently, I applied the same method as with *Metamorphosis*, using the advertisement for *Rupsen* in the *'s-Gravenhaegse Courant* of 23 November 1712.

The first on the list, Gerard onder de Linden (1682–1727), who had his shop at the corner of the Nes and the Lange-brugsteeg in Amsterdam, proved to be the man I was looking for. Onder de Linden was an esteemed printer and publisher who had contributed to the publishing of François Valentijn's *magnum opus* about the Dutch East Indies. I looked at many of Onder de Linden's books and finally found one of the four initials, the H, albeit upside down, in a "Complaint" (see Fig. 4).[24] The "H" on the left is from Onder de Linden; the one on the right is from *Rupsen*. There is another connection between Onder de Linden and Merian. The Library of the Netherlands' Entomological Society (NEV) in Leiden holds an interesting and beautiful copy of Merian's *Rupsen*, the so-called "Wor copy". It consists of beautifully colored counterproofs in parts one and two and images in watercolor (not printed) in part three. Adriaan Wor had married the widow of Gerard onder de Linden, Adriana van Daakenburgh.

Fig. 5 Initial "H" in, respectively, volume 3 of M.S. Merian, *Der Rupsen Begin, Voedzel en Wonderbaare Verandering*, Amsterdam 1717 (left) and J. Oe [J. Oosterwyk], *Paulus in Areópago*, Amsterdam 1710 (right). Artis Library, Allard Pierson, University of Amsterdam, AB Legkast 019.02 and Utrecht University Library, B qu 186:2.

Rupsen 1717

For the posthumously published third part of *Rupsen* (1717), I did not find matching initials in the works of Onder de Linden. It seemed logical that Johannes Oosterwyk should be the printer to investigate next, because, after all, he was the one who bought the contents of Merian's studio after her death, from her daughter Dorothea Maria. He also printed the Latin translation of *Rupsen* as early as 1718. The third part in Dutch (1717) only had one initial, an H. And although quite a few initials from the Latin publication (1718) looked like they came from the same set of initials, this edition did not have an "H" in it. Starting in 1720, I worked my way back through the printings of Oosterwyk—primarily plays and texts made for special occasions like marriages and funerals—and finally found the matching "H" in *Paulus in Areopago, of Desselfs Redenvoeringe in de Vierschaer van Athenen*, claimed to be written by Oosterwyk himself and printed in 1710 (Fig. 5).

Conclusion

One matching initial in three cases is perhaps in itself thin evidence. But when we take other facts into account, like the printer's background, similar layout, the newspaper advertisements, and a similar font, it must be considered very likely that Hendrik Wetstein printed the text of *Metamorphosis*, Gerard onder de Linden the texts of the first two parts of *Rupsen*, and Johannes Oosterwyk the third part.

Before ending my chapter, I need to get back to the beginning. There is still one text printing riddle to solve: who was the printer of the text of the preface of the *Neues Blumenbuch*? That preface was printed in 1680. The only digitized copy of the 1675 *Blumenbuch*, kept and digitized by the Staatsbibliothek Bamberg, has the same printed preface. However, when one reads the text, it is obvious that it was written and printed later, because it refers to the 1679 *Raupenbuch*. The text has a few decorated initials, albeit no distinctive ones. They show great similarities with the ones in the *Raupenbuch* (1679), printed by Andreas Knortz. Likewise, the ornaments at the top of the page bear resemblance to the ones printed in Knortz's work. It seems logical that Knortz, who did a good job printing the Caterpillar Book, may also have printed the preface of the *Neues Blumenbuch* a year later. In this case, however, we lack irrefutable evidence.

The question remains as to why Gerard Valk has such a prominent place on the title pages of *Metamorphosis* and the first two parts of *Rupsen*, while the printers of the texts are not mentioned at all. Could it be because, as foreman of the guild, Valk was well-known and influential? Of course, being connected to such a name could help sales. And we know that Merian was an excellent saleswoman. But perhaps we should also consider the possibility that the plates were printed at the specialized workshop of Gerard Valk.

As we slowly unravel the puzzles around Merian, there are still some waiting to be answered.

* This chapter is based upon the presentation I gave at the Merian conference in 2017.

While Painting Apricots in Agnes Block's Garden

I wanted the branch to ache
across the diagonal, lean, pitch,
inch toward light. I wanted leaves
open to memory and leaves curled
into small cups of longing. I wanted

the apricots small, freckled globes,
lemon yellow, horizon orange, cleft
like a baby's behind. I wanted you,
small yellow-breasted bird, still,
mid wobble, gymnast on high. I used

my finest tips to freckle the fruit,
vein leaves, feather the bird's belly.
So many conversations—cool blue
with white, red with orange,
dragonfly thin with opaque flat. This

was not the first time I'd entered
the scene. But it was the moment
I understood that thirst
for sugar, the bird's frenzied eye.

Patience

I've held you up to candle light,
as a farmer would an egg. Oh,
filament-laced wing. Oh, fat casing
on a lengthening abdomen. What
will coax you from soupy sleep?
Warmth? Shelter? Time? Before
you, I studied forty other cocoons.
I waited for their soft splintering,
the tentative antennae, wet progress.
But what crawled from that wreckage?
Only maggots and flies, drunken flies.

Sin

You call me obsessed.
But tell me this—How does one
serve God without obsession?
Your shirts are clean, supper hot
on the table, children cared for, fire
stoked. Will you begrudge me
those two or three hours a day
when I am still and among God's
smallest creatures?

At the Naturalist's Bedside,

A Daughter's Last Conversation

Nets drooping from a hook
on the wall, trunk mouths
open like fledglings, dust
on your wide-brimmed hat.

Where are you now? Foot in the jungle,
neck in hives, belly down in muck,
eye to a spindly leg skating on water,
or nose to leaf, where a wet wing
flexes through spittle and crust?

Your eyes closed, hands
resting in your lap. Does sleep
inch your fingers across
the feathered table, toward
that fine brush? Do you
wet its tip with your tongue,
darken the air? Tell me.
Open your mouth
to this barest accident of me,
stranded here
in a tin can of a boat,
on the black water
of your next open sea.

Poems by Cynthia Snow

The Merian-Rumphius Connection. Maria Sibylla Merian's Alleged Contribution to *D'Amboinsche Rariteitkamer*

Bert van de Roemer

In the history of Dutch book production, 1705 was a remarkable year. Two sumptuous publications appeared on the market: *Metamorphosis Insectorum Surinamensium* by Maria Sibylla Merian and *D'Amboinsche Rariteitkamer* by Georg Everhard Rumphius (1627–1702) (see Fig. 3 on p. 220 and Fig. 5 on p. 224 in the chapter by Van Deinsen). Both works formed in their own specific idiom an apex in the tradition of natural history illustrations. The high-quality prints made them exemplary reference books, and many authors after 1705 referred to the descriptions and images in Merian and Rumphius.[1] Their works became benchmarks for natural history research. Yet the differences between them are as remarkable as the similarities. In a Eurocentric oversimplification, one book was created by a woman in what the Dutch called "the West", the other by a man in "the East". Both authors were of German descent, and both were in later life able to express their passion for nature through Dutch colonial and economical practices that aimed at profit, exploitation, and subjection. Both combined minute empirical observations with knowledge obtained from local and indigenous people.[2] A significant difference between the two is that Merian was responsible for and had control over the materialization of her book, while Rumphius, who died in 1702 on the Indonesian island of Ambon, had to depend others to bring his publication to fruition posthumously. Furthermore, Rumphius was unable to make drawings of his *naturalia* after going blind in 1670, and therefore relied on assistance from others. In contrast, for the artistically far more talented Merian, depicting insects, animals, and plants was at the core of her research.

Both books were illustrated with sixty copperplate prints. The term "illustrated"

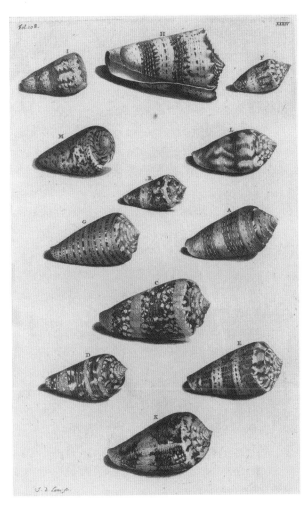

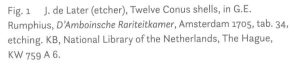

Fig. 1 J. de Later (etcher), Twelve Conus shells, in G.E. Rumphius, *D'Amboinsche Rariteitkamer*, Amsterdam 1705, tab. 34, etching. KB, National Library of the Netherlands, The Hague, KW 759 A 6.

Fig. 2 Unknown artist, Twelve Conus shells, early eighteenth century, watercolor and bodycolor on vellum, 375 x 278 mm. Saint Petersburg Archive of the Russian Academy of Sciences (SPbARAN), inv. no. R.IX. Op. 8. no. 82 © SPbARAN.

might be somewhat inappropriate, as it suggests a derivative relation to the text, but the images formed an essential part of a process of knowledge production that involved more hands than just the author's. Considering the concurring moment in time and the high quality of the illustrations, it is not surprising that the two projects are interconnected by

some scholars. As will be elaborated below, it has been generally believed that Merian accepted a commission to make the original drawings and designs for *D'Amboinsche Rariteitkamer* to finance her own book on Suriname. The archive of the Academy of Sciences in Saint Petersburg preserves 54 watercolors on parchment attributed to her that

correspond with 54 of the sixty prints in Rumphius's book. They depict shells, crustaceans, stones, and minerals. Many scholars consider them to be the originals that served as examples for the etchers of the book (Figs. 1, 2). The watercolors are part of a larger collection in the archive of 184 works attributed to Merian, most of which depict plants and insects.[3]

In this essay, I will first describe how the assumption of involvement with Rumphius's publication became a repeated element in Merian's biographies. Subsequently, I will argue that she was not responsible for the original illustrations and that it is difficult to regard the Saint Petersburg watercolors with the Rumphius illustrations as work by her hand. I will do this by scrutinizing the textual and visual evidence, but my argument can be placed in a broader perspective. Apart from adjusting a minor element in Merian's biography, this study also raises questions about her historiography. It is interesting to see how a small remark from the eighteenth century develops into an idea that was encapsulated in the image of an independent, enterprising woman who accepted a commission to fulfill her goal, had to forsake her own idiosyncratic style in the process, was not acknowledged for her work afterwards, and so anonymously aided the fame of a male naturalist on the other side of the globe. There is no question about it: Merian was a special, independent, and talented woman who had to work very hard to earn her place in a male-dominated world, but looking at it from a historio-graphical point of view, some data might have been framed too eagerly to fit this image. After more than half a century of Merian studies, novels, theatrical productions, comic books, artworks, poems, and more, a thorough and systematic reflection on the historical reception of Merian is certainly needed.[4]

A second, associated perspective and line of thought concerning this research has to do with the more traditional practice of connoisseurship aimed at attributing and dating works of art. The obvious focus on Merian in recent decades might have had a converging effect when it comes to the attribution of natural history illustrations. Recently, the discussion about her corpus has been broadened by involving the work of her two daughters, Johanna Helena (1668–1730) and Dorothea Maria (1678–1743).[5] However, Merian operated, in Germany as well as in Holland, in culturally vibrant milieus encompassing a vast network of—frequently female—drafts(wo)men of natural objects, often names we hardly know. Furthermore, as will be discussed later, soon after her death, Merian's style of depicting *naturalia* "after life" was introduced in Russia and founded a tradition. I will conclude with some remarks of the dissemination of Merian's work.

Assuming Involvement

The story about the Merian-Rumphius connection appears relatively late in literature. Her first two biographers, the Dutch Arnold Houbraken (1660–1719) and the German Johann Gabriel Doppelmayr (1677–1750), do not mention

any involvement of Merian in the Rumphius project.[6] As they might have had firsthand knowledge, this is telling. In the case of any involvement, it is even more remarkable that Merian's name is nowhere mentioned in *D'Amboinsche Rariteitkamer* itself. Other contributors—such as the benefactor Hendrik d'Acquet (1632–1706) and the editor Simon Schijnvoet (1652–1727)—are acknowledged elaborately in the preface of the book. Such an omission might be related to her gender or to the absence of her idiosyncratic style,[7] but seems awkward in a commercially driven milieu.[8] By around 1705, Merian had earned quite a name, and for a publisher it would have been a lucrative "selling point" to mention her on the title page or in the preface.

A first hint at a connection between Merian and Rumphius's book can be found in an overview of publications on shells written by the German theologian Johannes Andreas Cramer (1723–1788), first published in 1758 in *Auserlesne Schnecken, Muscheln und andre Schaalthiere* by Franz Michael Regenfuss (1713-1780) and reprinted eight years later in the German translation *Amboinische Raritäten-Cammer*. Cramer states that "the famous daughter of Merian" made the drawings (*Abzeichnungen*) for Rumphius. Even though he adds the prefix "Ab-" and "*after* the originals", which might refer to a real or drawn model, the statement can easily be read to mean that she was responsible for the designs.[9] This utterance was repeated and elaborated by the editor of the German translation of Rumphius, Johann Hieronymus

Chemnitz (1766–1800). In a published letter to a female collector, he regards Merian's "diligence" in her work for *D'Amboinsche Rariteitkamer* as proof of the significance of female contributions in the field of conchology, even though he does not call her by her own name, but as "the daughter of".[10] Another old source mentioned as evidence of her involvement is the auction catalogue of the library of the Dutch naturalist Arnout Vosmaer (1720–1799), published in 1800. It lists a copy of Rumphius's book "painted and illuminated by M.S. Merian herself from life according to her drawings on parchment".[11] This copy, with a note by Vosmaer, is now present in the Artis Library in Amsterdam.[12]

In early biographies of the twentieth century, the story of the Rumphius contribution is absent. Her first "modern" Dutch biographer, Jant Stuldreher-Nienhuis, states that Merian complied with the request to color some images of Rumphius by hand, and that these show her mastery of coloration.[13] She even mentions that a German traveler—who visited Merian in 1711 and will be discussed below—"overenthusiastically" reported that she painted everything in Rumphius's book "from life". The German biographers Elisabeth Rücker and Helmut Deckert do not mention that she performed work for Rumphius in their early studies.[14] A turning point came in 1974, with the publication of *Leningrader Aquarelle*, a majestic set of fifty reproductions of the 184 watercolors by Merian in the Academy of Sciences in Saint Petersburg. In the accompanying text, the life

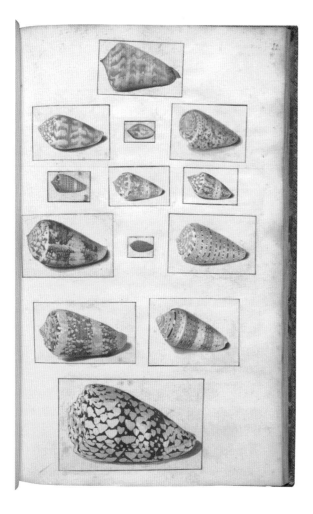

Fig. 3 Unknown artist, Thirteen *Conus* shells, in *Dessins originaux des raretés d'Amboine* par G.E. Rumphius, early eighteenth century, washed drawing with pen and black ink on paper, 395 x 245 mm. KB, National Library of the Netherlands, The Hague, KW 68 A 3, f. 22.

and the scientific value of Merian's work are discussed by Helga Ullmann and Wolf-Dietrich Beer. Ullmann states that it should surprise no one that the talented Merian obtained the commission for the Rumphius illustrations, and she sees them as proof of Merian's broad interest in nature.[15] Beer wonders why earlier biographers overlooked the commission

and places the drawings in the context of a burgeoning systematic approach towards nature, which was focused on formal analysis and taxonomy. In this way, according to the author, Merian contributed to the fame of Rumphius.[16]

Many subsequent authors followed this lead. In 1995, Nathalie Zemon Davis informs us that Merian found, together with the editor of Rumphius's book, Schijnvoet, specimens in Dutch collections and painted the sixty models for the copperplates in "Rumpf's expository style, not hers". It shows that "her way of representing nature was a choice, not a matter of skill or habit".[17] The 1997/98 exhibition on Merian in Frankfurt and Haarlem exhibited four of the Rumphius paintings. The catalogue follows Beer, informing the visitor that she made the watercolors partly from objects in Dutch collections and partly from the drawings sent from Ambon, and that Schijnvoet probably determined the arrangements.[18] In the same catalogue, the early biographer Rücker also incorporates this story; she suggests that Merian did not leave her name in the *D'Amboinsche Rariteitkamer* because the "compositional arrangement" differed too much from her own artistic style.[19] In recent literature on Merian, the assumption of the Rumphius contribution is still repeated.[20]

The literature on Rumphius shows significantly more reservations when it comes to Merian's alleged contribution. In her discussion of Rumphius's malacological work in the *Rumphius Memorial Volume* from 1959, biologist Woutera

van Benthem Jutting mentions a volume in the KB, National Library of the Netherlands in The Hague, and writes that she thinks they "are probably the original drawings". This eighteenth-century manuscript with the title *Dessins originaux des Raretés d'Amboine par G:E: Rumphius* holds 566 cut-out wash drawings with pen, brush, and black ink, pasted on 45 folios (Fig. 3). Almost all of the drawings correspond with objects depicted in *D'Amboinsche Rariteitkamer*, but the grouping of the objects on the folios does not correspond with the final prints. Apart from two drawings signed by Pieter de Ruijter, an artist who worked on Ambon between 1694 and 1700, it is not clear who made the drawings. The shells in the manuscript are all depicted in their natural state, without the lateral inversion most objects show in the plates of *D'Amboinsche Rariteitkamer* and in the watercolors in Saint Petersburg.[21] In the same memorial volume, Hendrik Engel discusses the echinoderms described by Rumphius and notices that the drawings in the album in The Hague "often bear a closer resemblance to the real objects ... than the plates in the book".[22] Linguist Eric Montague Beekman remarks briefly in his valuable translation of Rumphius's text, *The Ambonese Curiosity Cabinet* (1999), that he received information from the malacologist Hermann L. Strack, who was convinced that the 54 drawings in Saint Petersburg were never used as originals.[23] Six years later, biologists Florence Pieters and Rob Moolenbeek published the first thorough discussion of the album from The Hague. According to the authors, 360 of the 659 illustrated objects were sent from Ambon, while the rest were made from examples already present in Dutch cabinets. They state that they cannot imagine that the Rumphius plates in Saint Petersburg were designed by Merian, because it would imply a total change of style. Also, they note a lack of detail, small errors, and the occasional unnatural use of colors. They follow art historian Jan van der Waals, who suggested that the Saint Petersburg set comprises "models after which many copies in the workshop of Merian were colored".[24] The only Rumphius specialist who expresses a different opinion is engineer Wim Buijze, who published a vast biography in 2006. He is convinced that Merian was responsible for the originals. He sees a one hundred percent correspondence between the Saint Petersburg paintings and the prints in Rumphius, and he admires their accuracy, even though he admits they are less "artistic" than Merian's own work.[25]

Some confusion in the cases discussed above is understandable. It is known that Merian and her daughters ran a workshop in the Kerkstraat in Amsterdam, where they engaged in illuminating printed illustrations in natural history books—both Merian's own work as well as books by others. A possessor of a copy of Rumphius could commission them to color the illustrations. From her letters we know that Merian sold hand-colored copies of her own work and of *D'Amboinsche Rariteitkamer*, of

which some still exist.[26] Such coloring was most likely done in her workshop using models showing the original colors of the specimens depicted in Rumphius. This model set could have been made using specimens that Merian found—perhaps with the help of Schijnvoet—in various collections in Holland, as the drawings sent by Rumphius were in gray tones. Because Merian made color copies from Rumphius's drawings, it was an easy step for some scholars to presume she did more than that, and that she was also responsible for the original drawings and designs.

Close Reading of Sources

There are some written sources that are often used as evidence for the Rumphius-Merian connection. In two of her letters, Merian mentions the work of Rumphius, but she never states that she made the models for the prints. In both letters, she tries to promote and sell her own work. In the first letter, addressed to the Nuremberg doctor Johann Georg Volkamer (1662–1744) and dated 8 October 1702, she discusses the method of financing the *Metamorphosis*, which she planned to do by means of subscriptions in advance "just like the Ambonian work".[27] In the first years of the eighteenth century, both books were in production and must have formed quite comprehensive projects among the naturalists, artists, and publishers in Amsterdam. Merian was certainly aware of the simultaneous production of the Rumphius book, as the first letter shows. In the second letter, from 1711, Merian

offers historian Christian Schlegel (1667–1722) in Arnstadt hand-colored copies of her own publications and the *D'Amboinsche Rariteitkamer*. She informs him that she has only one remaining copy of the latter, and will not illuminate more.[28] Again, there is no mention of her making the original designs. What the letters from the period 1702–1705 do show, however, is that Merian was tremendously occupied with the production of her own book on Suriname, and thus probably far too busy to accept a major commission for another publication.

A second source that is often cited is the travel account of the Frankfurter patrician Zacharias Conrad von Uffenbach (1683–1734), who visited Merian in February 1711. At her house in the Kerkstraat, he saw a hefty volume with depictions of all the things described by Rumphius as "painted from life", as well as the "originals" of her own work. It is noticeable that he does not use the word "originals" in the context of Rumphius. The remark "painted from life" can suggest that Merian indeed found specimens in the Amsterdam cabinets to corroborate the natural colors of the objects illustrated in the book, and made a model set that could be used as examples in her workshop, as Van der Waals and Pieters & Moolenbeek suggest. But is this the set that ended up in the academic archive in Saint Petersburg?

Boris Lukin, Irina Lebedeva, and Natalya Kopaneva studied the complex history of the Merian drawings in Saint Petersburg: 184 in the Archive of the

Academy of Sciences and eighteen drawings in the Botanical Institute.[29] If there is something that can be discerned from their detailed investigations, it is that the drawings were constantly on the move. After the first purchase was made for Peter the Great, works on paper and parchment were added regularly to the collection until the end of the nineteenth century. In 1717 the tsar's physician, Robert Areskin (1677–1718), bought two volumes with 254 drawings in Amsterdam from Merian's daughter, Dorothea Maria, and her husband Georg Gsell (1673–1740), which formed the nucleus of the collection. At the same time, Areskin bought many pieces from the Merian legacy for his own collection, which, after his death in 1726, became part of the collection of the Academy of Sciences and its adjoining museum, the Kunstkamera. In 1734, Dorothea Maria, then working

Fig. 4 Two pages with holdings of Merian's work, *from Museum Imperialis Petropolitani*, volume 2,1, Saint Petersburg, 1741. Niedersächsische Staats- und Universitätsbibliothek Göttingen.

with her husband in Saint Petersburg as an interior designer of the museum and an art teacher for Russian students, returned to Amsterdam to pick up another 34 flower drawings by her mother. Drawings often left their repository in this period, as they were intensively used as examples for art classes in which young Russian art students were instructed in the Western style of drawing, and as reference material for entomological and botanical research (see the chapter by Dunaeva & Van de Roemer in this volume). Until the nineteenth century, drawings were added from Russian private collections as well. In 1864, Georg Adolf von Rauch (1789–1864), the Estonian-born physician to Tsar Nicolas I and Alexandra Feodorovna, bequeathed 54 works on paper attributed to Merian to the Academy. According to Lukin, who studied the archival records in Saint Petersburg, among these were 26 studies with "crabs, snails, mollusks, medusas, and sea urchins", and three with minerals.[30]

A good impression of a moment in time marked by a constantly changing situation is presented by the listing of the Saint Petersburg holdings in the catalogue *Musei Imperialis Petropolitani* of 1741, describing the collection of the Academy of Sciences and the Kunstkamera. Eight volumes with works by Merian are listed (Fig. 4). The Merian collection at that time was probably composed of the two volumes bought in 1717, the additions from the collections of Areskin, the work collected in Amsterdam by Dorothea Maria, and perhaps other additions which remain unknown

to us. Interestingly, and echoing Von Uffenbach's words, all the descriptions in the catalogue mention explicitly that the volumes contain "original work" ("opus archetypon", "archet.", etc.).[31] However, in the case of the description of number four, which correlates with the Rumphius illustrations, this term "original" is not mentioned. It reads: "A volume containing 60 drawings of lobsters, spiders, shells, murexes, and stones painted in watercolor on parchment by the same Meriana." We should remember that only 184 watercolors from these eight volumes have survived to the present day, and among them only 54 of the sixty illustrations by Rumphius that are mentioned in the catalogue.

Close Looking at Shells

In summary, the textual sources do not lead to the conclusion that Merian was responsible for Rumphius's originals. But could the Saint Petersburg set have been the "original" color model set by her hand, made from specimens in Holland and intended for use in illuminating copies of Rumphius's book in her workshop? This also seems unlikely, if we subject the watercolors to minute visual analysis. We already have seen that some authors on Rumphius noticed inaccuracies in the representations of shells. In *Leningrader Aquarelle*, Beer also observed the "strikingly inferior quality of some illustrations", and wonders if this should be attributed to the fact that Merian had to copy some models that were made in Ambon and subsequently sent by Rumphius to Holland.[32]

Thanks to Florence Pieters's discovery of Merian's contribution in the *album amicorum* of Peter Schenck (1660–1711), we are able to compare four depictions of the same shell, of which one is certainly done by her, because it is signed and dated (Fig. 5A; see also Fig. 4 on p. 81 in the chapter by Pieters & Van de Roemer in this volume). Merian painted this album contribution four years after the publication of *D'Amboinsche Rariteitkamer*, so it is likely she followed a colored example or model. The same shell, a *Conus aurisiacus*, was printed laterally inverted on plate 34 of the Rumphius book, among other *Conus* shells added by the editor Schijnvoet (Fig. 5B; here reproduced mirrored for the sake of comparison). So the original drawing of the shell must have been made in Holland. The same shell is also represented on sheet 82 of the Saint Petersburg collection (Fig. 5C), which shows a mirrored version of the print in *D'Amboinsche Rariteitkamer*. According to many authors on Merian, this should be regarded as the original watercolor on which the etching was based. A fourth version can be found as a washed drawing in gray tones on page 22 of the manuscript in the KB in The Hague (Fig. 5D). Some authors on Rumphius consider this the original drawing.[33]

Before subjecting the images to a thorough visual analysis, it should be noted that this *Conus aurisiacus* was extremely rare. The shell depicted originated from the cabinet of the Delft mayor Hendrik d'Acquet, who at the time was the only possessor of this specimen in Holland, and who supplied many shells for the Rumphius publication.[34] After his death in 1706, the shell was auctioned for 80 florins, so it was an expensive collector's item which the owner probably possessed with pride. It also served as an "iconotype", as Carl Linnaeus (1707–1778) referred to this image in his famous tenth edition of his *Systema Naturae* of 1758.[35] As every shell has a unique and specific design, comparable with fingerprints, an experienced connoisseur-collector would be able to discern subtle differences in form and markings, and a skilled artist would certainly have been aware of this. Furthermore, it is unfortunate that the quality of the four reproductions differs, especially the one in Saint Petersburg (C), but they certainly enable us to make a detailed visual comparison and draw some conclusions.

The four drawings show a fairly smooth, cone-shaped body topped by a blunt spire with a distinct suture. The base color of the body whorl is pinkish-white with three wide, orange-brown spiral bands in the colored version and only two in the black-and-white versions. The spire has the same orange-brown color. The body whorl is covered with thin, black-and-white-speckled spiral lines. The initial impression is that the rounded form of the shell stands out the most in B and D. This is partly caused by the more pronounced cast shadows, but also by the manner in which the details on the shell are rendered. The print from the book (B) is obviously more sharply delineated due to the etching technique. Differences in depiction become noticeable when the

dots and the forms of the black-and-white lines are compared. Evidently, every painted brushstroke is unique, but by comparison the differences are too substantial to be attributed to an accidental handling of the brush. For instance, the thickest black-and-white spiral cord below the suture shows a white section in the middle with two smaller black dots, flanked by two longer dark stripes to the sides and then two white sections again at the far ends. This pattern is followed in A, B, and D, but not exactly in C. Here, there are two additional white markings in the lower dark stripe. This seems a subtle digression but, as mentioned previously, for a connoisseur of shells it is notable. When we compare the other speckled lines, more incongruities become clear, such as the patterns and forms of the seven lines in the broadest orange-brown band in the middle of the shell. Where the body of the shell recedes inward towards the lip and the spotted lines fall in the shadow, the lines in C consist of solid black stripes with a random white dot. In A, B, and D the design is much more defined and varied—every line is rendered with its own specific pattern. Also, the rhythm between lines and interval spaces diverges; in C the lines run less parallel, and at times they even taper towards each other. In the three other versions, this is less noticeable. Here, the lines contribute substantially to the illusion of the rounded cone shape of the shell. In other words, the artists of A, B, and D understood that the course of these lines should be rendered in parallel to express the three-dimensional rounding of the shell in an

effective and faithful manner. The artist of shell C did not seem to understand this, or did not have the experience, expertise, or concentration to render this convincingly on the two-dimensional plane. It shows how depicting *naturalia* requires not solely artistic skill, but simultaneously involves cognitive processes and informed choices, two aspects that can hardly be separated.

There are other telling differences. The notching near the siphonal canal, which could be an accidental chip, as malacologist Jeroen Goud kindly informed me, also varies. It is notably depicted in D, clearly present in B, faintly discernable in A, and absent in C. Additionally, the top of the spire, or apex, is pointed in A and C, while in B and D it is more of a knob-like stump. According to Goud, this might be caused by wear, as most *Conus* shells have a more sharply pointed spire. He believes the spire of D is rendered most convincingly and thus reveals the structure of the shell and the spiral cord better; he wonders if Merian adjusted the eroded apex in version A, which would be analogous to other, more common *Conus* shells.[36] Also, the execution of the shadow of D is more convincingly rendered. It shows greater awareness of the subtle tonalities within cast shadows that are lightened by reflections from the object itself.[37] In comparison with the others, the shadow of C is executed in a flat gray tone. All these considerations raise new questions about the specific relationship between the four depictions, but I think it is fair to draw some conclusions.

Fig. 5 Four depictions of a *Conus aurisiacus*

A. M.S. Merian, Detail from *Stambuch* of Petrus
 Schenck, watercolor and bodycolor on paper. Leiden
 University Libraries, inv. no. LTK 903, f. 102r.
B. J. de Later (etcher), Detail from G.E. Rumphius,
 D'Amboinsche Rariteitkamer, Amsterdam 1705,
 tab 34, etching. KB, National Library of the
 Netherlands, The Hague, KW 759 A 6.

C. Unknown artist, Detail from Fig. 2, watercolor and
 bodycolor, early eighteenth century. Saint Petersburg
 Archive of the Russian Academy of Sciences
 (SPbARAN), inv. no. R.IX. Op. 8. no. 82 © SPbARAN.
D. Unknown artist, Detail from Fig. 3, drawing in
 manuscript, washed drawing with pen and black
 ink, sheet 395 x 245 mm, detail 58 x 83 mm. KB,
 National Library of the Netherlands, The Hague,
 KW 68 A 3, f. 22.

The longer we look at the examples, the harder it becomes to maintain that C, the Saint Petersburg version, served as an example for B, the etching in *D'Amboinsche Rariteitkamer*, or for A, the watercolor in the *album amicorum* which is certainly by Merian. When we accept this, then we have to assume that the etcher of the plate, Jacob de Later (1670–?), made alterations and improvements to the final print, and that Merian improved on her watercolors in Schenck's friendship album. This seems very unlikely. It seems more probable that D, from the manuscript in The Hague, was the original on which the print was based, that A was painted after an unknown color model that paralleled the original design of the washed drawing of D, and that C was a weak copy of the same or a similar color model. It is hard to imagine that an artist with the talent, quality, experience, and eye for detail like Merian would be responsible for

shell C. This also means that, based on this comparison, the Saint Petersburg watercolors cannot be regarded as the "original" colored model set. It could be possible that Merian contributed to the washed drawings in the album in The Hague, as she was acquainted with the editor, Schijnvoet. However, there are no wash drawings in gray tones known by her, and a first glance at the depicted objects reveals a more painterly and loose style compared to Merian's meticulous, smooth, and miniaturistic style. Elsewhere, I proposed some possible artists who might be responsible for the album in The Hague, including Cornelia de Rijck (1653–1726), Schijnvoet's wife and a capable painter of bird paintings in oil and insects from Suriname in watercolor, or the draftsman Jan Goeree (1670–1731), Schijnvoet's companion in many works and the designer of the title print of *D'Amboinsche Rariteitkamer*.[38] However, more research is needed to gain additional insight.

All of the Saint Petersburg watercolors of the Rumphius illustrations should be subjected to a thorough visual analysis, but there is not enough room to do this here. Sometimes the quality of the illustrations differs considerably, even on the same sheet. A few sheets reveal a higher quality than the one discussed above, but these are exceptions.[39] However, most of these watercolors indicate the same thing: in the overall design as well as in the execution of the separate specimens, they show a hand less skilled than that of Merian. I will give one more

example. If we compare sheet 88 of the Saint Petersburg collection with the corresponding print, Tab. 36 from *D'Amboinsche Rariteitkamer* depicting Strombidae (Figs. 6A and B), differences are also discernable. Obviously, no shadows are depicted in the watercolor, but this might have been a conscious choice. It is unlikely that the watercolor is a colored counterproof (an extra inverted print made from another, freshly printed wet sheet), as sometimes is suggested, because the mutual positions between the shells differ too much. The left shell in the upper row (*Turbinella pyrum*) is clearly positioned higher and appears larger, relative to the shell next to it (*Lambis lambis*), than in the print. On the second row the projections of the two shells (*Lambis millepeda* and *Lambis scorpius*) are practically interlocked, while there is much more interspacing in the print. Notably, the right shell has a straight projection near the siphonal canal, while on the print it is curved, as it should be and as Rumphius described it. It seems very unlikely that this would have been an intervention of the etcher. On the contrary, it seems more probable that the painter of the Saint Petersburg watercolor did not follow the example correctly. Furthermore, the course of the ribs in this shell differs considerably between the images; in the painting they seem to slide away to the left, while in the print the course is more vertical. In this case the print from the book corresponds more closely with the shell depicted in the set in The Hague (Fig. 6C) and the shell as it appears in

A

B

C

D

Fig. 6 A. J. Deur (etcher), Ten shells, in G.E. Rumphius, *D'Amboinsche Rariteitkamer*, Amsterdam 1705, tab. 36, etching. KB, National Library of the Netherlands, The Hague, KW 759 A 6.

 B. Unkown artist, Ten shells, watercolor and bodycolor, early eighteenth century, 373 x 275 cm. Saint Petersburg Archive of the Russian Academy of Sciences (SPbARAN), inv. no. R.IX. Op. 8. no. 88 © SPbARAN.

 C. Unknown artist, *Lambis scorpius*, in *Dessins originaux des raretés d'Amboine* par G.E. Rumphius, early eighteenth century, fol 24 (detail), washed drawing with pen and black ink, sheet 395 x 245 mm, detail 45 x 98 mm. KB, National Library of the Netherlands, The Hague, KW 68 A 3.

 D. Unknown artist, *Sinustrombus latissimus*, in *Dessins originaux des raretés d'Amboine* par G.E. Rumphius, early eighteenth century, fol. 25 (detail), washed drawing with pen and black ink, sheet 395 x 245 mm, detail 78 x 117 mm. KB, National Library of the Netherlands, The Hague, KW 68 A 3.

nature. Finally, we can examine the big white shell on the left in the third row, a *Sinustrombus latissimus*. In the drawing from The Hague, the radiations on the broad lip are rendered with soft transitions of gray tones (Fig. 6D). The print in the book has lost a bit of this subtlety through the rougher etching technique (Fig. 6A, at letter L). The wavy lines on top of the swelling of the body are also more sharply accentuated in the print. Both depictions show a prominent shadow below and to the right, in the curvature between the body and the lip. The radiations in the Saint Petersburg drawing (Fig. 6B) are schematic, with straight lines of white, lacking the subtle nuances seen in the other two images. The prominent shadow is hardly discernable, which makes the three-dimensionality of the form fade. The little knobs on the spirals of the shell are done in a schematic manner, as if this painter knew only one "manner" in which to paint a lobe without accentuating the actual diversity between separate individual forms. The drawings in the volume in The Hague do not show these inaccuracies and are much closer to the final illustrations in *D'Amboinsche Rariteitkamer*; according to some, the drawings in The Hague are more true to nature than the prints. It seems very plausible that these 559 black-and-white drawings served the etchers as examples.

Work by Students?

In general, the group of watercolors in the Saint Petersburg archive that corresponds with the Rumphius illustrations cannot be considered as the models the etchers used for the book, nor can they be seen as work by Merian's hand. At first sight, the colorful sheets are attractive, but after closer examination they reveal too many inaccuracies that point to a less skilled and experienced hand. It is difficult to imagine that Merian's talented daughters, Dorothea Maria or Johanna Helena, were responsible for work like this. It is more likely that they are copied from another, unknown colored set. I would even go so far as to consider most of these watercolors as being the work of students or apprentices in a workshop.

As such, they might have been produced in either Amsterdam or Saint Petersburg. We do not know anything about Merian's studio in Amsterdam, but it is likely that other women worked there, besides her daughters. In an Amsterdam newspaper from August 1692, the family advertised their services to people who wanted "their daughters to learn to draw flowers, or to paint in aquarelle".[40] It seems that Merian tried to establish anew a *Jungfern Combanny* (company of young women) like the one she tutored in Nuremberg two decades earlier (see the chapter by Sauer in this volume). If there were other women at work in her studio in Amsterdam, what would their involvement have been in its "official" production? And if the Saint Petersburg set was made in Amsterdam by a hand with less experience, could the tsar's agent, Areskin, have acquired the works from the Merian legacy without noticing the difference in quality? This seems doubtful.

Perhaps it is more likely that the Rumphius watercolors were not part of the Merian legacy, but were instead made in Saint Petersburg. As noted before, Merian's drawings were intensively used as reference material for naturalists and as examples for art students. In the same year that Merian's watercolors were transferred to Saint Petersburg, Dorothea Maria and her husband Georg Gsell settled in the new capital upon the invitation of Peter the Great, who wanted them to work for him. One of their tasks was to instruct young Russian artists in the Western tradition of painting "after life". In his overview in *Leningrader Aquarelle*, Lukin calls the Gsells "the custodians of the secrets of Maria Sibylla Merian's skills, who created a whole school of painters and drawers in Saint Petersburg", and he adds that Merian's watercolors were an indispensable aid in the classes. "The pupils carefully studied the works, penetrated the secret of the line and color, sometimes copied them, and only then went on to study from life."[41] There was even one student, Mikhail Nekrassov (1712–1778), who copied the watercolors "so successfully, that they were presented to the library of the Academy for preservation". A beautiful, hand-colored counterproof copy of *D'Amboinsche Rariteitkamer* from the collection of Albertus Seba (1665–1736), now preserved in the Zoological Institute of Saint Petersburg, might have served the students as another example to learn the métier of illuminating.[42]

In 1723, Dorothea Maria was directed to begin another comprehensive project: depicting every single object in the Kunstkamera. This project took place in the 1730s and 1740s, with the aid of some of her students.[43] More than two thousand illustrations from this "paper museum" are still preserved, and four of them are considered to be copies of Merian's originals painted by Nekrassov.[44] Over time it might well have been that works of talented but still less experienced students became intermingled with the collection of Merian watercolors kept in the archive. That the present set of Rumphius watercolors in the Saint Petersburg archive is interspersed with the work of others becomes clear from the collection itself. Two sheets obviously stand out. Sheet 1 shows a mirrored version of the frontispiece of *D'Amboinsche Rariteitkamer* on parchment, illuminated with unnatural, bright colors and rough and unrefined, hasty transitions by an artist (perhaps in training) who was unaware of how to render human anatomy in colors and tone. By close observation, we see how the artist painted over a (counterproof?) print, as the crosshatchings in ink are still visible under the thick layers of paint (Fig. 7). Sheet 103 is another anomaly, showing three shells against a dark gray background and painted on paper with much bolder and broader brushstrokes in a style that deviates from the other watercolors with shells.[45] A remaining question is why many of these "student" paintings are done on parchment rather than on paper, which was much cheaper. From the archival records we know that Dorothea Maria ordered parchments and paints in

Fig. 7 J. Goeree (design), J. de Later (etching), unknown artist (coloring), Frontispiece (detail) of G.E. Rumphius, *D'Amboinsche Rariteitkamer*, Amsterdam 1705, 34.5 x 22.5 cm. Saint Petersburg Archive of the Russian Academy of Sciences (SPbARAN), inv. no. R.IX. Op. 8. no. 1 © SPbARAN. Compare Fig. 5 on p. 224.

practices, teaching strategies, and archival fluctuations. Needless to say, in all these processes the "remarkable woman" Maria Sibylla Merian served as a nexus, but she played this role within a culturally vibrant network of natural history illustrators, etchers, printers, and publishers. Reevaluating the corpus of Merian paintings will be an immense task that ideally would combine traditional connoisseurship with new material and technical research. However, the question as to whether or not a work is by Merian's hand should not be the leading objective. A comparison with the history of the corpus of Rembrandt paintings imposes itself, as here, too, questions about attribution led eventually to a new understanding of workshop practices and a reevaluation of the concept of "authenticity".[47] It would certainly help to extend these questions to the rather unexplored topic of workshops practices of natural history illustrations. If the collection of Rumphius watercolors points to anything, it is to the complexities of these historical realities. Widening our scope from the material legacy of Merian to a broader idea of cultures of natural history illustrations could lead to interesting new questions and insights.

Amsterdam and supervised the manufacture of parchment in Saint Petersburg.[46] Was this material more readily available in the tsarist institute of art and science than it was elsewhere?

Do these findings mean that the set of Saint Petersburg watercolors with the Rumphius illustrations is of lesser value? Not if we look at it from a broader perspective and see them as the result of an intricate conjunction of workshop

* This essay is a more elaborate discussion of remarks I already made in Van Delft & Mulder (2016) p. 22–23. I would like to thank Kay Etheridge, Jeroen Goud, Hans Mulder, Florence Pieters, and Ad Stijnman for their valuable comments.

Maria Sibylla Merian and Johannes Swammerdam. Conceptual Frameworks, Observational Strategies, and Visual Techniques

Eric Jorink

Introduction

In his dedicatory poem to Maria Sibylla Merian's *Der Raupen wunderbare Verwandelung* (1679), Christoph Arnold (1627–1685) referred to some of the predecessors of the German artist/naturalist, including Thomas Moffet (1553–1604), Johannes Goedaert (1617–1668), and Johannes Swammerdam (1637–1680).[1] Decades later, Merian herself included a list of sources of inspiration in her *Metamorphosis Insectorum Surinamensium* (1705). There we encounter the same names, as well as references to the *Schou-burg* (1688), a successful book of Steven Blankaart (1650–1704), and the collections of naturalia by Frederik Ruysch (1638–1731) and Nicolaes Witsen (1641–1717). In the rich secondary literature on Merian, attention has been paid

to the ways in which she elaborated on the work of her predecessors and of contemporary colleagues. For example, Jenice Neri and Kay Etheridge have discussed how the illustrated works by Ulisse Aldrovandi (1522–1605) and Goedaert influenced Merian's depictions of the transformation from caterpillar into adult butterfly.[2] As they have stressed, an important aspect of Merian's work was the fact that she took the metamorphosis as well as the ecological context of each species into account. The full life cycle of many sorts of insects in their natural environment was now depicted and described. Entries in her books often start with a textual presentation of the host plant. And all insects, Merian maintained, come from an egg, being the result of mating. As we will see,

in the late seventeenth century this was still a rather novel idea.

In this chapter, I will take a closer look at the background of what has been called Merian's ecological approach.[3] My point of departure is the work of Johannes Swammerdam, who, like Merian, was a diligent observer and a talented draftsperson.[4] They were both drawn to religious movements. Swammerdam corresponded from 1673 onwards with the mystic Antoinette Bourignon (1616–1680) and stayed in her Schleswig community for nine months, from September 1675 to June 1676.[5] Merian joined the Labadist community in Wieuwerd, Friesland, toward the end of 1685, which basically shared the same spiritual ideals, and stayed there for six years. Somewhat before Merian, Swammerdam had taken great interest in the life cycle of insects; more specifically, the processes of generation and metamorphosis. He was one of the first to establish that insects come from eggs and not from spontaneous generation—in other words, that insects originate from sexual reproduction.

The earliest works by Swammerdam, *Historia Insectorum Generalis* (1669) and his subsequent *Ephemeri Vita* (1675), show interesting similarities with the observational and visual strategies presented in Merian's *Raupenbücher* (Caterpillar Books; first volume 1679; second volume 1683). Her research appears to have started in the same years, in the early 1660s. Besides Swammerdam's printed works—which Merian may have known—he left a voluminous manuscript including hundreds of exquisite drawings. Swammerdam died in 1680, a year after the publication of the first volume of Merian's Caterpillar Book, and his longer manuscript was published decades later, in 1737, as the *Bybel der Natuure*. His work included lifelike representations, attention for scale and ratio of space, ecological context, and the development of insects over time. In other words, many of the elements of the approach that made Merian famous had already been used by Swammerdam in his manuscript. In this chapter, I argue that our reading and understanding of Merian's oeuvre could—and also should—benefit from a comparison with that of her Amsterdam contemporary. In the rich literature on Merian, references to Swammerdam have been made in passing, but the similarities between the two have so far not been studied in detail.

With the increasing scholarly and artistic attention on insects in the second half of the seventeenth century, researchers had to experiment with various modes of representation, especially in the wake of the growing use of the magnifying glass and various types of microscopes.[6] They were, quite literally, mapping unknown territory. There was no single template for depicting the life cycle and habitat of insects, and although very impressive and successful, the epoch-making artwork by Merian was only one example. Scholars and artists alike had to develop new visual techniques. Any educated person knew that a chick grew out of an egg and what an elephant should look like, even without having seen one. However, the world of

insects was largely unknown. Whereas Swammerdam experimented with various artistic strategies, Merian's visual language was largely consistent and stable, making it seem self-evident and obscuring the underlying labor and practices. Looking at her stunning images, either the drawings, prints, or hand-colored counterproofs, can be an enchanting experience, which almost makes us forget that these are highly constructed. They reflect the process of careful breeding, observing, and drawing each stage of an insect's life, but also a conscious process of composing, copying, and pasting.

Moreover, behind Merian's visual representations of the life cycle of insects lay a philosophical concept that essentially was the same as Swammerdam's: the notion that every living creature in nature was built on the same basic anatomical principles and went through the same stages of growth and sexual reproduction. This was by no means self-evident in the 1670s. As historian of science Dániel Margócsy recently put it, by the closing decades of the seventeenth century:

> Most natural historians became convinced by microscopic discoveries that insects tended to reproduce sexually by laying tiny and sometimes invisible eggs and did not come out of nowhere [...] Merian played an important role in this story of discovery by documenting how the larvae of insects emerged from eggs and then metamorphosed into adults.[7]

However, Merian was not the first to study this process. As we will see, she not only worked along the same visual strategies as Swammerdam but also built her work on the same philosophical foundations.

Johannes Swammerdam and the Study of Insects

Scholars studying Merian have mentioned Swammerdam, but mostly in passing. Goedaert, rather than Swammerdam, has been a point of departure for reflections on Merian's work.[8] The fact that both Goedaert and Merian in the title of their publications explicitly addressed the issue of metamorphosis might be the background for this, though Merian only used "metamorphosis" in the title of her Suriname book (1705); in the titles of her *Raupenbücher* she called it "transformation" (*Verwandelung*). However, "metamorphosis" is a problematic and deceptive term which could both refer to a more general transformation as to a specific process of growth dictated by fixed laws and, by implication, excluding contingency, signifying spontaneous generation. Merian here followed Swammerdam rather than Goedaert.

In 1660 the first of the three volumes of Goedaert's *Metamorphosis Naturalis* was published. This was an important and influential event, as many subsequent naturalists referred to his work as Merian did. The Middelburg painter painstakingly caught, fed, observed, and drew an impressive number of species of butterflies, and visually represented stages of growth: caterpillar and imago

(adult insect) and, for some species, the pupa.[9] Earlier naturalists primarily ordered their descriptions on morphological similarities and represented all sorts of worms, larvae, and caterpillars in the same plate and, often hundreds of pages later, completely unrelated imagos in another plate.[10] In contrast, Goedaert captured two or three successive stages of each individual species in one single image. At a glance, the beholder could see the metamorphosis from one particular sort of caterpillar into one particular sort of butterfly. However, Goedaert was hugely inconsistent and often did not represent the pupal stage. At times, as for example in the case of the silkworm, he described the act of mating and the production of eggs. However, he was convinced that "many small creatures, which are said to be created spontaneously, that is by themselves, are bred from rotting and warmth".[11] The idea that nature obeys fixed laws was alien to Goedaert, nor did he see sexual reproduction at work in all sorts of insects. Being unaware of parasitism, he noted with amazement how, from one and the same sort of caterpillar, bred under identical circumstances, either a beautiful butterfly or a swarm of ugly flies could emerge.

At first sight, there might seem to be a direct link between Goedaert's fieldwork, step-by-step observations, and visual strategies and Merian's approach. However, the common use of the term metamorphosis and the visual sequence showing the transformation of caterpillar into butterfly in stages obscures the fact that Goedaert and Merian had two completely and mutually exclusive conceptions of nature. Through the last volume of his *Metamorphosis* (1668), Goedaert defended the idea of spontaneous generation. A decade later, Merian would not. The obvious question is: why?

It is here that Swammerdam comes in. It was actually Swammerdam who deliberately destroyed the idea of spontaneous generation of insects.[12] He started his research on insects around the year of publication of part one of Goedaert's *Metamorphosis*, and he died, as we saw, a year after part one of Merian's *Raupenbuch* came from the press. Swammerdam openly attacked Goedaert's concept of spontaneous generation and ridiculed his images. His orientation was fundamentally different from Goedaert's; they studied the same creatures but saw something completely different. Goedaert had represented pupae with unmistakably anthropomorphic features, and Swammerdam sarcastically called "these drawings based only on his imagination", "farcical" and "grotesque".[13] The pious Goedaert had seen spontaneous generation as a given and regarded it as an unfathomable wonder of God. According to Swammerdam, Goedaert "seems to describe a novel rather than a genuine history".[14] He wrote long diatribes against Goedaert's "mistakes", "errors", "falsehoods", and "terrible blunders".[15] Swammerdam proceeded from the axiom that everything in nature obeys the same "rules and order", which was the proof of the existence of "a wise and exceptional Spirit".[16] In her texts, Merian only sporadically refers to her predecessors, but her

work was rather more in the line of Swammerdam's than Goedaert's research and conceptual framework.

Swammerdam was the eldest son of an Amsterdam pharmacist and collector of *naturalia*. He registered as a student of medicine at Leiden University in 1661, by then the European hotspot for anatomical research and natural history. Together with his friends and fellow students, including the aforementioned Ruysch and Witsen, Swammerdam excelled in making anatomical discoveries. They experimented with new techniques of dissecting, preparing, injecting, observing, and embalming animal and human bodies, and they could draw very well. In addition, they—and Swammerdam most explicitly—were inspired by the new natural philosophy of René Descartes (1596–1650), who maintained that bodies could be compared to machines, and that everything in nature obeyed the same underlying, fixed laws. This conviction had enormous implications for the study of living beings. The heart was to be compared to a pump, movement understood as mechanics and hydraulics, and the internal structure of all living beings basically followed the same blueprint.

However, the philosophy of Descartes left one big question unanswered. If the body was a machine, where did the offspring of machines come from? Throughout his life, Descartes had struggled with this issue. His notes on this subject, which clearly made the question pertinent, were only published posthumously in *De Homine* (1662) and *Traité de la Formation du Foetus* (1664), works that were, interestingly enough, in the library of Merian's friend Christoph Arnold (1627–1685).[17] Around 1660, Swammerdam picked up the challenge presented by Descartes. He simply would not believe that—as the Ancients had written and contemporary students of nature, including William Harvey (1578–1657) and Goedaert, echoed—insects were devoid of an internal anatomy and were the result of random generation.[18] This would leave the door open to contingency and chance and, as such, deny God's omnipotence. According to Swammerdam, the scholastic hierarchy of the "great chain of being" was blasphemous, and there was no ontological and anatomical distinction between "higher" and "lower" creatures. The anatomy of an insect was as complicated as that of a lion or elephant—but even more worth studying because of its minute scale. Insects, amphibians, and other creepy-crawlies, traditionally despised and neglected, ought to have the same underlying principles of procreation as the so-called higher beings, and hence, the same reproductive system. *Generatio spontanea* was simply out of the question, and stories about dead caterpillars resurrecting as beautiful butterflies or sometimes randomly turning into swarms of small wasps were qualified as outright atheism in the mind of Swammerdam.

Guided by this conviction, as well as by new, self-developed techniques of preparation, a magnifying glass, and a single-lens microscope, Swammerdam

set out to make his point. Observation and empiricism might seem fact-neutral, unbiased activities, leading to inevitable truths. However, anyone who is certain that there are rivers on Mars could perhaps be convinced that they see these. Closer to our subject: a scientist guided by the idea of spontaneous generation can see proof of this everywhere. Those who look for parallels in the reproductive anatomy and processes in higher beings will, in turn, sooner or later find proof to support their ideas. The human male and female reproductive system, semen and eggs, and the act of fertilization would then be found in insects. Swammerdam was the first to do so. In 1665, he dissected caterpillars and chrysalises, discovering that the reproductive organs and structure of the future butterfly already could be discerned. The transformation of a caterpillar into a butterfly was not the result of an enigmatic metamorphosis, "wrongly described as change of form, casting off of shape, death and resurrection".[19] It was a growth process, exactly the same as "a chicken that does not *change* into a hen, but *becomes* a hen as its limbs grow".[20] As one could follow the cycle of mating between hen and rooster, the emergence of the chicken from the egg, and the process of growth, etc., one could also observe the same in the generation of insects.

The *Historia Insectorum Generalis*

Swammerdam's evidence for the parallels between reproduction in insects and other organisms was worked out in great detail in his *Historia Insectorum Generalis*, published in December 1669. In this pioneering work, he tried to identify the various modes by which insects are generated. The first consisted of insects like the louse, that emerge from the egg in a more or less adult form. By far the most complex mode was what Swammerdam called the third order—butterflies, dragonflies, and mayflies—that go through various stages. Besides giving an outline of each of the four orders, all with exemplary descriptions of various insects, Swammerdam included a series of etchings to illustrate his point.

Swammerdam was well aware of the epistemological value of images and was a very talented draftsperson. Like the Bible, the Book of Nature had to be studied with one's own eyes, with the same eye for detail, as every sentence, syllable, and iota referred to God. Nature was a "pretty picture" that "has become dirtied and contaminated" by "our fancies" and "corrupt traditions".[21] Swammerdam intended his own investigations to remove those layers of varnish and dirt, so that the painting would be restored "in all its radiance and beauty".[22] Here, we see the same religious motivation that also shaped Merian's work. Swammerdam often referred to the work of Joris Hoefnagel (1542– ca. 1600) as an enlightening example, and his own surviving original drawings demonstrate that his artistic talents at least equaled his Antwerp example (Fig. 1). Contrary to Merian, Swammerdam's illustrations have been little studied, and even now we know next to nothing about his training, working

Fig. 1 J. Swammerdam, A rhinoceros beetle, including microscopic details, original drawing, 287 x 197 mm. Leiden University Libraries, Ms BPL 126 B, f. 31r.

the micro-world. However, Hooke still vaguely subscribed to some theory of spontaneous generation.[24] Like others, he was aware that some insects laid eggs, that insects were tiny little automata, and also that, by some unexplainable mechanistic working, particles could randomly form a new lifeform. All these contradictory ideas were difficult to bring together under one conceptual umbrella. Rather than trying to make sense of this, Hooke stuck to the empirical facts. Thus he recorded the alienating world of insect eyes, molts, larvae, and the texture of cork with minute detail, publishing these in large foldout engravings. The utter strangeness of the micro-world was increased by the absence of visual markers needed for scale.[25] "Flea and louse as big as a cat", Christiaan Huygens (1629–1695) noted.[26] But looking at the egg of a silkworm or the larva of a mosquito, spectators had literally no clue what they actually saw.

In his *Historia*, Swammerdam initiated a visual dialogue with Hooke. He developed a new, step-by-step visual strategy. First, he depicted the larva of the mosquito, life-size and in its ecological context, right under the surface of the water (Fig. 2). Next to it, he represented the same creature, but now with a magnification comparable with Hooke's (about fifteen times), so the viewer could at a glance get a sense of both the creature's natural environment and its wonderful external anatomy.

Swammerdam's next step was to visually represent the entire process of growth, from egg to the adult insect. In the foldouts at the end of the *Historia*, he

methods, and use of various techniques and materials.[23] It is clear, however, that visual representation and communication for Swammerdam were as important as a written account—similar to Merian, the two were integral to each other. Swammerdam drew visual reports of his research well before Robert Hooke's *Micrographia* appeared in print in 1665. Hooke (1635–1703), rather than Goedaert, provided the point of departure for Swammerdam; *Micrographia* was the big game-changer in the field of the study of

Fig. 2 J. Swammerdam, The mosquito larva, life-size in its natural habitat (A and C) and magnified circa fifteen times (B and D), in J. Swammerdam, *Historia Insectorum Generalis*, Utrecht 1669, Tab. 2, etching. Leiden University Libraries.

presented the subsequent stages in a vertical column, so the viewer could "read" the life cycle of insects of the different orders. These were all given life-size. In representing the tiny eggs of most insects, this required a black background to make them visible, and the technique of etching rather than engraving, as etchings could show smaller details. On the horizontal axis, Swammerdam would zoom in on more specific details of each step in the process of transformation. An example is the transformation of the caterpillar, via the pupa, into the imago (Fig. 3). Here, he used a magnifying glass or a microscope with only limited magni-

fication. In order to demonstrate the conformity of nature and its underlying order, Swammerdam also included an etching of the process of growth of a frog and a carnation (Fig. 4).

Both the text of the *Historia* and its illustrations offered a template for further research. While the *Historia* was being printed, Swammerdam was presented a copy of Marcello Malpighi's *De Bombyce* (1669), the stunning work in which the Italian presented his research on the external and internal anatomy of the silkworm.[27] As we know, Swammerdam had earlier dissected caterpillars. Malpighi (1628–1694), now in much

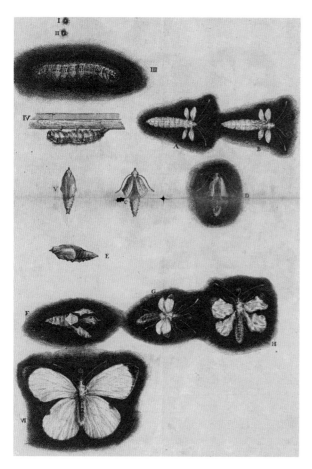

Fig. 3 J. Swammerdam (design), The metamorphosis of
caterpillars, including the silkworm, in J. Swammerdam,
Historia Insectorum Generalis, Utrecht 1669, Tab. 13, etching.
Leiden University Libraries.

Fig. 4 J. Swammerdam (design), The development of a frog and
a carnation, visually demonstrating the uniformity of nature,
in J. Swammerdam, *Historia Insectorum Generalis*, Utrecht 1669,
Tab. 12, etching. Leiden University Libraries.

more detail and with the aid of a micro-
scope, presented the alienating internal
structure of the economically most valu-
able of them all. The work challenged
Swammerdam to do the same. He next
embarked on a large-scale investigation
in which he, like Malpighi, had to devel-
op new techniques of preparation and
observation, and he increasingly used a
microscope. Earlier, he had used lenses
that could magnify a subject about fif-
teen times. In order to penetrate the in-

ner secrets of insects, he started using
a microscope capable of magnifying
between sixty and hundred times. He
worked with a design developed by the
mathematician Johannes Hudde (1595–
1647), a good friend of other scientists
working in the pioneering field of optics,
such as Christaan Huygens and Bene-
dictus de Spinoza (1632–1677).[28] Swam-
merdam now replicated Malpighi's
work on the silkworm. The surviving
drawings—thought to be lost, but

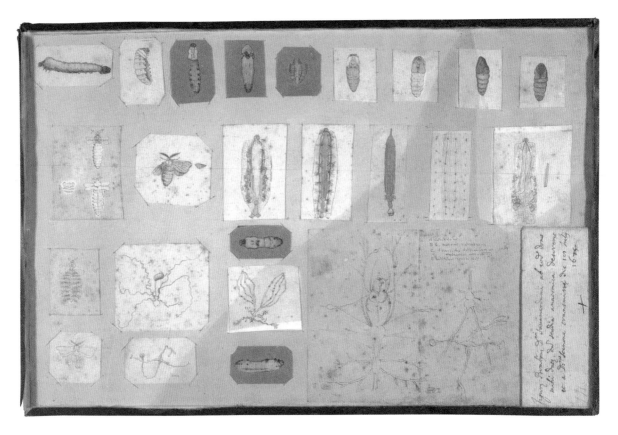

Fig. 5 J. Swammerdam, The stage-by-stage growth of the silkworm, also including microscopical details of its entrails, original drawing, 26 x 40 cm. Bologna University Library, Ms 936. Courtesy Bologna University Library.

rediscovered only recently—show essentially the same visual strategy as the etchings in the *Historia*: the use of time-lapse and magnified details (Fig. 5).[29]

At the same time, Swammerdam continued his research on the *ephemeron*, or mayfly. The work was published in 1675 and shows two new directions in Swammerdam's visual approach. As Swammerdam looked deeper and deeper within the creature's inner structure, details were seen that simply became incomprehensible without a legend. Like the map of a city, structures had to be marked with letters and enlightened

with notes such as "y is the nervous system". Dissecting the larva, Swammerdam observed and drew all visible inner organs and brought them together in one magnificent composite image, of which the original still exists (Fig. 6). In order to create this overview, while at the same time showing great detail, he had to dissect dozens of insects, make sketches of each detail, and put all these pieces of the puzzle together in one big overview. Once again, in order to give a sense of proportion, he drew the insect life-size, circa three centimeters long, in the lower left corner. Swammerdam, with much

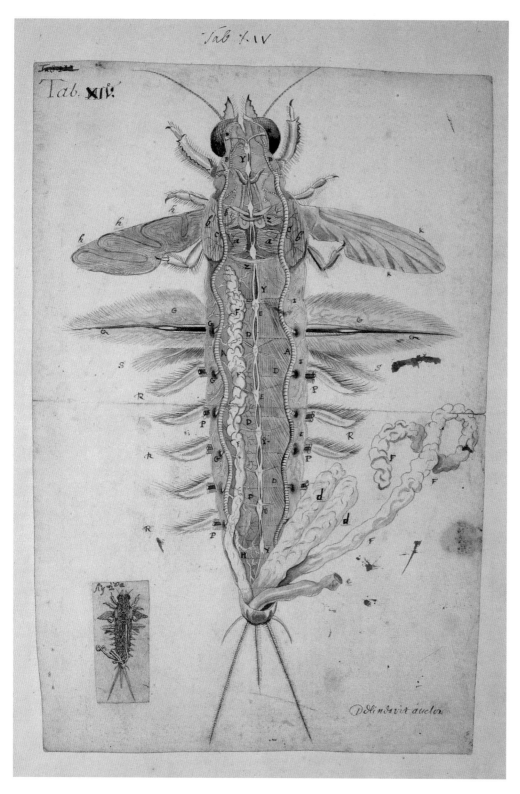

Fig. 6 J. Swammerdam, The anatomy of the mayfly, original drawing 295 x 201 mm (drawing). Leiden University Libraries, Ms BPL 126 b, f. 15r.

self-confidence, signed his anatomy of the mayfly with "delineavit auctor"—the author has drawn this himself. Like Merian, he was consciously working at the intersections of science and art. Expanding this approach to other insects, Swammerdam used the original etchings of the *Historia* to add details of his microscopic dissections on the vertical axis. The different stages of development of each sort of insect, later elaborated upon by Merian, was already present here. Their technique was basically the same. A careful drawing of each observed stage was made, and these were later combined in a composite image capturing the entire life cycle. However, as we saw, much of Swammerdam's work was not published before 1737.

A second development may have been known to Merian, though. In the *Historia*, Swammerdam had presented some insects in their context: gnat, water flea and rotifer under the surface of the water, a caterpillar on a leaf. Swammerdam now also visually presented the mayfly in its natural habitat: the larva, living three years in the riverbed; the imago emerging from the water, surrounded by its natural enemies; and the process of molting on the bank of the river. The course of Swammerdam's research, which increasingly was comparable to microscopy as pursued by Malpighi and Antonie van Leeuwenhoek (1632–1723), made him focus on the first approach: detailed drawings of inner structures, enlightened by letters and texts. The second approach, the ecological, was not the path Swammerdam would follow,

but it was the one that Merian would fully develop.

Concluding Remarks

In 1675, Swammerdam would publish his work on the mayfly, *Ephemeri Vita of Afbeeldingh van 's Menschen Leven, vertoont in de wonderbaarelijcke en nooyt gehoorde Historie van het vliegent ende eendagh-levent Haft of Oever-aas*. In this work, which also included many letters from his spiritual guide, Antoinette Bourignon, he announced his withdrawal from worldliness (including "sciences and curiosities").[30] Swammerdam would stay about a year in Bourignon's inner circle in Schleswig, but he returned to Amsterdam in 1676—not as a mental wreck, as is so often claimed, but eager to continue his microscopical research. Four years later, in 1680, he died. The "great work" as he called it, was only published in 1737 as the *Bybel der Natuure*. Thus, *Ephemeri Vita* was the last work to appear during Swammerdam's lifetime. Besides the detailed microscopical engravings and ecological images, it also contained many spiritual reflections.

Swammerdam and Merian had much in common: both undertook pioneering research in the uncharted territory of metamorphosis; both were brilliant observers and excellent artists; and both were attracted to spiritual ideas and lived for a while in a spiritual community. Although it was not until 1705 that Merian herself referred to the work of Swammerdam, there can be little doubt that she knew both his *Historia* (1669) and *Ephemeri Vita* (1675). Even if she

was not able to understand the Dutch text at that time (which is, of course, highly doubtful), she certainly comprehended the visual argument so clearly made by Swammerdam. She elaborated on the detailed, time-lapse etchings by Swammerdam, showing the full life cycle, including the emergence of the insect from eggs and the pupal stage, rather than on the crude etchings by Goedaert. She certainly subscribed to the philosophical framework that insects do not generate spontaneously, but obey the same fixed laws of nature as the higher beings, including sexual reproduction. Like Swammerdam, Merian at times also dissected insects, as can be seen in her notes on the tiger moth in the first volume of her Caterpillar Book; "But if the topmost skin is peeled away before they come forth, one can see how the insects are lying inside, as the image at the bottom, opposite the caterpillar, shows."[31] Parasites and parasitoids were also something Merian struggled to understand in her early work. The fact that she found these "false changes" odd, endorses the idea that both she and Swammerdam understood the progression of metamorphosis in a single type of insect. The references Swammerdam at some points made to the ecological context of insect life, especially in the *Ephemeri Vita*, were fully developed by Merian. That she might have been familiar with this work becomes clear from the laudatory poem Christoph Arnold wrote in the second volume of her Caterpillar Book, published in 1683, where both Malpighi's treatise on the silkworm and Swammerdam's anatomical description and pious meditations on the short and miserable life of the mayfly are singled out.[32] To what extent Merian developed her own ideas on the order of nature and the life cycle of insects will, due to the lack of sources, remain an open question, as will the development of her own visual language. But that Swammerdam was relevant to her seems evident.

Drawing in the Tropics. Maria Sibylla Merian's and Charles Plumier's Pictures of Caribbean Nature

Jaya Remond

During the early modern period, the (re)discovery of nature, locally and overseas, generated in Europe an intense production of images in a range of formats. Plants, local and foreign, offered unprecedented promises for profit—as medical remedies, foodstuffs, or collectibles—while their pictorial representations promoted their commercial potential and could also stand as artistic objects in their own right. Image making, particularly drawing, thus became a powerful tool of control and expertise as a specialized skill practiced by both artists and naturalists. This essay explores such depictions of nature, particularly those made by Europeans after plant specimens originating from the Caribbean in the late seventeenth and early eighteenth century. Since colonial expansion had exposed Western gazes and commercial appetites to new natural resources beginning in the early sixteenth century, the necessity of creating visual records felt increasingly pressing: seeds and plants (pressed or not) could be brought back to Europe to be later studied or grown and acclimated there (with varying degrees of success), but drawings, later turned into prints, permanently preserved their shapes and allowed artists to defy nature and decay.[1]

The last decades of the seventeenth century were especially important for the advancement of tropical botany in Europe. The year 1705 in particular was remarkable in that respect. In that same year, two major natural history publications based on drawings made *in situ* came out: German-born, Dutch-based Maria Sibylla Merian published in Amsterdam her *Metamorphosis Insectorum Surinamensium*, in Latin and Dutch, while the *Traité des Fougères de l'Amérique* by the Provence-born Frenchman Charles Plumier (1646–1704)

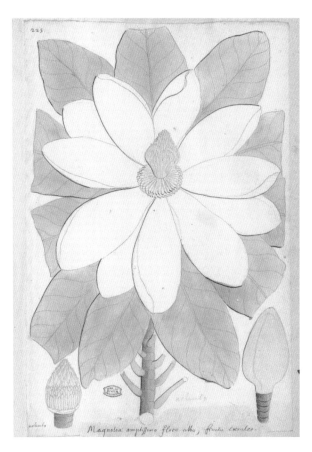

Fig. 1 Ch. Plumier, *Magnolia amplissimo flore albo*, in *Botanicum Americanum, seu Historia Plantarum in Americanis Insulis Nascentium*, plate 90, ca. 1689–1697, graphite, pen, ink, watercolor on paper, 385 x 245 mm. Bibliothèque centrale, Muséum national d'Histoire naturelle, Paris, Ms 6. © Muséum national d'Histoire naturelle.

tions of Nicolaes Witsen, Jonas Witsen, Frederik Ruysch, and Levinus Vincent. Taking the connection made by Goethe as a point of departure, this paper focuses on Merian and Plumier to explore some aspects of botanical image making in the Caribbean. To that end, I examine practices of draftsmanship and print-making alongside immersive protocols of viewing, which aim to draw viewers *inside* pictures; these encompass drawing methodologies and visual and discursive strategies that arose around pictorial productions resulting from transatlantic entanglements. This analysis raises questions pertaining to the efficacy of representations of nature, the mechanisms of control that undergirded such types of pictures, and the shapes pictorial authority could take. Casting plants and image makers as its main protagonists, this essay addresses a few aesthetic and material practices related to the representation of nature in the early modern world, as I argue that picture making, particularly draftsmanship, came to be regarded as a particularly valuable form of knowledge and an expression of scientific authority in the transatlantic examination of both flora and fauna. While Merian and Plumier came from different backgrounds, they shared a number of viewing and making practices in their scrutinization of neighboring territories and ecosystems. Their *modus operandi* sheds light on how early modern European observers, active overseas, grappled with nature.

Less famous in the collective imagination than Merian, Plumier was a cleric

was issued posthumously in Paris through the Imprimerie Royale. Both offer remarkable full-page pictures of plants accompanied by descriptive texts. Johann Wolfgang von Goethe (1749–1832) noted that Merian had been probably motivated to visit Suriname to emulate Plumier's example.[2] However, Merian makes it very clear in her preface to the *Metamorphosis* that she felt compelled to go there after seeing insects in the collec-

who belonged to the religious order of the Minims. An accomplished botanist, he also received some training as a draftsman and painter (though little is known about it). He went to Martinique, Saint-Domingue, and other Antillean islands on three separate occasions, in 1687, 1689, and 1694, for extended periods of time, to research and draw the fauna and flora of these islands, which had come under French rule in the seventeenth century.[3] He was appointed King's Botanist, and the outcome of his research was presented (partially) in three books: *Description des Plantes de l'Amérique* (1693), *Nova Plantarum Americanarum Genera* (1703), and *Traité des Fougères de l'Amérique* (1705). The product of a private initiative, Maria Sibylla Merian's *Metamorphosis*, a masterful collection of engraved and etched plates, represents the plants and insects of the Dutch colony of Suriname that were made after drawings produced onsite between 1699 and 1701.

While Merian's work was an individual initiative and Plumier's was state-sponsored, both enterprises are nonetheless firmly anchored in the European colonial context: they would not have existed without the conquests carried out by the French and the Dutch overseas. Merian and Plumier aimed at depicting plants (and, in the case of Merian, insects) *in word and image*: inventorying, naming, and classifying species often unknown in the West (at least for Plumier, in a pre-Linnaean framework) and recontextualizing them in their environment. This was a task that necessarily entailed the control and subjugation of natural resources, their domination and domestication, and their physical appropriation through exports to Europe.[4] Such works did not emerge in a vacuum but were informed by previous and recent sources, among which Georg Marcgrave and Willem Piso's *Historia Naturalis Brasiliae* (Amsterdam, 1648), which were referenced in the text.

The Power of Drawing

For both Merian and Plumier, the story starts with drawings. In the short preface to her *Metamorphosis*, Merian mentions how, once back in the Dutch Republic from Suriname, she showed her drawings to a public of *curieux*, who, impressed by what they saw, then encouraged her to publish them. In doing so, however, she also followed established authorial conventions relating to a rhetoric of modesty.[5] But she nonetheless emphasized drawings as pivotal objects in her working process and the making of the *Metamorphosis*. The pictures adorning the books by both Merian and Plumier were made after direct observation, as the subtitle of Merian's *Metamorphosis* makes clear (underlining that the images are made after life, *na het leven*) and as her text reiterates.[6] Similarly, Plumier's drawings, aiming primarily for didactic accuracy and precision, were presented as being based on first-hand observation and true to scale (*grandeur naturelle*).[7] Neither Merian nor Plumier expanded on the special status of images, as Leonhart Fuchs

(1501–1566), for instance, did in his groundbreaking *De Historia Stirpium Commentarii Insignes* (Basel, 1542), one of the first major works of modern botany, in which the author praised and commented on the ability of pictures to capture information about plants more effectively than words.[8] In the context of knowledge collection and production, pictures became especially powerful and reliable epistemic vehicles, the privileged media to stabilize ephemeral forms and to circulate morphological information that would remain incomprehensible without images.

As objects and practice, drawings and draftsmanship played a pivotal role, not just in the collection of facts. Drawing plants, like naming plants, was also a means of claiming ownership over recently conquered territories and their natural resources and inhabitants by reigning in the unknown (in a pre-photographic society) through metaphorical operations of fixing, shelving, and organizing.[9] Indigenous knowledge is occasionally included in textual descriptions when Merian and Plumier deal with use, remedies, and names. While Merian refers to the contributions of Black and Indigenous informants in her texts, they remain anonymous (see also the essay by Van Delft in this volume). If local sources are anonymized in Plumier and Merian, Western scientific sources (for example, Piso and Marcgrave or Hendrik van Reede) are, by contrast, duly recorded by name. Depicted against a blank background, the plants pictured in the books are decontextualized, there-

by playing a role in the Western commodification and exploitation of nature and people.

With their unparalleled biodiversity, these tropical terrains, boasting varied wildlife and vegetation, stimulated the image-making abilities of Western naturalists.[10] As new objects of scrutiny, plants encouraged new modes of representation, which reflected specific viewing practices. Habits of close inspection and immersive observation shaped the construction of the image, which offered new and unusual zoomed-in views of plants, dramatic foreshortening, and cut and cropped views on large sheets of paper with selected details of the plants.[11]

The constitution of drawn records was given pride of place in the context of such scientific expeditions. For example, the royal order dated 22 July 1687, relating to Plumier's first trip to the Antilles (under the aegis of Joseph-Donat Surian (165?–1691), a physician and chemist from Marseille), underlines this aspect. It states that Father Plumier is "to work to discover the properties of plants, seeds, oils, gums and essences and draw birds and fish and other animals".[12] Similarly, the royal order dated 18 May 1689, concerning Plumier's second trip to the Antilles, confirms the centrality of drawings; Plumier will "continue the *recueil* that he has started about the seeds, plants, and trees of the islands and compose one of the fish, birds, and other animals of this land".[13] Plumier's copious drawn production shows a desire for comprehensiveness, which is

Filix ramosissima Cicuta foliis

hinted at in the royal orders. It resulted in a vast repository of around six thousand drawings, including around four thousand three hundred drawings of plants, which are often accompanied by descriptive texts in Latin.[14]

Merian, who was trained as an artist, relied heavily on her talents in recording in minute detail the metamorphosis of insects and their food sources. While not formally trained like Merian, Plumier also made drawing a privileged mode of recording information. He developed a fairly consistent drawing methodology for plants: focusing on the outlines, he drew first rapidly in pencil and then over this initial sketch with pen and ink, often finishing with light swaths of watercolor, as in this drawing of a large blossom (*Magnolia amplissimo flore albo*, Fig. 1). The line is remarkably confident and assured, testifying to both athletic drawing skills and a desire for clarity. In the printed plates, Plumier put a similar emphasis on the outlines, harking back to sixteenth-century templates such as those displayed in Fuchs's *De Historia Stirpium Commentarii Insignes*. Plumier relied on straightforward geometric shapes to decompose and depict plants as a first representational step, as is visible in preparatory drawings. By doing so, he adopted a *modus operandi* recommended in early modern drawing manuals. In the drawing of a fern, the *Filix ramo-*

sissima cicutae foliis (Fig. 2), he started by sketching the leaves as triangles freehand, mobilizing the language of geometry to unpack nature visually and fix it on paper. In the artistic manuals that proliferated from the mid-sixteenth century onwards, one of the first lessons recommends to simplify the shapes of objects and beings, drawing them as geometric figures. For example, in the manual by Crispijn de Passe the Younger (ca. 1594–1670), birds are reduced to simple ovals as a first representational step.[15] Thus, the knowledge of geometry, along with the mastery of a grammar of lines and simple figures, helped mediate observations made after nature to transfer them onto paper. Drawing methods such as these constituted a pictorial toolbox that could be tapped into by artists but also by naturalists, such as Plumier, who wanted to have full control of the production of their pictures.

Bernard de Fontenelle (1657–1757), secretary of the Académie Royale des Sciences, argued that botany was not a "lazy" science: Plumier's and Merian's books and drawings were the outcome of a painstaking peripatetic search.[16] Plumier roamed coast and countryside, leaving a profuse paper trail behind him. Highlighting a comparable first-hand engagement with nature, the frontispiece of the 1719 edition of the *Metamorphosis*, published posthumously, shows

Fig. 2 Ch. Plumier, *Filix ramosissima cicutae foliis*, in Ch. Plumier, *Filicetum Americanum, seu Historia Filicum in Insulis Americanis Nascentium*, plate 35, ca. 1689–1697, graphite on paper, 372 x 240 mm. Bibliothèque centrale, Muséum national d'Histoire naturelle, Paris © Muséum national d'Histoire naturelle, Ms 1.

Merian at work in the field, catching insects with a net, in the background of the composition (Fig. 3). This mode of representation, which stages the artist in action outdoors, functions primarily as a rhetorical ploy. It does not necessarily provide an accurate portrayal of the author's experience, but rather reaffirms *in picture* the importance of the immediate and unmediated direct observation of nature as a key epistemic and artistic practice, an aspect already highlighted in Merian's text.

Tropical nature elicited a peculiar sense of amazement, which was constantly emphasized by its onlookers. While nature was generally understood as a mirror of God's glory, the rich fauna and flora of the Caribbean triggered an especially intense kind of response; they

Fig. 3 F. Ottens, Frontispiece (detail) in M.S. Merian, *Over de Voortteeling en wonderbaerlyke Veranderingen der Surinaemsche Insecten*, Amsterdam 1719, Artis Library, Allard Pierson, University of Amsterdam, AB Legkast 019.01 (see also the whole image on p. 225).

were more diverse, more colorful, with a new, monumental sense of scale and a richer color spectrum previously unseen in Europe. In the preface to his *Traité des Fougères de l'Amérique*, Plumier repeatedly refers to plants as "rare prodigies" and "rare marvels" that arouse admiration.[17] For Plumier, nature is the most admirable creation of God, and his books are praises to this miraculous splendor. By contrast, religious references and motivations are completely absent from Merian's (similarly admirative) *Metamorphosis*, while they feature in her other publications and private correspondence. This sense of awe pertains to a pictorial tradition that viewed exotic plants as being worthy of exceptional consideration. Already in the early sixteenth century, those new, strange, and beautiful botanical specimens were seen as deserving of being depicted by great artists, a claim present, for instance, in the *Historia General y Natural de Las Indias* by Gonzalo Fernández de Oviedo (1478–1557). The Spanish civil servant and chronicler stated that a particularly noteworthy tree found in the Americas should have been depicted by famous painters, such as Berruguete, Leonardo da Vinci or Andrea Mantegna.[18] Therefore, plants coming from overseas were deemed worthy of a distinctive aesthetic treatment; they commanded a special kind of attention that continued with Merian and Plumier.

Stabilizing and conveying pictorial information about plants undoubtedly presented a challenge for early modern naturalists, locally and globally. Words did not suffice, hence the crucial role played by images. In his *Mémoires pour servir à l'Histoire des Plantes* (Paris, 1676), Denis Dodart (1634–1707), a physician and a member of the Académie Royale des Sciences, highlighted the sheer difficulty of describing plants in words. He thus championed "new ways of speaking" and advocated an expansion of the vocabulary.[19] In the domain of color, for instance, he suggested borrowing from the lexica of painters, dyers, and tapestry makers, so as to enrich the botanist's vocabulary and color palette, suggesting that artists and craftsmen had expertise that went beyond the mere production of images. Merian's own interest in needlework, embroidery, and fabric painting, particularly during her early career, corroborates Dodart's intuition that interactions across media and professions could result in productive epistemic transfers. The struggle to communicate certain types of information, such as color, as precisely as possible through words is visible in Plumier's and Merian's texts, acknowledging the limits of pictures. To this purpose, Plumier relies on comparisons and uses a myriad of adjectives to qualify colors, such as different shades of green.

Control and Authority

In both Plumier's and Merian's work, the author is—crucially—responsible for both text and images. Like Merian, Plumier not only drew a considerable quantity of nature studies. He was also involved in the making of the prints, as

evident in the mention "Fr. C. Plumier [...] D.[elineavit] et Sc.[ulpsit]" (Frater C. Plumier drew and engraved) at the bottom of many plates in the *Traité des Fougères de l'Amérique*.[20] While Merian had been responsible for the making of the prints illustrating her previous books, she was prevented from doing so for the *Metamorphosis*, probably due to health issues. However, she employed the best etchers and engravers and rigorously supervised every step of the production process.[21] By retaining such tight control over the pictorial contents of their books, the authors thus ensured that the final printed plates were as close as possible to the original drawings on which they were based. They could thus avoid the discrepancies found in other works—particularly those dealing with American topics—where the tasks of writing texts and producing pictures were often performed by different individuals.[22] Manuscript notes suggest that Plumier may have desired to maintain control over the contents of his books— at least partly—in order to avoid the risk of mistakes in the translation process from drawing to print.[23] Moreover, material traces of reception show that it was not just the authors themselves who put a premium on image control but also later owners of the books. For instance, an eighteenth-century handwritten note inserted in a copy of the *Metamorphosis* (now at the Muséum national d'Histoire naturelle, Paris) emphasizes Merian's original input in the addition of color: "This copy is one of those that came out of the hands of Melle Merian, and which

were painted by herself, or at least under her eyes."[24] In fact, such claims about Merian's personal involvement were made quite frequently, even when physically impossible, for instance with plates from volumes printed after Merian's death.[25] Regardless of Merian's actual participation, such notes could function as marketing devices and testify to the significance given by collectors to Merian's real—or supposed—vigilant monitoring of the book's production process, from start to finish (including final hand-coloring). This evidently added market value to the *Metamorphosis* as an artwork and commodity. When the production of images was subject to such strict inspection (or when it was presented as such), pictures could also operate as reliable, legitimate, and authoritative evidence that could be used to prove a point and substantiate a claim, usually in tandem with the text. For instance, Plumier writes that he will show the difference between two varieties of plants in "the description, and the figure".[26]

Pictures could function as surrogates for the plants themselves, and their generous format served one main purpose: the legibility of the images for the viewer, as the big folio size of the illustrated plates was meant to facilitate the understanding of the plant structure and the acquisition of knowledge. Indeed, as Plumier underlines himself: "and as I knew from experience that it is very difficult to know a plant well through small figures, I wanted to draw them in their natural size."[27] The large engraved plates featured in Van Reede's *Hortus*

Malabaricus (Amsterdam 1678–1703), dedicated to the flora of southwest India, set an important precedent in that respect.[28]

The visual strategies adopted in the pictures—whether drawn or printed—mirror certain immersive practices of viewing. While some pictures in Plumier's work represent the plants in the mode found in sixteenth-century printed herbals, namely as complete with the root against a bare background, most of them focus on a specific part of the plant, cutting and cropping it, usually zooming in on the leaves or the flowers (Fig. 1). Usually represented close to the picture plane in the foreground, the plants take up most of the space of the folio, almost bursting from its limits, creating the illusion that viewers are standing very close to the object of their contemplation. Similarly, in her *Metamorphosis*, Merian uses large plates, which are considerably bigger than in her earlier books devoted to European flora and insects, whether it be the *Blumenbuch* or the *Raupenbuch*. In the first plate of the *Metamorphosis*, Merian also deploys immersive strategies, with even more vivid results: the pineapple emerges jubilantly from a firework of green and red foliage, providing a spectacular greeting to the reader (Fig. 4). It tilts slightly to the side, creating an impression of instability heightened by the menacing, greedy cockroaches crawling on the leaves. The plant is too big to be represented in its entirety, root included, on a single folio page; it extends beyond the frame of the sheet, conveying

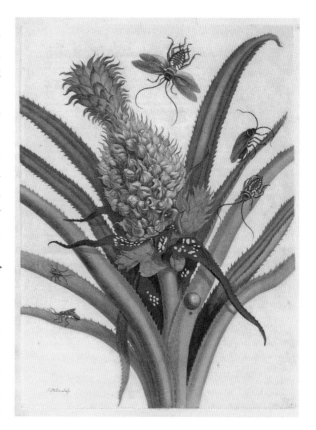

Fig. 4 M.S. Merian (design) & J. Mulder (etching), Pineapple, in *Metamorphosis Insectorum Surinamensium*, Amsterdam 1705, plate 1, hand-colored etching, 52 x 35 cm (page), KB, National Library of the Netherlands, The Hague, KW 1792 A 19.

the sense of a lush nature that will not be so easily tamed. Merian takes a close shot, staging the plant contiguous to the picture plane in the foreground. The lack of distance between plant and foreground conjures up the sensation that the viewer is standing in immediate proximity to the pineapple. This framing technique effectively draws viewers inside the image. Analogous effects are engineered in some other pictures, particularly those representing fruit, such as the banana, lemon, and watermelon. There, the use of foreshortening

193

reinforces the feeling that the fruits and flowers, projecting forward, are entering the viewers' physical space. In the same line, Merian's rendering of plants is intensely three-dimensional; whereas Plumier's pictures focus on contours for clarity's sake but impart a flatness reminiscent of pressed plants, Merian's plates make extensive use of sophisticated networks of dense hatching, suggesting sensual volume and textures as well as contrasts of light and shade.

Descriptions in the textual apparatus are replete with allusions to intense visual examination, testifying to practices of sustained and repeated scrutiny, sometimes over long periods of time or at different moments of the day. Plumier thus writes, "I observed as much as sight allowed me to."[29] In Merian's book, too, the descriptive texts accompanying the plates abound with allusions to practices of direct, prolonged, and in-depth visual absorption over the seasons to follow the evolution of a plant or an insect, and the interactions between both. Plumier and Merian did not just rely on their own eyes but also used mechanical aids, notably lenses and microscopes, to make up for the limits of the human eye.[30] In Merian's case, this leads to moments of revelation: under the magnifying lens, a caterpillar charms by its beauty, demanding scrupulous attention.[31] Plants are not merely looked at intently; authors also comment on their smell, the texture of their different components, as well as their flavor. The acquisition of botanical knowledge is a truly embodied process, involving sight, smell, taste, and touch.

Merian and Plumier may have recorded fleeting, ephemeral experiences, but their work had a lasting influence and continued to raise interest long after their publication. Posthumous editions of Plumier's botanical drawings were published in the Dutch Republic in the second half of the eighteenth century.[32] Merian's *Metamorphosis* was republished (in an augmented edition in 1719) and translated (including French editions published in 1726 in The Hague and in 1771 in Paris). The task such objects accomplish for the making of art and knowledge is immense. They strongly reinforced the importance of image making, rooted in drawing practices, as a science, namely as an analytical, practical, and visual pursuit involving the systematic examination of the configuration of the natural environment through attentive observation and experience.[33]

The images crafted in this process did not only capture the transient shape of natural specimens; they also provided new tools to observe and understand the natural world, revitalizing the pictorial and discursive apparatus to talk about and look at nature. Thus, image makers (formally trained or not, like Merian or Plumier) consolidated their positions as indispensable visual interpreters who were open about their control of the production process of pictures. They made sense of an ever-expanding visible world, while developing an aesthetic system based on the intellectual and sensuous interaction between humans and plants.

* I thank José Beltrán, Catherine Powell-Warren, and Bert van de Roemer for their thoughtful comments.

The Influence of Maria Sibylla Merian's Work on the Art and Science of Mark Catesby

Henrietta McBurney

Introduction

Maria Sibylla Merian's groundbreaking images of the tropical insect and plant life studied during her two-year stay in Suriname (1699–1701) had a significant impact on the scientific community of early eighteenth-century London. Perhaps more than any other, the English naturalist artist Mark Catesby (1683–1749), 26 years Merian's junior, was to be profoundly influenced by Merian's work, most notably her *Metamorphosis Insectorum Surinamensium* (1705). Sharing her belief in the need to study "animal and vegetable productions in their native countries",[1] Catesby made two extended visits to North America in the early 1700s, the results of which he published in his *Natural History of Carolina, Florida and the Bahama Islands* (London, 1731–1743). This essay discusses parallels between the work of these two pioneering naturalist artists, including the interaction they observed between animals and plants, the process involved in creating their images, and the close interdependence of art and science in their respective books.

Knowledge of Merian's Work in London in the Early Eighteenth Century

The impact of Merian's dramatically new images of tropical plants and insects was beginning to be felt in learned circles in London even before the publication of her *Metamorphosis*. In 1703 at the Royal Society:

> *Some new engraven prints of plants & insects of Surinam by Madam Sibylla Mariana Graffen were shewn. Many persons present approv'd of the design and promis'd to subscribe towards it.*[2]

The apothecary and collector James Petiver (ca. 1663–1718) met Merian in Amsterdam in 1711, the botanist Richard Bradley (1688–1732) in 1714, and both helped to promote her work.[3] By the 1720s and 1730s, Merian was widely admired in England, and copies of the

Metamorphosis were found in the libraries of Catesby's mentor, the botanist and apothecary Samuel Dale (1659–1739), his wealthy contemporaries, such as the Duchess of Beaufort, Sir Hans Sloane, and Dr. Richard Mead (1673–1754), and that of the Royal Society.[4]

By 1705, Sir Hans Sloane (1660–1753) already owned a substantial body of Merian's original work—an album containing 91 watercolors, mostly connected with subjects from Suriname (bought from Merian, via Petiver as intermediary, for 200 guineas— equivalent to almost €60,000 today), and another with 160 watercolors of earlier, mainly European insect studies.[5] The albums are recorded in the list of Sloane's two hundred or so "Books of Miniature", a collection which he made accessible to natural history artists, natural philosophers, and the "curious".[6]

Catesby visited Sloane's collections as a young man, where he had the opportunity to study Merian's watercolors and observations in her published work.[7] She provided the model of an explorer in the New World who was both naturalist and artist, who had not only traveled, studied, and collected fauna and flora "in its native country", but had painted it directly in the wild. Her pioneering example as a naturalist would have been inspiration enough, but added to this were the results of her work in painted and published form. Catesby's desire to see nature in its raw state (rather than simply in the collections of his contemporaries in London) and his ambition to create a publication out of his findings were inspired by Merian's example on multiple levels.

Merian and Catesby as Explorers and Pioneer Field Naturalists

Merian wrote in the introduction to her *Metamorphosis* that she "saw with wonderment the beautiful creatures brought back from the East and West Indies" in collectors' cabinets in Holland, adding that her real interest was the "origins and subsequent development" of these creatures. It was this that "stimulated me to take a long and costly journey... in order to pursue my investigations further".[8] Her journey was her pioneering voyage to the Dutch colony of Suriname, made in 1699 when she was 52, costly both in financial terms (she lacked the backing of patrons or sponsors) and in terms of health—suffering from an illness, she had to return after 21 months in the tropics.

She demonstrated the resilience of character required by the field naturalist, which called not only for botanical or zoological knowledge but also "for curiosity, zest, mental tenacity and a capacity to endure drudgery, hard work, discomfort and privation".[9] She showed determination under conditions that would have daunted most people. To begin with, access was difficult, as the rainforest was "so densely overgrown with thistles and thorn bushes that I had to send my slaves ahead with axe in hand to hack an opening for me to proceed even to a certain extent, which nevertheless was very difficulto".[10] There was little help from the Dutch colonists

who "jeer at me that I am looking for other things than sugar in the country".[11] She was fearless in her urge to collect, examine, and sample the unknown, and on occasion she reaped the consequences: the hairy caterpillar she found on the guava tree was "very poisonous; if one touches them with the hand, it swells up immediately and is very painful, as I discovered myself".[12] Learning from the indigenous peoples was the way to discover what was poisonous or potentially lethal; watching them press out the juice of the cassava plant, she discovered that if "a man or animal drink the extracted juice cold, he or it dies an extremely painful death; but if this water is boiled it makes a very good drink".[13]

The dedication and passion out of which Merian created her Suriname book were qualities which must have resonated with Catesby. Seven years after its publication in 1705, he set off, aged 29, to study, collect, and paint the natural history of Virginia:

> ... my Curiosity was such, that not being content with contemplating the Products of our own Country, I soon imbibed a passionate Desire of viewing, as well the Animal as Vegetable, productions in their Native Countries.[14]

He too embarked on this trip without patrons. But on his return seven years later, the specimens and paintings he was able to show members of the English natural history circle resulted in a second journey; traveling to the newer English colony of South Carolina, this time Catesby had the backing of twelve sponsors, half of whom were members of London's "Royal Society for the Improvement of Natural Knowledge". After three years in South Carolina and one in the Bahamas, the results of his work were published, in eleven instalments over a twenty-year period, in his two-volume folio-format *Natural History of Carolina, Florida and the Bahama Islands*, completed less than two years before he died.

Dangers from poisonous animals and plants were to be part of Catesby's experience in the wild in South Carolina and the Bahamas. Like Merian, he consulted indigenous peoples for reasons of self-preservation—to discover what was edible and what was harmful and poisonous—and for what he could learn from Native Americans of their use of plants and animals for food, medicine, clothing, ceremonies, and practical uses (see also the chapter by Van Delft in this volume). Driven by curiosity like Merian, he also sometimes paid for his fearlessness; encountering the manchineel tree when he visited the Bahamas, he was blinded when helping to cut one down:

> some of the milky poisonous Juice spurting in my Eyes, I was two Days totally deprived of Sight, and my eyes and Face much swelled, and I felt a violent pricking Pain the first twenty-four Hours.[15]

Recording in Words and Images
Merian recorded her first-hand observations in the texts printed opposite the

large-scale plates in her book, a format that Catesby was also to adopt for his book.[16] The fresh, direct style in which she described the physical attributes and behavior of animal and plant life, alongside occasional expressions of surprise or delight, made their impression on Catesby. This was a style he was to emulate. As naturalists and collectors in the field, both had to train themselves to observe and remember details of form, shape, and color, in addition to morphological configurations. Their written descriptions contain many vivid accounts of their detailed examinations. Merian added a hermit crab in a shell to her illustration of the common Surinam toad (*Pipa pipa*) and sea purslane (*Sesuvium portulacastrum*):

I had these shells brought up from the bottom of the sea in order to see what kind of creatures live in them. I pulled a number out with force and established they were a variety of crab with a rear view like a snail which had penetrated into the shell. By day they lay still, but at night they made a quiet noise with their legs and were very restless.[17]

Catesby was equally intrigued by Caribbean hermit crabs (*Coenobita clypeatus*), inhabiting seashells:

Nature has directed it for the Security of that tender Part [of the crab] to get into and inhabit the empty Shell of a Fish that best fits its Size and Shape: When the Crab grows too big for the Shell to contain, it leaves that and seeks another more commodious, so

continues changing his Habitation as he increases in largeness... They crawl very fast with the Shell on their Back, and at the Approach of Danger draw themselves within the Shell, and thrusting out the larger Claw in a defensive Posture, will pinch very hard whatever molests them.[18]

Both Merian and Catesby combined their activities as naturalists with those as artists—sketching and painting on the spot, where possible from life, if not from freshly dead specimens. But conditions in the field would not have made this easy; as Merian remarked, "the heat in this country is overwhelming and one can only work with tremendous difficulty."[19] Added to the physical difficulties of weather, plagues of insects, and other discomforts, the process of watercolor painting in the late seventeenth and early eighteenth centuries was much more elaborate than it is now. Raw pigments, bought from apothecaries or color shops, needed to be prepared—whether they were in their natural solid state or bought ready ground. They were mixed with a medium (often gum arabic or another plant resin) and diluted. In a letter to one of her painting pupils, Merian advised, "I am sending 2 shells with ground color and a small jar of good varnish," adding, "if you need any more paint I have... some beautiful colors."[20]

In both artists' cases, their large-scale, fully worked up watercolors were made later. Merian specifically recorded that she painted only what she needed to on the spot:

When I was in [Suriname] I painted and described the larvae and caterpillars as well as their kind of food and habits; but everything I did not need to paint [there] I brought [back] with me, such as butterflies and beetles and everything I could steep in brandy and everything which I could press... and I am now painting... everything on vellum in large format with the plants and creatures life-size....[21]

The only reference she made to painting in the field was in her account of some unidentified wasps, where she noted "I was plagued by these insects daily in Suriname; when I painted they flew about my head. They built a nest of mud near my paintbox...".[22] From this it would seem that she kept her painting materials in her house rather than taking them out on trips into the forest, which would hardly have been possible in the conditions. Catesby, however, did take his paints with him on his expeditions:

In these Excursions I employed an Indian to carry my Box, in which, besides Paper and Materials for Painting, I put dry'd Specimens of Plants, Seeds, &c. as I gather'd them... To the Hospitality and Assistance of these Friendly Indians I am much indebted, for I not only subsisted on what they shot, but their First Care was to erect a Bark Hut, at the Approach of Rain to keep me and my Cargo from Wet.[23]

From several drawings discovered on the versos of his finished sheets, it seems that he mainly drew in pen and ink in the field, recording a few details in watercolor, or sometimes with color notes.[24] Like Merian, Catesby recognized that color was an essential diagnostic ingredient for the naturalist in recording and identifying plants and animals, although, unlike her, he had to learn about pigments himself. In Merian's case, a knowledge of pigments would have been part of her training in the professional artistic environment in which she had been brought up in Frankfurt and Nuremberg. There she had been taught the techniques of both oil painting and watercolor in the studio of her stepfather, the Dutch still life painter Jacob Marrel (1614–1681), and later from his former pupil, Johann Andreas Graff (1636–1701), who became her husband. Her skills as both a painter and engraver were described by a contemporary biographer:

She acquired sound instruction in the art of drawing and painting in oil and watercolour of all kinds of decorations composed of flowers, fruit and birds... All this she depicted with great skill, delicacy and intelligence in watercolour on panels of silk, satin, or other materials; [...] most famous for her realistic and naturalistic way of engraving the above.[25]

Meanwhile, Catesby, as a self-trained artist, learned how to "lay on his colors" from manuals and by studying other artists' work. Instruction for amateurs on the process for limning or "Painting in Water-Colors" was given, for example, by his friend George Edwards (1694–1773).[26]

The use of color for natural history illustrations was in contrast to many of Catesby's predecessors, who depicted their subjects in black and white. Merian's large-scale color images provided a notable exception and reinforced his own belief in the importance of color. He was to state this belief in the Preface to his book:

> The Illuminating [of] Natural History is so particularly Essential to the perfect understanding of it, that I may aver a clearer Idea may be conceived from the Figures of Animals and Plants in their proper Colours, than from the most exact Description without them.[27]

He also recorded choosing his colors both for their durability and to achieve the greatest accuracy to the natural objects he was "illuminating":

> Of the Paints, particularly the Greens, used in the Illumination of the Figures, I had principally a regard to those most resembling Nature, that were durable and would retain their Lustre, rejecting others very specious and shining, but of an unnatural Colour and fading Quality.

There were other difficulties involved in capturing the colors of nature. Discovering that fishes lose their color quickly when out of water, he had to make several attempts at painting them "having a succession of them procur'd while the former lost their Colours".[28] Reptiles presented fewer problems, as "they will live many months without sustenance;

so that I had no difficulty in painting them while living".[29]

Merian too wrote of the difficulty of capturing living colors in her description of the Menelaus blue morpho butterfly (*Morpho menelaus*):

> I found [on the medlar tree] this yellow caterpillar which had pink stripes over its whole body... I took [it] home and it rapidly changed into a pale wood-coloured chrysalis, like the one here lying on the twig; two weeks later, towards the end of January 1700, this most beautiful butterfly emerged, looking like polished silver overlaid with the loveliest ultramarine, green, purple, and indescribably beautiful; its beauty cannot be rendered with the paint-brush.[30]

Environmental Connections, Arranging Compositions

Like all his contemporaries, Catesby would have been struck by Merian's dramatic illustrations of insects on their host plants. Her accompanying descriptions of the interdependency of plant and animal life and the statement with which she begins her Suriname book would also have made their impact: "All these Animals I have placed on the plants, flowers and fruits that provide their respective nourishment."[31] In his turn, Catesby was to state in the Preface to his book that "where it would be admitted of, I have adapted the Birds to those Plants on which they fed, or have any Relation to".[32] As with Merian, this impulse to portray interaction between different elements in the natural world was to represent an

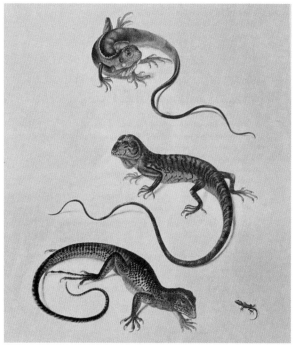

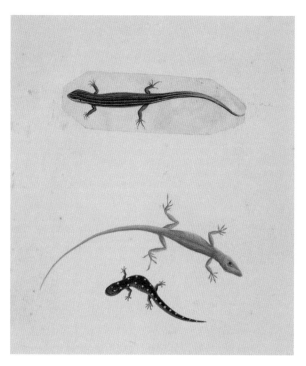

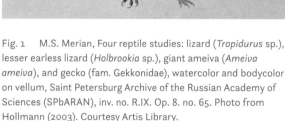

Fig. 1 M.S. Merian, Four reptile studies: lizard (*Tropidurus* sp.), lesser earless lizard (*Holbrookia* sp.), giant ameiva (*Ameiva ameiva*), and gecko (fam. Gekkonidae), watercolor and bodycolor on vellum, Saint Petersburg Archive of the Russian Academy of Sciences (SPbARAN), inv. no. R.IX. Op. 8. no. 65. Photo from Hollmann (2003). Courtesy Artis Library.

Fig. 2 M. Catesby, Reptile studies: Graham's anole (*Anolis grahami*), five-lined skink (*Plestiodon fasciatus*), and spotted salamander (*Ambystoma maculatum*), watercolor and bodycolor, 375 x 265 mm, Royal Collection, RCIN 926018. Royal Collection Trust / © Her Majesty Queen Elizabeth II 2021.

important departure from the work of his predecessors, and indeed also his contemporaries; it contrasts, for example, with George Edwards, who wrote that his portraits of birds were done "with some little decorations on the Ground Work in order to set off the Figures which are the Subject-Matter of the work".[33]

Both Merian and Catesby produced what we might call specimen sheets of the individual animals and plants they observed and collected (Figs. 1, 2). Merian's specimen drawings made in Suriname can be seen in her *Studienbuch*, now in Saint Petersburg; from these she later as-

sembled the elements of her compositions in which insects are seen together with their plant hosts.[34] While Catesby is also likely to have had a sketchbook in which he made his initial drawings, it has not survived. What does survive is the corpus of preparatory drawings for his *Natural History*, now in the Royal Library, Windsor Castle. This comprises a total of 263 drawings for 220 plates, with around forty further sketches on the versos of the drawing sheets. It is in this corpus of drawings that we can observe not only the stages by which Catesby created the compositions of his final etchings, but also the

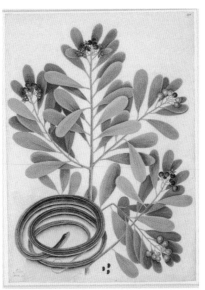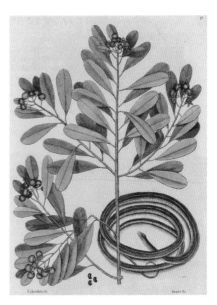

Fig. 3 M.S. Merian, Spanish jasmine (*Jasminum grandiflorum*), ello sphinx moth (*Erinnyis ello*), and garden tree boa (*Corallus hortulana*), watercolor and bodycolor with gum arabic over lightly etched outlines on vellum, 363 x 289 mm (vellum sheet), Royal Collection, RCIN 921203. Royal Collection Trust / © Her Majesty Queen Elizabeth II 2021.

Fig. 4 M. Catesby, Eastern ribbon snake (*Thamnophis sauritus*) and wild cinnamon (*Canella winterana*), watercolor and bodycolor, 371 x 273 mm, Royal Collection, RCIN 925998. Royal Collection Trust / © Her Majesty Queen Elizabeth II 2021.

Fig. 5 M. Catesby, Eastern ribbon snake (*Thamnophis sauritus*) and wild cinnamon (*Canella winterana*), in M. Catesby, *The Natural History of Carolina, Florida and the Bahama Islands*, volume 2, London 1743, plate 50, hand-colored etching, 35 x 25.5 cm. Royal Society of London, 188894.

ways in which Merian's illustrations influenced that process.

An examination of Catesby's drawings allows us to follow parts of the process involved in working out his compositions. In the *Metamorphosis* plate 44, Merian shows the Spanish jasmine (*Jasminum grandiflorum*), with the ello sphinx moth (*Erinnyis ello*), in three stages—as caterpillar, pupa, and adult—positioned on the plant stem and leaves. At the base of the plant is a decoratively curled garden tree boa (*Corallus hortulana*). The reason for this particular composition is explained in the accompanying text, where Merian writes that she had observed lizards, iguanas, and snakes hiding under the strong and sweet-

smelling jasmine, and "for this reason I added a very beautiful snake which I found under the hedge at the foot of this plant". In Catesby's *Natural History*, 2, 50 he shows a specimen of wild cinnamon (*Canella winterana*), with an eastern ribbon snake (*Thamnophis sauritus*), curled up at the base of the plant specimen. His drawing for this composition reveals that he had cut out the image of the snake from another sheet and pasted it over the base of the plant drawing, in the process awkwardly obscuring part of the plant stem as well as an inscription that already occupied that space. In the finished composition he corrected the spatial relationship between the plant and animal by positioning the snake

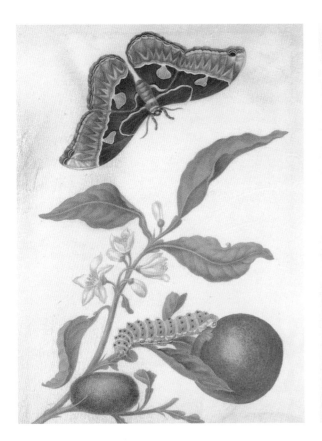

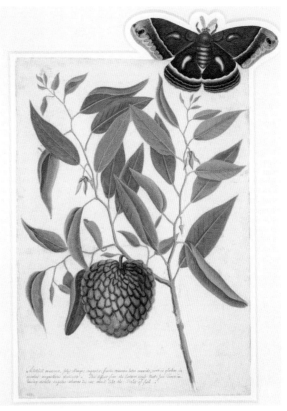

Fig. 6 M.S. Merian, Seville orange (*Citrus sinensis*) and golden Rothschild silk moth (*Rothschildia aurota*), watercolor and bodycolor with gum arabic over lightly etched outlines on vellum, 406 x 286 mm (vellum sheet), Royal Collection, RCIN 921209. Royal Collection Trust / © Her Majesty Queen Elizabeth II 2021.

Fig. 7 M. Catesby, Custard apple (*Annona reticulata*) and cecropia moth (*Hyalophora cecropia*), watercolor and bodycolor, 426 x 305 mm (sheet of paper) Royal Collection, RCIN 926048. Royal Collection Trust / © Her Majesty Queen Elizabeth II 2021.

to appear as if curled up behind the plant stem (Figs. 3, 4, 5). While there is no relationship between the plant which he found growing in "the thick woods of most of the Bahama Islands" and the snake, which is commonly found on the mainland around rivers, creeks or ponds, but not in the Bahamas, it would seem that it was the visual qualities of Merian's composition that suggested the combination of plant and animal in this image.

The stages by which Catesby reached the final composition of his custard apple (*Annona reticulata*), and cecropia moth (*Hyalophora cecropia*) with its cocoon (*Natural History*, 2, 86), reveals his debt to Merian in scientific content as well as in compositional terms. While Merian's book focused primarily on insects, the scope of Catesby's *Natural History* was much broader. In his Preface he notes that, among animals, he has concentrated first on birds, followed by other groups of animals, but that in the case of insects he did not have the time to make a comprehensive collection or "delineate a great Number of them".[35] Nonetheless, in this composition he reveals a close study of

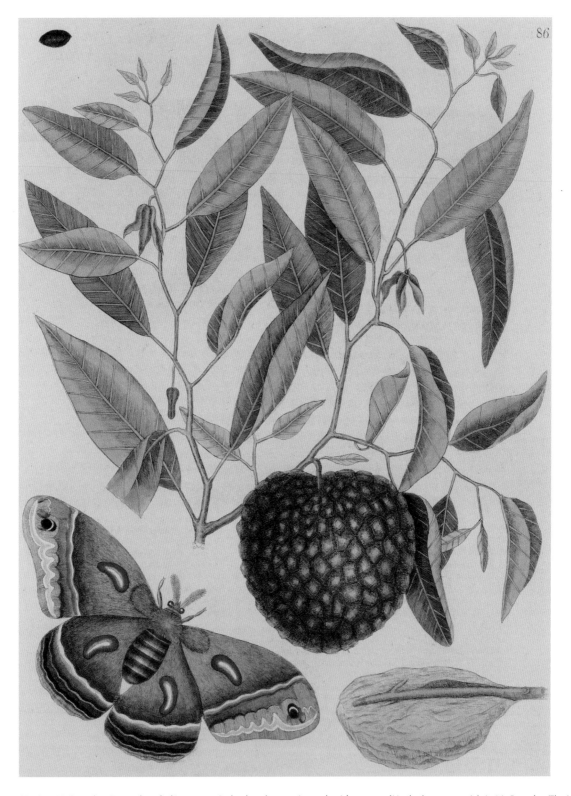

Fig. 8 M. Catesby, Custard apple (*Annona reticulata*) and cecropia moth with cocoon (*Hyalophora cecropia*), in M. Catesby, *The Natural History of Carolina, Florida and the Bahama Islands*, volume 2, London 1743, plate 86, hand-colored etching, 35 x 25.5 cm (plate). Royal Society of London, 188894.

Merian's work on insect metamorphosis. In visual terms he deliberately emulated the bold use of diagonals characteristic of many of Merian's compositions by collaging the image of the moth at the diagonal opposite corner of the sheet to the fruit to create a composition similar to Merian's *Metamorphosis* plate 52, in which she shows a branch of Seville orange (*Citrus sinensis*), with Rothschild's silk moth (*Rothschildia aurota*). However, as this trial composition would not have fitted onto the copperplate, he rearranged the elements, condensing the stem with fruit to fit the moth beneath it (Figs. 6, 7). He then made a further decision, echoing Merian, to include an image of the moth's cocoon alongside the fruit (Fig. 8). This is the only one of his illustrations in which he includes another stage of an insect's development; evidently it was Merian's pioneering work on the life cycles of insects that led him to examine and portray the cocoon, described in detail in his text:

> The Caterpillar of this Moth is enclosed by two Silk Bags of an oval Shape; the innermost smooth within; on the outside the Silk lying loose; and is covered by another Membrane of a thinner, smoother, and of a more compact Texture, and not of so uniform a Structure, as appears by the figure...[36]

Conclusion: Balancing Science and Art

Both Merian and Catesby regarded their artistic achievement as serving scientific research. For Catesby, observing and recording accurately from life went side by side with a constant urge to explore and invent. Just as he was an acute observer of nature in the wild, so he studied equally the illustrations and techniques of other natural history artists, including Merian. Such juxtaposition of scientific observation and artistic concern is also present in Merian's work. While she set out to represent her entomological and botanical research and observations exactly, she did so as an artist, using pictorial forms and creating strikingly dramatic and decorative compositions out of her findings. She herself noted that elements of her compositions were added for artistic reasons, making comments such as "I added the snake to complete the decoration of the plate" or "I added the large flying beetle at the top to fill up the sheet".[37]

A deeper connection exists in the work of each—a tension between science and art that arises precisely because they were both scientists and artists, or as Johann Wolfgang von Goethe (1749–1832) wrote on Merian, a "duality as well as fusion between art and science".[38] It is out of such tension that the originality of their eye and artistic practices emerges, which sets each of them apart from most other eighteenth-century natural history illustrators. The images that grew out of their practice as naturalists and artists are a synthesis of art and nature: their artistry went beyond the boundaries of a scientific document and has survived as a monument.[39] Ultimately each of them conveys through their images their delight in the beauty, novelty, and variety of the nature they encountered and recorded for the scientific world.

A Remarkable Woman. The Impact of Maria Sibylla Merian on Natural History in Germany

Anja Grebe

It is remarkable that women,
too, would venture
to treat the very matters
with serious intent
that scores of learned men
have pondered without end.

What Gessner, Wotton, Penn, and
Moffett did not publish for us
to read today;
is brought to light, O England,
by a gifted woman's hand,
in my own Germany.[1]

In 1679, Maria Sibylla Merian published the first volume of her *Der Raupen wunderbare Verwandelung* in Nuremberg. The book consists of fifty full-page etchings of insects in the various stages of transformation, together with their preferred food plants; each is accompanied by a short text in German, in which Merian describes her observations of the insects' metamorphoses, ecology, and behavior.[2] The *Lobgedicht* on Merian by the Nuremberg theologian and poet Christoph Arnold (1627–1685), excerpted above, served as a prelude to her book.[3] His praise of Merian may seem extraordinary for its time, but as will be presented here, her work was more highly regarded among both contemporary and later scholars in Germany than has been hitherto stated; this is particularly true among her Franconian compatriots.

In early modern times, songs of praise like the one composed by Arnold were an important poetical means of highlighting the objectives of a book, on the one hand, and of valuing the achievements of its author on the other.[4] But Arnold hardly gives any information on Merian and her work other than the fact that she was the daughter of the famous engraver and printer Matthäus Merian the Elder (1593–1650). Instead, he com-

pares her to well-known naturalists from different times and nations in Europe, among them Conrad Gesner (1516–1565), Thomas Moffet (1553–1604), Johannes Goedaert (1617–1668), and Johannes Swammerdam (1637–1680). According to Arnold, Merian was "remarkable" inasmuch as she combined the knowledge and virtues of a natural philosopher *and* of an artist, and, in addition, she was a woman. With Merian, Germany seemed suddenly able to outdo all other nations in the field of natural history. To make her stand out from her male counterparts, Arnold declared her a kind of natural wonder herself, because even as a young and unlearned woman she equaled and even surpassed the most distinguished scholars.

Merian's Artistic-Scientific Approach

In Merian's time, the usual language of science was Latin. Coming from a family of artists and artisans and being a woman, Merian had practically no chance to attend grammar school, where she would have learned Latin, or to go to university. In contrast, the naturalists that Christoph Arnold listed in his abovementioned "Song of Praise" of 1679 almost all had an academic background.[5] Most of them had studied medicine and had worked as physicians before their interest in physiology and anatomy had led them to study the biology of animals and insects. To be fully accepted as a voice in the scientific debate, it was almost compulsory for an author to make proof of his or her knowledge of

the relevant literature. From the viewpoint of scientific discourse, Merian remained an amateur throughout her life. Having never learned Latin, she was not able to fully participate in the academic discussions of her male colleagues.

However, what she lacked in classical academic training, Merian more than made up for in her artistic training and ability. Her lavishly etched plates have very little in common with the often awkward woodcut illustrations composed by mostly unknown artists scattered among earlier publications. The German physician Hermann Conring (1606–1681) was probably the first to comment on the groundbreaking quality of her scientific illustrations. In his 1687 *Introductio in Universam Artem Medicam Singulasque Eius Partes*, he compared Merian and her achievements to publications of other eminent entomologists, above all the Italian scientist and collector Ulisse Aldrovandi (1522–1605), author of *De Animalibus Insectis Libri Septem* (1602), Thomas Moffet, *Insectorum Sive Minimorum Animalium Theatrum* (1634), and Johannes Swammerdam, *Historia Insectorum Generalis* (1669).[6] Contrasting Merian's engraved illustrations to these earlier books, the difference becomes obvious. As a rule, the artists have depicted the insects without shadow. They are usually seen from above—a layout similar to contemporary butterfly collections—or from the side. The images render the physical characteristics of an insect, including the surface texture, for example, the pattern of lines on the exoskeleton or the wings, more or less accurately, however, they do

not really transmit a sense of volume. Even though Conring comments on the illustrations in Aldrovandi's publication as being "miraculously beautiful and exact", he praises only Merian's plates as "elegant and truly artful".[7]

It has been pointed out that despite Arnold's praise and Conring's assertions, the response of the predominantly male scientific community to Merian's publications was not very enthusiastic.[8] Thus, her books were regarded as "curious" and "artful", but they were not fully accepted as scientific literature. According to the art historian Heidrun Ludwig, "Merian's merits did not lie in new discoveries but in disseminating what was already known [...] in order to enable as many people as possible to participate in the wonders of metamorphosis."[9] Ludwig refers, among others, to Merian's contemporary, the German historian Johann Caspar Eberti (1677–1760), who had characterized her *Raupenbuch* as "a most charming, curious and agreeable work".[10] Ludwig, however, comments neither on the epistemological context of Eberti's appraisal, nor on his main source, Conring's *Introductio*, in which the earlier author had praised the *Raupenbuch* both for its fresh insights into the world of insects and for its aesthetic qualities.[11] However, contemporary judgements should be interpreted in their proper discursive context. To begin with, Eberti published his short appraisal of "Maria Sibylla Graffin" as part of his *Eröffnetes Cabinet deß Gelehrten Frauen-Zimmers* (1706), an encyclopedic survey of noticeable women from antiquity to modern times in alphabetical order, edited in German only. Eberti's book must be read as part of the ongoing *Querelle des Femmes* on the abilities of women as writers and savants, and Merian's inclusion in this "museum" of female biographies was almost something to be expected in view of her international renown as a woman author and naturalist at that time.[12]

In 1715, the German jurisprudent Gottlieb Siegmund Corvinus (1677–1647, alias Amaranthes) adopted Eberti's entry for his *Nutzbares, galantes und curiöses Frauenzimmer-Lexicon*.[13] In his article on "Maria Sibylla Grafin", Corvinus not only reiterated Eberti's characterization of Merian as "a woman well experienced in nature" but also copied his predecessor's faults. Thus, he erroneously identified her as "daughter of the famous physician Marian Graf" and confused her 1678 edition of the *Blumenbuch* with the first volume of the *Raupenbuch*. Corvinus maintained the reference to Conring, but left out Eberti's long Latin quotation from Conring's book for the benefit of a note regarding the appraisal of Merian by Joachim von Sandrart (1606–1688) in his *Teutsche Academie* of 1679, in order to highlight her "perfection" in the arts of painting, drawing, and stitching of flowers.

Besides biographies of notable women, Corvinus's *Frauenzimmer-Lexicon* contains entries on household utensils, furniture, clothing, fashion, books, pets, historical events, childcare, recipes, and religious and moral issues as well as many other topics considered to be of female interest. It consists of more than

eleven hundred pages and is considered to be the first and most influential dictionary especially addressed to women in German language, paralleling other encyclopedic projects of the era.[14] Revised versions appeared in 1739 and posthumously in 1773, underlining the impact of the *Frauenzimmer-Lexicon* in the German-speaking world.[15] Whereas, in the 1739 edition, the entry on Merian was reiterated practically untouched,[16] she was omitted altogether in the considerably enlarged posthumous edition of 1773, probably because the new editors chose to lay the focus more on general encyclopedic knowledge considered to be useful for a female audience and not so much on individual biographies.

Both Eberti's and Corvinus's dictionaries introduced Merian as part of the pre-Enlightened canon of female knowledge.[17] In contrast, Conring's earlier appreciation of Merian appeared as part of his *Introductio in Universam Artem Medicam*, a widely read medical manual in Latin which was re-edited in 1726.[18] This adds a much greater authority to his judgment within the male scientific community. Edwin Rosner characterizes the *Introductio* as "the first modern history of medicine" inasmuch as the author put the focus on methodological questions, for example, the need for physical examination, and explored its relation to neighboring fields such as natural history, citing more than six hundred authors altogether.[19]

Seen against this background, the lauding and—compared to other entries—relatively long passage dedicated to Merian in Conring's *Introductio* becomes even more exceptional. It means that Merian's *Raupenbuch* was recommended as reference work in entomology to a purely male academia as early as 1687. Moreover, Merian is the only woman author and her *Raupenbook* is one of the very few non-Latin sources cited by Conring. But Conring has been largely overlooked by modern scholarship on Merian, so this recognition is not widely known.

Merian's Reception in Eighteenth-Century Germany

Merian's work was copied by many artists and transformed into other media, from paintings and prints to textiles and porcelain. Some artists and artisans only cut out single elements, while others copied whole compositions.[20] However, the inherent narration of Merian's images with regard to the complex process of metamorphosis was often neglected by her followers, who were basically artists, not artists *and* natural scientists.

Only some of her (more or less explicit) followers, however, equally combined art and natural history. An example from the field of entomology is Albin's *A Natural History of English Insects* (1720).[21] Eleazar Albin (fl. 1690–ca. 1742), who was probably born in Germany and is documented in England from 1708 on, worked as an artist and naturalist and was in close contact with Joseph Dandridge (1665–1747) and James Petiver (ca. 1663–1718), two members of the Royal Society who probably introduced him to Merian's work.[22] In the bibliographical references following

each chapter of his *English Insects*, Albin repeatedly refers to Merian's *Raupenbuch*. Citing all of his references by the authors' last name only, Albin does not draw any difference between male and female authors. Hence, Albin valued Merian and her findings as much as any other (male) author and he drew his inspiration as artist and naturalist from her truly transdisciplinary approach to the world of insects.

Among the entomologists for whom Merian's publications were a matter of scientific debate beyond any gender issue is the German engraver and teacher Johann Leonhard Frisch (1666–1743). Frisch, who worked in Berlin from 1699 on, started his series *Beschreibung von allerley Insecten in Teutschland* in 1720 and produced thirteen issues until 1738, followed by a reprint published between 1730 and 1753.[23] Frisch concentrated on the domestic insects he had either observed in Berlin or collected during his excursions to Brandenburg. He focused on small and common insects or "vermin" such as louses, bugs, wasps, flies, or mosquitos and made ample use of the microscope. He frequently starts his chapters with a description of the larva and continues with describing the different stages of metamorphosis. From issue five onward, Frisch dedicated the introductory chapter to the work of a famous entomologist. Merian was not included in this list, although Frisch repeatedly referred to her observations and plates in the rest of the *Beschreibung von allerley Insecten in Teutschland*. One of the reasons might be that she did not share Frisch's focus on small domestic

insects and Ichneumonidae. Besides favorable statements on Merian and her work, he also criticizes some of her observations, for example, in the case of the swallowtail larva and its odor, which Merian described as "like fruit when many different kinds are mixed together".[24] For Frisch, this does not go far enough, as he repeatedly qualifies the odor as a "disgusting stench" which helped the animal to defend itself.[25]

Among the German entomologists who followed in Merian's footsteps are two naturalists from Nuremberg. The first is Martin Frobenius Ledermüller (1719–1769) who worked as a lawyer before he followed his vocation and became a natural scientist and artist.[26] In 1761, he published his *Mikroskopische Gemüths- und Augen-Ergötzung*, which contained one hundred engravings "drawn from nature and illuminated by colors" (Fig. 1).[27] The plates show microscopic images of plants, animals, insects, and minerals, including special attractions such as mold spores on grapes (plate II), dust on butterfly wings (plate 9), and the crystalline structure of a drop of urine (plate 15). Ledermüller frequently refers to the entomological literature and debates of experts, which underlines his scientific knowledge. Among the authors cited by Ledermüller is "our famous Merianin", whose journey to Suriname he describes as a kind of artistic butterfly hunt.[28] Similar to Merian's *Metamorphosis Insectorum Surinamensium*, Ledermüller's "Microscopic Delight" contains information on the different stages of metamorphosis of an insect as well as additional informa-

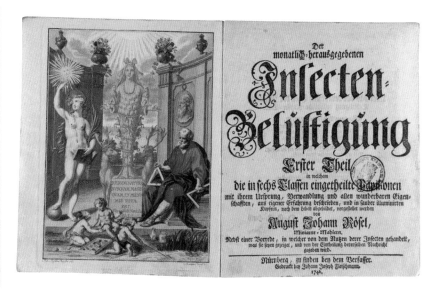

Fig. 1 M.F. Ledermüller (design),
A.W. Winterschmidt (etching), *Coccum
polonicum [= Porphyrophora polonica]*, in M.F.
Ledermüller, *Mikroskopische Gemüths- und
Augen-Ergötzung*, 1761, plate 32, etching,
25.5 x 21.5 cm. Stadtbibliothek Nürnberg,
Hert. II. 39.4°.

Fig. 2 J.A. Rösel von Rosenhof, *Der Monathlich-Herausgegebenen Insecten-Belustigung*,
volume 1, 1746, Title page and frontispiece, ca. 21 x 18 cm (page). Stadtbibliothek Nürnberg,
Will. IV. 6.4°.

tion on the cultural and environmental context in which it is found.

Even more interesting is the example of August Johann Rösel von Rosenhof (1705–1759), who came from a family of painters and engravers.[29] Very much like Merian, he combined scientific research with artistic practice. He published the results of his entomological research in the different volumes of his *Insecten-Belustigung*, which he edited between 1746 and 1755; a fourth volume was edited posthumously by his son-in-law, the painter and illuminator Christian Friedrich Carl Kleemann (1735–1789) (Fig. 2).[30] In contrast to Merian, Rösel had a stronger classificatory approach similar to the most eminent natural scientists of the time, above all Carl Linnaeus (1707–1778). He groups the insects in six *Classes*, from *Papilionum Nocturnorum* to *Papilionum diurnorum*, adding a section of "indigenous locusts and crickets". Compared to Merian, Rösel also made wider use of the microscope to study the anatomy and hitherto undiscovered parts of insects. The texts accompanying his engraved plates offer extensive descriptions going back to his own observations as well as a critical discussion of the state of research and opinions of other researchers, among them Merian.

Among the first class of the *Papilionum Nocturnorum*, Rösel describes the "grosse geschwänzte Windig-Raupe" (large-tailed bindweed caterpillar = Convolvulus hawkmoth (*Agrius convolvoli*))

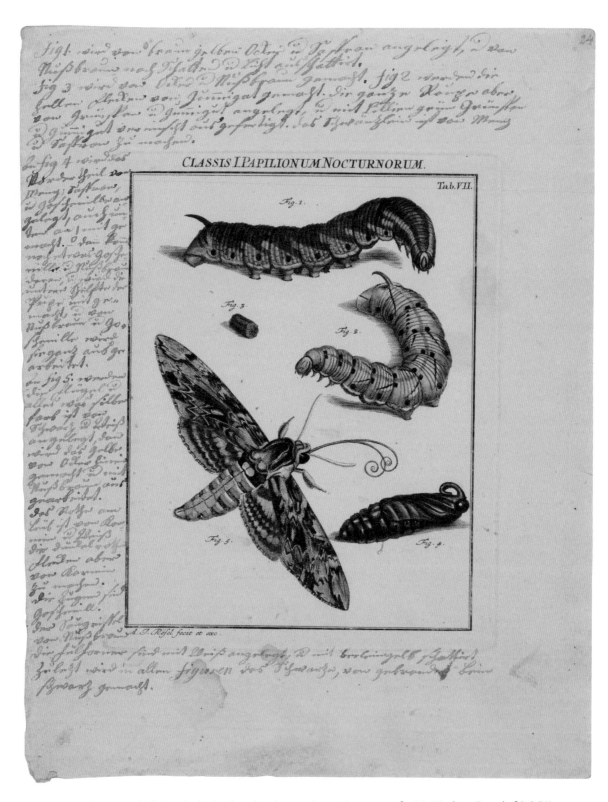

CLASSIS I. PAPILIONUM NOCTURNORUM.

Tab. VII.

Fig. 3 J.A. Rösel von Rosenhof, Convolvulus hawkmoth, color sample, ca. 28.5 x 22 cm, for J.A. Rösel von Rosenhof & C.F.K. Kleemann, *Der Monathlich-Herausgegebenen Insecten-Belustigung*, ca. 1740–1761. Stadtbibliothek Nürnberg, Nor. H. 934.

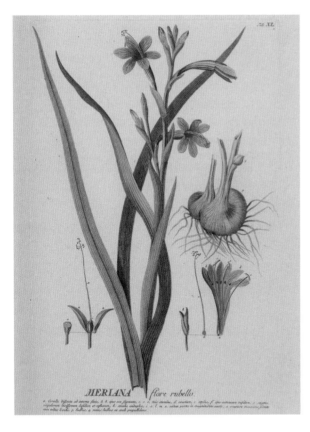

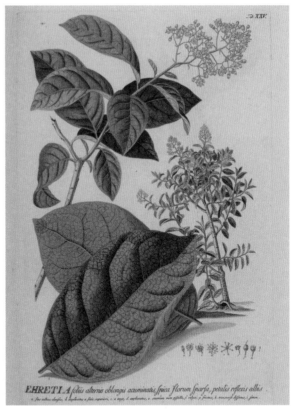

Fig. 4 G.D. Ehret, *Meriana flore rubello*, in C.J. Trew, *Plantae Selectae*, *Decuria* 4 (1754), plate 40, etching, 39.5 x 25 cm (plate). Allard Pierson, University of Amsterdam, OL 63-494.

Fig. 5 G.D. Ehret, *Ehretia*, in C.J. Trew, *Plantae Selectae*, *Decuria* 3 (1752), plate 25, etching, 40 x 26.5 cm (plate). Allard Pierson, University of Amsterdam, OL 63-494.

which also appears on plate 25 in the second volume of Merian's *Raupenbuch* (1683). The corresponding plate shows the different stages of the insect as well as the excrement of the caterpillar, which help lead the eye to this very camouflaged insect larva. In his commentary, Rösel discusses Merian's observations on this caterpillar and its metamorphosis, remarking that his own observations differ from hers on certain points. He especially comments on the preferred food of the insect, because, in contrast to Merian's assertions, he had observed that the animal preferred the green leaves of the plant, not its roots.[31] Like Merian, Rösel sold his *Insecten-Belustigung* in colored or uncolored copies. To guarantee exactness, he obviously made color samples for each plate. His son-in-law continued this practice, as the collection of color samples in the Stadtbibliothek of Nuremberg shows (Fig. 3).[32] On each plate the colors of each insect and element are meticulously rendered, both visually and in written form. The legends in the margins contain detailed descriptions of the different colors and pigments, the relationship of the various colors, and their brightness. The

213

differences between the color sample and the colored example can be explained by the varying quality of the pigments used and slight variations in the mixture of colors. However, the color values are generally rendered according to the model. Merian and her daughters probably used similar color samples to guarantee the chromatic exactitude of her books.[33]

With Merian, art definitely became an essential part of natural science. One of the internationally renowned scholars who acknowledged Merian's merits was the Nuremberg physician and botanist Christoph Jakob Trew (1695–1769).[34] In his *Plantae Selectae* (1750–1773), Trew baptized a bugle lily, *Meriana flore rubello*, to honor Merian. This plant was cultivated in the Chelsea Physic Garden from seeds brought from the Cape of Good Hope, and was in blossom for the first time in 1750. The scholar destined this *planta elegantissima* to preserve the memory of Merian, who had not only illuminated the world of insects but also the world of plants in her works.[35] The plant was drawn by Georg Dyonisius Ehret (1708–1770), who was widely known as the best botanical artist of his time (Fig. 4). In 1759, Linnaeus renamed it *Antholyza meriana*, refering to Ehret's illustration, while its current scientific name is *Watsonia meriana*.

Likewise, Trew named a beautiful plant of the borage family *Ehretia* to preserve the memory of his favorite artist (Fig. 5). Presently the genus *Ehretia* is still valid, and contains about fifty species. Ehret's plates may have been inspired by Merian, because he must have seen Merian's *Metamorphosis* in the libraries of his patrons.

Others merely copied Merian's plates, like the Nuremberg merchant/botanist Johann Christoph Volkamer (1644–1720). The last part of his *Continuation des Nürnbergischen Hesperidum, oder Fernere Gründliche Beschreibung der Edlen Citronat, Citronen, und Pomerantzen-Früchte* included Merian's pineapple (reproduced in the chapter by Etheridge in this volume). Furthermore, Merian's bird-eating tarantula is reproduced in the next plate. The same spider was copied from Merian in volume six of the first edition of the popular nineteenth-century animal encyclopedia *Brehm's Tierleben*.[36]

Conclusion

Although Maria Sibylla Merian attracted less attention from her contemporaries than most of her male colleagues, the numerous references as well as the discussion of her findings underline her position and fame in the academic world of the period.[37] For example, while looking at the few plant names in which people were honored in the *Plantae Selectae* and its supplement by Benedict Christian Vogel (1745–1825), she is mentioned among Ehret, Petiver, Boerhaave, and Malpighi.[38] All these famous men were members of the Royal Society. Merian must be given credit for establishing entomological research in Germany, as well as being the first to position it on empirical grounds. Her greatest achievement is the blending of scientific research and artistic practice.

Marketing Merian.
The Visual Branding
of the Late Female Naturalist

Lieke van Deinsen

On 28 September 1717, the Amsterdam notary Pieter Schabaalje witnessed the concluding of an agreement that marked a new chapter in the public image of the most prominent female naturalist of his time, Maria Sibylla Merian. Following Merian's death in January, her daughter Dorothea (1678–1743) had taken care of her mother's unfinished work. After the public presentation of the third and final volume of the popular Caterpillar Books, Dorothea and her husband were about to leave Amsterdam for Saint Petersburg, to join the court of Tsar Peter the Great (1672–1725).[1] Before the couple departed, however, Dorothea made sure her mother's legacy was left in capable hands. For the considerable sum of twelve hundred guilders, the Amsterdam publisher Johannes Oosterwyk (1672–1737) acquired the remaining stock of her printed texts and images, including the hand-colored copies and copperplates, as well as the exclusive rights to publish Merian's *Blumenbücher* and her books on European and South American insects.[2]

Over the next two years, the commercially focused publisher would seize every opportunity to boost the public image of the famous female naturalist.[3] For instance, he published the long-awaited first Latin translation of the completed *Raupenbücher* (Caterpillar Books) and reissued the Latin and Dutch editions of the *Metamorphosis Insectorum Surinamensium*. Moreover, he commissioned new laudatory poems and illustrations to accompany these publications and a new image of Merian. This printed portrait of the author, in particular, which he had made by the up-and-coming artist Jacobus Houbraken (1698–1780)—engraved after a portrait drawn by Merian's son-in-law and Dorothea's husband, Georg Gsell (1673–1740)—filled a lacuna (Fig. 1). Despite Merian's fame and widespread reputation, no printed portrait of her had been brought into circulation until that moment. In fact, undisputed images of Merian in general were so scarce that one could even speak of a "negative iconography". In her 1949 overview of

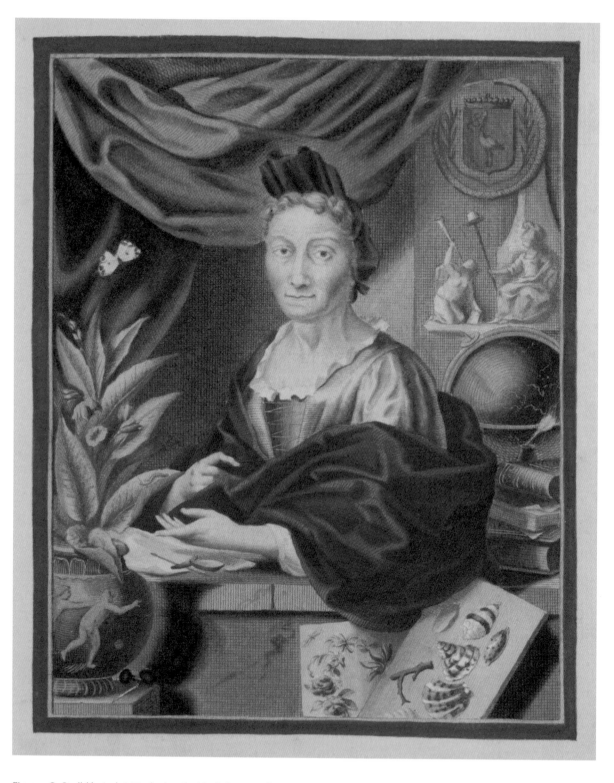

Fig. 1 G. Gsell (design), J. Houbraken (etching), *Portrait of Maria Sibylla Merian, 1708–1780*, in M.S. Merian, *Der Rupsen Begin,*
Voedzel en Wonderbaare Verandering, Amsterdam 1712–1717, hand-colored etching, 16.2 x 13 cm (plate). Artis Library, Allard Pierson,
University of Amsterdam, AB Legkast 019.02.

Merian's portraits, Margaret Pfister-Burkhalter optimistically stated that "from her childhood up until her old age, images of her are handed down".[4] However, only one of the numerous images that were once identified as possible likenesses of the famous naturalist holds its own for sure: the portrait commissioned by Oosterwyk. It does not come as a surprise that the portrait has played a defining role in Merian's public visual image from the moment it was published. The many likenesses of Merian produced in the following centuries that used the printed portrait as a model only enhanced its impact and iconicity.[5]

Taking this iconic portrait as a starting point, this chapter focuses on the visual imagery of Merian produced shortly after her death and included in her works. After a general introduction on the uses of portraits of intellectuals in the early modern period, I analyze how the imagery commissioned by Oosterwyk actively contributed to Merian's reputation as a female intellectual authority. Moreover, by comparing these illustrations to the frontispieces in the work of a renowned male colleague, specifically focusing on the iconographical strategies applied, this chapter illustrates how visual representations of Merian were used to challenge the persistent gender hierarchy in the early modern intellectual field.

Portraiture and the Branding of Intellectual Authority

The scarcity of authorized likenesses of Maria Sibylla Merian is remarkable in a period in which portraiture started to play a key role in the construction and dissemination of intellectual authority. Although portraits of the learned had been circulating since classical antiquity, the genre definitely gained popularity in the early modern period. Sixteenth-century humanists frequently included portraits of themselves in their letters, with the picture serving as the face-to-face introduction to a colleague whom they were unlikely to ever meet in person.[6] Images of learned men also received a prominent place in libraries and study rooms in this period.[7] It was thought that being surrounded by the images of learned predecessors would spark one's own intellectual mind. These likenesses were often painted in a very similar fashion and used as a direct reference for new generations of aspiring men who wanted to become part of this visual genealogy of the learned.

The popularity of scholarly portraits also gave rise to the production of engraved portraits of the learned and literate, which were sold, collected, and displayed separately, as well as included in books. Over the course of the seventeenth century, portrait frontispieces as well as engraved title pages featuring the author became omnipresent in newly published books. When visiting a bookshop, one was welcomed by piles of unbound printed pages with the likeness of the author on top.[8] Within the context of the book, these faces, as Roger Chartier argues, functioned as an "expression of an individuality that gives authenticity to the work".[9] These portraits and texts

combined should be read as transactional and have a preparatory function in the perception of the readers. Prominently placed in front of a book, they were used to glorify and ennoble the individual author, forcing the reader to recognize the authority conveyed by their gaze. As such, these likenesses played an important part in the purpose of the book's front matter, which consisted of both visual elements (including frontispieces, engraved title pages, and author portraits) and textual elements (such as prefaces, dedications, and privileges): they contributed to the construction of a strong and distinctive authorial image. Agents such as publishers and booksellers actively used a book's front matter to present authors and their brand (that is, a set of recurring and recognizable features) to their public.[10]

The Inevitable Invisibility of the Female Intellectual

The increased importance of the author's public *persona* and especially the demand for printed author portraits presented early modern learned women with a challenge.[11] While a rapidly growing number of female intellectuals found their way to the printing presses and published their works, printing their likeness complicated their public representation. The increasing autonomy of the individual in the early modern period notwithstanding, the opportunities for women to openly participate in the public and intellectual domain remained limited. If speaking and writing were already considered challenges to the prescribed definition of modest female behavior, printing a picture of one's person intended for the distribution among—and purchase by—a wide and often unknown audience seemed all the more scandalous. As a result, initially very few female author portraits were printed, and for a long period learned women remained relatively invisible in their works. The most noteworthy exception was, perhaps, the "learned maid" Anna Maria van Schurman (1607–1678), who consciously modeled her own portraits from the very start of her intellectual endeavors to enhance her public reputation as an intellectual authority.[12]

Generally speaking, however, when a woman manifested herself to the public, whether in word or image, her *persona* was oftentimes carefully disguised behind a topos of female modesty and positioned in the shadow of her male peers. This was also the case with Merian. While her male contemporaries increasingly manifested themselves in their works as intellectual authorities, Merian's authorial *persona* remained rather invisible in the works that were published during her lifetime. In addition to the lack of an author's portrait, she seemed reluctant to show her personality in her works. Publishing her first work in 1675, the debutant only made herself known to the public once. By including her name ("Maria Sibylla Graffin") on the Latin title page of the first volume of her *Blumenbuch*, however, she had no intention to claim independent intellectual authority. By stressing both her relational ties with her well-known late father ("Matthæi Meriani

Senioris Filia") and husband—who also happened to act as the publisher and printer ("Joh: Andreas Graff excudit")—emphasis was put on her role as daughter and wife. A similar strategy to stress Merian's relational authority was adopted by the renowned Nuremberger philologist and poet Christoph Arnold (1627–1685), who provided the preparatory poems to the two German volumes of the *Raupenbücher*, in which he addresses her respectively as the "industrious daughter of worthy Merian" and "Frau Gräffin".[13] It was only in the prefaces to the *Neues Blumenbuch* (1680), which combined the threefold series' previously separately published volumes, that Merian directly addressed her readers for the first time. Hiding behind a series of historical anecdotes, however, this preface barely showcased Merian's personal voice, presenting the public with little more than a glimpse of her erudition.

When the Dutch and Latin editions of her *Metamorphosis* were published in 1705, the front matter was limited to a short introduction by the author herself. Presenting her readers with a biographical insight into the lifelong fascination for insects which had led her to Suriname, this preface is one of the most personal of Merian's published accounts. Yet consciously limiting her words to barely two pages, Merian refuses to go into detail on her intellectual opinions, let alone her exceptional position as learned woman in the male-dominated intellectual field. "I could have lengthened the text," Merian explains "but because today's world is highly delicate and the opinions of the learned are dissimilar, I have simply limited myself to my observations. I thereby deliver material which anyone can reflect upon according to their own mind and opinion."[14] Again, her intellectual authority remains (at best) only implicitly addressed in the front matter.

Visualizing the Woman Naturalist

Merian's public image changed drastically when her paper legacy came into the hands of the eager Amsterdam printer Johannes Oosterwyk, shortly after her death. A true commercial talent, Oosterwyk frequently bought existing copperplates or stock from other publishers and remarketed the old material into an attractive new format.[15] He particularly used the front matter to optimally market his new "star authors", and he evidently did so mainly to boost sales. In the case of Merian, Oosterwyk strategically dedicated the new editions of her work to prominent Amsterdam notables; he commissioned laudatory poems and, more importantly, visual imagery to support Merian's public image.

His intention to market Merian as an independent intellectual authority is primarily demonstrated by the author portrait he had commissioned by Jacobus Houbraken to accompany the long-awaited Latin translation of the completed caterpillar books, as well as being sold separately. As was generally the case with portraits of the learned, Merian's likeness was carefully modeled and loaded with iconographical elements to stress

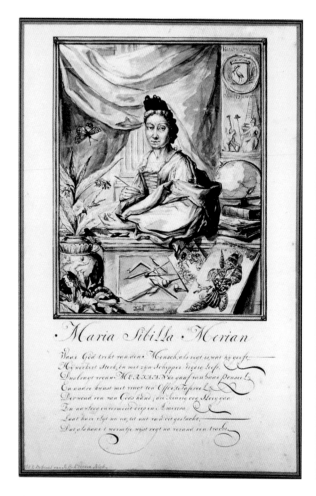

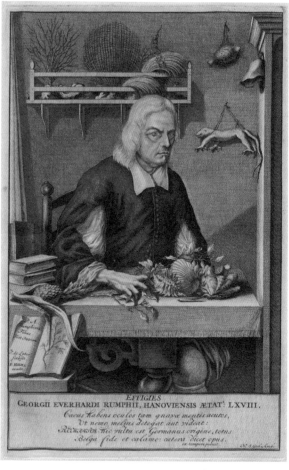

Fig. 2 G. Gsell, *Portrait of Maria Sibylla Merian*,
ca. 1715, brown ink on paper. Photographic reproduction;
whereabouts artwork unknown. RKD, The Hague. In the right
upper corner her date of birth and death is mentioned.

Fig. 3 P.A. Rumpf [= Rumphius] (design), J. de Later (etching),
Portrait of Georg Everhard Rumphius, 1696, in G.E. Rumphius,
D'Amboinsche Rariteitkamer, Amsterdam 1705, etching.
Artis Library, Allard Pierson, University of Amsterdam.

the sitter's capacities. This first printed portrait of the late naturalist presented her in her natural habitat. Dressed in a luxurious robe, Merian is depicted behind a desk, from the waist up, three quarters to the right, reaching out with her right hand. She is surrounded by the objects and fruits of her studies, such as three books—possibly representing her key works—an inkwell with feather, her recognizable plates of shells, flowers, and insects, a paintbrush, a magnifying glass, a celestial sphere, and, of course, a plant with a butterfly. Merian is portrayed as a learned woman and undisputed authority in the field of entomology based on her skills and expertise. Yet details in the background highlight two additional factors that contributed to her fame. On the wall hangs the coat of arms of the Merian family, surrounded by a laurel wreath—the symbol of honor—and an ouroboros,

the snake biting its own tail and symbol for eternity. It emphasizes, just like the poem of Arnold had done, Merian's place in a genealogy of successful predecessors in her family. Underneath the family coat of arms stands a sculptural group. Before a memorial pillar, yet another symbol of eternal fame, sits the Dutch Maiden carrying the cap of liberty on a pole. At her feet, a cherub leaning on a book trumpets praise, stressing the importance of the Dutch Republic to the name and fame of the German-born naturalist.

In constructing this elaborated iconographical program, Houbraken closely followed the portrait drawn by Gsell (Fig. 2). Houbraken's choice to almost identically translate Gsell's pencil lines onto the copper was perhaps not only inspired by the image's expressive and faithful design but also prompted by the fact that the likeness had already acquired some notoriety among Amsterdam art lovers, as part of the renowned collection of Johanna Koerten (1650–1715; see also the chapter by Pieters & Van de Roemer in this volume).[16] The most significant difference between the print and the drawing—beside the fact Houbraken seemed to put less emphasis on Merian's craftmanship, since he included fewer utensils in the portrait—was the necessary replacement of the Dutch laudatory poem that originally accompanied Gsell's drawing:

Waar God trekt van den Mensch, als regt is, wat hij geeft	God asks, by right, for all the bounty he creates,
Hij woekert sterk, en met zijn Schepper vredig leeft.	of man to live in peace and to proliferate.
Dus bragt vrouwe Merian de gaaf van haar Penseel	Thus Lady Merian, viewing with subtle eye
En andre kunst met vrugt ten Offer 't Tafereel	the wonders of God's hand, endeavored to apply
Der wondren van Gods hand, dit keurig oog sloeg gaa	her paintbrush and her art, to frame the replica
En navloog en vermeert diep in America,	of nature's splendors, here and in America.
Laat hare vlijt nu na, tot nut van dit geslacht,	She now bequeaths the fruit of industry t'her kind
Dat, als haar 't wormtje wijst regt na verand'ren tracht.	which, like the worm, will ever transformation find.[17]

Alluding to the Gospel of Matthew (25:14–30), the poem described how "Lady Merian" used her God-given talents to the benefit of mankind by carefully capturing the wonders of the Creation in her work. For the etching, these Dutch verses were replaced by a plain Latin epitaph "Maria Sibilla Merian / Nat: XII. Apr: MDCXLVII. Obiit XIII. Jan: MDCCXVII." Instead of providing a translation of the Dutch poem, the Jewish physician Salomon de Perez was asked to compose a new poem to precede the portrait in the Caterpillar Book's Latin translation. Conventionally starting with a description of the physical characteristics, Perez quickly turned to Merian's achievements and widespread fame as both an artist and naturalist. He drew inspiration from the same biblical passage as his predecessor, presenting her success as the optimal utilization of

her God-given talents.[18] As such, both the visual and textual portraits seamlessly fitted Oosterwyk's strategy to brand Merian as a strong and independent female artist and naturalist. In this image, family lineage played a small part in Merian's success. Under God's watchful eye, she had become an authority in her own right.

Male Models, Female Framing

In Oosterwyk's effort to brand Merian as an independent intellectual authority, it proved essential to highlight that she could easily measure up to established male colleagues, or even surpass them. In order to do so, both the portrait as well as the frontispiece he had commissioned for the Caterpillar Book's translation take a feminizing twist on the traditional iconography of the learned man. Thereby, the visual imagery of the well-known naturalist Georg Everhard Rumphius (1627–1702) (Fig. 3) was taken as a direct point of reference. It was an obvious choice, since the analogy between the two German-born naturalists was already clear for many contemporaries. Merian closely followed in the footsteps of her predecessor, moving oversees to optimally investigate the wonders of nature, and has been frequently associated with the completion of his *D'Amboinsche Rariteitkamer*, posthumously published in 1705 (see the chapter by Van de Roemer in this volume).

How the analogy between the two scholars was used for Merian's public image already becomes clear when comparing their printed portraits. Both Rumphius and Merian are portrayed in a very similar fashion: from the waist up, at work, and surrounded by the objects and attributes symbolizing their works. Merian's portrait, however, is a spin on the traditional genre, since it does not hide her evident female sex, nor the fact she had to challenge prescriptive social expectations to fulfill her scientific ambitions. On the contrary, the portrait subtly highlights Merian's rather unconventional life choices in favor of her intellectual career. This is demonstrated by the iconographical program on the vase. Carved or painted onto the front surfaces of the vessel, the attentive observer identifies a telling scene from Ovid's *Metamorphosis*: the nymph Daphne fleeing the lustful grasp of the god Apollo by turning into a laurel tree. Evidently alluding to the more general theme of metamorphosis central to Merian's work, this myth at the same time represents an episode in Merian's personal life: Daphne's metamorphosis reflects Merian's transition from being someone's daughter and wife to being (respected as) an independent woman and intellectual authority. By implementing an emancipatory iconographical program, Merian's portrait transcends the traditional conventions of the portrait of the learned as crystallized in the likeness of Rumphius and takes the depiction of female intellectual identity to the next level.

The extent to which Rumphius's imagery functioned as a model for the branding of Merian is all the more evident from the second print by Oosterwyk

Fig. 4 S. Schijnvoet, Frontispiece of M.S. Merian, *Der Rupsen Begin, Voedzel en Wonderbaare Verandering*, Amsterdam 1712–1717, hand-colored etching, 18.6 x 14 cm (plate). Artis Library, Allard Pierson, University of Amsterdam, AB Legkast 019.02.

Fig. 5 J. Goeree (design), J. de Later (etching), Frontispiece of G.E. Rumphius, *D'Amboinsche Rariteitkamer*, Amsterdam 1705, hand-colored etching, 35 x 22.3 cm (plate). Artis Library, Allard Pierson, University of Amsterdam, AB Legkast 005.

Fig. 6 F. Ottens, Frontispiece of M.S. Merian, *Over de Voortteeling en wonderbaerlyke Veranderingen der Surinaemsche Insecten*, Amsterdam 1719, hand-colored etching, 45.5 x 31.5 cm (plate). Artis Library, Allard Pierson, University of Amsterdam, AB Legkast 019.01 (see also the detail on p. 190).

(Fig. 4). While designing the requested frontispiece for the Caterpillar Book's Latin translation, the appointed artist, Simon Schijnvoet (1652–1727), clearly had the engraved frontispiece of Rumphius's popular *D'Amboinsche Rariteitkamer* in mind (Fig. 5). Despite the clear compositional similarities between the two title pages, however, Schijnvoet—who had acted as the editor of

Rumphius's work—gave his new design a clearly feminine twist. Whereas the title page for Rumphius's work depicts a male naturalist surrounded by men in classical garb, who share in the enthusiasm of his work, Schijnvoet pictures an all-female collective involved in the study of *naturalia*. At the far end of the table, the winged-head personification of Investigation, dressed in an ant-covered gown,

224

lectures Merian in the science of entomology. They are accompanied by two youthful women, possibly representing one of Merian's daughters being taught by the three-breasted personification of Nature. As such, the frontispiece presents the reader with a refreshing new perspective on women's female intellectual capacities. Indeed, women could act as respectable scholars and were not dependent on the guidance of male intellect. Revealingly, the only human males included in the image are the servants who lift and carry the trays of insects.

When Oosterwyk reissued the Dutch and Latin editions of the *Metamorphosis* in 1719, the image of Merian as an independent female intellectual authority reached its culmination (Fig. 6). The opening print of her famous study of the insects of Suriname, designed and engraved by Frederik Ottens (1694–1727), presented the first visualization of Merian's innovative fieldwork. Through a monumental stone arch, the observer sees her in the act of catching insects in the tropical landscape of Suriname. In the foreground, a nearly bare-breasted woman—most likely the personification of Natural Sciences—is seated at a table in the company of cherubs who play

with and order the *naturalia*. The open book on the ground reveals the best example of such studies, providing a preview of two actual prints included in Merian's *Metamorphosis*. As such, the final print by Oosterwyk visualizes Merian's definitive intellectual authority as a naturalist by depicting the research process, including the act of catching the insects, followed by arranging them in boxes and, lastly, their visual representation on the etchings included in Merian's publication.

There was perhaps only one man whom Merian ultimately had to thank for her undisputed reputation. While closing his laudatory poem to the Dutch and Latin editions of the *Metamorphosis*, the Dutch historian Mattheus Brouërius van Nidek (1677–1743) reserved a few lines to reflect on Oosterwyk's contribution to Merian's everlasting fame. Her legacy proved safe in the hands of Oosterwyk, who took care of her work, her so-called "Letter-orphan" (Letter-weeskind), "raised it and made it stand on its own two feet".[19] Significantly, Brouërius van Nidek chose to use the metaphor of the "caregiver"—a role, needless to say, primarily associated with mothers—to describe the publisher's involvement. In the end, the female sex, indeed, proved the authority.

The Place of Maria Sibylla Merian's Books in Eighteenth-Century Private Libraries

Alicia C. Montoya

Which early-modern books provided the intellectual contexts for readers first encountering the works of Maria Sibylla Merian? In this essay, I probe connections between various texts and genres and her books in order to shed light on the early reception of Merian's works. To do so, I use a database of hundreds of printed catalogues of eighteenth-century private libraries as well as historical bibliometric methods to ask a series of related questions.[1] How does the presence of specific titles in eighteenth-century private libraries correlate to the presence of books by Merian? What were the other books typically found sitting next to Merian's books on readers' bookshelves? And what do these tell us about the ways contemporary readers may have interpreted her works? In other words, what is the larger literary system or ensemble of connections between different works and authors, and between different cultural and scientific contexts, of which Merian's oeuvre was initially perceived to be a part?

Physico-Theology and Natural History

Maria Sibylla Merian was not the first author to evoke the caterpillar's wondrous metamorphosis into chrysalis and, finally, dazzling butterfly. This transformation provided one of the most compelling images in early-modern literature. From the mid-seventeenth to the end of the eighteenth century, it recurred in different works and textual genres, across different national and linguistic contexts. Thus, by the end of the eighteenth century, taking up a by then well-worn literary *topos*, Dutch novelist Elisabeth Maria Post (1755–1812) described a country walk undertaken by two female friends in her novel *Het land, in brieven* (1788). In the course of the walk, the young women enter a graveyard and stop before a tombstone on which they discover the carved image of a butterfly. Emilia, the alter-ego of the author, explains to her friend Eufrozyne the meaning of this image. Her account begins with an apparently naturalistic description of the caterpillar's transformation:

Yes, a butterfly [...] emerges out of its prison, and under its surface is the caterpillar as it first was. Nothing in all of nature gives us such an accurate image of the changing destiny of bodies as this little being: first it is a little worm, crawling over the earth, or on a tree; it is in continuous danger of being stepped on; then it weaves itself into a little cell, in which it passes a length of time in unfeeling slumber, until the moment when, newly equipped with wings, it emerges as a fine butterfly, and cleaves the air with brightly colored blades, flitting forth from place to place.

Lest the reader think this is merely a description of a natural phenomenon, such as in another well-known contemporary work, the bestselling *Histoire naturelle* (1749–1789) by Georges-Louis Leclerc de Buffon (1707–1788), the speaker then sets out the Christian meaning of this image. Implicitly referencing the etymological link with the Greek term *psyche*, denoting both the human soul and butterflies, she continues:

Do those who awake again in Jesus not undergo a similar transformation? Down here they drag along a weak, insignificant, necessitous body, that is bound to the earth with torpid slowness. This body shall one day pass into an unfeeling state of death; for years and centuries it will remain so; but on the day of resurrection, out of this vile dust, shall rise a fine, handsome, delightful, immortal body; a body that is

no longer bound to the earth, but that with the speed of light, with the swiftness of a seraph, will fly forth from one part of Creation to the other; and shall be similar to the body of the glorified Savior. How joyous is our expectation!

Readers familiar with Merian's work will easily recognize in the first part of this episode the image of natural metamorphosis that is at the center of her natural history publications. But the second part of the passage, which proposes a theological interpretation of the caterpillar's metamorphosis, may appear less obviously related to Merian—unless one bears in mind Merian's own Labadist ideas and her deep religiosity during the 1680s. Linking science with religion was not exceptional in this period. Much of the groundbreaking entomological research carried out in the seventeenth and eighteenth centuries, by the likes of Johannes Goedaert (1617–1668) and Johannes Swammerdam (1637–1680), was bound up with Christian religiosity and a distinct set of theological views. According to these, besides the Bible there was another book that individuals could study to honor God: the Book of Nature. The study of humble insects, in particular, the lowest of the lowly according to the traditional scheme of the natural world, the Great Chain of Being, was an ideal instrument to confront budding scientists with the wonders of creation. Encouraging the faithful to adopt the humility due towards God's almighty hand, natural scientists adopted an adage inspired by Pliny: "God is revealed in the

smallest creations" (*ex minimas patet ipsi Deus*). In the eighteenth century this strain of physico-theology would lead to works such as *Insecto-theologia* (1738) by Friedrich Christian Lesser (1692–1754), translated into English as *Insecto-Theology, or a demonstration of the being and perfections of God, from a consideration of the structure and economy of insects*. In the Netherlands, another work in this tradition, the four-volume *Katechismus der Natuur* by Johannes Florentius Martinet (1729–1795), published in 1777–1779, had a direct influence on Elisabeth Maria Post's novel.

The passage from Post's *Het Land* cited above is illustrative of a larger cultural and intellectual phenomenon, whereby the image of the caterpillar's metamorphosis recurred throughout eighteenth-century literature and thought. It surfaced not only in expressly scientific works, but also in physico-theological works, in sentimental novels, and in pedagogical publications aimed at a juvenile reading public. In another literary commonplace that was recycled throughout the century, pedagogues established a rhetorical comparison between the metamorphoses portrayed in fiction and the facts of science. Contrasting the false fairy tales and the *Metamorphoses* of Ovid to the true wonders of nature, epitomized by the caterpillar's metamorphoses, authors such as Marie Leprince de Beaumont and Félicité de Genlis argued that the latter were a subject vastly more worthy of young people's attention. It followed that natural history should hence take pride of place in modern educational

programs, and the caterpillar was itself conceived as a powerful metaphor for the child in need of nurturing. Given the ubiquity of these caterpillar-butterfly images, it might be hypothesized that such texts provided some of the cultural contexts in which contemporary readers first encountered Merian's works, and that physico-theological works would therefore be likely to appear in libraries alongside Merian's books.

Collectors and Libraries

In two earlier publications, I established that works by Merian were reported relatively frequently in eighteenth-century libraries. Based on a survey of 254 eighteenth-century Dutch private library auction catalogues that listed a total of 500,000 books, I concluded that one or more of Merian's titles were present in 19% of the catalogues, or about one in five libraries. This ranking put her almost on par with Georges-Louis de Buffon, whose *Histoire Naturelle* was reported in 26% of the catalogues printed after 1749, the date of publication of his first major work. A second study subsequently identified a number of additional Dutch private library auction catalogues that listed works by Merian, bringing the total number of Dutch collectors who reportedly owned her work to 78. Despite the suggestiveness of these early findings, however, these were no more than initial samplings, since the corpus of catalogues was exclusively Dutch and might therefore favor publications by an author who was also based in the United Provinces for

part of her life. More importantly, because these studies necessarily focused only on selected titles, it was not possible to establish comprehensive, comparative statistics.

To fully understand the position of Merian's work in eighteenth-century literature, digital methods and quantitative tools capable of leveraging "big data" are indispensable. Only such tools can reveal correlations between her works and others with which they may share key imagery. Such an approach to Merian's works is now possible, thanks to the digitization of a corpus of six hundred private library auction catalogues by the MEDIATE project (Measuring Enlightenment: Disseminating Ideas, Authors, and Texts in Europe 1665–1830), funded by the European Research Council. This project seeks to study the circulation of books and ideas in eighteenth-century Europe by drawing on a database of several hundred eighteenth-century private library auction catalogues. Although digitization is still underway at the moment of writing (April 2021), 580 of the six hundred catalogues have now been sourced, and the dataset is robust enough to allow some preliminary analyses. This dataset differs in significant ways from the ones I used to measure Merian's commercial success as published in my earlier article. First, its geographic scope is broader, as it embraces private library catalogues from the Netherlands, France, Italy, and British Isles. These are evenly distributed in the period 1700–1830, which is the focus of the analysis below, allowing for meaningful transnational comparisons. Secondly, while my earlier study also included anonymous collections, the MEDIATE dataset focuses on libraries that are clearly described as belonging to a named owner. These catalogues, I hypothesize, provide a more or less accurate snapshot of those individuals' library holdings at the moment when the catalogue was drawn up, typically after the owner's death. Finally, because the MEDIATE project seeks to address not the most well-known bibliophile collections and collectors, which have hitherto attracted most scholarly attention, but the more "ordinary" segment of the library auction market, it restricts its corpus to smaller libraries that mostly list fewer than one thousand titles.

Table 1 provides an overview of the libraries in the MEDIATE corpus that report one or more works by Merian. Perhaps the most surprising feature of this list is its modest size. My previous studies, drawing on fewer but larger, more bibliophilic private library auction catalogues identified 78 collectors whose libraries reported titles by Merian; the MEDIATE corpus of smaller catalogues turns up only 28. My 2004 study identified works by Merian in 19% of the eighteenth-century libraries I researched, but works by Merian are present in only 6% of the library catalogues in the MEDIATE catalogues of libraries sold between 1700 and 1830. This conspicuous difference may be explained by the relatively small size of the MEDIATE catalogues. As I noted in an earlier

Fig. 1 J. Buys, Frontispiece for Pieter Cramer, *De Uitlandsche Kapellen, voorkomende in de Drie Waereld-Deelen Asia, Africa en America*, Amsterdam & Utrecht 1779 (detail). Wikimedia Commons.

publication, collections reporting works by Merian "were, in general, slightly larger-than-average collections within the broader corpus of libraries sold at auction in the Dutch Republic". Collection size, a possible indication of the wealth of the collector, seems to be a significant factor determining whether Merian's works are present in libraries. Kate Heard's statement that, in the eighteenth century, "the *Metamorphosis* could be found in any self-respecting library" hence requires some nuance. Elite libraries certainly made room for these costly, luxurious works, but less bibliophilic collectors appear on occasion to have bypassed them for other, more accessible volumes.

Further patterns emerge from this overview of library catalogues in the MEDIATE database that report one or more of Merian's works. Generally speaking, this population of library

owners bears similarities with the one documented in earlier studies of Merian book ownership. Thus, it includes several art collectors, who presumably valued Merian's works for their visual aspect rather than their scientific content. Colonial administrators are also well represented, likely reflecting the exotic attractions of her Suriname volume. Most prevalent among the collectors are physicians and biologists. Among them figure collectors such as Pieter Cramer (1721–1776), author of the sumptuously illustrated *Uitlandsche Kapellen, voorkomende in de drie Waereld-Deelen Asia, Africa en America*, inspired by Carl Linnaeus (1707–1778) and published between 1775 and 1782, whose frontispiece also referenced Merian's works (Fig. 1). Another biologist and collector was Richard Pulteney (1730–1801), an English biographer and popularizer of Linnaeus, whose library was sold in London in 1802. But the best-known biologist in this dataset is without a doubt Jean-Baptiste Monet, chevalier de Lamarck (1744–1829). His modest working collection of 830 books was put up for auction by his destitute family upon his death and was sold off at his home in the Jardin du Roi (present-day Jardin des Plantes) on April 19, 1830.

Within this small subset of collections, Dutch libraries are overrepresented. Thirteen of the 28 libraries are Dutch, nine are French, five are British, and one is Italian. Eleven catalogues list more than one copy of a work by Merian (owners italicized in the table). The number of individual items is slightly higher, at 47,

Table 1
Catalogues reporting books by Maria Sibylla Merian in the MEDIATE corpus

Owner	Profession	Year	Place
Henri Desmarets (1633–1725)	Huguenot pastor, Bible editor	1725	The Hague
Hendrik Swart (dates unknown)	Admiralty of Amsterdam, Dutch West India Company official	1728	Amsterdam
John Coleman (?–ca. 1730)	unknown	1730	London
Jacobus van Nokken (?–1729)	physician	1741	Utrecht
Johan Bernhard van der Marck (dates unknown)	Warmond bailiff?	1747	Leiden
Gerard Schaak (dates unknown)	unknown	1748	Amsterdam
Jan Arnold van Orsoy (1700–1753)	merchant, poet-translator	1754	Amsterdam
Abraham de Brauw (?–1763)	Hof van Vlaanderen magistrate	1763	Middelburg
Marie-Joseph de Savalette de Buchelay (1727–1764)	fermier général, natural history collector	1764	Paris
Jean Nicolas Taverne de Renescure (1694–1769)	Parlement de Flandre magistrate	1764	Lille
Pierre-Jean Mariette (1694–1775)	art dealer and collector	1775	Paris
George Colebrooke (1729–1809)	East India Company chairman, M.P.	1777	London
Pieter Cramer (1721–1776)	merchant, entomologist	1777	Amsterdam
Jan Joost Marcus (1729–1780)	magistrate, Amsterdam orphanage regent	1780	Amsterdam
Christophe-François Nicolau de Montribloud (1733–1786)	baron, banker, art collector	1782	Lyon
Jean-Thomas Aubry (1714–1785)	Catholic priest, bibliophile collector	1785	Paris
Frangipani family	Roman patrician family	1787	Rome
Benjamin Newton Bartlett (1745–1787)	unknown (son of antiquarian)	1789	London
Robert Masters (1713–1798)	clergyman, historian	1798	London
Maria Suzanna Markon (née Barnaart) (?–1799)	widow of doctor and art collector, poet	1799	Leiden
Richard Pulteney (1730–1801)	physician, botanist, Linnaeus biographer	1802	London
Albert-Paul Mesmes, comte d'Avaux (1751–1812)	cavalry officer, gentilhomme d'honneur	1804	Paris
Cornelis Michiel ten Hove (?–1805)	magistrate	1806	The Hague
Pieter Smeth van Alphen (1753–1810)	merchant, banker	1810	Amsterdam
A. R. Jolles (dates unknown)	unknown (Albertus Richardus Jolles?)	1812	Amsterdam
Charles Léopold von der Heyden Belderbusch (1749–1826)	count, diplomat, prefect, senator	1826	Paris
François-Benoît Hoffmann (1760–1828)	playwright, critic	1828	Paris
Jean-Baptiste de Monet de Lamarck (1744–1829)	botanist, Muséum national d'Histoire naturelle curator	1830	Paris

due to what were probably convolutes or *Sammelbände* reported in a number of lots; in one case (Benjamin Newton Bartlett's library, sold in 1789), Merian's *Metamorphosis Insectorum Surinamensium* was bound together with the *Histoire des Insectes de l'Europe*, published in 1730.

Most often, however, her Caterpillar Books and *Metamorphosis* in Dutch or French were united in a single volume in folio: *Europische Insecten* or *Histoire des Insectes de l'Europe*, both published in 1730. Corroborating previous findings from advertisements, the list of libraries

Table 2
Merian works in private libraries and the language in which they are reported

Title	Dutch	Latin	French	German
Caterpillar Books	15	5	7	1
Metamorphosis Insectorum Surinamensium	10	6	3	-

reporting books by Merian suggests that most auctions of her works took place in the decades from the 1760s through 1790s; the largest concentration of library catalogues reporting her books (eight of the 28) date from the 1770s and 1780s.

The libraries listed in Table 1 held an average of 1,063 items, which makes them slightly larger than the average library in the MEDIATE corpus but, interestingly, there are also some smaller libraries. Six of the libraries that report more than one work by Merian held fewer than one thousand items, and two of them fewer than five hundred, namely the library of Benjamin Newton Bartlett (418 items, three of those works by Merian) and of *fermier général* Marie-Joseph de Savalette de Buchelay (399 items, four of those works by Merian). Finally, in contrast to my previous studies, based on another corpus of catalogues (see above) in which I found copies of all of Merian's works in Dutch catalogues, the MEDIATE corpus turns up only her Caterpillar Books, most frequently in Dutch translation, and her *Metamorphosis*. In keeping with Dutch overrepresentation, 25 of the 47 titles are in Dutch, versus eleven in Latin, and ten in French (Table 2). Only a single copy of Merian's Caterpillar Book in its original German edition was reported, in the li-

brary of the Amsterdam citizen Gerard Schaak. The scarcity of German editions means that most readers had access only to the severely truncated versions of Merian's work provided by the Dutch and other translations, negatively impacting the reception of her scientific work. However, it is likely that the buyers of the Dutch translation of the Caterpillar Book did not know that they had purchased a shortened version of the book.

In short, aside from the overall lower frequency of books by Merian in these smaller libraries, the distribution of titles and population of owners appears largely similar to the presence of her books in larger libraries, as is shown in my earlier studies. Let us turn now to the broader cultural contexts against which these books were potentially positioned.

Profiling the Merian-Holding Library

Eighteenth-century individuals who acquired books by Merian did not, of course, own only books by her. If only one—or at most, three or four—of the thousand-odd items in each of these catalogues was by Merian, this raises questions about the identity of the other books that sat on shelves beside hers and what they might reveal about the intellectual outlook of their owners. Ultimately, such

Table 3
Top-ranked authors in Merian-holding and in non-Merian-holding libraries, 1725–1830

Rank	Non-Merian-holding libraries (n=420)		Merian-holding libraries (n=28)	
	author	% libraries	author	% libraries
1	[Bible]	92%	Merian	100%
2	Ovid	79%	[Bible]	93%
3	Horace	76%	Ovid	89%
4	Virgil	75%	Horace	89%
5	Cicero	71%	Virgil	82%
6	Tacitus	67%	Erasmus	82%
7	Homer	65%	Tacitus	82%
8	Fénelon	65%	Fénelon	82%
9	Terence	64%	Cicero	75%
10	Erasmus	63%	Joseph Addison	71%
11	Grotius	62%	Grotius	68%
12	Plutarch	60%	Quintus Curtius	68%
13	Flavius Josephus	60%	Terence	64%
14	Voltaire	60%	Homer	64%
15	Seneca	58%	Juvenal	64%
16	Juvenal	58%	Pliny the Elder	64%
17	Quintus Curtius	57%	Flavius Josephus	64%
18	Julius Caesar	56%	Rumphius	64%
19	Pufendorf	55%	Plautus	64%
20	Joseph Addison	54%	Voltaire	61%

questions might help answer the larger question of how individuals actually interacted with Merian's books and how large-scale data on book ownership might be leveraged to provide new clues about eighteenth-century reading culture. What other works did Merian owners keep in their personal libraries? And does a comparison of library contents allow us to establish a correlation between ownership of Merian's works and other genres, specifically other types of text that similarly focus on the life cycle and metamorphoses of caterpillars? In other words, what is the profile of the typical Merian-holding library? In order to address these questions, I started by drawing up a list of the authors most frequently reported in the 28 Merian-holding libraries, compared to non-Merian-holding libraries (Table 3). I restricted my analysis to the period 1725–1830, since the first Merian book in the corpus was reported in 1725, in the library of Huguenot pastor and Bible translator Henri Desmarets, based in The Hague.

The most frequently reported authors in these libraries usually date back to classical antiquity. Only six (12%) of the top-ranked authors in non-Merian-holding libraries are post-medieval, and only

three of those—Fénelon, Voltaire, and Joseph Addison—are eighteenth-century authors. The picture is similar for Merian-holding libraries. Only seven of the twenty top-ranked authors are modern authors, including Merian herself. This classical dominance persists right down the list, for the first hundred top-ranked authors. The two books that were most likely to occur in a library with Merian's *Metamorphosis* were the Bible and, quite fittingly, another classic volume: Ovid's *Metamorphoses*. The commonplace eighteenth-century comparison between the metamorphoses of caterpillars and the mythological transformations described by Ovid may have reflected a book owner's reality, whereby the two books might have been found together in eighteenth-century libraries.

Despite this decidedly classical bent in the libraries sampled, there are differences between the two lists. Merian-holding libraries tend to contain larger proportions of works by any given author than non-Merian-holding libraries. For example, Ovid is reported in 89% of the Merian-holding libraries versus 79% of the non-Merian-holding libraries; expressed as a factor, works by Ovid are 1.13 times more likely to be found in the former than in the latter. This pattern holds throughout the table, with overall higher relative proportions of books by the top-ranked authors in Merian-holding libraries and an average factor of 1.09 for the entire top-twenty list. Only three authors figure relatively more frequently in non-Merian-holding libraries: Plutarch, Homer, and Seneca. The au-

thors in Merian-holding libraries who most significantly outperform their rankings in non-Merian-holding libraries are all modern: Joseph Addison (factor 1.31), Erasmus (1.3), and Fénelon (1.26). Thus, libraries that report one or more works by Merian could be described as slightly more modern in outlook than libraries without her works.

Not surprisingly, libraries that report works by Merian often hold another well-known, modern illustrated work of natural history, Georg Everhard Rumphius's *D'Amboinsche Rariteitkamer*. This work by Rumphius was published in 1705, the same year as Merian's *Metamorphosis*, with illustrations sometimes attributed to Merian herself. Rumphius's works were in 64% of the libraries that also contained works by Merian. By contrast, his works appear in only 5% of the libraries of non-Merian owners—an enormous difference. A less extreme contrast is provided by the relative ranking of the works of Pliny the Elder, whose *Naturalis Historia*, despite being superseded by the findings of modern natural history, remained a staple of learned collections until the end of the eighteenth century. While titles by Pliny are reported in 64% of the libraries that also held one or more works by Merian, they figure in only 45% of the libraries that did not. Such comparisons suggest that interest in the books of Maria Sibylla Merian might have been motivated as much by their exceptionally attractive illustrations (like Rumphius), as by their ostensibly scientific subject matter (like Rumphius and Pliny).

Table 4

Natural history authors in Merian-holding and non-Merian-holding libraries

Author	Merian-holding libraries	Non-Merian-holding libraries	Factor
Johannes Swammerdam	50%	7%	7.14
Georges-Louis de Buffon	46%	24%	1.92
Johannes Goedaert	46%	9%	5.11
Carolus Linnaeus	39%	16%	2.44
René-Antoine de Réaumur	32%	10%	3.20
Herman Boerhaave	29%	18%	1.61
Francesco Redi	18%	4%	4.50
Antoni van Leeuwenhoek	18%	7%	2.57

Scientific and Physico-Theological Works in Merian-Holding Libraries

If the top twenty authors listed in Merian-holding libraries reveal a modern outlook and a preference for works of natural history, then one might expect this pattern to hold among less frequently cited authors, too. The most obvious intellectual affinity that Merian's works harbor is with the works of other early scientists and entomologists, such as Goedaert's *Metamorphosis Naturalis* (1660–1669). Table 4 compares the percentage of Merian-holding versus non-Merian-holding collections containing works by a representative selection of seventeenth- and eighteenth-century entomologists and other natural history authors.

Clearly, libraries with one or more works by Merian reported more natural history books overall, ranging from a factor of 1.61 (Boerhaave) to a substantial 7.14 (Swammerdam). This disparity holds especially for works that examined insect life. Libraries with works by Merian are over seven times more likely to report Swammerdam's groundbreaking 1669 volume, *Historia Insectorum Generalis ofte Algemeene Verhandeling van de bloedeloose Dierkens*, as well as the posthumous edition of his work by anatomist Herman Boerhaave, bearing the significant title *Bybel der Natuure of Historie der Insecten= Biblia Naturae, sive Historia Insectorum* (1737). Swammerdam was another proponent of the physico-theological belief that the exquisite organization of the caterpillar's metamorphosis was an emblematic expression of the order of the universe itself, created by the Supreme Being. After Swammerdam, the second most reported author in Merian-holding libraries was Goedaert, towards whose *Metamorphosis Naturalis* (1662–1669) the title of Merian's own *Metamorphosis* appeared to gesture. Goedaert is followed by Italian physician-poet Francesco Redi, whose refutation of the Aristotelian theories of spontaneous generation, set out in *Esperienze intorno alla Generazione degl'Insetti*, was published just one year before the book by Swammerdam.

Table 5
Illustrated works of natural history in Merian- and non-Merian-holding libraries

Author	Merian-holding libraries	Non-Merian-holding libraries	Factor
Georg Everhard Rumphius	64%	5%	12.8
Mark Catesby	36%	2%	18.0
August Johann Rösel von Rosenhof	18%	3%	6.0
C. and J. C. Sepp	14%	2%	7.0
Eleazar Albin	11%	2%	5.5
Pieter Cramer	7%	0,07%	100.0

As noted above, however, the title that outperforms other modern titles by a factor of 12.8 in Merian-holding libraries is Rumphius's *Amboinsche Rariteitkamer*. Table 5 therefore compares the presence of other natural history works noted for their illustrations in both types of library.

Focusing on the specific genre of scientific illustration brings out the most defining feature of Merian-holding libraries. These were libraries not only with a modern outlook and a bias towards works of natural history, but libraries that also displayed a marked interest for richly illustrated works of natural history. Merian-holding libraries were five (Albin) to one hundred times (Cramer) more likely to also hold other illustrated works of natural history. While these findings are hardly surprising, they do show that bibliometric methods can confirm perceived links, noted by previous commentators, between Merian's works and titles such as Mark Catesby's *The Natural History of Carolina, Florida and the Bahama Islands* (1731–1747), or August Johann Rösel von Rosenhof's directly Merian-inspired *Insecten-Belustigung*. The latter was published in German in installments from 1746 onwards, and later in Dutch (ca. 1764–1766). The illustrations were made and etched or engraved by the author himself, just as Merian had illustrated her own works. Later installments were probably colored by his artist-scientist daughter, Katharina Barbara Rösel von Rosenhof. These myriad lines of intellectual affinity and even influence running between authors and works can thus be made newly visible through statistical analyses of the contents of eighteenth-century libraries.

Works that displayed a broader physico-theological outlook may have held a particular attraction for Merian owners. Table 6, finally, compares the frequency of works by physico-theological authors in both types of library. Casting the net widely, it includes authors working in various periods and national contexts, from the British Isles (Derham, Ray) to the Netherlands (Nieuwentijt, Martinet, Post), France (Pluche), Germany (Lesser), and Switzerland (Bonnet).

The relative frequencies in this final table are less notable than the ones in previous comparisons, but do indicate trends. Works by physico-theological authors are reported more often in

Table 6
Physico-theological authors in Merian-reporting and non-Merian-reporting libraries

Author	Merian-holding libraries	Non-Merian-holding libraries	Factor
Noël-Antoine Pluche	54%	44%	1.23
John Ray	32%	14%	2.29
William Derham	32%	26%	1.23
Bernard Nieuwentijt	25%	19%	1.32
Charles Bonnet	25%	8%	3.12
Johannes Florentius Martinet	14%	11%	1.27
Elisabeth Maria Post	11%	3%	3.67
Friedrich Christian Lesser	7%	4%	1.75

Merian-holding than in non-Merian-holding libraries. The most commercially successful of these authors, Elisabeth Maria Post, is almost four times more likely to figure in a Merian-holding library than in a non-Merian-holding library, although this apparent predominance may be skewed by the overrepresentation of Dutch library auction catalogues among Merian-holding libraries. Of the non-Dutch authors, the highest ratio is by Genevan naturalist and philosopher Charles Bonnet, whose 1745 *Traité d'insectologie* did much to update and reintegrate a Christian-inspired Great Chain of Being scheme into modern biology. Particularly prevalent authors such as Noël-Antoine Pluche (*Le spectacle de la nature*) and William Derham (*Physico-theology*), as measured by absolute numbers of books in the library catalogues in my corpus, are reported in Merian-holding libraries in frequencies comparable to non-Merian-holding libraries. Pluche and Derham are 1.23 times more likely to figure in Merian-holding libraries than in non-Merian-holding ones, only slightly more than the average overrepresentation factor of 1.09 obtained for *all* books in Merian-holding libraries.

Conclusion

Using the computational power of the MEDIATE database to construct a profile of eighteenth-century private libraries holding works by Maria Sibylla Merian allows historians to sketch the contours of the "common" Merian book owner. Comparisons of Merian-holding and non-Merian-holding libraries show measurable, if sometimes subtle differences between the two types of libraries. In some cases, these trends appear obvious enough to raise new questions and call for further, close-reading analyses of the similarities between these works to complement initial, distant-reading approaches.[2] Both kinds of libraries display the same predilection for the canonical authors and works of classical antiquity, but the libraries of Merian owners have a slightly more modern outlook and a distinct bent towards works of a scientific nature, particularly richly illustrated works of

natural history. What is more intriguing, perhaps, is that libraries that report one or more works by Merian also share more pronounced physico-theological leanings than non-Merian-holding libraries. This reminds us that to understand the broader intellectual contexts in which eighteenth-century individuals approached Merian's work, it is necessary to consider the theological framework within which early-modern work in natural history was embedded.

These contexts point not only to significant relations between art and science, but also between religion and science. Reconsidering the links between the development of Merian's religious identities and cultural contexts may therefore further elucidate the meanings that her two major works, the *Raupenbücher* and her *Metamorphosis*, held for contemporary readers, well into the eighteenth century.

The Rewarding Gaze.
How a French Triumvirate in Amsterdam Misused Johannes Goedaert's Work to Create Maria Sibylla Merian's "Collected Works" and What This Meant for My Art

Joos van de Plas

Part I - Stolen Observations

Around the dawn of the new millennium, almost unnoticed, a fascination from my childhood entered my studio. It was the fascination for the butterfly. In a very short time span, it took over my entire visual work and stayed with me up to the present day. First, it rekindled my interest in old books, books from the dawn of science. My utmost attention was again given to books on plants and insects. While becoming more and more familiar with these famous books, one specific area proved to be uniquely in-spiring to me: the metamorphosis of the butterfly and the way this mesmerizing process was discovered and later researched, documented, and depicted.

The Celebrity

My interest eventually led me to the study of the heritage of Maria Sibylla Merian, the development of natural history, and the scientific books of her time. This proved to be an important catalyst for my own art and research. In both her research and my own, observing—very concentrated observation—is crucial.

The impact of fathoming Merian's legacy urged me, among other things, to travel to Suriname in an attempt to see the tropics through her eyes.[1] There and elsewhere, I have been searching for Merian's moments of inspiration. What captured her imagination, what motivated her, how did she create those fabulous images? The moments of discovery in the meticulous observation of little-known insects and plants must have surely thrilled her. She must have felt like an explorer treading undiscovered ground.

In my visual work, my reading, and my nursing of caterpillars and butterflies, I regularly run into puzzles. Like finding the very plantations were Merian worked in Suriname and the research I did in the Gerning Collection at Museum Wiesbaden.[2] These puzzles tempted me to leave my studio for a while and delve into some mystery out there, in libraries, museums, and zoological and botanical gardens. They are the byproducts of my search for inspiration. They arouse my curiosity and, although they appear to lure me away from the path I follow in my studio, they ultimately make that path more exciting, and full of surprises.

One of the advantages of my position as an artist, as compared to that of a scientist, is it endows me with much more freedom. The intended end product of a scientist will be knowledge, possibly in support of a new theory. Gaining knowledge in the personal scientific domain should be a joyful and inspiring experience. Inspiration plays its part in science, but is never the leading part, as it is in art. My "research objective" is in-spiration; I seek subjects that inspire me and will form the impetus of new works of art. However, in the search for inspiration I sometimes make a discovery.[3]

The Careless Merian Publisher

On 11 May 2012, during one of my many visits to the Artis Library in Amsterdam, I came across a voluminous folio work titled *De Europische Insecten*. As I pored over the pages, it became clear that the publication brought together all of Merian's work: the *Metamorphosis Insectorum Surinamensium*, her three-part *Raupenbücher* (Caterpillar Books) and the three-part *Blumenbuch*, later published again, with a printed introduction, as *Neues Blumenbuch*. This impressive work by Merian was published posthumously in Amsterdam by a certain Jean Frédéric Bernard (1680–1744) in 1730, thirteen years after Merian's death.

Bernard, originally from Velaux, France, established himself in Amsterdam as a publisher in 1711. He had an almost complete set of Merian's original copperplates at his disposal, acquired from another Amsterdam publisher, Johannes Oosterwyk (1672–1737), who had published an edition of Merian's Caterpillar Books in Latin in 1718 and an enlarged edition of *Metamorphosis* in 1719 (see the chapter by Van Deinsen in this volume). This purchase ultimately led to the publication of her "collected works" in 1730, under the title *De Europische Insecten*. In the same year, he published an edition in French, entitled *Histoire des Insectes de l'Europe*, as well as a newly printed edition of

Metamorphosis. Having seen several copies of the editions in Dutch as well as in French, it appears that no two of these books are exactly the same. Some, for instance, include *Metamorphosis,* while others only include the Caterpillar Books and the *Blumenbücher.* Nevertheless, one can distinguish two main categories:

(1) The version I call "elaborate", because in this version the leaves of *De Europische Insecten* usually have only two etchings printed on one page. This is probably how the volume was conceived; in this arrangement, the beautiful plates are shown to their best advantage. However, some pages show only one plate, like the rose (plate 24) and the oak tree (plate 50) of the first Caterpillar Book. I found a copy representative of this "elaborate" version in the collections of the University of Amsterdam (Fig. 1).[4] In this particular copy the front cover is printed with the title: *M.S. MERIAN Surinaamsche en Europische INSECTEN.* This is an appropriate title, because the *Metamorphosis,* Oosterwyk's version of 1719, precedes *De Europische Insecten,* which consists of the three-part Caterpillar Books and the three *Blumenbücher.* The latter tomes were printed by Bernard and only contain European insects. In all the "elaborate" versions I have seen, the *Metamorphosis*

Fig. 1 M.S. Merian, *Metamorphosis Insectorum Surinamensium,* published by J. Oosterwyk (1719), bound with *De Europische Insecten,* published by J.F. Bernard (1730). The left page shows the wreath that separates the *Metamorphosis* from *De Europische Insecten* in the "elaborate" edition. Allard Pierson, University of Amsterdam, KF 61-3823 (1-2).

and the two sections of *De Europische Insecten* are divided by an extra plate decorated with twelve insects (see Fig. 1 and Appendix, remark a.).

(2) In the second version, the version I call "compact", individual copies differ even more. The book I refer to here is in the library of the Netherlands' Entomological Society (NEV), presently housed in Naturalis, Leiden (Merian & Marret, *De Europische Insecten*, published by J.F. Bernard in Amsterdam in 1730). In this version of *De Europische Insecten*,

four etchings are placed on one page (cf. Fig. 2).

The Forerunner

In the Artis Library, where I saw *De Europische Insecten* for the very first time, I paused at the section of the *Blumenbücher*. There was something unnerving about it; something was not right. Foreign elements had been added to Merian's compositions!

One of these added drawings, a chrysalis, kept nagging at the back of my

Fig. 2 An example of the positioning of the plates in the "compact" version. I used this facsimile of Merian & Marret, *De Europische Insecten* (2010), as my reference and notebook.

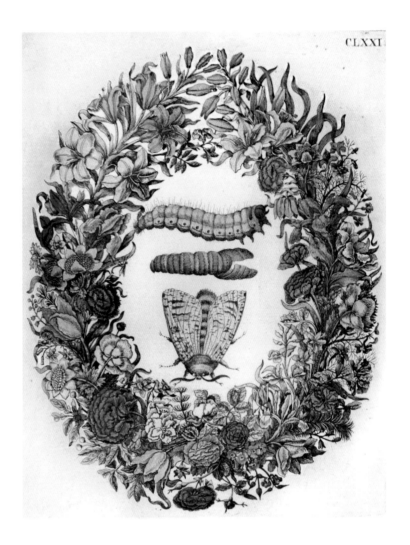

Fig. 3 On the left side, J. Goedaert, *Metamorphosis Naturalis*, Middelburg 1666–1669, volume 2, plate 33, 9.5 x 7.2 cm, is shown, while the right side shows Merian's original wreath with the copies of the Goedaert insects replacing the original title. Artis Library, Allard Pierson, University of Amsterdam, AB: 181-28 (left); Naturalis, Library of the Netherlands' Entomological Society (NEV), Leiden (right).

mind. It was a very un-Merianesque creature. I remembered it from somewhere else. One morning, just before awakening, I suddenly knew where I had seen it before: in the second volume of *Metamorphosis Naturalis* by Johannes Goedaert (1617–1668).

During my next visit to the library, I asked for Goedaert's books. With these in hand, I could conclude that his etchings had been the examples for the added illustrations in the *Blumenbuch* plates. It also became clear that these did not originate directly from Goedaert's plates. They were copied, redrawn from the images in his books, possibly straight onto the Merian copperplates. As a result, most of them were mirrored. The reproductions were

quite accurate, though some had been slightly adapted to fit Merian's composition (Fig. 3). Now I could link every single one of the 56 copied insect drawings to Goedaert's originals (see the comparative table in the Appendix). Goedaert himself could not have inserted these on the *Blumenbuch* copperplates. Like Merian, he was long deceased when this strange volume was published.

Looking at those "enhanced" plates, one cannot deny that the drawing styles of Merian and Goedaert are a strange match. Goedaert's sober drawings are a lot less fluently executed than Merian's baroque compositions. On top of that, the copyist placed them quite awkwardly in the Merian plates, sometimes even in rigid rows, the exact same way as they were drawn in Goedaert's books. Even in cases where Goedaert's creatures were modified to fit into Merian's "still lifes", they still look positively foreign.

The Eclectic Copyist

Looking for clues, I noticed that Bernard had also added another new ornament to the title page of his *De Europische Insecten*, I found a vignette and therein, almost hidden in a trumpet banner, a signature and a date: B. Picart, del, 1718. This Bernard Picart (1673–1733), so I discovered, was a French artist who lived in Amsterdam during the last decades of his life. He worked regularly for Jean Frédéric Bernard, the publisher. They had, for instance, cooperated earlier in the publication of the famous multivolume work *Cérémonies et Coutumes Religieuses de Tous les Peuples du Monde*

(1723–1743). The Rijksmuseum in Amsterdam houses a large collection of works by Picart. He was a well-known, talented artist, skilled in a wide range of styles and specialisms. As an "intermediary draughtsman", he worked mainly on commission. He likely had a workshop in Amsterdam, with some apprentices.

Another place that preserves works by Picart is the Prentenkabinet in Leiden University Libraries. Here I discovered some studies of the metamorphosis of the silkworm, done in red chalk. Picart's name is written underneath, albeit in black ink. These proved to be the preliminary sketches for the drawing that adorns the new center for the Merian wreath on the title page of the first part of the Caterpillar Books in the Bernard compilation (Fig. 4).

Neither Bernard nor Picart seem to have had any real knowledge of insects. So it could be that the latter designed a strangely incongruent new vignette for the titlepage of Bernard's 1730 edition of the Suriname book by copying the rather spectacular European caterpillar, *Cerura vinula*, from Goedaert and placing it in the center of a small wreath made earlier by Merian for her *Blumenbuch*, only showing European flowers.[5]

Later, in the collection of the Rijksmuseum, I found an etching by Picart with the life cycles of an ant. This etching matches the one that sits in the center of the wreath of the image that opens the third Caterpillar Book. These metamorphoses appear again in the wreaths in plate LI and CI, originally representing the frontispieces of the first and

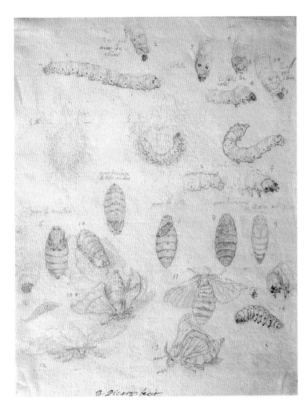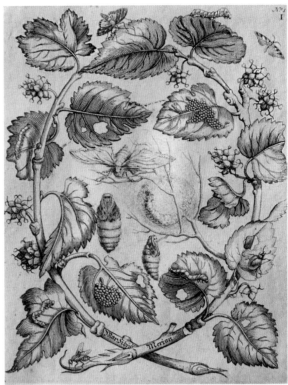

Fig. 4 Picart's sketches for the metamorphosis of the silkworm (197 mm x 154 mm) and how these were used in the title etching of the first volume of the Caterpillar Book. Prentenkabinet, Leiden University Libraries, PK AW 1296 (left) and Rijksmuseum, Amsterdam (right).

third *Rupsen* books. In the same collection, I also found etchings of beehives very similar to the one in the wreath that opens the second Caterpillar Book. From these facts we can safely infer that it was Picart who executed the new versions of Merian's title pages. Is it a flight of fancy, then, to suggest that, after changing the Merian frontispieces, the Goedaert copies also came from Picart's workshop, commissioned by the publisher Bernard, a fellow Frenchman? I dare to put this forward because I discovered several instances of Merian's oeuvre being used in Picart's work, but will come back to this later.

The Part-Time Plagiarizer

But my personal discoveries did not end there, because I knew that Merian's *Blumenbücher* were originally not very ambitious publications.[6] The young Merian's decorative plates were primarily meant to be used as patterns for embroideries (see the essay by Sauer in this volume). As such, there was no need for explanatory texts alongside the plates.

As part of *De Europische Insecten*, however, every *Blumenbuch* plate is usually accompanied by three paragraphs, although there are numerous exceptions with less than three. The first is a list of the names of the plants shown in the

plate, in French or Dutch and also in Latin. This is followed by informative texts about the insects. The bottom paragraph is about the plants. Evidently this was done to bring the *Blumenbücher* up to the quality and format of the Caterpillar Books and the *Metamorphosis*. According to the title page, the author of the descriptions of the plants that accompany the *Blumenbuch* illustrations is Jean Marret (1701-?), *Docteur en Medecine*. It also states that he is the author of the *explications* that describe the insects in the "eighteen new plates".[7]

The first thing the reader notices is a difference occurring in the three paragraphs on plates from the *Blumenbücher*. The first few lines are committed to the plant names in Dutch or French, together with their Latin name. The bottom paragraph, in smaller print, describes the plants in the Merian plates. These two paragraphs indeed show the hand of a specialist, Jean Marret. The middle paragraph describes the insects in the accompanying plate, usually just the added insects and not the ones Merian drew in some of the plates. Reading some of these explanatory notes, I found their style quite different from the other paragraphs. I experienced the same *déjà vu* with the texts as I did with the added insects on the plates. They echoed Goedaert!

When, with the help of Kees Beaart, who owns a splendid collection of original Goedaert books, I delved deeper into this matter, it became clear that almost all the written observations in the middle paragraphs were indeed derived from Goedaert's books. They were slightly changed here and there, and dates were placed in the eighteenth century rather than the seventeenth, while the first person singular now suggests Marret rather than Goedaert.[8] So not just Goedaert's illustrations were copied, but his texts were copied as well. When I counted the *explications*, there were indeed eighteen of them, thus the images they refer to are most likely the "new" plates mentioned on the title page.[9]

Quoting just one example of Marret's plagiarism from the text belonging to plate 175, where he almost literally follows Goedaert in volume II, plate 14 (from the contemporary translation into English by Martin Lister): "I then bethought my self of giving it to eat dead *Pismiers Beetls* [...] This *Worm* lay in the body of the *Beetle*, it had fed on, from the 18th. of *August*, untill the 8th. of *June*, the Year following; then out came a winged *Insect*, beautifull, and elegant."[10]

In Marret's words: "Je lui donnai des escarbots [...] Il resta dans cette retraite depuis le vingt-unième Août de l'année 1729 jusqu'au neufvième de Juin de l'année suivante. Alors il en sortit un petit Animal ailé fort beau."[11] Thus Marret simply used Goedaert's dates and brought Goedaert's observations into another century.

Conclusion

The ambitious Bernard-Picart-Marret project, the publication of Merian's "Collected Works", appears to have been, especially in the "compact" version, primarily a commercial endeavor. Her different books were simply bundled

together and given a new title. The changes in the original Merian title etchings are done in a style alien to Merian's. But strangest is the treatment of the *Blumenbücher*, "enhanced" in a casual way by stealing the etchings as well as the texts from Johannes Goedaert of Middelburg, the researcher and *fijnschilder* of the previous century.[12]

Part II - The Copyist Copied

The outcome of the findings described above were the works I presented in the recent exhibition titled *Chance and Change* at Galerie Wit in Wageningen (Fig. 5).[13] It showed most of the visual work I produced while doing the research for the present essay. Of the whole body of work that comprised that show, I want to describe one work that is most closely linked to my abovementioned research, a work titled "Stolen Observations".

In this thirteen-piece work, I started off as a copyist, copying not only Merian's and Goedaert's illustrations but also the Goedaert copies and Picart's own work. Hence, quite a few of my drawings are copies of copies. First of all, this gave me insight in the practice of a copyist. While copying the lines or brush marks of the original, the copyist must make many decisions. When, for instance, reproducing a particularly freely sketched drawing, do I then try to copy those lines as minutely as possible, resulting in lines less free and undulating, or do I try to give them exactly that characteristic and, as a result, make the copy less faithful? Then there is the "translation" of the original into a different technique, which brings with it the need for interpretation and thus a whole new set of problems. This, of course, is an age-old phenomenon. In Merian's time, the

Fig. 5 Galerie Wit, *Chance & Change*. Exhibition, 29 May 2020–13 June 2021, Wageningen.

engraver had to interpret the drawing or watercolor she handed him. Even when she herself was the engraver, she had to interpret it.

Every piece of the aforementioned "Stolen Observations" consists of a copy of a Merian plate from the *Blumenbuch* part of *De Europische Insecten* (Fig. 6), where I transformed Merian's images into *Schattenbilder* (silhouettes). As a child I regularly spent my vacations with my great-aunts and -uncles on their vineyard estate in Mainz, Germany. For me, the somewhat old-fashioned

Fig. 6 Part of *Stolen Observations* (Joos van de Plas, 2020), a thirteen-part polyptych, drawing, collage on paper, 280 x 100 cm.

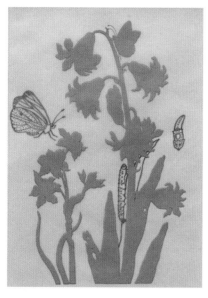
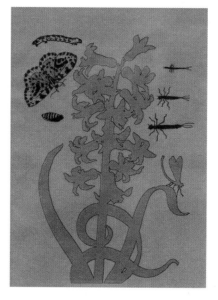
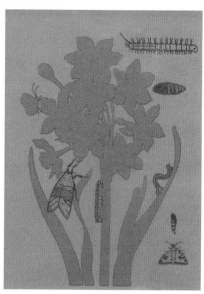

Schattenbilder they had on their walls, meticulously cut from black paper, stood for suspense and mystery. By reducing Merian's baroque drawings of plants to their black silhouettes, I also refer to how plants and insects are vanishing all over the world. Hiding them, as it were, under a veil of mourning.

I obtained the background color, for contrast and as a sign of hope, by reproducing the dominant color of the original individual plate in the hand-colored copy of *De Europische Insecten* in the library of the Netherlands' Entomological Society. These *Schattenbilder* have a semi-transparent overlay. This sheet shows the viewer where the elements that were added to Merian's illustrations ended up in the images. It specifically shows the subject of my research as well. By making Merian's images less dominant, the Goedaert creatures come to the foreground. I think this is a small compensation for the fact that his pioneering work often stands in a shadow—a shadow cast by the bright light of attention focused on Merian's virtuosity. Now the observer can look at those eighteenth-century "collages" through my eyes, and will hopefully find them as exciting as I do. My aim, after all, is an attempt to take the observer with me on my months-long journey, to illuminate the trail of my observations.

In the first part of this essay, we have seen how seventeenth- and eighteenth-century artists and scientists made new observations. These observations were captured in drawings and made public in magnificent books. The images that were produced for those books were often copied. As copies, they were regularly used in new combinations whereby new personal interpretations occurred—interpretations that were surely not meant as such by the original makers. For example, the Rijksmuseum preserves a Picart etching titled *Allegorie op de West- en Oost-Indische Compagnie*, dated 1726. In this plate he makes use of the most dramatic of all Merian scenes, the hummingbird devoured by a tarantula. The choice is interesting. With this image it was made clear that the colonial world was not all paradise. Thus, the image gained a philosophical meaning.

This phenomenon makes it clear that my work is a continuation of this free-for-all with centuries-old observations. Like Picart, I am not only searching for new knowledge but also for the philosophical and artistic meaning of the images and situations I have observed. To give my work the right tension, it is necessary to make accurate observations but, at the same time, to be completely free in my use of these rich and varied data. In this way, my method represents an equilibrium between comprehension and imagination.

* My special thanks to Frans Lampe, Michael van Hoogenhuyze, Florence Pieters, Kees Beaart, and Robert Kelly. You all kept me going.

APPENDIX: Comparative table of plates and texts used for *De Europische Insecten/Histoire des Insectes de l'Europe*.

The three-part "Neues Blumenbuch"-section of "De Europische Insecten"

	Merian		Goedaert		Marret		
Plate no.	**Part I**	Insects	**Origin of Goedaert's copies**	Insects	**Plates**	**Text ■**	Remarks
1	Title page, Wreath	4		12			a
2	Butterfly f.p.*	1	Vol. I, pl. XI	3	CLVII	■	b
3	Butterfly, Dragonfly f.p.	2	Vol. I, pl. XXXXI; Vol. III, pl. R	5	CLVI	■	c
4	Butterfly, Caterpillar f.p.	2			CLIX	■	
5	Butterfly f.p.	1	Vol. III, pl. G, pl. K	7	CLIV	■	
6	Butterfly, Fly f.p.	2			CLXXXI		
7	Fly, Bouquet	1			CLXXVIII		
8	Butterfly f.p.	1			CLXIII	■	d
9	Dragonfly, Butterfly f.p.	2			CLIII	■	e
10	Dragonfly, Spider f.p.	2			CLXVII	■	f
11	Butterfly f.p.	1			CLXXIV		
12	Bug, Butterfly f.p.	2			CLXIV	■	g
	Part II						
1+	Title page, Wreath		Vol. II, pl. 33	3	CLXXI–CLXXII	■	h
2+	Small Bouquets				CLXX		i
2+	Small Wreath, left		Vol. II, pl. 37	1	CLXX		j
3+	Dragonfly, Butterfly f.p.	2	Vol. III, pl. N	3	CLXV	■	k
4+	f.p.		Vol. I, pl. XVII	3	CLX	■	
5+	f.p.						l
6+	f.p.						m
7+	f.p.		Vol. II, pl. 40	3	CLXXVI	■	
8+	f.p.		Vol. I, pl. III	2	CLII	■	
9+	f.p.				CLXXX		
10+	f.p.		Vol. II, pl. 25	4	CLXXIX	■	
11+	Butterfly f.p.	1			CLXVI		
12+	Bouquet		Vol. II, pl. 14	3	CLXXV	■	
	Part III						
1-	Title page, Wreath						n
2-	Basket of Flowers				CLXIX		
3-	Vase of Flowers	5			CLXVIII		
4-	f.p.				CLVIII		
5-	f.p.				CLXXXII		
6-	Bouquet				CLXXVII	■	o
7-	f.p.		Vol. III, pl. D	4	CLXI	■	
8-	f.p.		Vol. I, pl. VII	3	CLV	■	
9-	Bird f.p.				CLXXIII		
10-	f.p.				CLXXXIV		
11-	Butterfly f.p.	1			CLXXXIII		
12-	f.p.				CLXII		

* f.p.= flowering plant(s)

The table is based on: Merian (1680); Merian et al. (1999); Goedaert & De Mey (1660–1669); Goedaert & De Mey (1700); Facsimile of Merian & Marret (2010); Beaart (2016) p. 114–121.

Remarks (see column at right-hand side):

a. This title wreath is the only plate without a Roman numeral. It includes twelve copies of Goedaert insects.

b. A leaf has been added to Merian's composition. This was done to give the caterpillar, also added, a foothold. The added leaf is the only botanical addition I found in the *Blumenbuch* plates.

c. The caterpillar and pupa on the left side of the plant and the three stages of the dragonfly larva on the right are copied from Goedaert. Goedaert's butterfly is larger and has different spots on the wings. The butterfly is Merian's.

d. Marret refers to "Cet Insecte se trouve décrit dans l'Explication trente-huitième". This is a text by Merian, *Rupsen*, Part I, XXXVIII.

e. No Goedaert copies. Butterfly and dragonfly are Merian's. Text by Marret, with no relation to Goedaert's texts, nor to Merian's insects.

f. Marret: "Je n'ai rien à remarquer sur la métamorphose de cet Insecte" (I have nothing to remark on the metamorphosis of this insect). This is a non-description.

g. No Goedaert copies. Bug and butterfly are Merian's. Marret's text is derived from Goedaert, plate 6, volume II. This is the only instance where Marret writes anything about an insect drawn by Merian; as usual, however, he uses a text by Goedaert.

h. Plates CLXXI–CLXXII both describe the wreath and insects in a single plate. Within the wreath are copies after Goedaert depicting the three life stages.

i. It was a real puzzle to find the right number for this plate, because only the text has a plate number, not the image. These two bouquets are the same as in Merian's *Blumenbuch*, though here they are printed upside-down.

j. This small wreath usually decorates the title page of the Suriname book when it is bound with the "compact" version of Merian & Marret (1730) in Dutch. In this reissue of the title page, in which the vignette is changed, the center of that wreath is adorned with a caterpillar copied from Goedaert (Merian (1730)).

k. Using a text by Goedaert, Marret describes a certain fly. But there is no fly depicted on plate CLXV.

l. This plate from the *Blumenbuch* does not appear in both editions of Merian & Marret (1730).

m. This plate from the *Blumenbuch* does not appear in both editions of Merian & Marret (1730).

n. This wreath does not appear in both editions of Merian & Marret (1730).

o. Marret: "J'ai donné la description de cette Plante, & Madame Merian n'y aient point placé d'Insecte, on ne peut y joindre aucune description." Although Marret states that he cannot describe insects in this plate because Merian did not include any, he never describes the insects Merian drew, just the added insect drawings after Goedaert. There is only one exception: plate CLXIV.

How to Crack Such Shells? Maria Sibylla Merian and Catalogues of Zoological Specimens

Yulia Dunaeva & Bert van de Roemer

In the early modern period, collecting was an omnipresent pastime in Europe among different social strata of society.[1] Many collectors were involved in the exchange and trade of *naturalia*. A significant problem in the communication between these collectors, naturalists, and traders was the correct nomenclature of the specimens they were corresponding about, as names were not yet standardized. Books with illustrations of plants and animals played an important role in the identification of specimens and were often used to be more precise. Historian of science Dániel Margócsy coined this communicational mode with the phrase "refer to folio and number", as authors always needed to name the publication, the page number, and the number of the illustration in order to acknowledge that they were talking about the same thing.[2] The published images of Maria Sibylla Merian were of essential importance in this process. We will describe how her works were employed for this method of "referring to folio and number" by discussing five catalogues of zoological specimens, concluding with the celebrated publication by the famous Swedish naturalist Carl Linnaeus (1707–1778), the tenth edition of *Systema Naturae* (1758), which is usually seen as a threshold constituting the starting point of modern scientific zoological nomenclature.

After the publication of the *Systema Naturae*, the standardization of the identification of animals started to develop.[3] Before this seminal publication, there was a proliferation of names and different taxonomic systems.[4] Naturalists used vernacular names or diagnostic phrase names containing morphological or biological features. Consistency seemed not to be their aim, as a naming of one species might change within the same publication of one author.[5] Many scholars

considered this abundance of names and systems a troublesome problem. Botanist John Tradescant the Younger (1608–1662) wrote about the difficulties he encountered with naming zoological specimens when he compiled the catalogue of his father's collection. When trying to explain why he composed the list partly in Latin and partly in English, he added an expressive phrase: "Encroachers upon that faculty, may try how they can crack such shells."[6] Likewise, the German naturalist Georg Everhard Rumphius (1627–1702) mentioned that one of the reasons for his publication about crustaceans, shells, and minerals on the Indonesian island of Ambon was because enthusiasts of *naturalia* ("*Liefhebbers*") could not understand each other due to the many names given to various species.[7] Merian was also aware of the complexities concerning nomenclature, stating in the preface of *Metamorphosis Insectorum Surinamensium* (1705) that she only employed plant names used by indigenous people and inhabitants, and that she relied on Caspar Commelin (1668–1731), the professor of botany in Amsterdam, for the Latin names. Did she foresee the role her work would play in the exchange of information about specimens? Certainly she published her work with an eye to the *Liefhebber*, as she dedicated her work to these enthusiasts, many of whom tried to make their identifications more precise by referring to her published images of similar organisms.[8]

The quality of these images made by Merian was very high. When composing the plates for her books, Merian used her detailed watercolors of insects that she had previously made in her *Studienbuch*. She etched most of the plates in her books herself, and for others she closely supervised the artisans who cut the plates. She was very concerned with color accuracy (see also the chapter by Schmidt-Loske and Etheridge in this volume).[9] Every image contained many fine visual details of an animal that could help identifying a specimen and make it recognizable as a specific type.[10] No wonder that her illustrations did not escape the attention of compilers of scholarly and commercial catalogues.

The Pharmacist with a Network of Agents: James Petiver

An example of a naturalist and collector who refined the descriptions of his insect specimens with references to Merian's books was James Petiver (ca. 1663–1718). Petiver was the proprietor of an apothecary shop in London and had a passion for *naturalia*. He managed to arrange one of the largest and most varied collections of specimens of natural history that existed in England during the early eighteenth century.[11] To enrich his collection with exotic specimens, Petiver organized a network of persons who sailed over the Atlantic or lived in different places, from Moscow to the British colonies in the so-called New World, and from the Cape of Good Hope to the Spanish settlements in the Philippines. A few dozen correspondents and contributors—shipmasters, ship's surgeons, missionaries, physicians, servants of trading companies, etc.—sent

or brought him natural objects from all over the world.[12]

Petiver owned Merian's publications and corresponded with her about the exchange of specimens, finding clientele in England for her Suriname book and translating her work into English.[13] In 1695, he published the first part of his catalogue entitled *Musei Petiveriani Centuria Prima Rariora Naturae Continens*. Five more parts followed: *Centuria secunda & tertia* (1698), *Centuria quarta & quinta* and *Centuria sexta & septima* (1699), *Centuria octava* (1700), and the last issue, *Centuria nona & decima* (1703). The pagination in these issues was continuous.[14] In total he described one thousand specimens of *naturalia* in batches of a hundred, called *Centuriae*. The larger part concerned plants, but he also included many animals. All issues of the catalogue except the second one (1698) contained descriptions of insects. These were partly in Latin and partly in English.

As a rule, each of Petiver's descriptions of insects begins with a Latin diagnostic phrase name. The first word in such a phrase often indicates a higher taxonomical group that a specimen can be grouped under: butterflies (*Papilio*), moths (*Phalaena*), dragonflies (*Libella*), beetles (*Scarabaeus*), flies (*Musca*), and so on. This is followed by one, two, or more morphological features of a specimen that usually concern the size, form, and colors of an insect. He also includes Latinized geographic names indicating the countries of origin. These phrase names were followed by references to published sources with information about the insect. After the references, Petiver gave also an English name, if one existed. At the end of each description he usually reported very briefly some biological traits of an insect. When specimens were received from abroad, Petiver added the name of the donor.

As was the custom in those days, Petiver presented the published references in an abbreviated form. As a rule, they contain no more than three or four letters of the last name of an author and the number of the page or plate. He presented a list of abbreviations with the first *Centuria*, so it is clear which authors he meant. Most common were "Aldr." (Aldrovandi), "Mof." (Moffet), and "Johnst." (Jonston). In many descriptions of insects, he mentions "Graf. v. 1" and "Graf. v. 2." The list of abbreviations explains it refers to "Graf. v. 1: Mar. Sibyll. Graffin, of Insects. Dutch. Nürn. 1679. 4°" and "Graf. v. 2: Her 2nd vol. in Dutch. Franc. ad Moen. 1683. 4°".[15] With these references he meant the first and second volume of *Der Raupen wunderbare Verwandelung*, which Merian published under her husband's last name, "Graffin". He mentions the first part seven times and the second three times, in descriptions of six butterflies, two moths, one caterpillar, and one pupa. Obviously, all these descriptions concern European insects.

In the first *Centuria*, Petiver referred three times to plate 29 from the first *Raupenbuch* (Fig. 1). This plate illustrates the developmental stages of the common magpie moth (*Abraxas*

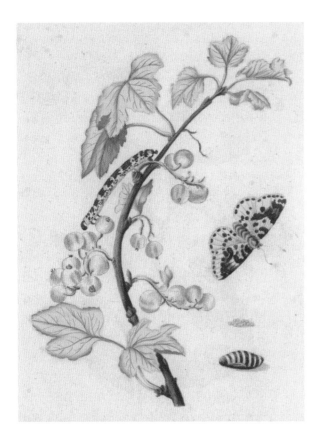

Fig. 1 M.S. Merian, The development stages of the common magpie moth (*Abraxas grossulariata*) on a white currant (*Ribes rubrum*), in M.S. Merian, *Der Rupsen Begin, Voedzel en Wonderbaare Verandering*, part I, Amsterdam 1712, plate 29, hand-colored etching, counterproof, 18.6 x 14 cm (plate). Artis Library, Allard Pierson, University of Amsterdam, AB Legkast 019.02. Same image (reversed) as in *Der Raupen wunderbare Verwandelung*, Nuremberg 1679.

descriptions and to stress their temporal coherence. Did it seem more logical for him to describe the dried imago apart from the caterpillar and the pupa preserved in alcohol? In any case, he added to all three descriptions references to the same plate in Merian's book, emphasizing the connection between the three stages and so giving additional indication of the moth's metamorphosis.

The Curious Preserver: Levinus Vincent

At the end of his catalogue, Petiver added an "acknowledgment": a list of persons he was obliged to for sending specimens. Among these persons, he mentioned the "curious preserver of all natural and artificial rarities, 'myn heer' Levinus Vincent at Amsterdam", who had sent to Petiver "divers admirable insects".[18] Merian, Petiver, and Vincent belonged to the same international network of exchanging specimens, information, and documentation. The letters from both Merian and Vincent to Petiver, preserved in the British Library, show there was some conflict between the two concerning who would be Petiver's contact person in the Dutch Republic.[19]

Levinus Vincent (1658–1727) was a Dutch designer, producer, and seller of luxurious cloth, and together with his wife, Joanna van Breda (1653?–1715), he owned and curated a "Wonder Theatre of Nature". Their collection was considered one of the finest in the Dutch Republic around 1700. Vincent published four catalogues of his collection

grossulariata) on a white currant (*Ribes rubrum*).[16] Petiver listed the imago, the caterpillar, and the pupa as three different specimens in his collection, and he placed the description of the imago on another page.[17] From his notes on the caterpillar and the pupa it is clear that he was aware that these were stages of the metamorphosis of the moth described on the previous page. Apparently, he felt no need to combine the three

Fig. 2 R. de Hooghe (design), J. van Vianen (etching), Allegorical representation of the collection of Levinus Vincent and Joanna van Breda. Frontispiece of L. Vincent, *Wondertooneel der Nature*, Amsterdam 1706. Allard Pierson, University of Amsterdam.

1708), giving an allegorical impression of the collection (Fig. 2).

Just like Petiver, Vincent organized his list of specimens in hundreds. There are six of these, which describe six hundred glass jars with specimens. These are followed by a list of 45 items concerning toads and frogs, a special interest of Vincent's. The catalogue ends with a list of one hundred ethnographical objects. In the first group of a hundred specimens, Vincent listed both vertebrate and invertebrate animals. Insects are absent from this publication, because he preserved them in separate boxes and drawers. However, he does mention some caterpillars, for which he occasionally used Merian's *Metamorphosis* as source of reference. The descriptions in this catalogue are less informative than those of Petiver, because Vincent used the diagnostic phrase names without the notes on biological traits of the animals. Moreover, he rarely added references to other sources of information and, when he did, he almost never clarified a reference with the number of the page or plate. However, there are few exceptions. He supplemented twelve descriptions in the catalogue with references to Merian's *Metamorphosis*; in eleven of these, he specified the numbers of the relevant plates.[21] All of these particular descriptions concerned the larvae of South American insects: eleven moths or butterflies and one beetle. Just like Petiver, Vincent ignored the association between the larvae and some imagoes of insects, though the references to Merian's plates supplied this information.

between 1706 and 1726. In the catalogue of 1719, which also lists the contents of his library, he mentions Merian's *Metamorphosis*, but not her European Caterpillar Books. In 1726, Vincent published his most extensive bilingual catalogue in Latin and French, titled *Catalogue et description des animaux [...]*. This is an inventory of a part of his zoological collection listing primarily the specimens kept in alcohol and some ethnographical objects.[20] It was published *in quarto* without illustrations, but included an earlier etched frontispiece by Romeyn de Hooghe (1645–

The Pharmacist's Treasures: Albertus Seba

Rich collections like those of Levinus Vincent could evoke admiration or lead to competition by other Dutch collectors, such as Albertus Seba (1665–1736). This German-born pharmacist curated another famous and highly esteemed collection of *naturalia* in Amsterdam at the beginning of the eighteenth century.[22] In 1715, Seba offered his extensive collection for sale to the Russian Tsar Peter the Great (1672–1725). In a letter of 4 October 1715, Seba wrote to Peter's agent that his collection was more complete than that of Vincent.[23] Soon after successfully completing the bargain, Seba acquired a new collection that was even richer than the previous one. He decided to publish an illustrated catalogue of his *naturalia* and invited qualified artists to produce the plates by which all of his specimens should be displayed. The result was the appearance of *Locupletissimi Rerum Naturalium Thesauri* (1734–1765), one of the most impressive works of eighteenth-century natural history.[24] Seba's *Thesaurus*, as it is mostly called, comprises four large volumes *in folio* with 449 plates. Only the first and second volumes of this extensive work were published during Seba's lifetime. By the time of his death in 1736, the etchings for the third and the fourth volumes were nearly all ready, but the text was not yet finished.[25] Seba wrote the text in Dutch, which was translated into Latin and in French. There were two bilingual editions: Latin and French or Latin and Dutch. After Seba's death, Arnout Vosmaer (1720–1799) supplemented and revised the text of the third volume with the participation of other naturalists and wrote the text of the fourth volume. These were published in 1759 and 1765.[26] The content of the first volume is a mixture of plates showing various specimens of plants and vertebrate and invertebrate animals; the second volume concerns snakes, the third is devoted to fishes and other aquatic animals, and the fourth to the insects and minerals.

Like Vincent, Seba did not add many references to the descriptions of his specimens. However, Merian's Suriname book was also among those few sources of information to which he repeatedly referred. There are four references to Merian in the first volume and no less than sixteen in the fourth. Seba and Vosmaer formulated their references in a different mode than Petiver and Vincent. In all cases, they mention the author, either "D. Merian" or "Mad. Merian" or "Meriana". Most of the references in the fourth volume by Vosmaer were clarified with the plate numbers. Only few of these were supplied with inaccurate titles of the book, such as *Historia insectorum Surinamensium* or *Description insectorum Surinamensium*, or *Insectorum Surinamensium*.

In the first volume of the catalogue, Seba added references to Merian in the descriptions of animals other than insects: an opossum ("Muris, sylvestris, Americani, foemella"), a giant lizard ("Lacerta Tejuguacu, Americana, maxima, Sauvegarde dicta..."), and a caiman ("Crocodilus, Americanus, amphibius").[27]

Fig. 3 Two depictions of a female opossum with young on its back. Above: in A. Seba, *Locupletissimi rerum naturalium thesauri*, volume 1, Amsterdam 1734, plate 31, figure 5, etching. Below: in M.S. Merian, *Dissertatio de Generatione et Metamorphosibus Insectorum Surinamensium*, Amsterdam 1719, plate 66 (detail), etching. Both: Library of the Russian Academy of Sciences at the Zoological Institute, Saint Petersburg.

This shows that Seba relied on the second edition of the *Metamorphosis* from 1719 (or one of the later editions), because the publisher of this posthumous edition added twelve extra plates to the sixty originals of the 1705 edition. All the abovementioned animals are represented on these twelve extra plates.[28] This was also the case in the fourth volume of Seba's *Thesaurus*, where there is one reference to plate 65.[29]

The image of the mouse opossum (*Marmosa murina*) on plate 31 of the first volume in Seba's *Thesaurus* shows a strong resemblance with the animal on plate 66 of the *Metamorphosis* of 1719, which could hardly be accidental (Fig. 3). Both images show a female opossum with young on her back. Their number and placement are identical on both plates, and the positions of the heads, legs, and bodies are the same. However, Merian's opossum is rendered with greater awareness of the three-dimensionality of the forms (for instance, in the treatment of shadows), and with more understanding of the anatomy of the animal (for instance, in the structure of the head and ears). It seems unlikely that the illustrations were drawn from the same preserved specimens, because there are also some remarkable differences. Obviously, the stretched tail was turned upright in the Seba version, which might be caused by the smaller size of the copperplate used by Seba's etcher. In nature, young opossums do not curl their tail like that around the mother's tail, whether stretched or upright.[30] Another remarkable difference is that in Merian's plate the hind legs of the adult opossum were depicted incorrectly, with one toe pointed backward. This was corrected on the plate for the Seba catalogue. In any case, as all postures of the animals are similar, it is safe to assume that Seba's etcher followed Merian's image and was instructed by Seba to make a small correction. In the text, Seba comments on Merian's images and that the specimen he owned did not have claws

like a bird, as in Merian's picture, but hands like a monkey, with four fingers and a thumb with short claws. This example poses interesting questions about how Merian's work was used as a source of reference for illustrators as well as the more general practice of copying natural history illustrations.

The Kunstkamera of Saint Petersburg and Merian

In 1714, Tsar Peter the Great founded the first Russian public museum, the Kunstkamera, in Saint Petersburg. The tsar considered such an institute to be essential for enhancing the scientific prestige of Russia in Europe and to develop the educational system in his empire. He made many efforts to improve and replenish the museum. Several large collections were bought abroad, including the abovementioned collection of Albertus Seba and the famous anatomical cabinet of Frederik Ruysch (1638–1731).[31] The tsar decreed that all unusual and curious things found in Russia should be sent to Saint Petersburg to be preserved in the Kunstkamera. Moreover, the Russian government organized several expeditions to Siberia in the first half of the eighteenth century. Many specimens were collected during these voyages, and they enriched the Kunstkamera as well. As the museum's holdings increased rapidly, the need for systematization and cataloguing was felt in due course.

Between 1741 and 1745 the first extensive printed catalogue of the Kunstkamera, titled *Musei Imperialis Petropolitani*, was published in two octavo volumes in Latin and without illustrations. The first volume listed the *naturalia* and the second the *artificialia*. Seven thousand zoological specimens are described in the first part of the first volume.[32] The descriptions are brief and usually include the name of the animal, a brief account of its external features, the place of origin, and—like the examples discussed above—references to other publications with illustrations or information on the animal. The catalogue lists about 1,400 references to 49 sources by 42 authors. Among these references the works by Merian are mentioned 169 times. We can discern three groups here. First, there are 41 references to her Suriname book, formulated as "Mad. Merian. Metamorph. Insect. Surinamens." or "Mad. Mer. Insect. Surinam. Metamorph." or "M. Merian. Insect. Surinam." In addition to the shortened title of the book, each reference contains the number of a plate. The second group of references, 64 in all, leads us to different parts of the Caterpillar Books, formulated as "*Raupen-Verwandlung* Part I" (34 references), "*Raupen-Verwandlung* Part II" (23 references), and "*Raupen-Verwandlung* Part III" (seven references). These references in the catalogue are printed in a different Gothic font. Apparently, the compilers made no distinction in the linguistic differences between the first two German parts from 1679 and 1683 and the third part of 1717, which was in Dutch.

Remarkably, researchers in Saint Petersburg had one special and unique source by Merian at their disposal that remained unknown to other researchers

in Europe. In all, 64 references mention the manuscript journal of Merian, the so-called *Studienbuch*. This is a unique document containing her handwritten observations on metamorphosis, insect behavior, relationships with parasites, and other biological traits, accompanied by detailed watercolors on small pieces of vellum (see also the Introduction as well as the chapter by Schmidt-Loske and Etheridge in this volume).[33] Tsar Peter the Great's chief physician and adviser, Robert Areskin (1677–1718), bought this *Studienbuch*, among many other watercolors on larger sheets of vellum, in 1717 in Amsterdam and brought it to Russia. After Areskin's death, the manuscript entered the first Russian public library, which was closely related to the Kunstkamera.[34] The references to this manuscript are usually formulated as "Mad. Merian Journal" with added numbers of pages and figures. Importantly, the compilers of the Russian catalogue had access to these first-hand observations by Merian and used them for their cataloguing work. It is intriguing that they considered it an important reference source, even though it was not accessible for readers abroad. Therefore they frequently added a reference to a corresponding image in Merian's published work, as many of the *Studienbuch* images were also reprinted in her books.

Two Butterflies

The references to Merian images in the catalogue of the Kunstkamera can help to interpret the data much better, as the following example will show. One but-terfly is described as: "Papilio Suri-namensis nigra, ochroleucis maculis varia, alis inferioribus rufa macula in-signitis: depicta a Mad. Merian. Meta-morph. Insect. Surinam. Tab. XXXI" (A black butterfly from Suriname with var-ious pale yellow spots and with distinc-tive red spots on hind wings: pictured by Madame Merian in the *Metamorphosis* on plate 31).[35] A colored copy of plate XXXI of the *Metamorphosis* shows two butterfly imagoes with different color-ation (Fig. 4). The coloration of the lower butterfly partly corresponds with the description in the Kunstkamera cata-logue. The wings are dark with various pale yellow spots, but there are no dis-tinctive red spots on the underside of the hind wings. On the contrary, the upper butterfly has red spots, but the upper sides of the wings are dark green. At present, the identity of all insect species depicted by Merian in her *Metamorpho-sis* has been determined. The stages of lepidopteran development presented on plate XXXI represent the subspecies of the butterfly *Papilio* (*Heraclides*) *andro-geus androgeus* (Cramer, 1775), which is found in Suriname.[36] The adults of this subspecies are known for their sexual dimorphism; males and females have different coloration, and that is what Merian depicted here. The upper sides of male wings are dark with pale yellow spots, whereas the wings of females are dark green. There are small red spots on the undersides of the hind wings of both sexes.[37] The extremely concise descrip-tion of the butterfly in the catalogue of the Kunstkamera tells us very little

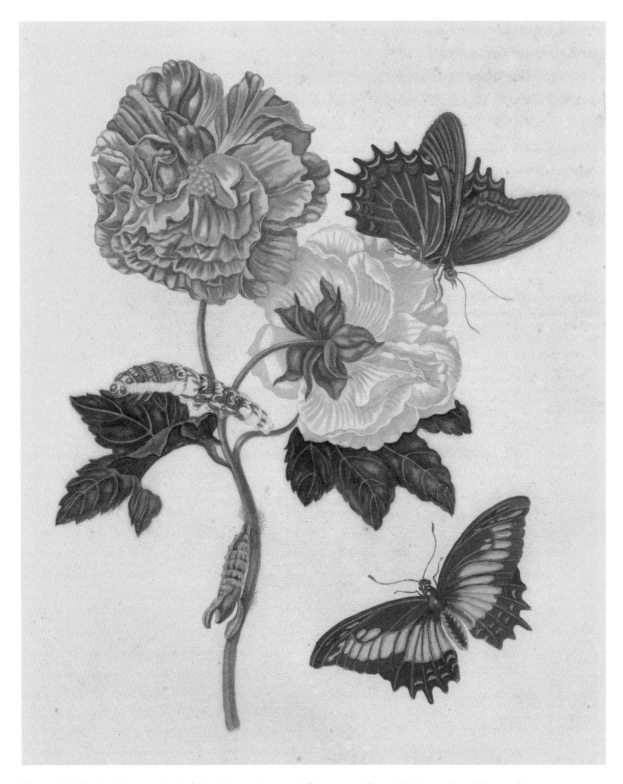

Fig. 4 M.S. Merian, Metamorphosis of *Heraclides androgeus* on *Hibiscus mutabilis*, in M.S. Merian, *Over de Voortteeling en wonderbaerlyke Veranderingen der Surinaemsche Insecten*, Amsterdam 1719, plate 31, hand-colored etching, counterproof. Artis Library, Allard Pierson, University of Amsterdam, AB Legkast 019.01.

about the specimen, but the added reference to Merian's plate led us to the name of the subspecies and even the gender of the insect that was preserved in the collection. Thanks to the links to Merian's books, we can get a visual representation of the zoological specimens of the Kunstkamera.

Linnaeus and Merian

Another example of the importance of Merian's illustrations for zoological identification in early modern natural history can be found in the work of no less a person than the famous Swedish naturalist Carl Linnaeus. He also used Merian's publications to "refer to folio and number", and we will illustrate this by discussing two works. Between 1751 and 1754 he worked for the King of Sweden, Adolf Fredrik (1710–1771), who maintained a natural history cabinet in the royal castle of Ulriksdal, located near Stockholm. Linnaeus, then professor in Uppsala, spent several weeks at the palace to prepare a catalogue of the *naturalia* collection, titled *Museum Regis Adolphi Friderici*. The catalogue was published in Stockholm in two volumes, in 1754 and 1764. The first volume is a luxury edition *in folio* with numerous engravings.[38]

Linnaeus used in this catalogue for the first time his binominal nomenclature for zoological specimens. The catalogue refers seven times to plates in Merian's *Metamorphosis*: four beetles, a peacock katydid (*Gryllus ocellatus*), a cicada (*Cicada mannifera*), and a tarantula (*Aranea avicularia*).[39] For the beetles, Linnaeus used the following names:

Scarabaeus elongatus, Cerambyx longimanus, Cerambyx cervinus, and *Buprestis maxima*.[40] These species were later included in the tenth edition of his *Systema Naturae* (1758), which will be discussed below. Linnaeus changed the names in three cases: *Scarabaeus elongatus* became *Scarabaeus interruptus, Cerambyx cervinus* became *Cerambyx cervicornis*, and *Buprestis maxima* became *Buprestis gigantea*.[41] As he was referring in both publications to the same images by Merian, we are certain he was talking about the same species. It also shows that the beetles in the Swedish royal collection can be considered as the type specimens for the respective species described in the *Systema Naturae*.

The famous tenth edition of Linnaeus's *Systema Naturae* did not describe the holdings of an actual collection; it was instead an attempt to systematize the whole natural world in order to solve the problem of the proliferations of names, mentioned earlier. Even though the tenth edition lists general species instead of specific specimens, it was organized in a way comparable to a catalogue of a collection. In the beginning of the chapter on "Insecta", Linnaeus enumerates Merian among those entomologists who made a considerable contribution through her outstanding images of the metamorphosis of insects.[42] Following this praise, he refers to her work 136 times. Botanist William T. Stearn published the first extensive discussion of Linnaeus's use of Merian's work in 1982, but this was restricted to the *Metamorphosis,* whereas we will discuss refer-

ences to all of her works.[43] The significant total number of 136 references shows that Merian's images were of great value for Linnaeus. This is especially notable in the section of *Systema Naturae* on butterflies, which has 99 references to Merian. Additionally, there are references to images of nineteen beetles, four cicadas, and several other insects, such as flies, mayflies, true bugs, and even aphids. There is also a reference to the famous image of the bird-eating spider (see Fig. 1 on p. 14 in the chapter by MacGregor in this volume), a frog, a lizard, and a bird.

The references to Merian's works in *Systema Naturae* can be divided in three groups. The first contains 46 references that concern organisms in the Suriname book. They are indicated with "Merian surin.", "Merian sur.", or "Mer. surin.", followed by a number of the page or plate, which always coincide (e.g., "Merian sur. 17 t. 17."). As these numbers run from 2 to 71, it is certain that Linnaeus used the posthumous publications of the *Metamorphosis* from 1719, 1726, or 1730, which contained twelve extra plates, as we have seen above.

The second group consists of 77 references to the different parts of the European Caterpillar Books and are indicated with "Merian europ.", "Merian eur.", or "Mer. eur". They are also followed by plate numbers. Among this group, 44 have another number ("1", "2", or "3") indicating the different parts of the Caterpillar Books. For instance, "Merian eur. 2. t. 35." indicates plate 35 (*tabula*) of the second part of the Caterpillar Book.

A third group of thirteen references is less specific and leaves some doubts as to the specific work Linnaeus means. These ambiguous references are formulated as "Merian ins." or "Mer. ins.", indicating only that it was a work about insects. As four of them are followed by the number "2", it probably is safe to assume that Linnaeus was in these cases referring to the second part of the Caterpillar Book. The other nine cases remain unclear.

A comparison between the insect names in the *Systema Naturae* and the images of the Merian plates indicates that Linnaeus likely used at least two different editions of the Caterpillar Books. In 42 instances, plate numbers between 2 and 181 are given.[44] The Dutch and French editions of 1730 numbered the original plates of the three Caterpillar Books consecutively and added some extra plates, like the title plates and plates originating from Merian's *Blumenbuch*; this resulted in a total of 184 numbered plates in these combined volumes that were published after her death (see also the chapter by Van de Plas in this volume). The separate parts of the earlier editions of the Caterpillar Books each contained plate numbers from 1 to 50. On the contrary, the 48 references in Linnaeus's work with the numbers "1", "2", or "3" added to them never mention plate numbers higher than 50, so we can conclude that Linnaeus used the 1730 edition as well as the three separate volumes on European caterpillars in naming these type specimens; these volumes were published between 1679 and 1718 in German, Dutch, and Latin.

The six catalogues of zoological specimens discussed above show the important role Merian's publications played in the process of the identification of species and establishing a standardized nomenclature. First, her work was used as sources of reference by private collectors to help them with the identification of objects in their own collections and as an aid for the communication with others through the method of "referring to folio and number". Gradually, her body of work was increasingly employed in a steadily growing modern scientific context, as it was used for the institutional collection of the Kunstkamera and in the foundation of modern taxonomic order by Linnaeus. In a way, Linnaeus increased the scientific importance of Merian's work. Her high-quality depictions of insects were so precise and detailed that later collectors and researchers were able to identify species or even subspecies of an insect. For present-day research, her work has proven especially valuable in comparison with non-illustrated catalogues compiled before Linnaeus's standardization. Through consultation of Merian's artful and accurate images, species in historic collections can be identified that otherwise would have remained unknown, thus giving insight in early modern taxonomical procedures.

To Maria, the Naturalist
From Esther, the Arawak Servant

You ask me to bring you a hawkmoth.
I return with a lantern fly, a huntsman
spider, and fourteen leaf cutter ants.

You send me out again. "Hawkmoth,"
you say. I bring you a mesquite bug, a longhorn
beetle, and a South American palm weevil.

A third time, you plead, "Please, just the hawkmoth."
The jungle, a green hoard, reaches,
gropes at the hem of my skirt.

You fail to know——the hawkmoth favors
the bellyache bush, a bush I visited after that man,
after my belly, after my aunt made me

chew those seeds until black as tobacco, then
swallow, then more, again, until doubled over squat

by that ditch, it was done.

———

Cynthia Snow

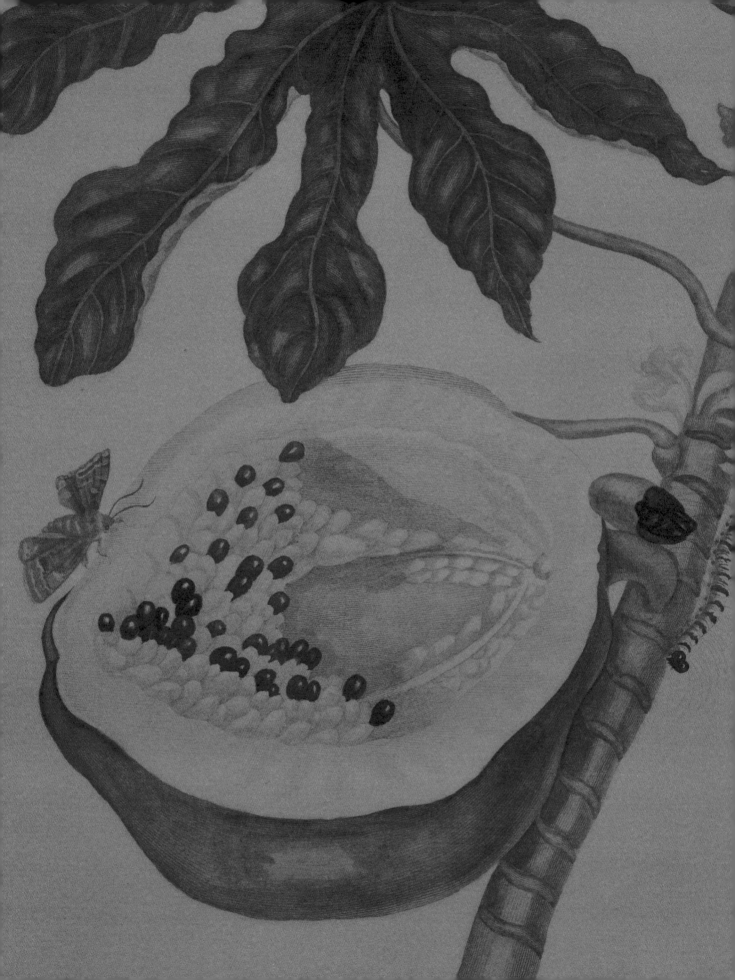

Endnotes

Maria Sibylla Merian. "Between Art and Science, Between Nature Observation and Artistic Intent"

Arthur MacGregor, p. 15–23

1 An analogous triad proposed by Jacob Christian Schäffer in 1763, comprised systems (*Lehrgebäude*), lexicons (*Wörterbücher*), and images (*Abbildungen*), Schäfer (1763) p. 2–4.

2 See Reitsma (2016) p. 17.

3 "... in ihren Darstellungen sich zwischen Kunst und Wissenschaft, zwischen Naturbeschauung und malerischen Zwecken hin und her bewegte", Goethe (1817) p. 85.

4 Harris (1766) p. 34.

5 Merian (1679), title page: "eine ganz neue Erfindung"; Etheridge (2011); Etheridge (2021).

6 Egmond (2017).

7 Swammerdam's agenda in revealing evidence of the Creation within the "Book of Nature" is reviewed by Eric Jorink (2010) p. 219–238.

8 Reitsma (2016) p. 13.

9 Swammerdam (1669); Redi (1668); Malpighi (1669). See also Reitsma (2008) p. 67–80.

10 Etheridge (2021) p. 37.

11 The concept is investigated most fully in Ogilvie (2006).

12 As discussed most comprehensively by Etheridge (2021).

13 *Metamorphosis* (1705), "Aan den Leezer": "dat zulks alreede door andere overvloedig gedaan is, als door MOUFET, GODART, SWAMMERDAM, BLANCKAART en andere."

14 "Ik had het Schrift wel langer konnen uitbreiden, maar door dien de tegenwoordige Wereld zeer delicaat en de gevoelens der Geleerde verschillig zyn, zo heb ik maar eenvoudig by myn ondervindingen willen blyven." For the occasional errors in her observations, see Schmidt-Loske (2007) p. 15, and Van Andel et al. (2016).

15 See Baigrie (1996) for a critique of the long-contested role of images within scientific discourse.

16 Ogilvie (2003) p. 46.

17 See Stearn (1978) p. 14; Etheridge (2021) p. 143.

18 Neri (2011) p. 176.

19 Hooke's observation is redeployed to good effect by Alpers (1983) p. 73, 85.

20 Kemp (1990) p. 132.

21 On the latter, see Hollmann (2003).

22 Pieters & Winthagen (1999). Valiant (1992) p. 48, finds her drawing style "was fully formed by the age of thirteen and remained unchanged throughout her life."

23 For examples of how these highly nuanced terms might be employed, see Swan (1995); Kusukawa (2019).

24 Schmidt-Loske (2007) p. 14, and Etheridge (2016) p. 34, note evidence for observations by Merian made under magnification, although no more than the occasional changes of scale can be detected in the drawings.

25 Quoted in Freedberg (2002) p. 412–413.

26 Charmantier (2011).

27 Linnaeus (1737) no. 218.

28 See Smith (2006). Even in Europe, most butterflies "had neither vernacular nor scientific names when Maria Merian began to study them." Stearn (1978) p. 16.

29 Ivins (1953) p. 2.

30 Neri (2011) p. 142–154, however, traces some continuing influence from these early compositions in the visual style of her image production.

31 Etheridge (2021) p. 108–119. See further the chapter by Alicia Montoya in this volume.

32 Valiant (1993) p. 473–478.

33 Dr. Charlie Jarvis has drawn my attention to a series of three papers by James Petiver which feature Merian's work (Petiver, 1708–1709), the content of which was later reproduced in the compendious *Jacobi Petiveri Opera* (Petiver, 1767) p. 22–26, plates 140–151.

34 Guilding (1834).

The World of Maria Sibylla Merian

Kay Etheridge, p. 24–40

1 See www.themariasibyllameriansociety.humanities.uva. nl and https://merianin.de for more background and resources on Merian.

2 Merian traveled from Germany, where the Julian calendar was in use (Old Style), to the Republic with the Gregorian calendar (New Style). In the time line and the book, the dates of the events in Germany and England are given following Old Style and in the Republic and Suriname in New Style, as was the custom in the respective countries.

3 Aldrovandi (1602); Moffet et al. (1634); Jonston (1653).

4 Jonston (1653) and Jonston (1660).

5 For more on the peacock butterfly plate and a colored version, see the chapter by Schmidt-Loske & Etheridge in this volume.

6 See, for example, Etheridge & Pieters (2015).

7 For more on Marrel and his influence on Merian, see Etheridge (2021) p. 46–49.

8 For more on Merian's students, see the chapter by Sauer in this volume.

9 Etheridge (2021) p. 39–45.
10 For details on the printing of Merian's work, see the chapter by Mulder in this volume.
11 Davis (1995) p. 157–166.
12 Her notes are bound together with the vellum studies mounted on paper usually two or three to a page (320 x 225 mm). This manuscript is now held in the Library of the Russian Academy of Sciences in Saint Petersburg, at the Manuscripts Department, inv. no. F 246. See Beer (1976) for more details.
13 Beer (1976). This facsimile volume of Merian's *Studienbuch* includes her notes and images that are now in the Library of the Academy of Sciences in Saint Petersburg, Russia.
14 Van de Roemer (2016).
15 For more on her travel to Suriname and work there, see the chapter by Van Delft in this volume.
16 Merian (1717).
17 Etheridge (2021) p. 88.
18 For more on the latter, see the chapter by Van de Roemer in this volume.
19 See, for example, Jorink (2010), Ogilvie (2008), and Montoya's chapter in this volume.
20 Davis (1995) p. 157–166 and Lölhöffel's chapter in this volume.
21 Merian (1679) p. 47.
22 Ray (1710).
23 Swammerdam (1669); Swammerdam (1737–1738).
24 Merian (1679) p. 72.
25 See the chapter by Heard in this volume.
26 Merian (1705) text with plate 19.

Maria Sibylla Merian Reconsidered. Art and Nature in Contemporary Art

Kurt Wettengl, p. 41–51

1 Wettengl (1998); Wettengl (2003).
2 Schiebinger (1995).
3 Rheinberger (2015) p. 11.
4 Rheinberger (2015) p. 13.
5 Latour (2000) p. 23, translation by K. Wettengl; Latour (2008).
6 Dion (2009) p. 257.
7 On the variety of artistic methods and procedures, see Lange-Berndt (2009); Miller (2014); Myers (2015); Ramos (2016); and the various issues of the journal *Antennae*.
8 On the decorative aspects in Merian's visual strategy, see Neri (2011).
9 See Albus (1997). Many of her drawings are in the collection of the Kunsthalle zu Kiel, Germany.
10 Fries (2009) p. 87.
11 Huemer (2018); Huemer (2020).
12 Flügelschlag (2019).

13 Wettengl (2014) both entries.
14 Greenfort (2009) p. 210, translation by K. Wettengl.
15 Erickson (2017).
16 As a gift from the Gaby and Wilhelm Schürmann Collection in the collection of Museum Ostwall in the Dortmunder U.
17 Raffles (2013).
18 Thompson (2014).
19 Raffles (2013) p. 31, translation by K. Wettengl.
20 See https://vimeo.com/471346039 (visited 12 February 2021).
21 Haas & Wolf (2019); Knicker (2014).
22 Knicker & Wettengl (2014).
23 Prüfer (2017).
24 Braun (2010).
25 For more about "animal architecture," see Roesler (2012).
26 Van de Plas (2013) p. 42, in *Second Life*.
27 Jeybratt (2012).
28 Kannisto (2011).
29 Latour (2000) p. 43, translation by K. Wettengl.
30 Dion (2005).
31 Van de Plas (2008); Van de Plas (2013, all three references mentioned); Van de Plas (2019).

Johann Andreas Graff. Forgotten Artist and Partner of Maria Sibylla Merian for Twenty Years

Margot Lölhöffel, p. 52–62

1 Doppelmayr (1730) p. 255; the name is written in this source as "Häberlein."
2 Ratsschulbibliothek, Zwickau, cat. no. 48.8.7(4); see also Lölhöffel (2015) p. 47–49.
3 Merian (1679) preface. For more detailed information on Merian's life and work during her time in Nuremberg, see the website www.merianin.de.
4 Doppelmayr (1730), unique volume with additional handwritten notes by the author in Germanisches Nationalmuseum, Sig. Hs 1010871, opposite of p. 268, digitized copy online, p. 584.
5 Keywords "Kraus, Johann Ulrich" and "Küsel, Kupferstecherfamlie," www.stadtlexikon-Augsburg.de (visited 24 January 2022).
6 Beer (1976) p. 227. See also Lölhöffel (2015) p. 61, and https://merianin.de/home/merian-garten.
7 Förderverein Kunsthistorisches Museum Nürnberg (2017) p. 47ff; see also https://merianin.de/home/scheidung.
8 Doosry (2014) p. 173–174.
9 Förderverein Kunsthistorisches Museum Nürnberg (2017) p. 38, 47, 52f, 65, and following.
10 Förderverein Kunsthistorisches Museum Nürnberg (2017) p. 48.
11 Exhibition catalogue, Förderverein Kunsthistorisches Museum Nürnberg (2017).
12 Mulzer (1999) p. 47.

Painting Flowers with Needles

Christine Sauer, p. 63–73

1 Neri (2011) p. 139–180, especially p. 142–154.

2 Sandrart (1675) part 2, book 3, p. 339; http://ta.sandrart.
 net/de/text/567#idx567.3 (visited 25 September 2017).

3 Bürger & Heilmeyer (1999); http://digital.slub-dresden.de/
 werkansicht/dlf/81016/6/ (visited 25 September 2017).

4 Mentioned in a letter dated 25 July 1682; Schmidt-Loske et
 al. (2020) p. 11–15, Brief 1.

5 This essay summarizes and expands the results of an
 exhibition catalogue by Sauer (2017) and a contribution
 to a conference, Sauer (2021).

6 Schnabel (2003); Schnabel (2013).

7 Schnabel (2003) p. 104–113, 309–311, 369f., 467.

8 For an example of a learned woman in Nuremberg,
 see Sauer (2021).

9 Sauer (2021).

10 Taegert (1997); Lölhöffel (2016) p. 67–71; Pieters (2017).

11 Letters dated 8 May 1685 (Germanisches Nationalmuse-
 um, Historisches Archiv, Familie Imhoff, Teil II, Fasz. 50)
 and 3 June 1685 (Stadtbibliothek Nürnberg, Autogr. 165);
 Schmidt-Loske et al. (2020) p. 24–31, Brief 4–5. For Clara
 Regina Imhoff and her brother, see Sauer (2017) p. 9f., 15,
 19, 21, Kat. 25f., 44f.; for Christoph Friedrich Imhoff as
 collector, see Valter (2021).

12 Letter dated 29 August 1697 (Stadtbibliothek Nürnberg,
 Autogr. 167); Schmidt-Loske et al. (2020) p. 32–35, Brief 6.

13 Stadtbibliothek Nürnberg, Nor. H. 1278, f. 51v–52r;
 Schnabel (1995) No. 180/16; Sauer (2017) p. 13, Fig. 1.6;
 Grebe & Sauer (2017) p. 56, Kat. 20 .

14 For this technique, see Wilckens (1997) p. 92–122, 261.

15 Neri (2011) p. 142–154.

16 Beer (1720) plate 20–21, 24–27, 37, 39–40; Sauer (2017)
 p. 10, 12 Fig. 1.4: Grebe & Sauer (2017) p. 61, Kat. 28.

17 Stadtbibliothek Nürnberg, Nor. H. 1622, f. 62v–63r,
 64v–65r, 66v–67r; Schnabel (1995) No. 184/81–83; Sauer
 (2017) p. 15; Grebe & Sauer (2017) p. 57, Kat. 22.

18 Germanisches Nationalmuseum, Bibliothek, Hs. 162.750,
 f. 73r; Kurras (1994) No. 102/119; Sauer (2021) Fig. 5.

19 Germanisches Nationalmuseum, Bibliothek, Hs. 162.750,
 f. 86r; Kurras (1994) No. 102/118.

20 Stammbuch of Johann Leonhard Oehm (1740–1791),
 Stadtbibliothek Nürnberg, Nor. H. 1299, p. 84–85;
 Schnabel (1995), No. 186/92; Sauer (2017) p. 15; Grebe &
 Sauer (2017) p. 56, Kat. 21.

21 Stadtbibliothek Nürnberg, Nor. H. 1459, p. 326–327;
 Schnabel (1995) No. 202/186.

22 Stadtbibliothek Nürnberg, Nor. H. 1305, f. 84v–85r;
 Schnabel (1995) No. 175/32; Sauer (2017) p. 15; Grebe &
 Sauer (2017) p. 58, Kat. 23.

23 Bürger & Heilmeyer (1999) 1. series, Tab. 2; http://digital.
 slub-dresden.de/werkansicht/dlf/81016/9/ (visited
 25 September 2017).

24 Berlin, Staatliche Museen zu Berlin, Kupferstichkabinett,
 KdZ 8929; Weller (2017) p. 172, Kat. 122.

25 Ludwig (1996); Ludwig (1998) p. 94–102.

26 Sketchbook, dated 1710: Stadtbibliothek Nürnberg, Nor. H.
 1665; sketchbook, dated 1711: Stadtarchiv Nürnberg, E 28/
 II No. 1335; sketchbook dated 1712: Grünsberg, Freiherr
 von Stromersche Familienstiftung; Ludwig (1996); Ludwig
 (1998) p. 96f., 256 and Fig. 50; Sauer (2017) p. 12; Grebe &
 Sauer (2017) p. 58, Kat. 24.

27 1710: Stadtbibliothek Nürnberg, Nor. H. 1665, f. 23; Sauer
 (2021); 1711: Stadtarchiv Nürnberg, E 28/II No. 1335, f. 25;
 Sauer (2017) p. 12, Grebe & Sauer (2017) p. 58, Kat. 24.

28 Nürnberg, Germanisches Nationalmuseum, Bibliothek,
 Hs. 185.172/2, Lö. 2, f. 1; Ludwig (1996); Ludwig (1998)
 p. 96f., 256f. and Fig. 51.

29 Stadtarchiv Nürnberg, E 28/II No. 1335, f. 36.

30 Erhard Reusch (1711, p. 15) describes Margaretha
 Wurfbain as outstanding wife and artist: "Noblemen
 admire the various paintings produced with a needle,
 especially animals and birds skillfully formed out of silk,
 as well as other of her artworks; and they strive to add
 these objects to others they already avidly keep in store. So
 exceedingly skillful does the practiced hand render objects
 that they seem to be living" ("Picturas varias acu factas,
 praesertim animalia et aves ex serico affabre efformatas,
 aliaque ejus artificia Viri Principes admirantur, eademque
 reliquis, quae studiose asservant, arte factis adjungenda
 expetunt. Adeo scite omnia manus perita ducit, ut vivere
 videantur"). Reusch continues with comparing Margare-
 tha Wurfbain not only to famous female artists known
 from legend but also to the male painter Parrhasius, who
 managed to deceive his contester Zeuxis with a painting of
 a curtain. According to Pliny the Elder (*Naturalis Historia*,
 XXXV, 64), Parrhasius asked Zeuxis to draw aside the
 curtain to reveal a hidden masterpiece. Only when Zeuxis
 attempted to do so, he realized that the curtain was not
 real. For Margaretha Wurfbain, see Sauer (2017) p. 15;
 Grebe & Sauer (2017) p. 54–55, Kat. 18; Sauer (2021).

31 For images in this technique, see Spamer (1930) p. 106–112.

32 Stadtbibliothek Nürnberg, Nor. H. 1621a, f. 102r, 104r,
 114r; Schnabel (1995) No. 130/44–45, 130/53; Sauer (2017)
 p. 15; Grebe & Sauer (2017) p. 54–55, Kat. 18; Sauer (2021).

33 Bürger & Heilmeyer (1999), series 1, title page, and
 http://digital.slub-dresden.de/werkansicht/dlf/81016/3/
 (visited 25 September 2017); Sauer (2017) p. 15; Grebe &
 Sauer (2017) p. 54–55, Kat. 17–18.

34 For Maria Sibylla Merian's house in Nuremberg,
 see Mulzer (1999) and Lölhöffel (2015) p. 51–54; for the
 house of the Wurfbains, see Grieb (2007) p. 1710f.

35 Hauß-Halterin (1703) p. 10–168; for the literary genre,
 see Gray (1987).

36 Hauß-Halterin (1703) p. 16.

37 Braun (1773–1793); Wilckens (1982) p. 59f.

38 *Bilderstich*: Braun (1773–1793), here vol. 2, no. 23.
 Sprinkled on silk: Braun (1773–1793), here vol. 4, no. 38.

39 For this role model, see Leßmann (1991), especially
 p. 73–96, 160–187, and Ludwig (1998) p. 102–106; for
 positive aspects, see Sauer (2017) p. 12–16; Moffitt Peacock
 (2017), especially p. 75–79; Sauer (2021).

40 Moffitt Peacock (2017, p. 79) concludes: "While women
 may have accepted needlework as a traditional female art
 form, they also challenged male hegemony in the making
 of art."

41 Spamer (1930) p. 60–175, especially p. 80–111.

42 Sturm (1704) p. 30, 50f. On Sturm, see Dolezel (2018).

43 Sauer (2017) p. 21; Valter (2021).

44 *Blumen und Insecten-Buch*, see Merian (ca. 1713).

In Search of Friendship. Maria Sibylla Merian's Traces in Friendship Albums (*alba amicorum*)

Florence F.J.M. Pieters & Bert van de Roemer, p. 74–86

1 Taegert (1997).

2 See, for example, the chapter by Van de Roemer in this
 volume.

3 See Graak (1982), Thomassen (1990).

4 Keil & Keil (1893) p. 4–6, Kerdijk-Eskens (1975).

5 Klose (1982) p. 42–45, 49.

6 Schnabel (2013) p. 218–221.

7 Keil & Keil (1893); Schnabel (2013); Reinders (2017).

8 Taegert (1997) p. 89; British Library, Egerton MS 1324.
 The album contains 123 dedications entered between
 1649 and 1653; separate dedications were added in
 Nuremberg later.

9 About father and son Arnold, see also Blom (1981).

10 Translations of these poems are given in Pick (2004)
 p. 327–331 (all three poems), and Etheridge (2021)
 p. 134–136 (only the two poems in the first volume).

11 Sauer (2017) p. 17.

12 Etheridge (2021) p. 248.

13 Stammbuch des Andreas Arnold, Herzog August
 Bibliothek, Wolfenbüttel, Cod. Guelf. 226 Blank., f. 271r;
 see also Thöne (1967).

14 Blom (1981) p. 13.

15 Stammbuch des Andreas Arnold, Herzog August
 Bibliothek, Wolfenbüttel, Cod. Guelf. 226 Blank., f. 257r,
 269v & 270r.

16 These letters are also discussed in the chapter by Sauer
 in this volume.

17 See also Sauer (2017) p. 9.

18 Schmidt-Loske et al. (2020) p. 24–27.

19 Schmidt-Loske et al. (2020) p. 28–31.

20 Beer (1976) p. 63 & Tab. 94 drawing 239. See also Wettengl
 (1997) p. 135, Cat. No. 85.

21 See Pieters (2014) endnote 14. The album is present in
 Leiden University Libraries, Special Collections, inv. no.
 LTK 903. The spelling on the spine of this typical oblong
 format reads: "STAM / BUCH". About the collection of

22 See Kaag & Storm (2019).

23 Schmidt-Loske et al. (2020) p. 87.

24 Original text: "Gott und die tugent ist mein Ziel. / diesses
 mahlte ich Maria Sÿbilla Merian / im 62 Jahr meines
 Alters, / dem herren besitzer diesses buches, / Ao 1709 den
 2 Martz in Amsterdam."

25 Weise's poem occurs as the very first song in an undated
 Bergliederbüchlein published in the last quarter of the
 seventeenth century; see Mincoff-Marriage & Heilfurth
 (1936) p. 1–2.

26 Keil & Keil (1893) p. 167.

27 Weise (1673) p. 79: "Die Menschen mögen mich beneiden /
 Gott wolle nur barmhertzig seyn / so will ich mitten in den
 Leiden / mich über mein Gelücke freun / Gott und die
 Tugend ist mein Ziel / So hab ich, was ich haben will."
 Translation by Marianne Arentshorst.

28 Manuscript formerly attributed to Albertus Seba,
 "*De Veranderinge van eenighe Rupsen en Wurmen*"
 ("The changes of some Caterpillars and Worms"), Artis
 Library, Allard Pierson, University of Amsterdam,
 AB Legkast 37.1, p. [9]; see Engel (1937) ; Mulder (2021);
 Pieters (2021).

29 Van de Roemer (2016) p. 25; Schmidt-Loske (2007) p. 92–98.

30 See also Pieters (2014). About Merian's work related to
 Rumphius' book, see the chapter by Van de Roemer in this
 volume.

31 Original text: "Men Eer dit Beeld, wiens geest en Schaar
 kan wond'ren teelen, / 't Papier herscheppende in
 onschatb're Kunst tafreelen / KATARINE LESCAILJE."
 Translation by Marianne Arentshorst.

32 Testas de Jonge (1744) p. 12. The catalogue was also
 published in Dutch; for authorship and date of publica-
 tion, see Kaldenbach (2014); N.B. Even after Koerten's
 death the album was steadily extended by her husband.

33 Merian & Marret (1730b), edition in Dutch. Artis Library,
 Allard Pierson, University of Amsterdam, AB Legkast
 018.01. Original text: "K heb u penceelen ooft geschonken /
 Joanna wyd en zyds berugt / Door konst papiere schaaren
 vrugt / Oft mee mogt in uw stamboek pronken. /
 M. S. Meriaan." Translation by Marianne Arentshorst.

34 Koerten (1735) p. 46–48; transcription available on the Web
 (visited 22 February 2022): https://www.dbnl.org/tekst/
 koer005stam01_01/koer005stam01_01_0050.php?q=
 Meriaan#hl1. Translation by Marianne Arentshorst.

35 Raffel (2012) p. 46–47. With thanks to Katja Lorenz of the
 Herzogin Anna Amalia Bibliothek, Weimar, for informa-
 tion about the portrait, April 2021.

Alba amicorum in Leiden University Libraries, see Van
Duijn (2015) (visited 13 April 2021).

Alida Withoos and Maria Sibylla Merian. Networking Female Botanical Artists in the Netherlands

Liesbeth Missel, p. 87–97

1 Graft (1943) p. 136; Röver (1730, 1739-…).
2 Sotheby's (2004) p. 95, item 128.
3 Heijenga-Klomp (2005) p. 126–128.
4 Schama (1987) p. 402–419.
5 Boersma (2021).
6 Seelig (2017) p. 23, 48–50.
7 Heijenga-Klomp (2005) p. 116.
8 Missel (2000) p. 13–14.
9 https://rkd.nl/nl/explore/artists/85145 (visited 16 September 2021)
10 Boersma (2021); Schepper (1990) p. 66–69.
11 Heijenga-Klomp (2005).
12 Zwollo (1972) p. 83; Pascoli (1981) p. 22.
13 Kloek, Sengers & Tobé (1998) p. 9–19.
14 Weyerman (1729) vol. 2, p. 241, translation by L. Missel.
15 Kooijmans (1985) p. 202.
16 Zaal (1991).
17 Leeuwen (2011) p. 31–45.
18 Poelhekke (1963) p. 3–28.
19 Graft, van der (1943) p. 136; Röver (1730, 1739-…)
20 Reitsma (2008) p. 141–144.
21 Block (undated) [album once owned by Agnes Block, entitled *Plusieurs espèces de fleurs dessinées d'après la naturel*. Rijksmuseum, Amsterdam, loose paper slips.
22 Wijnands (1983) p. 16–20.
23 *Moninckx Atlas* (1687–1756).
24 Commissie van Toezigt (1699) no. 39.
25 Reitsma (2008) p. 116–119.
26 Wageningen University & Research Library, Special Collections, R355A02.
27 MuseuMAfricA Library, Johannesburg, inv. nos. W226–W228; Kennedy (1968) vol. 5, p. 142.
28 Berkhey (1784).
29 Archivo del Real Jardín Botánico-CSIC, Div XIV; San Pio Aladrén (2012) p. 38–45; Cabré i Pairet & Carlos Varona (2018) p. 98–153.
30 Westfries Archief, Hoorn, DTB (parish registers) 67-227a, 103–47; Amsterdam City Archives, DTB 532–315.
31 Prak (2020) p. 300–302.
32 Amsterdam City Archives, DTB 1103-74.
33 Sotheby's (2004) p. 96–97, item 133.
34 Kok (1794) vol. 32, p. 229–230, translation by L. Missel.

The Transition Stage. Merian's Studies of Pupa, Chrysalis, and Cocoon

Katharina Schmidt-Loske & Kay Etheridge, p. 98–110

1 Merian (1679) Preface. The quotations from the *Raupenbuch* are translated from the German by Michael Ritterson (Etheridge, 2021); from *Metamorphosis* from the Dutch by Patrick Lennon (Van Delft & Mulder, 2016); from the *Studienbuch* by Katharina Schmidt-Loske.
2 Beer (1976) p. 143, *Studienbuch* entry 1.
3 Merian (1679) plate 1.
4 Merian (1679) preface.
5 Merian (1705) plate 58.
6 By the time Merian published the last Caterpillar Book, she understood the phenomenon of parasitism, see Merian (1717) plate 15 with text.
7 Etheridge (2021) p. 82 and Beer (1976) p. 149, *Studienbuch* entry 10.
8 Merian (1705) plate 53.
9 Merian (1679) p. 5–6.
10 Merian (1679) p. 12.
11 Merian (1679) p. 54
12 Merian (1683) plate 4.
13 Merian (1717) plate 38 with text; translated by Katharina Schmidt-Loske.
14 Beer (1679) entry 275.
15 Merian (1705) plate 14.
16 On the relationship of Merian's studies to her finished plates, see Etheridge (2021) p. 92–96.
17 Merian (1705) plates 21, 34, 47.
18 British Museum, Sloane collection, https://www.britishmuseum.org/collection/object/P_SL-5276-9 (visited 9 March 2021).
19 Merian (1705) plate 7.
20 Merian (1705) preface, translated from the Dutch.
21 In the description of many species, this results in a request from the database: "Photo sought." See, for example, http://www.lepiforum.de/lepiwiki.pl?Fotouebersicht_Macroglossinae_1_Puppen; http://www.lepiforum.de/lepiwiki.pl?Fotouebersicht_Macroglossinae_1_Raupen (visited 9 March 2021); and https://www.butterfliesofamerica.com/L/Neotropical.htm (visited 9 March 2021).

A Story of Metamorphosis

Jadranka Njegovan, p. 111–117

1 Merian (1679) p. 99.
2 Etheridge (2021) p. 351. Kay Etheridge has been doing research on Merian's work from a biologist's point of view. She has studied Merian's scientific work on the plants and animals appearing in her plates, particularly in the 1679 *Raupenbuch*, and is familiar with the scientific names we use today. She identified *Mamestra brassicae* on the plate in Merian's *Raupenbuch* for me, and I received an image and a translation of the corresponding text in the book from her.
3 Etheridge (2021) p. 352.
4 Merian (1679) p. 99.

Maria Sibylla Merian and the People of Suriname

Marieke van Delft, p. 118–130

1 See Schiebinger & Swann (2007). Especially 'Introduction' by the editors and Chapter 7 by Londa Schiebinger.
2 Den Heijer (2005).
3 Raleigh & Keymis (1598).
4 Tang (2013) p. 170.
5 Den Heijer (2021) p. 25–48.
6 For the history of the Labadists, see Saxby (1987).
7 Saxby (1987) p. 264, 274.
8 This section is based on Dittelbach (1692) p. 51–61; Knappert (1926/27); Saxby (1987) p. 273–286.
9 For a description of this journey, see Knappert (1926/27) p. 206–217; includes a map of the colony in the years 1686–1687.
10 Knappert (1926/27) p. 203.
11 Dittelbach (1692) p. 54.
12 Dittelbach (1692) p. 55. Translation by M. van Delft.
13 Dittelbach (1692) p. 18–19.
14 Knappert (1926/27) p. 200, note 2.
15 De Kom (1987) p. 51–114; Sint Nicolaas & Smeulders (2021) p. 84–105.
16 Sint Nicolaas & Smeulders (2021) p. 102–105.
17 Warren (1669); *Außführliche* (1673).
18 *Guava*, Van Delft & Mulder (2016) plate 19; Warren (1669) p. 13–14.
19 *Cassava*, Van Delft & Mulder (2016) plate 5; Warren (1669), p. 8–9.
20 The plates and numbers refer to Van Delft & Mulder (2016).
21 The Hague, National Archives, Sociëteit van Suriname, inv. 228, no. 133–134 (1699, 1700); no. 383 (1701).
22 All English translations of Merian's texts in this chapter are by Patrick Lennon, taken from Van Delft & Mulder (2016).
23 Reitsma (2008) p. 169–195; Stuldreher-Nienhuis (1945) p. 103–120; Davis (1995).
24 The Hague, National Archives, Sociëteit van Suriname, inv. 228, no. 133–134 (1699, 1700); no. 383 (1701).
25 Reitsma (2008) p. 183.
26 Kunikawa (2012) p. 100–101; Davis (1995) p. 175, 193.
27 Van Delft & Mulder (2016) plate 45
28 The Hague, National Archives, Sociëteit van Suriname, inv. 228, no. 525.
29 Oostindie & Maduro (1986) p. 6–14; Ponte (2019).
30 Reitsma (2008) p. 198–199; Davis (1995) p. 194.
31 Stadsarchief Amsterdam, Notary Wijmer, 4864, inv. no. 23, p. 112–114; 4849, inv. no. 42, p. 192–198.
32 Kunikawa (2012, passim).
33 See also Davis (1995) p. 184–188.
34 Alcantara-Rodriguez (2019). This is a result of a project running from 2018–2022 at Leiden University: *BRASILIAE. Indigenous knowledge in the making of science: Historia Naturalis Brasiliae* (1648); www.universiteitleiden.nl/en/research/research-projects/archaeology/brasiliae.-indigenous-knowledge-in-the-making-of-science-historia-naturalis-brasiliae-1648#tab-1; visited 14 April 2020.
35 Kriz (2000).
36 McBurney (2021) p. 198; p. 239, 242 (letters to William Sherard)
37 Leuker et al. (2020) p. 53 and further.
38 Peeters (2020) p. 30.
39 Beekman (2011) p. 64.

"One of the most Curious Performances … that ever was published". Maria Sibylla Merian's Drawings in the British Royal Collection and the *Metamorphosis Insectorum Surinamensium*

Kate Heard, p. 131–142

1 The present essay uses the term 'drawing' to refer to watercolor painting, to distinguish these works from hand-colored prints.
2 For Merian see, among others, Davis (1995); Wettengl (1998); Pieters & Winthagen (1999); Reitsma (2008); Etheridge (2011); Roth et al. (2017); Etheridge (2021).
3 On the *Metamorphosis* see particularly Rücker & Stearn (1982), Wirth (2007) and, most recently, Van Delft & Mulder (2016).
4 Royal Society of London (1710–1712) p. 350; Memoirs (1711) p. 300.
5 Langford (1755), 14th night, lot 66 "[*A capital collection*] of *exotics, flowers and insects*, by MERIAN, 95 in number, *likewise elegantly bound* in 2 vol."
6 Reitsma (2008) p. 213, suggests Dorothea was responsible for the caiman drawing (RCIN 921218).
7 Herman Henstenburgh, *Cyclamen*, RCIN 921242.
8 Clayton in Roberts (2002) no. 374 (p. 418–419); Schrader, Turner & Yocco (2012) p. 166.
9 Schrader, Turner & Yocco (2012).
10 British Museum, London, SL,5275.1–60. It is possible that another set survives among the fine group of Merian's drawings in the Russian Academy of Sciences, Saint Petersburg, but the author has not seen these and cannot comment on them. The Saint Petersburg watercolors are discussed in, among others, Hollmann & Beer (2003).
11 For the production of *Metamorphosis* see Mulder & Van Delft (2016). See also the chapter by Mulder in this volume.
12 Schrader, Turner & Yocco (2012) p. 164; Mulder (2019) p. 42 and n. 11; Martin Sonnabend in Roth, Bushart, Sonnabend & Heroven (2017) p. 153–154.
13 Sabine Weller in Roth, Bushart, Sonnabend & Heroven (2017) p. 161–166; Etheridge (2021) particularly p. 98–101.
14 Susan Owens in Attenborough (2007) p.151.
15 The luxury versions of plates 6, 9, 10, 18, 45, 49 and 50 are based entirely on printed lines; the luxury versions of plates 11, 21, 37, 40, 42 and 58 have no underlying printing.
16 Wirth (2007) p.126 and 133.
17 British Library, London, MS Sloane 4039, f. 49, letter from

John Ray to Hans Sloane, 16 December 1702.

18 Royal Society of London (1703) p.i.

19 Bodleian Library, Oxford, MS Eng. Hist c.11, f. 33, letter from Petiver to Tancred Robinson, undated but before 1705.

20 British Library, London, MS Sloane 4063, f. 204, letter from Merian to Petiver, 28 June 1703: "13 Platen Van Gereet zÿn." Available online at https://www.themaria sibyllameriansociety.humanities.uva.nl/sources/letters/ (visited 11 June 2020). See also Wettengl (1998) p. 266, from which the translation here is taken.

21 Wirth (2007) p. 125.

22 Wirth (2007); Wirth (2014).

23 Plates 2, 16, 17, 19, 20, 25, 32, 33 and 39.

24 By, among others, Wirth (2007) p.119, and Reitsma (2008) p. 204. The three unsigned plates are 11, 14 and 35.

25 British Library, London, MS Sloane 4064, f. 60, letter from Levinus Vincent to James Petiver, 6 March 1705.

26 Wirth (2007) p. 129, Wirth (2014).

27 Reitsma (2008) p. 203.

The Printers of Merian's Texts

Hans Mulder, p. 143–151

1 Part of it has been published in Dutch; see Mulder (2019); Reske (2007) p. VII.

2 These distinctions certainly also existed in seventeenth-century Amsterdam, where the intaglio printers were designated by the guild and where engravers were forbidden to print their own work. See Stijnman (2012) p. 160–162.

3 Merian (1679).

4 Reske (2007) p. 738–739.

5 Reske (2007) p. 745.

6 Reske (2007) p. 258.

7 For instance: Zeiller (1663)—other people involved were Matthäus the Younger and Caspar Merian. This work on the topography of Alsace belongs to the second edition of the *magnum opus* by Matthäus Merian the Elder with text by Martin Zeiller, *Topographia Germaniae*. After Matthäus Merian the Elder's death, besides Caspar Merian and Matthäus Merian the Younger, Johann Georg Spörlin was also involved, the latter being the text printer.

8 Etheridge (2021) p. 106–107.

9 Although most catalogues still follow the dates given by Max Adolf Pfeiffer (1931), 1713 for part 1 and 1714 for part 2, advertisements by Merian show that she offered both parts for sale as early as 1712. See Mulder (2014).

10 Van Eeghen (1960–1978); Kleerkooper & Van Stockum (1914–1916).

11 For more on Valk, see Egmond (2009) p. 233; for Gerard Valk as globe maker, see Krogt (1993).

12 For more information on intaglio printing, see Stijnman (2012).

13 This is the conclusion of Ad Stijnman, who closely examined all of Merian's images, confirmed by Charles Dumas and Yvonne Bleyerveld. See also Etheridge (2021) p. 96–98.

14 See Mulder & Van Delft (2016).

15 Bidloo (1685).

16 Tony Willis, curator of Oak Spring Garden Library (Rachel Mellon, Upperville, Virginia, USA), had their copy of *Metamorphosis* dismounted and noticed that the text sheets were not folded. This makes it reasonably certain that the text was printed in plano (one page printed on the recto side and the next on the verso side of the paper).

17 The later editions of Merian's work have new typesetting.

18 Dijstelberge (2007).

19 Jagersma & Dijkstra (2014) p. 278–310.

20 As stated by Hollmann (2003) p. 16. Merian's contribution to the *D'Amboinsche Rariteitkamer* has, however, been disputed by Bert van de Roemer (see his chapter in this volume) and by Pieters & Winthagen (1999) p. 15, endnote 6.

21 Rumphius (1705), Artis Library, Allard Pierson, University of Amsterdam, AB, Legkast 005. The handwritten inscription by Arnout Vosmaer about Merian's coloring is reproduced in Pieters & Rookmaaker (1994) p. 20.

22 Mulder (2014).

23 Etheridge (2021) p. 113.

24 Ruyter (1712).

The Merian-Rumphius Connection.
Maria Sibylla Merian's Alleged Contribution
to *D'Amboinsche Rariteitkamer*

Bert van de Roemer, p. 154–170

1 For more on this subject as it relates to Merian, see the chapter by Dunaeva & Van de Roemer in this volume; for Rumphius, see De Wit (ed.) (1959).

2 For more on this subject as it relates to Merian, see the chapter by Van Delft in this volume; for Rumphius, see Leuker et al. (2020).

3 All images are available online at http://ranar.spb.ru/rus/vystavki/id/130/ (visited 2 February 2022). Saint Petersburg Archive of the Russian Academy of Sciences (SPbARAN), inv. no. R.IX. Op. 8. nos. 1–184. The numbers connected to *D'Amboinsche Rariteitkamer* are 1, 69–102; 104–123. Of the sixty prints appearing in Rumphius's book, plates 18, 20, 21, 23, 45 and 59 are missing.

4 For an early example, see Schmidt-Linsenhoff (1997) p. 202–219. For a general critical reflection on the "heroes of science," see Theunissen & Hakfoort (1996).

5 Grabowski (2017); Reitsma (2008).

6 Houbraken (1721); Doppelmayer (1730). I disregard Merian's first biographer, Joachim von Sandrart, as he wrote a biography of Merian prior to her Amsterdam period.

7 Beer (1974) p. 82; Rücker (1997) p. 259.

8 Margócsy (2014).

9 Cramer, in Regenfuss (1758) p. 8.

10 Chemnitz (1760) p. 74. There is some discussion about the true identity of this female collector.

11 Vosmaer (1800) no. 137.

12 Pieters & Rookmaaker (1994) p. 21–24.

13 Stuldreher-Nienhuis (1945) p. 125–126.

14 Deckert (1957); Rücker (1967) both entries.

15 Ullmann (1974) p. 48.

16 Beer (1974) p. 98–106.

17 Davis (1995) p. 178–179.

18 Wettengl et al. (1997) p. 251.

19 Rücker (1997) p. 259. See also Rücker & Stearn (1982) p. 34–35.

20 See, for example, Kries (2017) p. 78–79 and Beuys (2016) p. 232.

21 Benthem Jutting (1959). See also L.B. Holthuis in the same publication, p. 67. For the problem of the lateral inversions, which cannot be discussed here, see Pieters & Moolenbeek (2005).

22 Engel (1959) p. 209.

23 Beekman (1999) p. lxxxix.

24 Pieters & Moolenbeek (2005) p. 130. See also Pieters (2014); Van der Waals (1992) p. 224.

25 Buijze (2006) p. 177–182.

26 Schmidt-Loske et al. (2020) p. 86–87. Illuminated copies survive in the Artis Library, Allard Pierson, University of Amsterdam, AB Legkast 005, and the Library of the Russian Academy of Sciences at the Zoological Institute, Saint Petersburg, H 85, inv. no. 202.

27 Schmidt-Loske et al. (2020) p. 39: "als wie mit dem Ambonischen Werck." See also Reitsma (2007) p. 207.

28 Schmidt-Loske et al. (2020) p. 86.

29 Lukin (1974) p. 115–149; Lebedeva (1996); Kopaneva (2009).

30 Lukin (1974) p. 134.

31 *Musei Imperialis Petropolitani*, vol. 1.2 (1745) p. 174–175.

32 Beer (1974) p. 100.

33 The same *Conus aurisiacus* appears in a watercolor in the British Museum depicting a still life with shells and insects, attributed to Antony or Herman Hengstenburg. See Schmidt-Loske (2007) p. 234. I agree with her attribution to M.S. Merian.

34 Schijnvoet, in Rumphius (1705) p. 108; Beekman (1999) p. 154.

35 Linnaeus (1758) p. 716.

36 Written information by Jeroen Goud (received 28 August 2021).

37 Written information by Ad Stijnman (received 22 January 2022).

38 Van de Roemer (2016) p. 23–24.

39 For instance, sheet 73 with a gorgon's head and sheet 122 with dendrites. See endnote 3.

40 *Amsterdamse Courant*, 5 August 1692. Advertisement by Jacob Hendrik Herolt.

41 Lukin (1974) p. 128.

42 Library of the Russian Academy of Sciences at the Zoological Institute, Saint Petersburg, H 85, inv. no. 2027.

43 Kistemaker et al. (2005) p. 87, 92.

44 Kistemaker et al. (2005) catalogue numbers 246, 247, 248 and 249.

45 See http://ranar.spb.ru/rus/vystavki/id/130/ (visited 2 February 2022). Saint Petersburg Archive of the Russian Academy of Sciences (SPbARAN), inv. no. R.IX. Op. 8. nos. 1 and 103.

46 Kistemaker et al. (2005) p. 90; Lukin (1974) p. 124.

47 Brown et al. (1991); Grijzenhout (2014); Bal (2003).

Maria Sibylla Merian and Johannes Swammerdam. Conceptual Frameworks, Observational Strategies, and Visual Techniques

Eric Jorink, p. 171–183

1 Arnold 'Lobgedicht', in Merian (1679). The research for his chapter has been made possible by NWO (Dutch Council for Scientific Research), in the context of the project *Visualizing the Unknown: Scientific Observation, Representation and Communication in 17th-century Science and Society* (grant number 405.20.FR.012).

2 Neri (2011); Etheridge (2021).

3 Etheridge (2021).

4 On Swammerdam in this context, see Jorink (2010) p. 219–239.

5 On Swammerdam and Bourignon, see De Baar (2004) p. 367–376; 473–479.

6 Egmond (2017); Jorink (2018).

7 Margócsy (2021).

8 See, for example, Etheridge (2021) p. 31–37 and *passim*.

9 On Goedaert in this context, see Jorink (2010) p. 201–209; Etheridge (2021) p. 31–37.

10 Etheridge (2021) p. 4, 29.

11 Goedaert (1660–1669) vol. 2, p. 136.

12 Cobb (2002); Jorink (2010) p. 219–239; Jorink (2012).

13 Swammerdam (1669) p. 18, 21.

14 Swammerdam (1737–1738) p. 487.

15 Swammerdam (1669) *passim*.

16 Swammerdam (1669) p. 1–3.

17 Jürgensen (2002) p. 779–798.

18 Cobb (2002).

19 Swammerdam (1669) p. 27.

20 Swammerdam (1669) p. 9, my italics.

21 Swammerdam (1669) p. 56–57.

22 Swammerdam (1669) p. 57.

23 Cobb (2002); Jorink (2011).

24 Jorink (2018).

25 Bertoloni Meli (2010).

26 Jorink (2010) p. 201.

27 Cobb (2002).

28 Bolt et al. (2018).

29 Cobb (2002).

30 Swammerdam (1675) p. 218.

31 Quoted in Etheridge (2021) p. 169.

32 "Die Seidenwürmer hat uns Malpigh gezeiget / Dass man sich vor Ihm neiget: / [...] Nach ihm gab Swammerdam den Menschen zu betrachten / was ihrer wenig achten / den sogenannten Haft / Das schnöde Ufer-aas nach seiner Eigenschaft,".

Drawing in the Tropics. Maria Sibylla Merian's and Charles Plumier's Pictures of Caribbean Nature

Jaya Remond, p. 184–194

1 Bleichmar (2017) p. 45–89.
2 Goethe (1831) p. 235–236. On parallels between Plumier and Merian, see also Davis (1995) p. 179–180.
3 Hrodej (1997) p. 100. For Plumier's biography, see Pietsch (2017) p. 21–37. The bibliography on Merian cannot be mentioned in full here; for overviews, see Davis (1995) p. 140–202; Neri (2011) p. 139–179.
4 Mukerji (2005); Hollsten (2012).
5 Font Paz & Geerdink (2018).
6 On "after nature," the nuances and pitfalls of its interpretation, see Swan (1995); Balfe & Woodall (2019).
7 Plumier uses the term "au naturel" in some drawings of a crocodile's bones; see Beltran (2019).
8 On the epistemic status of early modern images, see Kusukawa (2012) p. 100–123; Daston (2015).
9 On (text-focused) dynamics of ownership, see Pratt (1992).
10 This biodiversity remains a key feature of the tropics, though it is under threat; see, for example, Barlow et al. (2018).
11 On the use of photographic/cinematic language for prints and drawings, see Smith (2000); Egmond (2017). Egmond discusses zoomed-in views of plants in earlier (mostly sixteenth-century) examples. Such practices seem to be even more widespread in later images of non-Western flora, with more exaggerated close-ups.
12 Hrodej (1997) p. 100. Michel Bégon, intendant of Saint Domingue from 1682 to 1685, played a pivotal role in the organization of the journey. Whitmore (1967) p. 188.
13 Hrodej (1997) p. 101.
14 Pietsch (2017) p. 34.
15 De Passe the Younger (1643–1644) Book V.
16 Fontenelle (1709) p. 176.
17 Plumier (1705) p. i.
18 Elliott (1992) p. 21.
19 Dodart (1676) p. 5.
20 For instance, Plumier (1705) plate 22, among many. It should be noted that Plumier etched his plates.
21 Mulder & Van Delft (2016) p. 46. Three unsigned plates have been attributed to Merian or her daughter Dorothea Maria.
22 On labor division, direct observation, and image making, see Davies (2016) p. 10–13, 50–52, 120–146; Burke (2001).
23 Fragments of notes, Ms 33 (not numbered), Bibliothèque centrale, Muséum national d'Histoire naturelle, Paris. These seem to be transcriptions, recorded by Plumier himself, of a review of one of his books. I thank José Beltrán for sharing this information.
24 'Bibliothèque centrale, Muséum national d'Histoire naturelle, Paris, Fol. Res. 32.
25 Montoya & Jagersma (2018).
26 Plumier (1693) p. 49. Plumier also comments on some of his pictorial choices, as in Plumier (1693) Preface. Nonetheless, the production of images for early modern books usually involved a number of participants, comprising publisher, author, draftsman, and engraver; Bassy (1990).
27 Plumier (1693) Preface. On the importance of large figures, see also Dodart (1676) p. 6. By contrast, the woodcut images of the *Historia Naturalis Brasiliae* are relatively small.
28 Raj (2007) p. 44–52.
29 Plumier (1693) p. 2.
30 Plumier (1705) p. ix, x, xii, xiii; Merian (1705) p. 10.
31 Merian (1705) p. 8.
32 Published in ten installments with annotations and engravings by Johannes Burman. Burman (1755–1760).
33 For some earlier precedents on image making and knowledge, see for example Remond (2022).

The Influence of Maria Sibylla Merian's Work on the Art and Science of Mark Catesby

Henrietta McBurney, p. 195–205

1 Catesby (1731–1743) Preface, p. i.
2 Royal Society, London, Journal Book Original/11/28, 14 July 1703.
3 Henrey (1975) p. 426.
4 For Dale's copy: McBurney (2021) p. 40; Beaufort: Laird (2013) p. 116; Mead and Sloane: Reitsma (2008) p. 219.
5 Reitsma (2008) p. 203.
6 Sloane's 'Books of Miniature & Painting' are listed in BL, Sl. MS 3972C; entries for Merian watercolors are volume IV, f. 15r, items 3, 4, 5, 8.
7 McBurney (2021) p. 123.
8 Rücker & Stearn (1982) p. 85 [Preface to *Metamorphosis*].
9 Stearn (1958) p. 176.
10 Rücker & Stearn (1982) p. 117 [*Metamorphosis*, plate 36].
11 Rücker & Stearn (1982) p. 117 [*Metamorphosis*, plate 36].
12 Rücker & Stearn (1982) p. 135 [*Metamorphosis*, plate 57].
13 Rücker & Stearn (1982) p. 91 [*Metamorphosis*, plate 5].
14 Catesby (1731–1743) Preface, p. i.
15 Catesby (1731–1743) vol. 2, p. 95.
16 McBurney (2021) p. 74.
17 Rücker & Stearn (1982) p. 137 [*Metamorphosis*, plate 59].
18 Catesby (1731–1743) vol. 2, p. 33.
19 Letter to Johann Georg Volkamer, 8 October 1702: Rücker & Stearn (1982) p. 65.
20 Letter to Clara Regina Imhoff, 8 December 1684: Rücker & Stearn (1982) p. 62.

21 Letter to Johann Georg Volkamer, 8 October 1702: Rücker & Stearn (1982) p. 65.

22 Rücker & Stearn (1982) p. 132 [*Metamorphosis*, plate 54].

23 Catesby (1731–1743) Preface, p. iv.

24 McBurney (2021) p. 106.

25 Joachim von Sandrart, quoted in Rücker & Stearn (1982) p. 2.

26 Edwards (1743–1751) vol. 4, p. 215.

27 Catesby (1731–1743) Preface, p. vi–vii.

28 Catesby (1731–1743) Preface, p. vi.

29 Catesby (1731–1743) Preface, p. vi.

30 Rücker & Stearn (1982) p. 131 [*Metamorphosis*, plate 53]; Stearn, W.T. (1982), p. 529, who notes her "perception of their close interrelationship [was] almost unique when she began [her work]."

31 Rücker & Stearn (1982), p. 86.

32 Catesby (1731–1743) Preface, p. vi.

33 Edwards (1743–1751) vol. 4, p. 212.

34 For Merian's *Studienbuch*, see Etheridge (2021) p. 83–88; Valiant (1993) p. 468–470.

35 Catesby (1731–1743) Preface, p. v.

36 Catesby (1731–1743) vol. 2, p. 87.

37 Rücker & Stearn (1982) p. 91 [*Metamorphosis*, plate 5], 127 [*Metamorphosis*, plate 48].

38 Quoted in Rücker & Stearn (1982) p. 1.

39 Wilson (1970–1971) p. 171–172.

A Remarkable Woman. The Impact of Maria Sibylla Merian on Natural History in Germany

Anja Grebe, p. 206–214

1 Lobgedicht by Christoph Arnold in Merian (1679). English translation quoted from Etheridge (2021) p. 134.

2 Etheridge (2021).

3 Arnold also composed a *Raupen-lied* full of religious connotations which was included in the *Raupenbuch*; see Grebe & Sauer (2017) p. 64–65, cat. 34; Etheridge (2021) p. 135–138.

4 Niefanger (2012) p. 87–138.

5 An exception is Johannes Goedaert, who was trained as a painter; see Ogilvie (2008).

6 Aldrovandi (1602); Conring (1687) p. 293–294; Moffet et al. (1634); see also Bodenheimer (1928) p. 247–288; Fischel (2009); Simili (2001).

7 Conring (1687) p. 293.

8 See Ludwig (1997) p. 59–65.

9 Ludwig (1997) p. 60.

10 Eberti (1706) p. 167–168.

11 Conring (1687) p. 294. On Conring, see Stolberg-Wernigerode (1957) p. 342–343; Stolleis (1983).

12 See Gössmann (1988); Guentherodt (1988); Andréolle & Molinari (2011).

13 Corvinus (1715), col. 679–680, see also col. 1261. On Corvinus, see Roßbach (2009).

14 On Corvinus and the question of "gendered knowledge," see Roßbach (2009).

15 On the *Frauenzimmer-Lexicon* and its socio-literary context, see Roßbach (2015).

16 Corvinus (1739) col. 586.

17 See Roßbach (2015).

18 Conring (1687).

19 Rosner (1969).

20 Sauer (2017); Neri (2011), especially p. 139–180.

21 Albin (1720).

22 Bristowe (1967). On Merian's correspondence with Petiver, see Schmidt-Loske et al. (2020), especially p. 48–67; 76–83.

23 Frisch (1720–1738).

24 Merian (1679) plate 38. English translation quoted from Etheridge (2021) p. 303.

25 Frisch (1720–1738) vol. 2 (1721) p. 41; about Frisch, see Winter (1961).

26 Willnau (1926).

27 Ledermüller (1761–1763) vol. 1; see Grebe & Sauer (2017) p. 68–69, cat. 40.

28 Ledermüller (1761–1763) vol. 1, p. 20.

29 Mayer (2001); see also Himmel & Klemmer (2009).

30 Rösel von Rosenhof (1746–1761); Grebe & Sauer (2017) p. 69, cat. 41.

31 Rösel von Rosenhof (1746–1761) vol. 1, p. 51.

32 See Grebe & Sauer (2017) p. 69–72, cat. 42.

33 Reitsma (2008) p. 133–167.

34 Pirson (1953); Dickel et al. (2021); Müller-Ahrndt (2021).

35 Trew (1750–1773) plate 40; see also Dickel & Uhl (2019) p. 86–87; Dickel (2021) p. 346; Uhl (2021) p. 281–284.

36 Etheridge (2016) p. 54–70.

37 For further references, see Valiant (1993); Etheridge (2011), and the chapter by McBurney in this volume.

38 Merian (*Meriana*, Tab. 40); Ehret (*Ehretia*, Tab. 25); Petiver (*Petiveria*, Tab. 67); Boerhaave (*Boerhaavia*, Tab. 111), and Malpighi (*Malpighia*, Tab. 112).

Marketing Merian. The Visual Branding of the Late Female Naturalist

Lieke van Deinsen, p. 215–225

1 Stuldreher-Nienhuis (1945) p. 132–133.

2 Amsterdam City Archives, Notary Pieter Schabaalje inv. no. 6107, 28 September 1717. "De platen, plaatdrucks, en letterdrucks, zo wel afgezet, als onafgezet, mets de welken het Regt van Copy."

3 See also Davis (1995) p. 201.

4 "Vom zarensten Kindesalter bis zur Müden Greisin wird ihr Antlitz überliefert," Pfister-Burkhalter (1949) p. 31. On the problematic identification of likenesses of Merian, see also Wettengl (1997 and 98) p. 13–14; Pick (2004) p. 58–70. The best contender to be the second authentic likeness of Merian is a portrait currently in the collection of the Kunstmuseum Basel, inv. no. 436, reproduced as frontispiece in the present book.

5 For multiple examples, see Pfister-Burkhalter (1949) p. 35–40.

6 Waquet (1991) p. 22–28.

7 Le Thiec (2009) p. 7–52.

8 On the commercial purpose of author portraits, see Griffiths (2016), p. 396–397; The Multigraph Collective (2018) p.143–144.

9 Chartier (1994) p. 52. See also Burke (1998) p. 150–162.

10 On the mechanisms of authorial branding in the early modern Dutch Republic, see Van Deinsen & Geerdink (2021).

11 Simonin (2002); Ezell (2012); Van Deinsen (2019).

12 Van Deinsen (2022).

13 For the relationship between Arnold and Merian, see Etheridge (2021) p. 56–61.

14 "Ik had het Schrift wel langer konnen uitbreiden, maar door dien de tegenwoordige Wereld zeer delicaat en de gevoelens der Geleerde verschillig zyn, zo heb ik maar eenvoudig by myn ondervindingen willen blyven, en daar door stoffe aan de hand leevere, waar uit een ieder na sijn eige zin en meening reflexien kan maaken," from "Aan den Leezer," in *Metamorphosis* (1705). Translation by Patrick Lennon in Van Delft & Mulder (2016) p. 177.

15 On Oosterwyk's career, see Van Eeghen (1960–1978) vol. 4, p. 26–29. On his strategies to reframe the stock he purchased from other publishers, see Van Deinsen (2017) p. 105–108.

16 For the auction catalogue, see Testas de Jonge (1744). The portrait is mentioned here under no. 15 on p. 12: "Le Portrait de Marie Sebille Meriaan, dessiné par Gesellen." The collection also included a portrait of her drawn by Houbraken ("en crayon rouge"). On the genesis and dating of the collection, see Te Rijdt (1997). See also Plomp (1989).

17 Translation by Han van der Vegt.

18 "Hæc ancilla bona & fida est, quæ quinque recepit / Mille talent suo reddidit illa Deo" [*4r].

19 "Nu *Oosterwyk*, die uyt ontfarmen / Haer Letter-weeskind maakte groot, / Het steunen leert op eygen armen."

The Place of Maria Sibylla Merian's Books in Eighteenth-Century Private Libraries

Alicia C. Montoya, p. 226–238

1 This database was created in the MEDIATE project. This project has received funding from the European Research Council (ERC) under the European Union's Horizon 2020 research and innovation program under grant agreement No. 682022. See also the project website, www.mediate18. nl (visited 6 February 2021).

2 Post (1987) p. 124.

3 Ibid.

4 Reitsma (2008) chapter 4.

5 Jorink (2010); Ogilvie (2006).

6 Jorink (2010) p. 185.

7 Montoya (2018).

8 Montoya (2004).

9 Montoya & Jagersma (2018).

10 There are, however, multiple issues—a full discussion of which would fill many articles and books on their own—in using library auction catalogues as unproblematic reflections of a named individual's actual library contents, or reading culture in general. Some of these issues are addressed in Montoya (2004) and Montoya & Jagersma (2018).

11 Montoya & Jagersma (2018) p. 64.

12 Heard (2016) p. 28.

13 See also the chapter by Van de Plas in this volume.

14 Montoya & Jagersma (2018) p. 68.

15 Etheridge (2021) p. 113.

16 Montoya (2004); Montoya & Jagersma (2018).

17 Reitsma (2008); Pieters (2014). See also the chapter by Van de Roemer in this volume.

18 See also the chapter by Eric Jorink in this volume.

19 In the case of Pieter Cramer, the numbers are obviously skewed by the fact that the author was himself one of the library owners included in the corpus.

20 For more on the concepts of "close reading" and "distant reading," see Moretti (2013).

The Rewarding Gaze. How a French Triumvirate in Amsterdam Misused Johannes Goedaert's Work to Create Maria Sibylla Merian's "Collected Works" and What This Meant for My Art

Joos van de Plas, p. 239–251

1 Van de Plas (2008); Van de Plas (2009).

2 Van de Plas (2013), all titles mentioned; a summary of my work in Wiesbaden is given by Schmidt-Loske (2021) p. 73.

3 Van de Plas (2019).

4 Amsterdam, Allard Pierson, University of Amsterdam, uncolored, inv. no. KF 61-3823 (1–2).

5 See remark j. in the Appendix at the end of this essay.

6 Stuldreher-Nienhuis (1945) p. 46.

7 See the comparative table in the Appendix; the "new" plates are indicated by red squares.

8 Text accompanying plates CLXI–CLXV (year has been changed). Furthermore, he wrote in French je ("I") in the edition ten times altogether, as if he had observed these metamorphoses himself.

9 It is explicitly mentioned on the title pages of both Dutch and French editions of Merian & Marret (1730) that Marret gives explications of eighteen new plates. There are nineteen texts, but those concerning CLXXI–CLXXII refer to only one plate (see the table in the Appendix).

10 Goedaert, J. & M. Lister (1682) p. 93–94.

11 Merian & Marret (1730), in Dutch, p. 82.

12 *Fijnschilder*, Dutch (literally, "fine painter") for a painter with a meticulously precise style.

13 *Chance & Change*, May 2020–June 2021, Joos van de Plas and Herman de Vries, Galerie Wit, Wageningen.

How to Crack Such Shells? Maria Sibylla Merian and Catalogues of Zoological Specimens

Yulia Dunaeva & Bert van de Roemer, p. 252–264

1 MacGregor (2007); Daston & Park (1998); Jorink (2010), chapter 5; Van de Roemer (2004).
2 Margócsy (2014) p. 30–64.
3 Stoll (1961) p. VII.
4 Blunt (2001) p. 251; Kouprianov (2005) p. 1–60; Müller-Wille & Scharf (2009) p. 4–16; Pavlinov (2015) p. 7.
5 Koerner (1996) p. 149.
6 Tradescant (1656) 'To the Ingenious Reader'.
7 Beekman (1999) p. 5.
8 Dunaeva (2015) p. 21–22; Margócsy (2010) p. 79.
9 Etheridge (2011) p. 34.
10 Etheridge (2021) p. 7.
11 Stearns (1952) p. 244; Murphy (2013) p. 639–640.
12 Stearns (1952) p. 359.
13 Etheridge & Pieters (2015) p. 53; Schmidt-Loske et al. (2020) p. 32; Jorink (2012), p. 66–67.
14 Petiver (1695–1703) p. 3–93.
15 Petiver (1695–1703) p. 16.
16 Etheridge (2021) p. 268.
17 Petiver (1695–1703) p. 3–4.
18 Petiver (1695–1703) p. 96.
19 Van de Roemer (2016) p. 25–28; Van de Roemer (2014).
20 Vincent (1726) p. 1–68.
21 Vincent (1726) p. 13 [B57], 41 [F102], 44 [F133; F134; F135; F140], 46 [F163; F167; F174], 47 [F180; F185], 48 [F195].
22 Juriev (1981) p. 109; Driessen-van het Reve (2015) p. 67.
23 Juriev (1981) p. 110; Driessen-van het Reve (2015) p. 109.
24 Margócsy (2014) chapter 3 (p. 74–108).
25 Holthuis (1969); Juriev (1981) p. 113–114.
26 Juriev (1981) p. 114; Driessen-van het Reve (2015) p. 68.
27 Seba (1734–1765) vol. 1, p. 49, 154, 168–169; pl. 31 fig. 5, pl. 99 fig. 1, pl. 106 fig. 1.
28 Etheridge & Pieters (2015) p. 55.
29 Seba (1734–1765) vol. 4, p. 31.
30 Schmidt-Loske (2007) p. 17, 112–113.
31 Driessen-van het Reve (2015) p. 107–156; Radziun (1997) p. 98–114.
32 Kopaneva (2012) p. 290.
33 Beer (1976).
34 Lebedeva (1997) p. 330.
35 *Musei Imperialis Petropolitani* (1742) p. 663.
36 Van Andel et al. (2016) p. 194.
37 *Inventair national* (undated) https://inpn.mnhn.fr/espece/cd_nom/778883 (visited 6 February 2022).
38 Kullander (1997–2001) http://linnaeus.nrm.se/zool/madfrid.html.en (visited 28 January 2021).
39 Linnaeus (1754) p. 82–85.
40 Linnaeus (1754) p. 82.
41 Linnaeus (1758) p. 389, 408.
42 Linnaeus (1758) p. 341.
43 Stearn (1982) p. 76–83.
44 Linnaeus (1758) p. 591, 468.

Bibliography

Albin, E. (1720) *A Natural History of English Insects [...] and, (for those who desire it) Exactly Coloured by the Author*, London.

Albus, A. (1997) *The Art of Arts. Rediscovering Painting*, New York. Original edition in German published 1997 as well.

Alcantara-Rodriguez, M., M. Françozo & T. van Andel (2019) 'Plant knowledge in the *Historia Naturalis Brasiliae* (1648). Retentions of seventeenth-century plant use in Brazil' in: *Economic Botany*, 73, p. 390–404; doi. org/10.1007/s12231-019-09469-w.

Aldrovandi, U. (1602) *De Animalibus Insectis Libri septem [...]*, Bologna.

Alpers, S. (1983) *The Art of Describing. Dutch Art in the seventeenth Century*, Chicago/London.

Andel, T. van, H. Gernaat, A. Hielkema & P. Maas (2016) 'Determinering van dieren en planten op Merians platen = Determination of animals and plants on Merian's plates' in: M. van Delft & H. Mulder (eds.), *Maria Sibylla Merian 1705. Metamorphosis Insectorum Surinamensium*, Tielt/ The Hague, p. 190–198.

Andréolle, D.S. & V. Molinari (2011) 'Introduction' in: D.S. Andréolle & V. Molinari (eds.), *Women and Science, 17th Century to Present. Pioneers, Activists and Protagonists*, Newcastle upon Tyne, p. xi–xxv.

Antennae (2007–present) *The Journal of Nature in Visual Culture*, www.antennae.org.uk.

Attenborough, D. (2007), with contributions by S. Owens, M. Clayton & R. Alexandratos, *Amazing rare Things. The Art of Natural History in the Age of Discovery*, New Haven/London.

Ausführliche (1673) *Außführliche Beschreibung der Insul Surinam. Betreffend Ihre frembde Gewohnheiten, Sitten und seltsame Lebens-Ordnung*, [S.l.]: tudigit.ulb.tu-darmstadt. de/show/Gue-10338-33/0023.

Baar, M.P.A. de (2004) *'Ik moet spreken'. Het spiritueel Leiderschap van Antoinette Bourignon (1616–1680)*, [Zutphen], PhD Thesis, University of Groningen.

Baigrie, B.S. (1996) *Picturing Knowledge. Historical and Philosophical Problems concerning the Use of Art in Science*, Toronto.

Bal, M.G. (2003) 'Her Majesty's masters' in: M.F. Zimmermann (ed.) *The Art Historian. National Traditions and institutional Practices*, Williamstown, MA, p. 81–109.

Balfe, T. & J. Woodall (2019) 'Introduction: From living presence to lively likeness—the lives of ad vivum' in: T. Balfe, J. Woodall & C. Zittel (eds.), *Ad Vivum? Visual Materials and the Vocabulary of Life-likeness in Europe before 1800*, Leiden/Boston, p. 1–43.

Barlow, J., F. França, T.A. Gardner, et al. (2018) 'The future of hyperdiverse tropical ecosystems' in: *Nature*, 559, p. 517–526.

Bassy, A.-M. (1990) 'Le texte et l'image' in: R. Chartier & H.-J. Martin, *Histoire de l'Édition française*, vol. 2. *Le Livre triomphant 1660–1830*, Paris, p. 173–200. First ed. 1984.

Beaart K. (2016) *Johannes Goedaert Fijnschilder en Entomoloog*, Middelburg.

Beekman, E.M. (1999) *The Ambonese Curiosity Cabinet—Georgius Everhardus Rumphius, translated, edited, annotated, and with an Introduction*, New Haven/London.

Beekman, E.M. (2011) 'Introduction' in: *The Ambonese Herbal being a Description of the most noteworthy Trees, Shrubs, Herbs, Land- and Water-plants which are found in Amboina and the surrounding Islands* [by] Georgius Everhardus Rumphius. Translated, annotated, and with an introduction by E.M. Beekman, New Heaven/London, vol. 1, p. 1–179.

Beer, A. (ca. 1720) *Wol-anständige und Nutzen-bringende Frauen-Zim[m]er-Ergözung in sich enthaltend ein nach der allerneuesten Façon eingerichtete Neh- und Stick-Buch, welches diesem Kunst und Geschicklichkeit liebendem Geschlecht, vermittelst sehr vieler vollkomenen und auf allerhand Art inventirten practicablen Risse und andern netten Zeichnungen [...] vorgestellt worden*, Nuremberg.

Beer, W.-D. (1974) 'Maria Sibylla Merian and the natural sciences' in: E. Ullmann (ed.) *Maria Sibylla Merian. Leningrader Aquarelle*, II. Kommentar, Leipzig, p. 77–110.

Beer, W.-D. (ed.) (1976) *Maria Sibylla Merian. Schmetterlinge, Käfer und andere Insekten. Leningrader Studienbuch, Faksimile mit Transkription und Tafeln* (2 vols.), Leipzig.

Beer, W.-D. (1976) 'The significance of the "Leningrad Book of Notes and Studies" biographically and in the history of Maria Sibylla Merian's work' in: W.-D. Beer (ed.), *Maria Sibylla Merian. Schmetterlinge, Käfer und andere Insekten. Leningrader Studienbuch*, Leipzig, p. 51–65.

Beer, W.-D. (ed.) (2011) *Maria Sibylla Merian. Schmetterlinge, Käfer und andere Insekten. Leningrader Studienbuch, Faksimile mit Transkription*, Saarbrücken. Facsimile reprint of Beer (1976) in 1 vol.

Beltran, J. (2019) 'Nature au naturel in late seventeenth-century France' in: T. Balfe, J. Woodall & C. Zittel (eds.), *Ad Vivum? Visual Materials and the Vocabulary of Life-likeness in Europe before 1800*, Leiden/Boston, p. 272–293.

Benthem Jutting, W.S.S. van (1959) 'Rumphius and malacology' in: H.C.D. de Wit (ed.), *Rumphius Memorial Volume*, Baarn, p. 181–207.

Berkhey, J. le Francq van (1784) *Eerste Catalogus van de uitgebreide systhematische natuurkundige Verzameling van Teekeningen, Printen en afgezette Afbeeldingen, van allerleye Classen van Dieren en Planten [...]*, Amsterdam.

[Bernard, J.F.] & B. Picart (1723–1743) *Cérémonies et Coutumes Religieuses de tous les Peuples du Monde [...]*, Amsterdam, 9 vols.

Bertoloni Meli, D. (2010) 'The representation of insects in the seventeenth century. A comparative approach' in: *Annals of Science*, 67, p. 405–442.

Beuys, B. (2016) *Maria Sibylla Merian. Künstlerin, Forscherin, Geschäftsfrau*, Berlin.

Bidloo, G. (1685) *Anatomia Humani Corporis [...]*, Amsterdam.

Blankaart, S. (1668), *Schou-burg der Rupsen, Wormen, Ma'den, en vliegende Dierkens daar uit voortkomende [...]*, Amsterdam.

Bleichmar, D. (2012), *Visible Empire, Botanical Expeditions and visual Culture in the Hispanic Enlightenment*, Chicago.

Bleichmar, D. (2017) *Visual Voyages. Images of Latin American Nature from Columbus to Darwin*, New Haven/London.

Block, A. (undated) *Plusieurs Espèces de Fleurs dessinées d'après le Naturel*, Rijksmuseum, Amsterdam, inv. no. RP-T-1948-119. Art book with drawings once owned by Agnes Block, manuscript.

Blom, F.J.M. (1981) *Christoph & Andreas Arnold and England. The Travels and Book-Collections of two seventeenth-century Nurembergers*. PhD Thesis, University of Nijmegen.

Blunt, W. (2001), *Linnaeus. The Compleat Naturalist*, Princeton/Oxford.

Blunt, W. & W.T. Stearn (1994), *The Art of Botanical Illustration*, Woodbridge. First edition 1950.

Bodenheimer, F.S. (1928) *Materialien zur Geschichte der Entomologie bis Linné*, Berlin.

Boersma, A. (2021) *Ander Licht op Withoos*, Amersfoort.

Bolt, M., T. Cocquyt & M. Korey (2018) 'Johannes Hudde and his flameworked microscope lenses', *Journal of Glass Studies* 60, p. 207–222.

Braun, A.M. (1773-1793) *Vier Kunstbücher*, Nuremberg, Germanisches Nationalmuseum, T8181,1-4: dlib.gnm.de/item/Kunstbuch_Braun.

Braun, B. (2010) *Ein Stück Himmel*: meyer-riegger.de/en/data/exhibitions/129/).

Bristowe, W.S. (1967) 'More about Joseph Dandridge and his friends James Petiver and Eleazar Albin' in: *Entomologist's Gazette*, 18 (4), p. 197–201.

Brooks, E. St. John (1954) *Sir Hans Sloane. The great Collector and his Circle*, London.

Brown, Chr., J. Kelch & P.J.J. van Thiel (eds.) (1991), *Rembrandt. The Master & his Workshop. Paintings*, New Haven/London.

Bürger, Th. & M. Heilmeyer M. (eds.) (1999) *Maria Sibylla Merian. Neues Blumenbuch*, Munich/London/New York.

Buijze, W. (2006) *Leven en Werk van Georg Everhard Rumphius (1627-1702). Een Natuurhistoricus in Dienst van de VOC*, The Hague.

Burke P. (1998) 'Reflections on the frontispiece portrait in the Renaissance' in: A. Köstler & E. Seidl (eds.), *Bildnis und Image. Das Portrait zwischen Intention und Rezeption*, Cologne, p. 150–162.

Burke, P. (2001) *Eyewitnessing. The Uses of Images as Historical Evidence*, London.

Burman, J. (ed.) (1755–1760) *Charles Plumier, Plantarum Americanarum [...]*, 10 installments, Amsterdam/Leiden.

Cabre i Pairet, M. & M.C. de Carlos Varona (2018) *Maria Sybilla Merian y Alida Withoos. Mujeres, Arte y Ciencia en la Edad moderna*, Santander.

Catesby, M. (1731–1743) [=1729–1747], *The Natural History of Carolina, Florida and the Bahama Islands [...]*, 2 vols., London.

Cellarius, A. (1708) *Harmonia Macrocosmica [...]*, Amsterdam.

Charmantier, I. (2011) 'Carl Linnaeus and the visual representation of nature' in: *Historical Studies in the Natural Sciences*, 41 (4), p. 365–404.

Chartier, R. (1994) *The Order of Books. Readers, Authors, and Libraries in Europe between the fourteenth and the eighteenth Centuries*. Cambridge.

Chemnitz, J.H. (1760) *Kleine Beyträge zur Testaceotheologie oder zur Erkäntniss Gottes aus den Conchylien [...]*, Nuremberg.

Cobb, M. (2002) 'Malpighi, Swammerdam and the colourful silkworm. Replication and visual representation in early modern science' in: *Annals of Science*, 59, p. 111–147.

Colditz-Heusl, S. et al. (2017) see Förderverein.

Commelin, C. (1702) *Horti Medici Amstelaedamensis rariorum tam Africanarum, quàm utriusque Indiae, aliarumque Peregrinarum Plantarum [...] Descriptio et Icones [...] Pars altera = Beschryvinge en curieuse Afbeeldingen van rare vreemde Oost-West-Indische en andere Gewassen vertoont in den Amsterdamsche Kruyd-hof [...], tweede deel*, Amsterdam.

Commelin, J. (1676) *Nederlantze Hesperides, dat is, Oeffening en Gebruik van de Limoen- en Oranje-Boomen, gestelt na den Aardt en Climaat der Nederlanden*, Amsterdam.

Commelin, J., F. Ruysch & F. Kiggelaar (1697) *Horti Medici Amstelodamensis rariorum tam Africanarum, quàm utriusque Indiae, aliarumque Peregrinarum Plantarum [...] Descriptio et Icones = Beschryvinge en curieuse Afbeeldingen van rare vreemde Oost-West-Indische en andere Gewassen vertoont in den Amsterdamsche Kruyd-hof [...]*, Amsterdam.

Commissie van Toezigt (1684–1795) *Memoriael van de Hortus Medicus der Stad Amsteldam, beginnende de 3 Febr. Ao. 1684*, manuscript, Stadsarchief Amsterdam, Archive No. 626, Inv. 29/30, no. 3–5.

Conring, H. (1687) *In Universam Artem Medicam singulasq; ejus Partes Introductio [...]*, Helmstedt.

Corvinus, G.S. (1715) *Nutzbares, galantes und curiöses Frauen-zimmer-Lexicon [...]*, Leipzig.

Corvinus, G.S. (1739) *Nutzbares, galantes und curiöses Frauen-zimmer-Lexicon [...]*, Leipzig.

Corvinus, G.S. (1773) *Nutzbares, galantes und curiöses Frauen-zimmer-Lexicon [...]*, 2 vols., Leipzig.

Daston, L. (2015) 'Epistemic images' in: A. Payne (ed.), *Vision and its Instruments. Art, Science, and Technology in early modern Europe*, University Park, PA, p. 13–35.

Daston, L. & K. Park (1998) *Wonders and the Order of Nature, 1150–1750*, New York.

Davies, S. (2016) *Renaissance Ethnography and the Invention of the Human. New Worlds, Maps and Monsters*, Cambridge.

Davis, N. Zemon (1995) *Women on the Margins. Three seven-teenth-century Lives*. Cambridge (MA)/London.

De, see Fontenelle, Kom, Oviedo.

Deckert, H. (1957) *Das Blumenbuch der Maria Sibylla Merian. Untersuchungen an der Hand der Dresdner Exemplare* in: *Zentralblatt für Bibliothekswesen*, 71 (5), p. 352–370.

Deckert, H. (ed.) (1966) *Maria Sibylla Merian, Neues Blumenbuch*. Mit einem Begleittext von Helmut Deckert, 2 vols, Leipzig.

Deinsen, L. van (2017) *Literaire Erflaters. Canonvorming in Tijden van culturele Crisis*. Hilversum.

Deinsen, L. van (2019) 'Visualising female authorship. Author portraits and the representation of female literary au-thority in the eighteenth century' in: *Quaerendo*, 49 (4), p. 283–314.

Deinsen, L. van (2022) 'Female faces and learned likenesses. Author portraits and the construction of female author-ship and intellectual authority' in: K. Scholten, D. van Miert & K.A.E. Enenkel (eds.), *Memory and Identity in the learned World*, Leiden/Boston, p. 81–116.

Deinsen, L. van & N. Geerdink (2021) 'Cultural branding in the early modern period. The literary author' in: H. van den Braber, J. Dera, J. Joosten & M. Steenmeijer (eds.), *Branding Books across the Ages. Strategies and Key Concepts in Literary Branding*, Amsterdam, p. 31–60.

Delft, M. van & H. Mulder (eds.) (2016) *Maria Sibylla Merian. Metamorphosis Insectorum Surinamensium 1705. Veran-dering der Surinaamsche Insecten = Transformation of the Surinamese Insects*, Tielt/The Hague. Facsimile + additional chapters.

Descartes, R. (1662) *De Homine [...]*, Leiden.

Descartes, R. (1664) *L'Homme [...] et un Traité de la Formation du Foetus [...]*, Paris.

Dickel, H. (2021) 'Botanische Bilder zwischen Kunst und Wis-senschaft' in: H. Dickel, E. Engl & U. Rautenberg (eds.), *Frühneuzeitliche Naturforschung in Briefen, Büchern und Bildern. Christoph Jacob Trew als Sammler und Gelehrter*, Stuttgart, p. 325–347.

Dickel, H., E. Engl & U. Rautenberg (eds.) (2021) *Frühneuzeitliche Naturforschung in Briefen, Büchern und Bildern. Chris-toph Jacob Trew als Sammler und Gelehrter*, Stuttgart.

Dickel, H. & A. Uhl (2019) *Die Bildgeschichte der Botanik. Pflanzendarstellungen aus vier Jahrhunderten in der Sammlung Dr. Christoph Jacob Trew (1695–1769)*, Petersberg/Erlangen.

Dijstelberge, P. (2007) *De Beer is los! Ursicula: een Database van typografisch Materiaal uit het eerste Kwart van de zeven-tiende Eeuw als Instrument voor het identificeren van Drukken*, [Amsterdam].

Dion, M. (2005) *The Brazilian Expedition by Thomas Enders— reconsidered*: www.akbild.ac.at/portal_en/university/activities/exhibitions_didacticprogram/2005/event_903.

Dion, M. (2009) 'Wissenschaftler haben kein Monopol an der Vorstellung von Natur. Mark Dion im Gespräch mit Dieter Burchhardt' in: *Kunstforum International*, 199, p. 249–259.

Dittelbach, P. (1692), *Verval en Val der Labadisten, of derselver Leydinge, en Wyse van doen in haare Huyshoudinge, en Kerk-formering, als ook haren Op- en Nedergang, in hare Coloniën of Volk-plantingen, nader ontdekt [...]*, Amsterdam.

Dodart, D. (1676), *Mémoires pour servir à l'Histoire des Plantes*, Paris.

Döhring, E. (1957) 'Conring, Hermann' in: O. zu Stolberg-Wernigerode et al. (eds.), *Neue deutsche Biographie*, vol. 3, Berlin, p. 342–343.

Dolezel, E. (2018) 'Das "vollständige Raritätenhaus" des Leon-hard Christoph Sturm. Ein Modell für die Museologie des 18. Jahrhunderts' in: E. Dolezel, R. Godel, A. Pečar & H. Zaunstöck (eds.), *Ordnen—Vernetzen—Vermitteln. Kunst- und Naturalienkammern in der Frühen Neuzeit als Lehr- und Lernorte*, Halle (Saale), p. 21–47 (*Acta historica Leopoldina* 70).

Doosry, J. (ed.) (2014) *Von oben gesehen. Die Vogelperspektive*, Nürnberg. Ausstellungskatalog Germanisches National-museum, Nuremberg.

Doppelmayr, J. G. (1730) *Historische Nachricht von Nürnbergischen Mathematicis und Künstlern*, Nuremberg, p. 268–270.

Driessen-van het Reve, J. J. (2015) *De Kunstkamera van Peter de Grote. De Hollandse Inbreng, gereconstrueerd uit Brieven van Albert Seba en Johann Daniel Schumacher uit de*

Jaren 1711–1752, Hilversum. PhD thesis, University of Amsterdam. Also published in Russian in Saint Petersburg.

Duijn, M. van (2015) *Collection Guide Alba Amicorum Collection, University of Leiden*://digitalcollections.universiteitleiden.nl/view/item/1887225.

Dunaeva, Y. (2015) 'What books from the Academic Library were the compilers of the zoological section of the first printed catalog of the Kunstkamera guided by?' in: *Peterburgskaya Bibliotechnaya Shkola*, 2 (50), p. 20–24. In Russian.

Eberti, J.C. (1706) *Eröffnetes Cabinet deß Gelehrten Frauen-Zimmers [...]*, Frankfurt/Leipzig.

Edwards, G. (1743–1751) *A Natural History of uncommon Birds [...]*, 4 vols., London.

Eeghen, I. van (1960–1978) *De Amsterdamse Boekhandel, 1680–1725*, 5 parts in 6 vols., Amsterdam.

Egmond, F. (2017) *Eye for Detail. Images of Plants and Animals in Art and Science, 1500–1630*, London.

Egmond, M. (2009) *Covens & Mortier. Productie, Organisatie en Ontwikkeling van een commercieel-kartografisch Uitgevershuis in Amsterdam (1685–1866)*, 't-Goy-Houten.

Elliott, J.H. (1992) *The Old World and the New, 1492–1650*, Cambridge. First edition 1970.

Engel, H. (1937) 'De heer Engel vertoont en bespreekt een oud handschrift "De Veranderinge van eenighe Rupsen en Wurmen" uit de bibliotheek van het Kon. Zoöl. Gen. "Natura Artis Magistra" te Amsterdam'. *Tijdschrift voor Entomologie* 80, p. xvi–xx.

Engel, H. (1959) 'The echinoderms of Rumphius' in: H.C.D. de Wit (ed.) *Rumphius Memorial Volume*, Baarn, p. 209–223.

Erickson, R. (2017) (ed.) *Mark Dion. Misadventures of a 21st-Century Naturalist*, Boston.

Etheridge, K. (2011) 'Maria Sibylla Merian. The first ecologist?' in: D.S. Andréolle & V. Molinari (eds.), *Women and Science, 17th Century to Present: Pioneers, Activists and Protagonists*, Newcastle upon Tyne, p. 35–54.

Etheridge, K. (2016) 'De biologie in *Metamorphosis insectorum Surinamensium* = The biology of *Metamorphosis insectorum Surinamensium*' in: M. van Delft van & H. Mulder (eds.), *Maria Sibylla Merian. Metamorphosis Insectorum Surinamensium* 1705, Tielt/The Hague, p. 29–39.

Etheridge, K. (2016) 'The history and influence of Maria Sibylla Merian's bird-eating tarantula. Circulating images and the production of natural knowledge' in: P. Manning & D. Rood (eds.), *Global scientific Practice in the Age of Revolutions, 1750–1850*, Pittsburgh, p. 54–70.

Etheridge, K. (2021) *The Flowering of Ecology. Maria Sibylla Merian's Caterpillar Book*, Leiden/Boston.

Etheridge, K. & F.F.J.M. Pieters (2015) 'Maria Sibylla Merian (1647–1717). Pioneering naturalist, artist, and inspiration for Catesby' in: E.C. Nelson & D.J. Elliot (eds.), *The Curious Mr. Catesby—a "truly ingenious" Naturalist explores New Worlds*, Athens/London, p. 39–56.

Ezell, M.J.M. (2012) 'Seventeenth-century female author portraits, or, the company she keeps' in: *Zeitschrift für Anglistik und Amerikanistik*, 60 (1), p. 31–45.

Findlen, P. (1994) *Possessing Nature. Museums, Collecting, and scientific Culture in Early Modern Italy*, Berkeley.

Fischel, A. (2009) *Natur im Bild. Zeichnung und Naturerkenntnis bei Conrad Gessner und Ulisse Aldrovandi*, Berlin.

Flügelschlag (2019) *Flügelschlag. Insekten in der zeitgenössischen Kunst*, Bad Homburg von der Höhe. Stiftung Nantesbuch, exhibition catalogue Museum Sinclair-Haus.

Förderverein Kunsthistorisches Museum Nürnberg e.V. (2017) S. Colditz-Heusl, M. Lölhöffel, T. Noll & W. Schultheiß (eds.), *Johann Andreas Graff 1636–1701*. Catalogue accompanying the exhibition: *Johann Andreas Graff, Pionier Nürnberger Stadtansichten im Kunstkabinett der Stadtbibliothek Nürnberg*, Nuremberg.

Font Paz, C. & N. Geerdink (2018) 'Introduction: Women, Professionalisation, and Patronage' in: Font Paz, C. & N. Geerdink (eds.), *Economic Imperatives for Women's Writing in Early Modern Europe*, Leiden/Boston, p. 1–15.

Fontenelle, B. de (1709) 'Éloge de M. de Tournefort' in: *Histoire de l'Académie Royale des Sciences 1708*, p. 174–188.

Freedberg, D. (2002) *The Eye of the Lynx. Galileo, his Friends, and the Beginnings of modern Natural History*, Chicago.

Fries, P. (2009) 'The skins of painting. A dialogue between Camille Morineau and Pia Fries' in: *Pia Fries, Merian's Surinam*, Galerie Nelson-Freeman, Paris and Verlag der Buchhandlung Walter König, Cologne.

Frisch, J.L. (1720–1738) *Beschreibung von allerley Insecten in Teutsch-Land [...]*, 13 vols., Berlin.

Frisch, J.L. (1730–1753) *Beschreibung von allerley Insecten in Teutschland [...]*, 13 vols., Berlin.

Fuchs, L., (1542) *De Historia Stirpium Commentarii Insignes [...]*, Basel.

Goedaert, J. (1660–1669) *Metamorphosis Naturalis [...]*, 3 vols., Middelburg.

Goedaert, J. (1700) *Histoire Naturelle des Insectes selon leurs differentes Métamorphoses*, 3 vols., Amsterdam.

Goedaert, J. & M. Lister (1682) *Johannes Godartius of Insects. Done into English, and methodized, with the Addition of Notes*, York.

Gössmann, E. (1988) 'Für und wider die Frauengelehrsamkeit. Eine europäische Diskussion im 17. Jahrhundert' in: G. Brinker-Gabler (ed.), *Deutsche Literatur von Frauen*, vol. 1, Munich, p. 185–197.

Goethe, J.W. von (1817) 'Blumen-Malerei' in: J.W. von Goethe, *Ueber Kunst und Alterthum in den Rhein und Mainz Gegenden*, 1 (3), p. 81–91.

Goethe, J.W. von (1831), *Goethes Werke. Vollständige Ausgabe letzter Hand*, vol. 39, Stuttgart/Tübingen.

Graak, K. (1982) *Vergiss mein nicht—gedenke mein. Vom Stammbuch zum Poesiealbum*, Munich.

Grabowski, C. (2017) *Maria Sibylla Merian zwischen Malerei und Naturforschung. Pflanzen- und Schmetterlingsbilder neu entdeckt*. Berlin.

Gräffin, M.S., see Merian, M.S.

Graff, J.A. (2017) see Förderverein etc. (2017).

Graft, C.C. van der (1943) *Agnes Block. Vondels nicht en vriendin*, Utrecht.

Gray, M.W. (1987) 'Prescriptions for productive female domesticity in a transitional era. Germany's Hausmütterliteratur, 1780–1840' in: *History of European Ideas*, 8, p. 413–426.

Grebe, A. (2021) 'Art, nature, metamorphosis. Maria Sibylla Merian as artist and collector' in: M. Faietti & G. Wolf (eds.), *Motion—Transformation. Proceedings of the CIHA Florence 2019 Congress*, Bologna, p. 175–180.

Grebe, A. & C. Sauer (2017) *Maria Sibylla Merian. Blumen, Raupen, Schmetterlinge*, Nuremberg (*Ausstellungskatalog der Stadtbibliothek Nürnberg* 110).

Greenfort, T. (2009) '"Der Nachhaltige". Tue Greenfort im Gespräch mit Dietmar Stange' in: *Kunstforum International*, 199, p. 208–215.

Grieb, M.H. (2007) *Nürnberger Künstlerlexikon. Bildende Künstler, Kunsthandwerker, Gelehrte, Sammler, Kulturschaffende und Mäzene vom 12. bis zur Mitte des 20. Jahrhunderts*, 4 vols., Munich.

Griffiths, A. (2016) *The Print before Photography. An Introduction to European Printmaking 1550–1820*, London.

Grijzenhout, F. (2014) 'Rembrandt. Alle schilderijen' in: J. Rutgers & M. Rijnders (eds.), *Rembrandt in Perspectief. De veranderende Visie op de Meester en zijn Werk*, Zwolle, p. 257–285.

Guentherodt, I. (1988) '"Dreyfache Verenderung" und "Wunderbare Verwandelung". Zu Forschung und Sprache der Naturwissenschaftlerinnen Maria Cunitz (1610–1664) und Maria Sibylla Merian (1647–1717)' in: G. Brinker-Gabler (ed.), *Deutsche Literatur von Frauen* 1, Munich, p. 197–221.

Guilding, L. (1834) 'Observations on the work of Maria Sibilla Merian on the insects &c. of Surinam' in: *The Magazine of Natural History and Journal of Zoology, Botany [...]*, 7, p. 355–375.

Haas, F. & A. Wolf (2019) *Gruppe Finger*: fingerweb.org.

Harris, M. (1766) *The Aurelian: or, a Natural History of British Insects*, London.

Hauß-Halterin (1703) *Die so kluge als künstliche von Arachne und Penelope getreulich unterwiesene Hauß-Halterin, oder dem Frauen-Zimmer wohlanständiger Kunst-Bericht und gründlicher Haußhaltungs-Unterricht*, Nuremberg: mdz-nbn-resolving.de/urn:nbn:de:bvb:12-bsb10228804-1.

Heard, K. (2016) *Maria Merian's Butterflies*, London. Exhibition Catalogue Royal Collection, Buckingham Palace.

Heijenga-Klomp, M.W. (2005) 'Matthias Withoos en zijn kinderen. Een Amersfoortse schildersfamilie' in: *Flehite, Historisch Jaarboek voor Amersfoort en Omstreken*, 6, p. 108–131: dspace.library.uu.nl/handle/1874/302956.

Heijenga-Klomp, M.W. (2005) 'Jasper van Wittel (ca. 1652–1736) een Amersfoortse schilder in Italië' in: *Flehite, Historisch Jaarboek voor Amersfoort en Omstreken*, 6, p. 132–147.

Heijer, H. den (2005) 'Over warme en koude landen'. Mislukte Nederlandse volksplantingen op de Wilde Kust in de zeventiende eeuw' in: *De Zeventiende Eeuw*, 21, p. 79–90.

Heijer, H. den (2021), *Nederlands Slavernijverleden. Historische Inzichten en het Debat nu*, Zutphen.

Henrey, B. (1975), *British Botanical and Horticultural Literature before 1800. The eighteenth Century*, London.

Himmel, T.K.D. & K. Klemmer (2009) 'Maria Sibylla Merian (1647–1717) und ihr Einfluss auf das Lebenswerk von August Johann Rösel von Rosenhof (1705–1759)' in: *Sekretär. Beiträge zur Literatur und Geschichte der Herpetologie und Terrarienkunde*, 9 (2), p. 33–48.

Hollmann, E. (ed.) (2003) *Maria Sibylla Merian. The St. Petersburg Watercolours, with Natural History Commentaries by W.-D. Beer*, Munich/Berlin/London/New York.

Hollmann, E. (ed.) (2003) *Maria Sibylla Merian. Die St. Petersburger Aquarelle, mit naturkundlichen Erläuterungen von W.-D. Beer*, Munich.

Hollsten, L. (2012) 'An Antillean plant of beauty, a French botanist, and a German name. Naming plants in the early modern Atlantic world' in: *Estonian Journal of Ecology*, 61 (1), p. 37–50.

Holthuis, L.B. (1959) 'Notes on pre-Linnean carcinology (including the study of Xiphosura) of the Malay Archipelago' in: H.C.D. de Wit (ed.), *Rumphius Memorial Volume*, Baarn, p. 63–125.

Holthuis, L.B. (1969) 'Albertus Seba's "Locupletissimi rerum naturalium thesauri...." (1734–1765) and the "Planches de Seba" (1827–1831)' in: *Zoölogische Mededelingen uitgeven door het Rijksmuseum van Natuurlijke Historie te Leiden*, 43 (19), 239–255.

Houbraken, A. (1721) *De groote Schouburgh der Nederlantsche Konstschilders en Schilderessen [...]*, vol. 3, Amsterdam, p. 220–224.

Hrodej, P. (1997) 'Saint-Domingue en 1690. Les observations du père Plumier, botaniste provençal' in: *Revue française d'Histoire d'Outre-Mer*, 84 (317), p. 93–117.

Huemer, M. (2018) *This Exhibition has an Utopian Superfluity*, Bratislava. Exhibition catalogue Danubia Meilenstein Art Museum.

Huemer, M. (2020) *The Oranges don't like the Kiwi in the Painting*, Cologne. Exhibition catalogue Philipp von Rosen Galerie.

Inventair national (undated) 'Papilio androgeus Cramer, 1775 (Arthropoda, Hexapoda, Lepidoptera)' in: *Inventair national du patrimoine naturel. Le portail de la biodiversité française, de métropole et d'outre-mer*: inpn.mnhn.fr/espece/cd_nom/778883.

Ivins, W.M. (1953) *Prints and visual Communication*, London.

Jagersma, R. & T. Dijkstra (2014) 'Uncovering Spinoza's printers by means of bibliographical research' in: *Quaerendo*, 43 (4), p. 278–310.

Jeybratt, L. (2012) 'Interspezies-Kollaborationen. Kunstmachen mit nicht-menschlichen Tieren' in: *Tierstudien*, 1, p. 105–121.

Jonston, J. (1653) *Historiae Naturalis de Insecti, libri III [...]*, Frankfurt am Main.

Jonston, J. (1660) *Dr. I. Jonstons naeukeurige beschryving van de natuur der gekerfde of kronkel-dieren, [...]*, Amsterdam.

Jorink, E. (2010) *Reading the Book of Nature in the Dutch Golden Age, 1575–1715*, Leiden/Boston, 2010.

Jorink, E. (2011) 'Beyond the lines of Apelles. Johannes Swammerdam, Dutch scientific culture and the representation of insect anatomy' in: *Nederlands Kunsthistorisch Jaarboek*, 61, p. 148–183.

Jorink, E. (2012) 'Sloane and the Dutch Connection' in: A. Walker, A. MacGregor & M. Hunter (eds.), *From Books to Bezoars. Sir Hans Sloane and his Collections*. London, p. 57–70.

Jorink, E. (2018) 'Insects, philosophy and the microscope' in: H.A. Curry, N. Jardine, J.A. Secord & E.C. Spary (eds.), *Worlds of Natural History*, Cambridge, p. 131–150.

Jorink, E. & B.A.M. Ramakers (eds.) (2011), *Art and Science in the Early Modern Netherlands—Kunst en Wetenschap in de Vroegmoderne Nederlanden*, Zwolle.

Jürgensen, R. (2002). *Bibliotheca Norica. Patrizier und Gelehrtenbibliotheken in Nürnberg zwischen Mittelalter und Aufklärung*, 1, Wiesbaden.

Juriev, K.B. (1981) 'Albert Seba and his contribution to the development of herpetology' in: *Proceedings of the Zoological Institute, Russian Academy of Sciences*, 101, p. 109–120. In Russian.

Kaag, S. & A. Storm (2019) *Peter Schenck. Der berühmteste Elberfelder, der jemals in Vergessenheit geriet*, Wuppertal. Exhibition catalogue of Von der Heydt-Museum.

Kaldenbach, C.J. (ca. 1988) *Tekeningen uit het Album Amicorum (Stamboek) van Joanna Koerten Blok (1650–1715), een Overzicht met Index*. Unpublished typoscript in the Rijksmuseum Research Library, Amsterdam, online: kalden.home.xs4all.nl/auth/KoertenBlok1.htm.

Kannisto, S. (2011) *Fieldwork. Sanna Kannisto*, New York.

Keating, J. & L. Markey (2011) 'Introduction. Captured objects. Inventories of early modern collections' in: *Journal of the History of Collections*, 23 (2), p. 209–213.

Keil, R. & R. Keil (1893) *Die deutschen Stammbücher des sechzehnten bis neunzehnten Jahrhunderts*, Berlin.

Kemp, M. (1990) 'Taking it on trust. Form and meaning in naturalistic representation' in: *Archives of Natural History*, 17 (2), p. 127–188.

Kennedy, R.F. (1968) *Catalogue of Pictures in the Africana Museum* 5 (T–Y, Index), Johannesburg.

Kerdijk-Eskens, H. (1975) *Vrienden doen een Boekje open. De Geschiedenis van het Album Amicorum*, The Hague.

Keyes, G.S. (1981) *Hollstein's Dutch and Flemish etchings, engravings and woodcuts ca. 1450–1700*, vol. XXV: *Pieter Schenck*, ed. K.G. Boon, Amsterdam.

Kistemaker, R.E., N. Kopaneva & A. Overbeek (eds.) (1997) *Peter de Grote en Holland. Culturele en wetenschappelijke Betrekkingen tussen Rusland en Nederland ten Tijde van Tsaar Peter de Grote*, Bussum.

Kistemaker, R.E., N.P. Kopaneva & D.J. Meijers (eds.) (2005) *The Paper Museum of the Academy of Sciences in St Petersburg, c. 1725–1760*, Amsterdam.

Kleerkooper, M.M. & W.P. van Stockum, Jr. (1914–1916) *De Boekhandel te Amsterdam, voornamelijk in de 17e Eeuw. Biographische en geschiedkundige Aanteekeningen*, 2 vols., The Hague.

Kloek, E., C.P. Sengers & E. Tobé (1998) *Vrouwen en Kunst in de Republiek. Een Overzicht*, Hilversum.

Klose, W. (1982) 'Stammbücher—eine kulturhistorische Betrachtung' in: *Bibliothek und Wissenschaft*, 16, p. 41–67.

Knappert, L. (1926–1927) 'De labadisten in Suriname' in: *De West-Indische gids*, 8, p. 193–218.

Knicker, K. (2014) 'Künstlergruppe Finger. Frankfurter Bienenhaus' in: K. Knicker & K. Wettengl (eds.), *Arche Noah. Über Tier und Mensch in der Kunst.*, Dortmund, p. 90–93. Exhibition Catalogue, Museum Ostwall im Dortmunder U.

Knicker, K. & K. Wettengl (eds.) (2014) *Arche Noah. Über Tier und Mensch in der Kunst*, Dortmund. Exhibition Catalogue, Museum Ostwall im Dortmunder U.

Koerner, L. (1996) 'Carl Linnaeus in his time and space' in: N. Jardine, J.A. Secord & E.C. Spary (eds.), *Cultures of Natural History*, Cambridge, p. 145–162.

Koerten, J. (1735) *Het Stamboek op de Papiere Snykunst van Mejuffrouw Joanna Koerten, Huisvrouw van den Heere Adriaan Blok. Bestaande in Latynsche en Nederduitsche Gedichten der voornaamste Dichters*, Amsterdam, p. 46-48. Retyped text online available: www.dbnl.org/tekst/koer005stam01_01/koer005stam01_01_0141.php.

Koerten, J. (1736) *Gedichten op de overheerlyke Papiere Snykunst van wyle Mejuffrouwe Joanna Koerten, Huisvrouwe van*

wylen den Heere Adriaan Blok, gedrukt na het origineel Stamboek. Benevens een korte Schets van haar Leven, Amsterdam.

Kok, J. & J. Fokke (1794) 'Withoos, (Alida)' in: *Vaderlandsch Woordenboek, oorspronklyk verzameld door Jacobus Kok*, 32 (W), Amsterdam, p. 229–230.

Kom, A. de (1987) *We Slaves of Surinam*, London. Original edition in Dutch: Amsterdam, 1934.

Kooijmans, L. (1985) *Onder Regenten. De Elite in een Hollandse Stad Hoorn 1700–1780*. PhD Thesis, University of Amsterdam.

Kopaneva, N.P. (2009) *Watercolors by Maria Sibylla Merian in the St. Petersburg Branch of the Archive of the Russian Academy of Sciences*: www.ras.ru/sybilla/5fc6668f-7898-4b93-adbd-5529b1ff332c.aspx.

Kopaneva, N.P. (2012) 'The first catalog of zoological collections of the Kunstkammer in Russian language' in: N.V. Slepkova (ed.), *Zoological Collections in Russia in the 18–21 Centuries*, Saint Petersburg. In Russian.

Kouprianov, A.V. (2005) *The Prehistory of the Biological Systematics. The "Folk Taxonomy" and the Development of Ideas about the Method in Natural History from the End of the 16th to the Beginning of the 18th Century*, Saint Petersburg. In Russian.

Krelage, E.H. (1948) *Catalogue of the Botanical Library of Dr. E.H. Krelage, Haarlem*, Amsterdam.

Kries, R. von (2017) *Maria Sibylla Merian. Künstlerin und Forscherin. Die 'Metamorphosis Insectorum Surinamensium' aus kunsthistorischer und biologischer Sicht*, Petersberg.

Kriz, K.D. (2000) 'Curiosities, commodities, and transplanted bodies in Hans Sloane's "Natural history of Jamaica"' in: *The William and Mary Quarterly*, 3rd Series, 57, p. 35–78.

Krogt, P. van der (1993) 'The eighteenth century. Valk's globe factory' in: P. van der Krogt, *Globi Neerlandici. The Production of Globes in the Low Countries*, Utrecht, p. 299–336.

Kullander, S.O. (1997–2001) 'Museum Adolphi Friderici' in: *The Linnaeus Web Server of the Swedish Museum of Natural History*: linnaeus.nrm.se/zool/madfrid.html.en.

Kunikawa, T. (2012) 'Science and whiteness as property in the Dutch Atlantic world. Maria Sibylla Merian's *Metamorphosis insectorum Surinamensium* (1705)' in: *Journal of Women's History*, 24 (3), p. 91–116.

Kurras, L. (1994) *Die Stammbücher*, Teil 2: *Die 1751 bis 1790 begonnenen Stammbücher*, Wiesbaden (*Die Handschriften des Germanischen Nationalmuseums Nürnberg* 5).

Kusukawa, S. (2012), *Picturing the Book of Nature. Image, Text, and Argument in sixteenth-century Human Anatomy and Medical Botany*, Chicago.

Kusukawa, S. (2019) 'Ad vivum images and knowledge of nature in early modern Europe' in: T. Balfe, J. Woodall & C. Zittel (eds.), *Ad Vivum? Visual Materials and the Vocabulary of Life-likenesses in Europe before 1800*, Leiden/Boston, p. 89–121.

Laird, M. (2013) *A Natural History of English Gardening, 1650–1800*, London.

Lange-Berndt, P. (2009) *Animal Art. Präparierte Tiere in der Kunst, 1850–2000*, Munich.

Langford, A. (1755) *A Catalogue of the genuine, entire and curious Collection of Prints and Drawings [...] of the late Doctor Mead [...] which [...] will be sold by Auction by Mr Langford [...] on Monday the 13th of January 1755*, London.

Latour, B. (2000) *Die Hoffnung der Pandora*, Frankfurt am Main. First edition published 1999 in English.

Latour, B. (2008) *Wir sind nie modern gewesen*, Frankfurt am Main. First edition published 1991 in French.

Lebedeva, I.N. (1996) 'De nalatenschap van Maria Sibylla Merian in Sint-Petersburg' in: R.E. Kistemaker, N. Kopaneva & A. Overbeek (eds.), *Peter de Grote en Holland. Culturele en wetenschappelijke Betrekkingen tussen Rusland en Nederland ten Tijde van Tsaar Peter de Grote*, Bussum, p. 60–66.

Lebedeva, I.N. (1997) 'The artistic and scientific heritage of Maria Sibylla Merian in St. Petersburg' in: N.P. Kopaneva, R.E. Kistemaker & A. Overbeek (eds.), *Peter the Great & Holland. Russian-Dutch artistic & scientific Contacts*, Saint Petersburg, p. 318–334. In Russian.

Ledermüller, M.F. (1761–1763) *Mikroskopische Gemüths- und Augen-Ergötzung [...]*, 2 vols., Nuremberg.

Leeuwen, A. van (2011) 'Hollandse flora's. Over elitevrouwen en hun lusthoven aan het einde van de zeventiende eeuw' in: *Cascade*, 20 (2), p. 31–45.

Leningrader Aquarelle (undated), see http://ranar.spb.ru/rus/vystavki/id/130/. All paintings attributed to M.S. Merian in the Saint Petersburg Branch of the Russian Academy of Sciences (SPbARAN) are reproduced here.

Leßmann, S. (1991) *Susanna Maria von Sandrart (1658–1716). Arbeitsbedingungen einer Nürnberger Graphikerin im 17. Jahrhundert*, Hildesheim/Zurich/New York (*Studien zur Kunstgeschichte* 59).

Le Thiec, G. (2009) 'Dialoguer avec des hommes illustres. Le rôle des portraits dans les décors de bibliothèques (fin XVe–début XVIIe siècle)' in: *Revue française d'Histoire du Livre*, 130, p. 7–52.

Leuker, M.-T., E.H. Arens & C. Kießling (2020) *Rumphius' Naturkunde. Zirkulation in kolonialen Wissensräumen*, Wiesbaden.

Linnaeus, C. (1737) *Critica Botanica [...]*, Leiden.

Linnaeus, C. (1754) *Museum S:ae R:ae M:tis Adolphi Friderici Regis Svecorum, Gothorum, Vandalorumque [...]*, Stockholm.

Linnaeus, C. (1758) *Caroli Linnaei [...] Systema Naturae per Regna tria Naturae, secundum Classes, Ordines, Genera, Species, cum Characteribus, Differentiis, Synonymis, Locis, Tomus 1*. 10th ed., Stockholm.

Lölhöffel, M. (2015) 'Maria Sibylla Merianin und Johann Andreas Graff. Gemeinsames und Trennendes. Erster Teil' in: *Nürnberger Altstadtberichte*, 40, p. 37–76.

Lölhöffel, M. (2016) 'Maria Sibylla Merianin und Johann Andreas Graff. Gemeinsames und Trennendes. Zweiter Teil' in: *Nürnberger Altstadtberichte*, 41, p. 64–116.

Lölhöffel, M. (2017) 'Maria Sibylla Merianin und Johann Andreas Graff. Gemeinsames und Trennendes. Dritter Teil' in: *Nürnberger Altstadtberichte*, 42, p. 1–28.

Ludwig, H. (1996) 'Nürnberger Blumenmalerinnen um 1700 zwischen Dilettantismus und Professionalität' in: *Kritische Berichte. Zeitschrift für Kunst und Kulturwissenschaften*, 24 (4), p. 21–29.

Ludwig, H. (1997) 'Das "Raupenbuch". Eine populäre Naturgeschichte' in: K. Wettengl (ed.), *Maria Sibylla Merian, 1647–1717. Künstlerin und Naturforscherin*, Ostfildern, p. 52–67.

Ludwig, H. (1998) *Nürnberger naturgeschichtliche Malerei im 17. und 18. Jahrhundert*, Marburg an der Lahn (*Acta Biohistorica* 11).

Lukin, B.V. (1974) 'On the history of the collection of the Leningrad Merian watercolours' in: E. Ullmann (ed.), *Maria Sibylla Merian. Leningrader Aquarelle, II. Kommentar*, Leipzig, p. 115–149.

MacGregor, A. (ed.) (1994) *Sir Hans Sloane. Collector, Scientist, Antiquary, Founding Father of the British Museum*, London.

MacGregor, A. (2007) *Curiosity and Enlightenment. Collectors and Collections from the sixteenth to the nineteenth Century*, New Haven, Conn.

Malpighi, M. (1669) *Dissertatio Epistolica de Bombyce [...]*, London.

Margócsy, D. (2010). '"Refer to folio and number'. Encyclopedias, the exchange of curiosities, and practices of identification before Linnaeus' in: *Journal of the History of Ideas*, 71 (1), p. 63–89.

Margócsy, D. (2014) *Commercial Visions. Science, Trade, and visual Culture in the Dutch Golden Age*, Chicago.

Margócsy D. (2021) 'The pineapple and the worms' in: *KNOW. A Journal on the Formation of Knowledge*, 5 (1), p. 53–81.

Mayer, L. (2001) 'Rösel von Rosenhof—ein großer Nürnberger Entomologe' in: *Natur und Mensch. Jahresmitteilungen der Naturhistorischen Gesellschaft Nürnberg*, p. 69–78.

McBurney, H. (2021) *Illuminating Natural History. The Art and Science of Mark Catesby*, London.

Memoirs (1711) *Memoirs of Literature, containing a weekly Account of the State of Learning, both at Home and Abroad*, (August 1711) London.

Meriaen (1719), (1730), see Merian, M.S.

Merian, M.S. (undated) *Studienbuch*. Original in the Library of the Russian Academy of Sciences, Saint Petersburg, inv. no. F 246. Facsimile, see Beer, W.-D. (ed.) (1976) and (2011).

Merian, M.S. (1675) *Florum Fasciculus primus*, Nuremberg.

Merian, M.S. (1677) *Florum Fasciculus alter*, Nuremberg.

Merian, M.S. (1679) *Der Raupen wunderbare Verwandelung, und sonderbare Blumen-nahrung, worinnen, durch eine ganz-neue Erfindung, der Raupen, Würmer, Sommervögelein, Motten, Fliegen, und anderer dergleichen Thierlein, Ursprung, Speisen, und Veränderungen, samt ihrer Zeit, Ort, und Eigenschaften, den Naturkündigern, Kunstmahlern, und Gartenliebhabern zu Dienst, fleissig untersucht, kürtzlich beschrieben, nach dem Leben abgemahlt, ins Kupfer gestochen, und selbst verlegt, von Maria Sibylla Gräffinn, Matthaei Merians, des Eltern, Seel. Tochter*, Nuremberg/Frankfurt am Main/Leipzig.

Merian, M.S. (1680) *Florum Fasciculus tertius*, Nuremberg.

Merian, M.S. (1680) *Neues Blumenbuch. Allen kunstverständiger Liebhabern zu Lust, Nutz und Dienst, mit Fleiß verfertiget*, Nuremberg. Facsimile, see Bürger Th. & M. Heilmeyer (eds.) (1999) and Deckert (1966).

Merian, M.S. (1683) *Der Raupen wunderbare Verwandlung, und sonderbare Blumen-nahrung, Anderer Theil. Worinnen durch eine ganz neue Erfindung, der Raupen, Würmer, Maden, Sommervögelein, Motten, Fliegen, Bienen und anderer dergleichen Thierlein Ursprung, Speisen, und Veränderungen, samt ihrer Zeit, Ort, und Eigenschaften, den Naturkündigern, Kunstmahlern, und Gartenliebhabern zu Dienst, selbst fleissigst untersucht, kürtzlich beschrieben, nach dem Leben abgemahlt, und wiederum in fünfzig Kupfer (darauf über 100. Verwandlungen) gestochen, und verlegt, von Maria Sibylla Gräffin, Matthäi Merians, des Eltern, Seel. Tochter*, Frankfurt am Main/Leipzig/Nuremberg.

Merian, M.S. (1705) *Metamorphosis Insectorum Surinamensium. Ofte Verandering der Surinaamsche Insecten. Waar in de Surinaamsche Rupsen en Wormen met alle des zelfs Veranderingen na het Leven afgebeeld en beschreeven worden, zynde elk geplaast op die Gewassen, Bloemen en Vruchten, daar sy op gevonden zyn; waar in ook de Generatie der Kikvorschen, wonderbaare Padden, Hagedissen, Slangen, Spinnen en Mieren werden vertoond en beschreeven, alles in America na het Leven en Levensgroote geschildert en beschreeven*, Amsterdam.

Merian, M.S. (1705), see also: Rücker, E. & W.T. Stearn (1982) and Delft, M. van & H. Mulder.

Merian, M.S. (1712) *Der Rupsen Begin, Voedzel en wonderbaare Verandering. Waar in de Oorspronk, Spys en Gestaltverwisseling: als ook de Tyd, Plaats en Eigenschappen der Rupsen, Wormen, Kapellen, Uiltjes, Vliegen, en andere diergelyke bloedelooze Beesjes vertoond word: ten Dienst van alle Liefhebbers der Insecten, Kruiden, Bloemen en Gewassen: ook Schilders, Borduurders &c.: naauwkeurig onderzogt, na 't Leven geschildert, in Print gebragt, en in 't Kort beschreven*, vol. 1–2, Amsterdam.

Merian, M.S. (ca. 1713) *Blumen und Insecten-Buch [...]*, Nuremberg. Regensburg, Staatliche Bibliothek, inv. no.

286

999/2Philos.2942: reader.digitale-sammlungen.de/resolve/display/bsb11057845.html.

Merian, M.S. (1717) *Derde en laatste Deel der Rupsen Begin, Voedzel en wonderbaare Verandering. Waar in de Oorspronk, Spys en Gestaltverwisseling: als ook de Tyd, Plaats en Eigenschappen der Rupsen, Wormen, Kapellen, Uiltjes, Vliegen, en andere diergelyke bloedlooze Beesjes vertoond word; ten Dienst van alle Liefhebbers der Insecten, Kruiden, Bloemen en Gewassen: ook Schilders, Borduurders &c.: naauwkeurig onderzogt, na 't Leven geschildert, in Print gebragt, en in 't Kort beschreven door Maria Sibilla Merian saalr. In Print gebracht en in 't Licht gegeven door haar jongste Dochter, Dorothea Maria Henricie*, Amsterdam.

Merian, M.S. (1718) *Erucarum Ortus, Alimentum et paradoxa Metamorphosis, in qua Origo, Pabulum, Transformatio, nec non Tempus, Locus & Proprietates Erucarum, Vermium, Papilionum, Phalaenarum, Muscarum, aliorumque hujusmodi exsanguium Animalculorum exhibentur in Favorem, atque Insectorum, Herbarum, Florum, & Plantarum Amatorum, tùm etiam Pictorum, Limbolariorum, aliorumque commodum exacte inquisita, ad Vivum delineata, Typis excusa, compendiosèque descripta per Mariam Sibillam Merian*, vol. 1–3, Amsterdam.

Merian ('Meriaen'), M.S. (1719) *Over de Voortteeling en wonderbaerlyke Veranderingen der Surinaemsche Insecten, waer in de Surinaemsche Rupsen en Wormen, met alle derzelver Veranderingen naer het Leven afgebeeldt, en beschreeven worden; zynde elk geplaest op dezelfde Gewassen, Bloemen, en Vruchten, daer ze op gevonden zyn; beneffens de Beschrijving dier Gewassen. Waer in ook de wonderbare Padden, Hagedissen, Slangen, Spinnen, en andere zeldzame Gediertens worden vertoont en beschreeven. Alles in America door den zelve M.S. Meiraen naer het Leeven en Leevensgrootte geschildert en nu in 't Koper overgebracht. Benevens een Aenhangsel van de Veranderingen van Visschen in Kikvorschen, en van Kikvorschen in Visschen*, Amsterdam.

Merian ('Meriaen'), M.S. (1730) *Over de Voortteeling en wonderbaerlyke Veranderingen der Surinaamsche Insecten, waar in de Surinaamsche Rupsen en Wormen, met alle derzelver Veranderingen, naar het Leeven afgebeelt en beschreeven worden; zynde elk geplaatst op dezelfde Gewassen, Bloemen en Vruchten, daar ze op gevonden zyn; beneffens de Beschryving dier Gewassen. Waar in ook de wonderbare Padden, Hagedissen, Slangen, Spinnen, en andere zeltzaame Gediertens worden vertoont en beschreeven. Alles in Amerika door den zelve M.S. Meriaen naar het Leeven en Leevensgrootte geschildert en nu in 't Koper overgebragt. Benevens een Aenhangsel van de Veranderingen van Visschen in Kikvorschen, en van Kikvorschen in Visschen*, Amsterdam.

Merian, M.S. & J. Marret (1730) *De Europische Insecten, naauwkeurig onderzogt, na 't Leven geschildert, en in Print gebragt door Maria Sibilla Merian. Met een korte Beschrij- ving, waar in door haar gehandelt word van der Rupsen Begin, Voedzel en wonderbare Verandering, en ook vertoond word de Oorspronk, Spys en Gestalt-verwisseling, de Tyd, Plaats en Eigenschappen der Rupzen, Uiltjes, Vliegen en andere diergelyke bloedeloose Beesjes. Hier is nog bygevoegt een naauwkeurige Beschryving van de Planten, in dit Werk voorkomende; en de Uitlegging van agtien nieuwe Plaaten, door dezelve Maria Sibilla Merian geteekent, en die men na haar Dood gevonden heeft. In 't Frans beschreeven door J. Marret, Medicinae Doctor, en door een voornaam Liefhebber in 't Nederduits vertaalt*, Amsterdam.

Merian, M.S. & J. Marret (1730) *Histoire des Insectes de l'Europe, dessinée d'après Nature & expliquée par Marie Sibille Merian, Où l'on traite de la Generation & des différentes Metamorphoses des Chenilles, Vers, Papillons, Mouches & autres Insectes, & des Plantes, des Fleurs & des Fruits dont ils se nourissent, traduite du Hollandois en François par Jean Marret, Docteur en Medecine, augmentée par le même d'une Description exacte des Plantes, dont il est parlé dans cet Histoire; & des Explications de dix-huit nouvelles Planches, dessinées par la même Dame, & qui n'ont point encore paru. Ouvrage qui contient XCIII. Planches*, Amsterdam.

Merian, M.S. & J. Marret (2010) *De Europische Insecten [...]*, Saarbrücken. Facsimile edition of Merian & Marret (1730).

Miller, A.I. (2014) *Colliding Worlds. How cutting-edge Science is redefining contemporary Art*, London/New York.

Mincoff-Marriage, E. & G. Heilfurth (eds.) (1936) *Bergliederbüchlein. Historisch-kritische Ausgabe*, Leipzig.

Missel, L. (2000) *De Wereld van Alida Withoos (1662–1730), botanisch Tekenares in de Gouden Eeuw*, [Utrecht]: library.wur.nl/WebQuery/wurpubs/65591.

Moes, E.W. (1904) 'Korte mededeelingen over Nederlandsche plaatsnijders. IV. Een "album amicorum" van Petrus Schenck' in: *Oud-Holland*, 22, p. 146–154.

Moffet, Th., E. Wotton, C. Gessner, Th. Penny & Th. Turquet de Mayerne (1634) *Insectorum sive minimorum Animalium Theatrum [...]*, London.

Moffitt Peacock, M. (2017) 'Women, art, and the subversive sampler in the Dutch golden age' in: B.U. Münch, A. Tacke, M. Herzog & S. Neudecker (eds.), *Künstlerinnen. Neue Perspektiven auf ein Forschungsfeld der Vormoderne*, Petersberg, p. 73–88 (*Kunsthistorisches Forum Irsee* 4).

Moninckx Atlas (1687–1756) *Afteekeningen van verscheyden vreemde Gewassen, in de Medicyn-Hoff der Stadt Amsteldam*, Allard Pierson, Amsterdam, OTM: hs VI G 1–9.

Montoya, A.C. (2004) 'French and English women writers in Dutch library catalogues, 1700–1800. Some methodological considerations and preliminary results' in: S. van Dijk, P. Broomans, J.F. van der Meulen & P. van Oostrum (eds.), *'I have heard about you'. Foreign Women's writing crossing the Dutch Border. From Sappho to Selma Lagerlöf*, Hilversum, p. 182–216.

Montoya, A.C. (2018) 'Des chenilles aux papillons. Une scène primitive de la littérature de jeunesse au XVIIIe siècle' in: Schulte Nordholt, A. & P.J. Smith (eds.), *Jeux de Mots—Enjeux littéraires de François Rabelais à Richard Millet*, Leiden, p. 243–260.

Montoya, A.C. & R. Jagersma (2018) 'Marketing Maria Sibylla Merian, 1720–1800. Book auctions, gender, and reading culture in the Dutch republic' in: *Book History*, 21, p. 56–88.

Moretti, F. (2013) *Distant Reading*, London.

Müller-Ahrndt, H. (2021) *Die Künstler der Naturgeschichte. Eine Studie zur Kooperation von Kupferstechern, Verlegern und Naturforschern im 18. Jahrhundert*, Herausgegeben von Kärin Nickelsen und Hans Dickel, Petersberg.

Müller-Wille, S. & S. Scharf (2009) *Indexing nature. Carl Linnaeus (1707–1778) and his fact-gathering strategies*. Working papers on the nature of evidence: how well do 'facts' travel?, Department of Economic History, London School of Economics and Political Science, London.

Mukerji, C. (2005) 'Dominion, demonstration, and domination. Religious doctrine, territorial politics, and French plant collection' in: L. Schiebinger & C. Swan (eds.), *Colonial Botany. Science, Commerce, and Politics in the Early Modern World*, Philadelphia, p. 19–33.

Mulder, H. (2014) 'Merian puzzles. Some remarks on publication dates and a portrait by Johannes Thopas' in: *Proceedings of the Symposium "Exploring M.S. Merian"*, Amsterdam: www.themariasibyllameriansociety.humanities.uva.nl/research/essays2014/.

Mulder, H. (2019) 'Wie drukten de tekst van de Amsterdamse publicaties van Maria Sibylla Merian?' in: *De Boekenwereld*, 35 (3), p. 76–81.

Mulder, H. (2021) 'Albertus Seba en een raadselachtige tekst met aquarellen' in: H. Mulder, *De Ontdekking van de Natuur*, Amsterdam, p. 134–145.

Mulder, H. & M. van Delft (2016) 'De productie van *Metamorphosis insectorum Surinamensium* 1705 = The production of *Metamorphosis insectorum Surinamensium* 1705' in: M. van Delft & H. Mulder (eds.), *Maria Sibylla Merian. Metamorphosis Insectorum Surinamensium*, Tielt/The Hague, p. 40–48.

Multigraph Collective, The (2018) *Interacting with Print. Elements of Reading in the Era of Print Saturation*, Chicago.

Mulzer, E. (1999) 'Maria Sibylla Merian und das Haus Bergstraße 10' in: *Nürnberger Altstadtberichte*, 24, p. 27–56.

Murphy, K.S. (2013) 'Collecting slave traders. James Petiver, natural history, and the British slave trade' in: *The William and Mary Quarterly*, 70 (4) p. 637–670.

Musei Imperialis Petropolitani (1742) I. *Pars prima qua continentur Res Naturales ex Regno Animali*, Saint Petersburg.

Musei Imperialis Petropolitani (1745) I. *Pars secunda qua continentur Res Naturales ex Regno Vegetabili*, Saint Petersburg.

Myers, W. (2015) *Bio Art. Altered Realities*, London.

Neri, J. (2011) *The Insect and the Image. Visualizing Nature in Early Modern Europe, 1500–1700*, Minneapolis/London.

Niefanger, D. (2012) *Barock. Lehrbuch Germanistik*, Stuttgart/Weimar.

Ogilvie, B.W. (2003) 'Image and text in natural history, 1500–1700' in: W. Lefèvre, J. Renn & U. Schoepflin (eds.), *The Power of Images in Early Modern Science*, Berlin, p. 141–166.

Ogilvie, B.W. (2006) *The Science of Describing. Natural History in Renaissance Europe*, Chicago/London.

Ogilvie, B.W. (2008) 'Nature's bible. Insects in seventeenth-century European art and science' in: *Tidsskrift for Kulturforskning*, 7 (3), p. 5–21.

Ogilvie, B.W. (2012) 'Attending to insects. Francis Willughby and John Ray' in: *Notes and Records of the Royal Society of London*, 66 (4) p. 357–372.

Oostindie, G. & E. Maduro (1986) *In het Land van de Overheerser*, II: *Antillianen en Surinamers in Nederland, 1634/1667–1954*, Dordrecht.

Oviedo, G.F. de (1535) *Historia General y Natural de Las Indias [...]*, Sevilla.

Paravisini-Gebert, L. (2012) 'Maria Sibylla Merian. The dawn of field ecology in the forests of Suriname, 1699–1701' in: *Review. Literature and Arts of the Americas*, 45 (1), p. 10–20.

Pascoli, L. (1981) *Vite de' Pittori, Scultori, ed Architetti [...]*, [Treviso]. First edition published 1730.

Passe the Younger, C. de (1643–1644). *'t Light der Teken en Schilderkonst [...]*. Amsterdam.

Pavlinov, I. Ya. (2015) *Nomenclature in the systematics. History, Theory, Practice*, Moscow. In Russian.

Peeters, N. (2020) *Rumphius' Kruidboek—Verhalen uit de Ambonese Flora*, Zeist.

Petiver, J. (1695–1703) *Musei Petiveriani centuria prima- [decima] Rariora Naturae continens: viz. Animalia, Fossilia, Plantas, ex variis Mundi Plagis advecta, Ordine digesta, et Nominibus propriis signata*, London.

Petiver, J. (1708–1709) 'Madam Maria Sybilla Merian's history of Surinam insects, abbreviated and methodized, with some remarks' in: *Monthly Miscellany, or, Memoirs for the Curious*, 2 (1708), p. 287–294 and [with variant titles] 2, p. 327–334 and 3, p. 5–12.

Petiver, J. (1767) *Jacobi Petiveri Opera, Historiam Naturalem Spectantia [...]*, London.

Pfeiffer, M.A. (1931) *Die Werke der Maria Sibylle Merian*, Meissen.

Pfister-Burkhalter, M. (1949) 'Ikonographischer Überblick über die Bildnisse der Maria Sibylla Merian (1647–1717)' in: *Stultifera Navis. Mitteilungsblatt der Schweizerischen Bibliophilen-Gesellschaft*, 6 (1), p. 31–42.

Pfister-Burkhalter, M. (1980) *Maria Sibylla Merian. Leben und Werk 1647–1717*, Basel.

Pick, C.M. (2004) *Rhetoric of the Author Representation. The Case of Maria Sibylla Merian.* PhD Thesis, University of Texas at Austin.

Pieters, F. (2014) 'Interpreting Merian. Challenges in transcribing her manuscripts with special attention to Merian's work for Rumphius's book on Ambonese rarities' in: *Proceedings of the Symposium "Exploring M.S. Merian"*, Amsterdam: www.themariasibyllameriansociety.humanities. uva.nl/research/essays2014/.

Pieters, F. (2017) 'Gott und die Tugent ist mein Ziel' in: *Maria Sibylla Merian. De Schatkamercollectie*, Amsterdam, p. 53–55. Exhibiton catalogue, Cromhouthuis Amsterdam.

Pieters, F.F.J.M. (2021) 'Ophef en raadsels rond insectentekeningen voor de Thesaurus van A. Seba' in: *De Boekenwereld*, 37 (2) p. 16–23.

Pieters, F. & R. Moolenbeek (2005) 'Rare schelpen en schaaldieren. Raadsels rond de illustraties bij *D'Amboinsche Rariteitkamer* van Georgius Everhardus Rumphius' in: *Jaarboek van het Nederlands Genootschap van Bibliofielen*, 12 (2004) p. 111–136.

Pieters, F.F.J.M. & L.C. Rookmaaker (1994) 'Arnout Vosmaer, topcollectionneur van naturalia en zijn *Regnum animale* = Arnout Vosmaer, grand collectionneur de curiosités naturelles, et son *Regnum animale*' in: B.C. Sliggers & A.A. Wertheim (eds.), *Een vorstelijke Dierentuin. De Menagerie van Willem V = Le Zoo du Prince. La Ménagerie du Stathouder Guillaume V*, Haarlem/Paris/Zutphen, p. 10–38, 62, 115–116.

Pieters, F.F.J.M. & D. Winthagen (1999) 'Maria Sibylla Merian, naturalist and artist (1647–1717). A commemoration on the occasion of the 350th anniversary of her birth' in: *Archives of Natural History*, 26 (1), p. 1–18.

Pietsch, T.W. (2017), *Charles Plumier (1646–1704) and his Drawings of French and Caribbean Fishes*, Paris.

Pirson, J. (1953) 'Der Nürnberger Arzt und Naturforscher Christoph Jakob Trew (1695–1769)' in: *Mitteilungen des Vereins für Geschichte der Stadt Nürnberg*, 44, p. 448–575.

Piso, W. & G. Marcgraf (1648) *Historia Naturalis Brasiliae [...]*, Leiden/Amsterdam.

Plas, J. van de (2008) *Proeftuin Suriname*, Helvoirt. Artist book.

Plas, J. van de (2009) *Journaal Duitsland-Nederland*, Helvoirt. Artist book.

Plas, J. van de (2013) *Metamorphosis Insectorum Surinamensium. Eine Entdeckungsreise neu erlebt = Expedition revisited*, compiled in collaboration with F. Geller-Grimm, D. Hoffmann & S. Kridlo, Wiesbaden. Exhibition catalogue, Museum Wiesbaden.

Plas, J. van de (2013) *Second Life—Metamporphosis Insectorum Surinamensium revisited*, compiled in collaboration with F. Geller-Grimm, D. Hoffmann & S. Kridlo, Wiesbaden. Exhibition catalogue, Museum Wiesbaden.

Plas, J. van de (2013) *Portfolio Wiesbaden*, Artist book.

Plas, J. van de (2019) *Het gestolen Kijken—Stolen Observations. How a French encounter coupled the seventeenth-century Naturalists Johannes Goedaert and Maria Sibylla Merian*, Helvoirt.

Plomp, M. (1989) 'De portretten uit het stamboek voor Joanna Koerten (1650–1715)' in: *Leids Kunsthistorisch Jaarboek*, 8, p. 323–344.

Plumier, C. (1693) *Description des Plantes de l'Amérique [...]*, Paris.

Plumier, C. (1703) *Nova Plantarum Americanarum Genera*, Paris.

Plumier, C. (1705) *Traité des Fougères de l'Amérique*, Paris.

Poelhekke, J.J. (1963) 'Elf brieven van Agnes Block in de Universiteitsbibliotheek te Bologna medegedeeld en ingeleid door J.J. Poelhekke met een botanisch-historische toelichting door H.C.J. van Oomen' in: *Mededelingen van het Nederlands Historisch Instituut te Rome*, 32 (2), p. 1–28.

Ponte, M. (2019), '"Al de swarten die hier ter Stede comen" Een Afro-Atlantische gemeenschap in zeventiende-eeuws Amsterdam', in: *TSEG—The Low Countries Journal of Social and Economic History*, 15 (4), p. 33–62.

Post, E.M. (1987) *Het Land, in Brieven*, ed. B. Paasman, Amsterdam. First edition published 1788.

Prak, M. (2020) *Nederlands Gouden Eeuw. Vrijheidsdrang en Geldingsdrang*, Amsterdam.

Pratt, M.L. (1992) *Imperial Eyes. Travel Writing and Transculturation*, London/New York.

Prüfer, M. (2017) *Brut. 2013–2016*, publication in conjunction with the exhibition in Neue Galerie Höhmannshaus (Augsburg), Berlin.

Radziun, A.B. (1997) 'The anatomical collection of F. Ruysch' in: N.P. Kopaneva, R.E. Kistemaker & A. Overbeek (eds.), *Peter the Great & Holland. Russian-Dutch artistic & scientific Contacts*, Saint Petersburg, p. 90–114. In Russian; also published in Dutch, see R. Kistemaker.

Raffel, E. (2012) *Galilei, Goethe und Co. Freundschaftsbücher der Herzogin Anna Amalia Bibliothek; immerwährender Kalender*, Weimar. Exhibition Herzogin Anna Amalia Bibliothek.

Raffles, H. (2013) 'Insektopädie' in: J. Schalanski (ed.), *Naturkunden*, vol. 7, Berlin, p. 19–43.

Raj, K. (2007) *Relocating Modern Science. Circulation and the Construction of Knowledge in South Asia and Europe, 1650–1900*, London.

Raleigh, W. & L. Keymis (1598) *Waerachtighe ende grondighe Beschryvinge van het groot ende goudt-rijck Coninckrijck van Guiana gheleghen zijnde in America [...]*, Amsterdam.

Ramos, F. (ed.) (2016) *Documents of contemporary Art. Animals*, London/Cambridge (MA).

Ray, J. (1710) *Historia Insectorum [...]*, London.

Redi, F. (1668) *Esperienze intorno alla Generazione degli Insetti [...]*, Florence.

Regenfuss, F.M. (1758), *Auserlesne Schnecken, Muscheln und andre Schaalthiere [...] = Choix de Coquillages et de Crustacés [...]*, Copenhagen.

Reinders, S. (2017) *De Mug en de Kaars. Vriendenboekjes van adellijke Vrouwen, 1575–1640*, Nijmegen.

Reitsma, E. (2008) in collaboration with S.A. Ulenberg, *Maria Sibylla Merian and Daughters. Women of Art and Science*, Amsterdam/Los Angeles.

Reitsma, E. (2016) 'Maria Sibylla Merian. Een uitzonderlijke vrouw = Maria Sibylla Merian. An exceptional woman' in: M. van Delft & H. Mulder (eds.), *Metamorphosis Insectorum Surinamensium 1705*, Tielt/The Hague, p. 9–18.

Remond, J. (2022) 'The pictorial idioms of nature. Image making as phytographic translation in early modern Northern Europe' in: K. Krause, M. Auxent & D. Weil (eds.), *Premodern Experience of the Natural World in Translation*, London/New York. In press.

Reske, C. (2007) *Die Buchdrucker des 16. und 17. Jahrhunderts im deutschen Sprachgebiet. Auf der Grundlage des gleichnamigen Werkes von Josef Benzing*, Wiesbaden (*Beiträge zum Buch- und Bibliothekswesen 51*).

Reusch, E. (1711) *Memoria Wurfbainiana*, [Altdorf], nbn-resolving.org/urn:nbn:de:bvb:19-epub-24137-1.

Rheinberger, H.-J. (2015) *Natur und Kultur im Spiegel des Wissens*, Heidelberg.

Rijdt, R.J. te (1997) 'Jan Goeree, het stamboek van Joanna Koerten en de datering ervan' in: *Delineavit et Sculpsit*, 17, p. 48–56.

Roberts, J. (ed.) (2002) *Royal Treasures. A Golden Jubilee Celebration*, London.

Roemer, B. van de (2004) 'Neat nature. The relation between nature and art in a Dutch cabinet of curiosities from the early eighteenth century' in: *History of Science*, 42 (1) p. 47–84.

Roemer, B. van de (2014) 'Redressing the balance. Levinus Vincent's wonder theatre of nature' in: publicdomainreview.org/2014/08/20/redressing-the-balance-levinus-vincents-wondertheatre-of-nature.

Roemer, B. van de (2016) 'Merians netwerk van verzamelende natuurliefhebbers = Merian's network of collector-naturalists' in: M. van Delft & H. Mulder (eds.), *Maria Sibylla Merian. Metamorphosis Insectorum Surinamensium*, Tielt/The Hague, p. 19–28.

Rösel von Rosenhof, A.J. (1746–1761) *Der monathlich-herausgegebenen Insecten-Belustigung [...]*, 4 vols., Nuremberg.

Roesler, S. (2012) 'Bauen ohne Hand und Hirn. Anmerkungen zum Begriff der Tierarchitektur' in: *Tierstudien*, 1, p. 93–104.

Röver, V. (1730, 1739–...) *Catalogus van mijne Verzameling van Tekeningen, 't sedert den Jaare 1705 tot heden 31 December 1731 [...]*, manuscript, Allard Pierson, University of Amsterdam, inv. no. II A 18.

Rosner, E. (1969) 'Die Bedeutung Hermann Conrings in der Geschichte der Medizin' in: *Medizinhistorisches Journal*, 4 (3/4), p. 287–304.

Roßbach, N. (2009) 'Wissenstransfer—Lexikographie—Gender. Gottlieb Siegmund Corvinus' Nutzbares, galantes und curieuses Frauenzimmer-Lexicon (1715, 1739, 1773)' in: S. Schönborn & V. Viehöver (eds.), *Gellert und die empfindsame Aufklärung. Wissens- und Kulturtransfer um 1750*, Berlin, p. 175–188.

Roßbach, N. (2015) *Wissen, Medium und Geschlecht. Frauenzimmer-Studien zu Lexikographie, Lehrdichtung und Zeitschrift*, Frankfurt am Main/Berlin/Bern/Bruxelles/New York/Oxford/Wien.

Roth, M., M. Bushart, M. Sonnabend & C. Heroven (eds.) (2017) *Maria Sibylla Merian und die Tradition des Blumenbildes von der Renaissance bis zur Romantik*, Munich.

Royal Society (1703) *Philosophical Transactions [...]*, 23 (for 1703).

Royal Society (1710–1712) *Philosophical Transactions [...]*, 27 (for 1710, 1711 and 1712).

Rücker, E. (1967) 'Maria Sibylla Merian' in: *Fränkische Lebensbilder*, Neue Folge, 1, p. 221–254, Würzburg.

Rücker, E. (1967). *Maria Sibylla Merian 1647–1717*, Nuremberg. Exhibition catalogue, Germanisches Nationalmuseum, Nuremberg.

Rücker, E. (1997) 'Maria Sibylla Merian. Unternehmerin und Verlegerin' in: K. Wettengl (ed.), *Maria Sibylla Merian 1647–1717 Künstlerin und Naturforscherin*, Ostfildern, p. 254–261.

Rücker, E. & W.T. Stearn (1982) *Maria Sibylla Merian in Surinam. Commentary to the Facsimile Edition of* Metamorphosis Insectorum Surinamensium (*Amsterdam 1705*) *based on the original Watercolours in the Royal Library, Windsor Castle*, London.

Rumphius, G.E. (1705) *D'Amboinsche Rariteitkamer, behelzende eene Beschryvinge van allerhande zoo weeke als harde Schaalvisschen [...]*, Amsterdam.

Rumphius, G.E. (1705) see also Beekman (1999, 2011).

Rumphius, G.E. & J.H. Chemnitz (1766) *Amboinische Raritäten-Cammer [...]*, Vienna.

Ruyter, J. (1712) *Klaagschrift over de onchristelyke Beschuldigingen tegen den onschuldigen Johannes Ruyter [...]*, Amsterdam.

San Pio Aladrén, M.P. (2012) *Passion for Flowers. Drawings from the Van Berkhey Collection*, Exhibition catalogue Museum Naturalis, Leiden.

Sandrart, J. von (1675) *L'Academia Todesca della Architectura, Scultura & Pittura: oder Teutsche Academie der Edlen Bau- Bild- und Mahlerey-Künste [...]*, Nuremberg/Frankfurt am Main; consulted in: T. Kirchner, A. Nova, C. Blüm, A. Schreurs & T. Wübbena (eds.): *Wissenschaftlich kommentierte Online-Edition*, 2008–2012: ta.sandrart.net.

Sauer, C. (2017) 'Maria Sibylla Merian im Kreis der kunst- und tugendliebenden Frauenzimmer in Nürnberg' in:

A. Grebe & C. Sauer, *Maria Sibylla Merian. Blumen, Raupen, Schmetterlinge*, Nuremberg, p. 7–23 (*Ausstellungskatalog der Stadtbibliothek Nürnberg*, 110).

Sauer, C. (2021) 'Christoph Jacob Trews Besucherbuch und die Pflanzenbilder weiblicher Inskribenten und Künstlerinnen in Nürnberger und Altdorfer Stammbüchern' in: H. Dickel, E. Engl & U. Rautenberg (eds.) *Frühneuzeitliche Naturforschung in Briefen, Büchern und Bildern. Christoph Jacob Trew als Sammler und Gelehrter*, Stuttgart, p. 147–164.

Saxby, T.J. (1987) *The Quest for a new Jerusalem, Jean de Labadie and the Labadists, 1610–1744*, Dordrecht. Chapter 11: 'On heart and soul. Labadists at Wieuwerd, 1675–1692', p. 241–271; Chapter 12: 'Disaster in the jungle. Labadist colonial enterprise in Surinam, 1683–1719', p. 273–288.

Schäffer, J. C. (1763) *Erläuterte Vorschläge zur Ausbesserung und Förderung der Naturwissenschaft*. Regensburg.

Schama, S. (1987) *The Embarrassment of Riches. An Interpretation of Dutch Culture in the Golden Age*, New York.

Schepper, M. (1990) *Matthias Withoos, een veelzijdig Talent*, [Nijmegen].

Schiebinger, L. (1995) 'Das private Leben der Pflanzen. Geschlechterpolitik bei Carl von Linné und Erasmus Darwin' in: B. Orland & E. Scheich (eds.), *Das Geschlecht der Natur. Feministische Beiträge zur Geschichte und Theorie der Naturwissenschaften*, Frankfurt am Main, p. 245–269.

Schiebinger, L. & C. Swann (eds.) (2007), *Colonial Botany. Science, Commerce and Politics in the early modern World*, Philadelphia.

Schmidt-Linsenhoff, V. (1997) 'Metamorphosen des Blicks: "Merian" als Diskursfigur des Feminismus' in: K. Wettengl (ed.), *Maria Sibylla Merian. Künstlerin und Naturforscherin (1647–1717)*, Ostfildern, p. 202–219.

Schmidt-Loske, K. (2007) *Die Tierwelt der Maria Sibylla Merian (1647–1717). Arten, Beschreibungen und Illustrationen*, Marburg/Lahn. (*Acta Biohistorica* 10).

Schmidt-Loske, K. (2010) 'Historical sketch, Maria Sibylla Merian—Metamorphosis of insects' in: *Deutsche Entomologische Zeitschrift*, Neue Folge, 57 (1), p. 5–10.

Schmidt-Loske, K. (2021) 'Maria Sibylla Merian. A woman's pioneering work in entomology' in: A. Leis & K.L. Wills (eds.), *Women and the Art and Science of Collecting in eighteenth-century Europe*, New York/London, p. 61–77.

Schmidt-Loske, K., H. Prüßmann-Zemper & B. Wirth (eds.) (2020) *Maria Sibylla Merian, Briefe 1682 bis 1712*, Rangsdorf (*Acta Biohistorica* 20).

Schnabel, W.W. (1995) *Die Stammbücher und Stammbuchfragmente der Stadtbibliothek Nürnberg*, Wiesbaden (*Die Handschriften der Stadtbibliothek Nürnberg*, Sonderband 1–3).

Schnabel, W.W. (2003) *Das Stammbuch. Konstitution und Geschichte einer textsortenbezogenen Sammelform bis ins erste Drittel des 18. Jahrhunderts*, Tübingen (*Frühe Neuzeit* 78).

Schnabel, W.W. (2013) 'Das Album Amicorum. Ein gemischtmediales Sammelmedium und einige seiner Variationsformen' in: A. Kramer & A. Pelz, *Album. Organisationsform narrativer Kohärenz*, Göttingen, p. 213–239.

Schrader, S., N. Turner & N. Yocco (2012) 'Naturalism under the microscope. A technical study of Maria Sibylla Merian's Metamorphosis of the insects of Surinam' in: *Getty Research Journal*, 4, p. 161–172.

Seba, A. (1734–1765) *Locupletissimi Rerum Naturalium Thesauri [...]*, 4 vols., Amsterdam.

Seelig, G. (2017) *Medusa's Menagerie. Otto Marseus van Schrieck and the Scholars*, Schwerin.

Simili, R. (ed.) (2001) *Il Teatro della Natura di Ulisse Aldrovandi*, Bologna.

Simonin C. (2002) 'Les portraits de femmes auteurs ou l'impossible représentation' in: R. Crescenzo (ed.), *Espaces de l'Image, Europe XVI–XVIIe siècle*, Nancy, p. 35–57.

Sint Nicolaas, E. & V. Smeulders (eds.) (2021) *Slavery. The story of João, Wally, Oopjen, Paulus, Van Bengalen, Surapati, Sapali, Tula, Dirk, Lohkay*, Amsterdam.

Sloan, K. & J. Nyhan (2020) 'Enlightenment architectures. The reconstruction of Sir Hans Sloane's cabinets of "Miscellanies" in: *Journal of the History of Collections*, 33 (2), p. 199–218.

Sloane, H. (1707–1725) *A Voyage to the Islands Madera, Barbados, Nieves, S. Christophers and Jamaica [...]*, London, 2 vols.

Smith, H.D., II (2000) '"He frames a shot!". Cinematic vision in Hiroshige's *One hundred famous views of Edo*' in: *Orientations*, 31 (3), p. 90–96.

Smith, P.H. (2006) 'Art, science and visual culture in early modern Europe' in: *Isis*, 97 (1), p. 83–100.

Sotheby's (2004) *The Unicorno Collection. Fifty five Years of Collecting Drawings. Amsterdam Wednesday 19 May 2004*, Amsterdam. Auction Catalogue.

Spamer, A. (1930) *Das kleine Andachtsbild vom XIV. zum XX. Jahrhundert*, Munich.

Stearn, W.T. (1958) 'Botanical exploration to the time of Linnaeus' in: *Proceedings of the Linnean Society of London*, 169, p. 173–96.

Stearn, W.T. (1978) *The wondrous Transformation of Caterpillars. Maria Sibylla Merian. Fifty Engravings selected from Erucarum Ortus (1718)*, Ilkley.

Stearn, W.T. (1982) 'Maria Sibylla Merian (1647–1717) as a botanical artist' in: *Taxon*, 31 (3) p. 529–534.

Stearns, R.P. (1952) 'James Petiver—promoter of natural sciences, c. 1663–1718' in: *Proceedings of the American Antiquarian Society*, 62, p. 243–365.

Stijnman, A. (2012) *Engraving and Etching 1400–2000. A History of the Development of manual Intaglio Printmaking Processes*, Houten.

Stolberg-Wernigerode, O. zu (1957) 'Hermann Conring' in: *Neue deutsche Biographie*, Berlin, vol. 3, p. 342–343.

Stoll, N.R. (1961) 'Introduction' in: *International Code of Zoological Nomenclature adopted by the XV International Congress of Zoology*, London, p. vii–xvii.

Stolleis, M. (ed.) (1983) *Hermann Conring (1606–1681). Beiträge zu Leben und Werk*, Berlin.

Studienbuch, see Beer, W.-D. (ed.) (1976) and (2011).

Stuldreher-Nienhuis, J. (1945) *Verborgen Paradijzen. Het Leven en de Werken van Maria Sibylla Merian 1647–1717*, 2nd ed., Arnhem. First ed. 1944.

Sturm, L.C. (1704) *Die geöffnete Raritäten- und Naturalien-Kammer, worinnen der galanten Jugend, andern Curieusen und Reisenden gewiesen wird, wie sie Galerien, Kunst- und Raritäten-Kammern mit Nutzen besehen und davon raisoniren sollen [...]*, Hamburg: resolver. staatsbibliothek-berlin.de/SBB00019oD3ooooooo.

Swammerdam, J. (1669) *Historia Insectorum generalis ofte Algemeene Verhandeling van de bloedeloose Dierkens [...]*, Utrecht.

Swammerdam, J. (1675) *Ephemeri Vita. Of Afbeeldingh van 's Menschen Leven, vertoont in de wonderbaarlijcke en nooyt gehoorde Historie van het vliegent ende een-daghlevent Haft of Oever-aas [...]*, Amsterdam.

Swammerdam, J. (1737–1738). *Bybel der Natuure [...] = Biblia Naturae [...]*, 2 vols., Leiden.

Swan, C. (1995) 'Ad vivum, naer het leven, from the life. Defining a mode of representation' in: *Word & Image*, 11 (4), p. 353–372.

Tang, D.J. (2013), *Slavernij. Een Geschiedenis*, Zutphen.

Taegert, W. (1997) '"Deß Menschen leben ist gleich einer Blum". Stammbuch-Aquarelle der Maria Sibylla Merian' in: K. Wettengl (ed.), *Maria Sibylla Merian, 1647–1717. Künstlerin und Naturforscherin*, Ostfildern, p. 88–93.

Te, see Rijdt.

[Testas de Jonge, P.] [1744]. *Catalogue d'un manifique [sic] Cabinet de Papier de Coupe, par feu Demoiselle Johanna Koerten Epouze de feu Monsieur Adriaan Blok, découpé en Papier avec les siseaux [sic]. Avec l'Album relatif à la Découpure [...] = Catalogus van een overheerlyk Konstkabinet Papiere Snykonst, door wylen Mejuffrouw Johanna Koerten, Huisvrouw van wylen den Heer Adriaan Blok, met de Schaar in Papier gesneeden; Benevens de relative Stamboeken, [...]*, Amsterdam. Rijksmuseum Research Library, Amsterdam, shelf no. 321/E/11.

Theunissen, B. & C. Hakfoort (eds.) (1997) *Newtons God en Mendels Bastaarden. Nieuwe Visies op de 'Helden van de Wetenschap'*, Amsterdam/Leuven.

Thöne, F. (1967) 'Bemerkungen zu Baurissen, Veduten und Künstlerzeichnungen in der Herzog-August-Bibliothek zu Wolfenbüttel' in: *Niederdeutsche Beiträge zur Kunstgeschichte*, 6, p. 167–206.

Thomassen, K. (ed.) (1990) *Alba Amicorum. Vijf Eeuwen Vriendschap op Papier gezet. Het Album Amicorum en het Poëziealbum in de Nederlanden*. Maarssen/The Hague.

Thompson, H. (2014) *Chernobyl's Bugs. The Art and Science of Life after nuclear Fallout*: www.smithsonianmag.com/arts-culture/chernobyls-bugs-art-and-science-life-after-nuclear-fallout-180951231/.

Tradescant, J. (1656) *Museaum Tradescantianum, or, a Collection of Rarities preserved at South-Lambeth neer London*, London.

Trew, C.J. (1750–1773) *Plantae Selectae [...]*, Augsburg.

Uffenbach, Z.C. von (1745) *Merkwürdige Reisen durch Niedersachsen, Holland und Engelland*, vol. 3, Ulm/Memmingen.

Uhl, A. (2021) 'Die "Plantae selectae" von Christoph Jacob Trew im wissenschaftlichen Kontext der neuzeitlichen Botanik' in: Dickel, H., E. Engl & U. Rautenberg (eds.) *Frühneuzeitliche Naturforschung in Briefen, Büchern und Bildern. Christoph Jacob Trew als Sammler und Gelehrter*, Stuttgart, p. 269–288.

Ullmann, E. (ed.) (1974) *Maria Sibylla Merian. Leningrader Aquarelle*, 2 vols., Leipzig. All illustrations of vol. I are available on the web: http://ranar.spb.ru/rus/vystavki/id/130/.

Ullmann, E. (1974) 'Maria Sibylla Merian—her time, her life and her work' in: E. Ullmann (ed.) *Maria Sibylla Merian. Leningrader Aquarelle*, II. Kommentar, Leipzig, p. 15–75.

Valentijn, F. (1726) *Verhandeling der Zee-horenkens en Zee-gewassen in en omtrent Amboina [...]*, Amsterdam/Dordrecht.

Valiant, S.D. (1992) 'Questioning the caterpillar' in: *Natural History*, 101 (12), p. 46–59.

Valiant, S. (1993) 'Maria Sibylla Merian. Recovering an eighteenth-century legend' in: *Eighteenth-Century Studies*, 26 (3) p. 467–479.

Valter, C. (2021) 'Bürgerliche Kunst- und Naturalienkabinette in Nürnberg' in: C. Sauer (ed.), *Wunderkammer im Wissensraum. Die Memorabilien der Stadtbibliothek Nürnberg im Kontext städtischer Sammlungskulturen*, Wiesbaden, p. 113–126 (*Beiträge zur Geschichte und Kultur der Stadt Nürnberg* 27).

Van, see Benthem Jutting, Deinsen, Delft, Duijn, Eeghen, Plas, Roemer, Waals.

Vincent, L. (1706) *Wondertooneel der Nature, [...]*, Amsterdam.

Vincent, L. (1726) *Catalogus et Descriptio Animalium volatilium, Reptilium, & aquatilium [...] = Catalogue et Description des Animaux volatils, aquatils, et des Reptiles [...]*, The Hague.

Vogel, B.C. (1790) *Supplementum Plantarum Selectarum quarum Imagines Manu artificiosa doctaque pinxit Georgius Dionysius Ehret [...]*, [Augsburg].

Volkamer, J.C. (1708–1714) *Nürnbergische Hesperides, oder, gründliche Beschreibung der edlen Citronat- Citronen- und Pomerantzen-Früchte [...]*, Nuremberg.

Volkamer, J.C. (1714) *Continuation des Nürnbergischen Hesperidum, oder, fernere gründliche Beschreibung der edlen Citronat, Citronen, und Pomerantzen-Früchte [...] Benebenst einem Anhang von etlichen raren und fremden Gewächsen, Der Ananas, des Palm-Baums, der Coccus-Nüsse, der Baum-Wolle u.a.m. welche ebenfalls in Kupffer-Rissen vorgestellet sind*, Nuremberg/Frankfurt/Leipzig.

Von, see Goethe, Kries, Sandrart, Wilckens.

Vosmaer, A. (1800) *Catalogue de Livres en plusieurs Langues & Facultes, principalement d'Histoire Naturelle [...] delaissés par feu M. Arnout Vosmaer [...]*, The Hague.

Waals, J. van der (1992) 'Met boek en plaat. Het boeken- en atlassenbezit van verzamelaars' in: E. Bergvelt & R. Kistemaker (eds.), *De Wereld binnen Handbereik. Nederlandse Kunst- en Rariteitenverzamelingen, 1585–1735*, Zwolle, p. 205–231.

Waarneming (undated): www.waarneming.nl.

Waquet F. (1991) 'Les savants face à leurs portraits' in: *Nouvelles de l'Estampe*, 117, p. 22–28.

Warren, G. (1669), *Een onpartydige Beschrijvinge van Surinam, gelegen op het vaste Landt van Guiana in Africa [...]*, Amsterdam.

[Weise, Christian] (1673) *Eine andere Gattung von den überflüssigen Gedancken in etlichen Gesprächen vorgestellet von D.C.*, Leipzig.

Weller, S. (2017) 'Maria Sibylla Merian. Einige Beobachtungen zu ihrem Werk' in: M. Roth, M. Bushart & M. Sonnabend (eds.), *Maria Sibylla Merian und die Tradition des Blumenbildes von der Renaissance bis zur Romantik*, Munich, p. 161–189.

Wettengl, K. (1997) (ed.) *Maria Sibylla Merian 1647–1717. Künstlerin und Naturforscherin*. Ostfildern. Exhibition catalogue, Historical Museum Frankfurt.

Wettengl, K. (1998) (ed.) *Maria Sibylla Merian. Artist and Naturalist*, Ostfildern. Exhibition catalogue, Historical Museum Frankfurt

Wettengl, K. (2003) *Von der Naturgeschichte zur Naturwissenschaft. Maria Sibylla Merian und die Frankfurter Naturalienkabinette des 18. Jahrhunderts*, Stuttgart (*Kleine Senckenberg-Reihe* 46).

Wettengl, K. (2014) 'Mensch. Tier. Stadt', in: K. Knicker & K. Wettengl, *Arche Noah. Über Tier und Mensch in der Kunst*, Dortmund, p. 19–22. Exhibition catalogue, Museum Ostwall im Dortmunder U.

Wettengl, K. (2014) 'Naturzerstörung', in: K. Knicker & K. Wettengl, *Arche Noah. Über Tier und Mensch in der Kunst*, Dortmund, p. 81–83. Exhibition catalogue, Museum Ostwall im Dortmunder U.

Weyerman, J.C. (1729) 'Withoos' in: *De Levensbeschryvingen der Nederlandsche Konstschilders en Konstschilderessen*, vol. 2, p. 240–243, The Hague: archive.org/details/delevensbeschryv02weye/page/240/mode/2up?q=withoos.

Whitmore, P.J.S. (1967), *The Order of Minims in seventeenth-century France*. The Hague 1967.

Wijnands, D.O. (1983) *The Botany of the Commelins [...]*, Rotterdam.

Wilckens, L. von (1982) '"Baderleins Geschnür und Geschling". Über Perlenarbeiten im 17. und 18. Jahrhundert' in: *Kunst und Antiquitäten*, 7, p. 58–63.

Wilckens, L. von (1997) *Geschichte der deutschen Textilkunst. Vom späten Mittelalter bis in die Gegenwart*, Munich.

Willnau, C. (1926) *Ledermüller und v. Gleichen-Rußworm. Zwei deutsche Mikroskopisten der Zopfzeit*, Leipzig.

Wilson, D.S. (1970–1971) 'The Iconography of Mark Catesby' in: *Eighteenth Century Studies*, 4, p. 169–183.

Winter, E. (1961) 'Frisch, Johann Leonhard' in: O. zu Stolberg-Wernigerode et al. (eds.), *Neue deutsche Biographie*, vol. 5, Berlin, p. 616.

Wirth, B. (2007) 'Maria Sibylla Merian, Baltasar Scheid und Richard Bradley. Die Künstlerin und Naturforscherin, ein Kaufmann und ein Botaniker' in: *Annals of the History and Philosophy of Biology*, 12, p. 115–153.

Wirth, B. (2014) 'Maria Sibylla Merian, Baltasar Scheid and Richard Bradley—some remarks on their letters and on incorrect transcriptions and translations of Merian letters' in: *Proceedings of the Symposium "Exploring M.S. Merian"*, Amsterdam: www.themariasibyllameriansociety.humanities.uva.nl/research/essays2014/.

Wit, H.C.D. de (ed.) (1959) *Rumphius Memorial Volume*, Baarn.

Zaal, A (1991) *Herman Henstenburgh (1667–1726) Hoorns Schilder en Pasteibakker*, Hoorn.

Zeiller, M. (1659) *Topographia Germaniae inferioris [...]*, 2nd edition, Frankfurt am Main.

Zeiller, M. (1663), *Topographia Alsatiae, &c. completa [...]*, 2nd edition, Frankfurt am Main.

Zemon Davis, N., see Davis.

Zu, see Stollberg-Wenigerode.

Zwollo, A. (1972) *Hollandse en Vlaamse Veduteschilders te Rome 1675–1725*, [Amsterdam].

Index

About the authors

Lieke van Deinsen is an assistant professor of historical Dutch literature at KU Leuven. She conducts research on the visual representations of female authorship and authority in early modern Europe. In 2017 she completed her PhD on processes of literary canon formation (*Literaire erflaters. Canonvorming in tijden van culturele crisis*). As the Rijksmuseum's Johan Huizinga Fellow, she published *The Panpoëticon Batavûm. The Portrait of the Author as a Celebrity* (2016).

Marieke van Delft was until her retirement in March 2021 curator of Early Printed Editions at KB, national library of the Netherlands. She publishes on the history of the book in the Netherlands in various periods, and co-edited the facsimile of M. S. Merian, *Metamorphosis insectorum Surinamensium* (2016). In 2019, together with her husband, she published *De geschiedenis van Nederland in 100 oude kaarten*.

Yulia Dunaeva is a scientific researcher at the Library of the Zoological Institute in Saint Petersburg, a department of the Library of the Russian Academy of Sciences. Her scientific interests are centered around the European zoological literature of the sixteenth to eighteenth centuries. She studies the historical origins of the collection of old, rare zoological books held in the Library of the Russian Academy of Sciences and has published several papers on the subject.

Kay Etheridge is a Professor of Biology Emeritus at Gettysburg College and an editor of the Brill book series, *Emergence of Natural History*. Her publications in physiology and ecology include studies on tropical bats, manatees, lizards, and salamanders. She contributed to the facsimile of M. S. Merian, *Metamorphosis Insectorum Surinamensium* (2016), and is one of the founding members of the Maria Sibylla Merian Society. Her current scholarship centers on the integration of natural history images and the history of biology. Her most recent publications examine artist-naturalist Merian's biological contributions, such as the book *The Flowering of Ecology: Maria Sibylla Merian's Caterpillar Book* (2021).

Anja Grebe is Professor of Cultural History and Collection Studies at Danube University Krems. After completing her PhD in art history in 2000, she worked as an assistant curator at the Germanisches Nationalmuseum in Nuremberg. Grebe has taught art history at different universities in Germany. In 2017 she was co-curator of the Merian exhibition at the Stadtbibliothek Nürnberg. Her research focuses on the history of collecting, book illustration, and the intersections between art and science.

Kate Heard is Senior Curator of Prints and Drawings, Royal Collection Trust, and a Fellow of the Society of Antiquaries of London. She was curator of *Maria Merian's Butterflies* (The Queen's Galleries, London and Edinburgh, 2016/17) and authored the book which accompanied this exhibition.

Eric Jorink holds the Teylers chair "Enlightenment and Religion" at Leiden University and is senior researcher at the Huygens Institute (Royal Netherlands Academy of Art and Sciences). He has published on scientific culture in early modern Europe, including the culture of collecting, the relation between art and science, and the emergence of radical biblical criticism. He is currently leading the international project *Visualizing the Unknown: Scientific Observation, Representation and Communication in 17th-century Science and Society* (2021–2026; funded by the Dutch Council for Scientific Research, NWO). Jorink is currently finishing a biography of the microscopist Johannes Swammerdam.

Margot Lölhöffel has researched Maria Sibylla Merian's life and work for more than ten years, using methods borrowed from the Social Sciences. She is particularly interested in the beginning of Merian's extraordinary career in Nuremberg, and is supported by her husband and by citizens interested in garden culture and natural history. Lölhöffel has published the results of this project on a multifaceted website (www.merianin.de). Boosted by Merian's growing popularity as the "first ecologist," she is currently developing new projects for protecting nature and biodiversity in urban settlements.

Arthur MacGregor is currently a visiting professor at the V&A Research Institute; formerly he was for almost thirty years a curator at the Ashmolean Museum. He has a DLitt from Durham University, has published more than a dozen edited volumes and is sole author of a further four. A founding editor of the *Journal of the History of Collections*, he is also co-general editor of *The Paper Museum of Cassiano dal Pozzo*.

Henrietta McBurney is an art historian and curator. She was formerly curator in the Royal Library, Windsor Castle (1983–2002). Her particular interest in the intersection of art and science has resulted in publications such as *The Florilegium of Alexander Marshal at Windsor Castle* (2000), *Birds, Animals and Natural Curiosities: The Paper Museum of Cassiano dal Pozzo* (2017), and *Illuminating Natural History: The Art and Science of Mark Catesby* (2021).

Liesbeth Missel retired in 2021 as curator of Special Collections, Academic Heritage and Art at the Wageningen University & Research (WUR) Library. Starting as an assistant, she worked at the Special Collections for almost forty years, becoming the curator in 2000. Prior to that, she studied history at Utrecht University, focusing on social and cultural actors in the use and imagery of nature and landscape.

Alicia Montoya is Principal Investigator of the ERC-funded MEDIATE project (www.mediate18.nl) and Professor of French Literature at Radboud University in Nijmegen. She is the author of *Medievalist Enlightenment: From Charles Perrault to Jean-Jacques Rousseau* (2013), *Marie-Anne Barbier et la tragédie post-classique* (2007), and has co-edited several volumes, including *Lumières et histoire = Enlightenment and History* (2010) and *Literaire bruggenbouwers tussen Nederland en Frankrijk. Receptie, vertaling en cultuuroverdracht sinds de middeleeuwen* (2017).

Hans Mulder is curator of natural history at the Allard Pierson, the collections of the University of Amsterdam, and keeper of Artis Library. He teaches and publishes on natural history and the history of the book. Mulder co-edited the facsimile of M. S. Merian, *Metamorphosis Insectorum Surinamensium* (2016), and authored *De ontdekking van de natuur* (2021), for which he received the Jan Wolkersprijs for best nature book in the Netherlands.

Jadranka Njegovan lives and works in The Hague. As a student of horticulture at the University of Zagreb in the early 1980s, she made drawings for the Entomology department. Years later she studied art at the Royal Academy of Art in The Hague. Since 2000, she works as an autonomous artist and occasionally as an illustrator. She considers herself a visual artist and gardener with an interest in entomology.

Florence F.J.M. Pieters studied biology and philosophy of science at Radboud University in Nijmegen. In 1969 she was appointed as scientific librarian (and later curator) of the Artis Library, University of Amsterdam. From 1974 until 2000 she also acted as managing editor of the scientific journal *Contributions to Zoology*. Since her retirement, she continues her investigations into the history of early Dutch collections and collectors of natural history, working as guest researcher at the Artis Library.

Joos van de Plas is a visual artist whose oeuvre is based on intensive research. In the course of this work she came upon *Metamorphosis Insectorum Surinamensium* by M. S. Merian. From that point on, Merian's legacy became a powerful source of inspiration. This led her to Suriname, as well as various museums and their depots and a number of important libraries. The discoveries she made in these places are the motivation for her visual work.

Jaya Remond is Assistant Professor of Art History in the Department of Art History, Musicology and Theater Studies at Ghent University. She works on early modern Northern European art, with a particular focus on drawing and print cultures at the intersection of art and science. She has published on art pedagogy and drawing manuals in Northern Europe, on botany and picture making, and on the circulation of prints in early modern Europe.

Bert (G. M.) van de Roemer is a senior lecturer at the Cultural Studies department of the University of Amsterdam. His fields of interest are the history of collections, the relationship between the visual arts and the natural sciences in the past and present, and modern museology. He has published on several subjects, including the Dutch collectors Simon Schijnvoet, Frederik Ruysch, Levinus Vincent, and Maria Sibylla Merian, and the art theorists Samuel van Hoogstraten and Willem Goeree.

Christine Sauer studied Art History at the University of Delaware and finished her PhD at the Ludwig-Maximilians-Universität, Munich, in 1990. Her dissertation was published as *Fundatio und memoria: Stifter und Klostergründer im Bild, 1100 bis 1350* (1993). From 1991 to 1995 she worked on the *Catalogue of gothic illuminated manuscripts at the Württembergische Landesbibliothek, Stuttgart*. Since 1996, she is head of the Department of Historical Collections at the Stadtbibliothek Nürnberg. In 2017 she curated the anniversary-exhibition on Merian in the Stadtbibliothek Nürnberg.

Katharina Schmidt-Loske is Head of Biohistoricum at Leibniz Institute for the Analysis of Biodiversity Change, Museum Koenig in Bonn. She studied Biology at the Universities of Münster and Bonn and gained her doctorate at the Faculty of Mathematics and Natural Sciences at Bonn University. Her field of interest is the history of biology. Her latest publica-

tion is *Maria Sibylla Merian Briefe 1682 bis 1712* (2020).

Cynthia Snow is a poet. Her writing has appeared in the *Massachusetts Review, Crannóg, Plant-Human Quarterly*, and elsewhere. Her poetry has been nominated for a Pushcart Prize, and her chapbook, *Small Ceremonies*, was published by Slate Roof Press. Her poem, "To Maria, the Naturalist, from Esther, the Arawak Servant," earned an Honorable Mention in the Robinson Jeffers Tor House 2017 Prize for Poetry. She holds an MFA in Poetry, works at Greenfield Community College, and lives in Shelburne Falls, Massachusetts.

Kurt Wettengl, art historian, DPhil, was director of the Museum am Ostwall in Dortmund until 2015. Before that, he was deputy director of the Historical Museum Frankfurt, where he headed the painting collection and the graphics collection since 1991. He is curator of numerous exhibitions and author and editor on the art of the late Middle Ages, the Baroque (Georg Flegel, Maria Sibylla Merian, Wettstreit der Künste), and the nineteenth century, as well as contemporary art and cultural history. The exhibition he curated on Maria Sibylla Merian (1997/98) was also shown at the Teylers Museum in Haarlem. He teaches at TU Dortmund University as an honorary professor of art history since 2008.

www.lannoo.com

Register on our website to regularly receive a newsletter with
information about new books and interesting exclusive offers.

Edited by Bert van de Roemer, Florence Pieters, Hans Mulder, Kay Etheridge & Marieke van Delft
Managing editor: Marieke van Delft
English copy-editor: Dutton Hauhart

Design: Studio Lannoo in collaboration with Keppie & Keppie
Cover image: M.S. Merian, 'Branch of Pomelo with Green-Banded Urania Moth',
from M.S. Merian, *Metamorphosis Insectorum Surinamensium*, Amsterdam 1705,
plate 29 (detail), hand-colored etching, 52 x 35 cm (page). KB, National Library of the Netherlands, The Hague, KW 1792 A 19.
Frontispiece: Attributed to J. Marrel, Portrait of 32-year old Maria Sibylla Merian, 1679,
oil on canvas, 59 x 50.5 cm. Kunstmuseum Basel.

This book includes material presented at the Maria Sibylla Merian conference of 2017,
Changing the Nature of Art and Science. Intersections with Maria Sibylla Merian,
and additional new work. The conference was organized by the Maria Sibylla Merian Society
(www.themariasibyllameriansociety.humanities.uva.nl), which also supervised this publication.

With special thanks to the Artis Library, Allard Pierson (Amsterdam) and
the KB, National Library of the Netherlands (The Hague) for their photographs

Sponsored by the Amsterdam University Fund (Artis Library Fund)

ALLARDPIERSON
De Collecties van de 🛡 Universiteit van Amsterdam